VIENNA
1·9·0·0
ART·ARCHITECTURE & ·DESIGN·

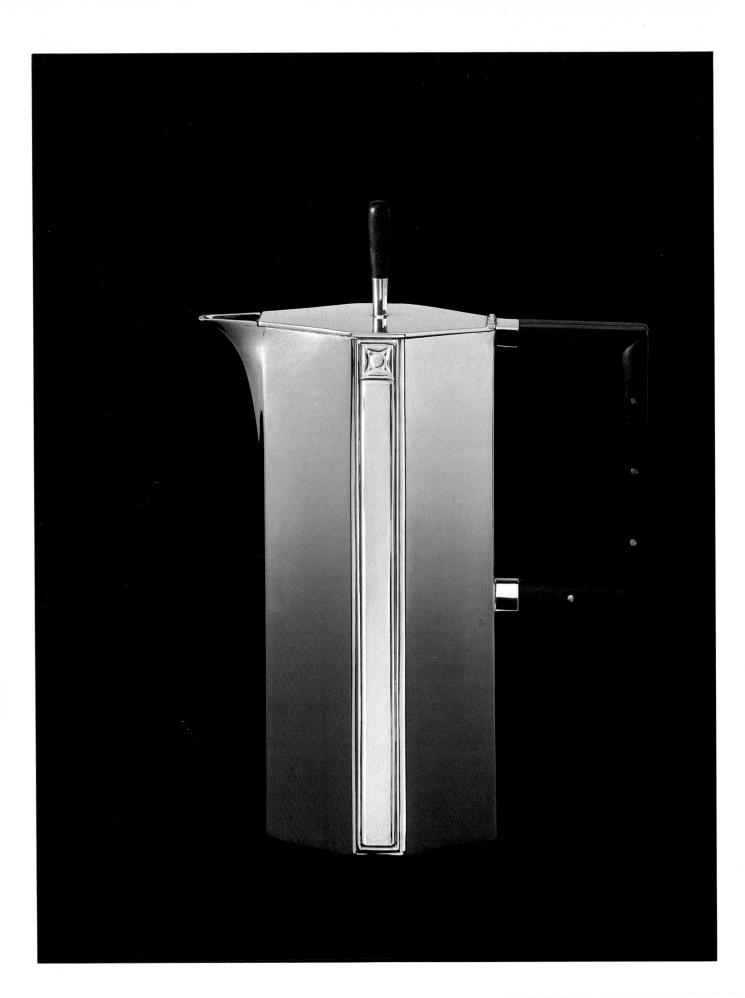

VIENNA
1·9·0·0
ART·ARCHITECTURE & ·DESIGN·

KIRK VARNEDOE

THE MUSEUM OF
MODERN ART
· NEW YORK ·

Published on the occasion of the exhibition
Vienna 1900: Art, Architecture & Design,
July 3–October 21, 1986, directed by Kirk
Varnedoe, Adjunct Curator, Department
of Painting and Sculpture, The Museum
of Modern Art

The Museum acknowledges, with gratitude,
generous support of this exhibition from
Mr. and Mrs. Ronald S. Lauder and the
Lauder family, and additional support from
The International Council of The Museum
of Modern Art. An indemnity for the
exhibition has been provided by the Federal
Council on the Arts and the Humanities.

Edited by James Leggio
Design and title lettering by Steven Schoenfelder
Production by Susan Schoenfeld
Typeset by Concept Typographic Services, New York
Printed by Princeton Polychrome Press, Princeton, New Jersey
Bound by Sendor Bindery, New York

Distributed outside the United States and Canada by
Thames and Hudson Ltd., London

The Museum of Modern Art
11 West 53 Street
New York, New York 10019

Printed in the United States of America
Second printing, 1986

Frontispiece: Josef Hoffmann. Coffeepot. 1905.
Silver and ebony, 9¾ × 6⅞ × 2¼″ (24.8 × 17.6 × 5.8 cm).
Private collection

Vignettes
P. 13: Steven Schoenfelder
P. 23: Josef Hoffmann. Vignette for *Ver Sacrum*. 1899
P. 77: Koloman Moser and Josef Hoffmann. Trademark
of the Wiener Werkstätte. c. 1903
P. 147: Oscar Dietrich. Detail of a decorative pattern
for a bowl designed by Josef Hoffmann. 1913
P. 217: Josef Hoffmann. Detail of a decorative pattern
for a wine glass. 1912

CONTENTS

FOREWORD

The exhibition which this book accompanies had its origins in the splendid exhibition of Viennese cultural history, *Traum und Wirklichkeit: Wien, 1870–1930*, presented at the Künstlerhaus in Vienna from March to October 1985. We are deeply indebted to the creators of that exhibition for their initial organization of a vast body of material, and for the valuable catalogue they established. Special gratitude is owed to Hofrat Dr. Robert Waissenberger, Direktor, Historisches Museum der Stadt Wien, who was responsible for the scholarly concept of *Traum und Wirklichkeit,* and to Prof. Hans Hollein, who designed the installation in Vienna. Despite the demands of their own exhibition and of their crowded schedules, both have given generously of their time, advice, and encouragement in our endeavors. *Traum und Wirklichkeit* was sponsored by the City of Vienna. The city, especially through Dr. Helmut Zilk, Landeshauptmann und Bürgermeister von Wien, and Franz Mrkvicka, Amtsführender Stadtrat für Kultur und Sport, has been continuously helpful and supportive in our efforts to shape the New York exhibition. We are also immensely grateful for the crucial assistance provided us by the Republic of Austria, and most especially by Dr. Heinz Fischer, Bundesminister für Wissenschaft und Forschung. The Commissioner named for the exhibition at The Museum of Modern Art was John Sailer, a longtime friend with whom it has been our pleasure to work on this project. We have been invaluably aided by his efforts on our behalf.

Much of the material presented in *Traum und Wirklichkeit* was also included in the exhibition shown at the Centre Georges Pompidou in Paris, *Vienne, 1880–1938: Naissance d'un siècle.* In arranging our own exhibition, we have depended greatly on the generous cooperation of the organizers of that exhibition, and most especially Jean Clair, Commissaire Général, and Martine Silie, Chef du Service des Expositions.

The preparation for our exhibition required considerable research in the rich collections in and around Vienna. Our work in this regard was greatly aided by the cooperation of many of the museum directors who also lent so generously to our exhibition: Hofrat Dr. Waissenberger, Historisches Museum der Stadt Wien; Hofrat Dr. Hubert Adolph, Österreichische Galerie; Hofrat Dr. Walter Koschatzky, Graphische Sammlung Albertina; Prof. Oswald Oberhuber, Hochschule für angewandte Kunst; Peter Noever, Österreichisches Museum für angewandte Kunst; Hofrat Prof. Peter Weninger, Niederösterreichisches Landesmuseum; Peter Baum, Neue Galerie der Stadt Linz/Wolfgang-Gurlitt-Museum; and Dr. Wilfried Seipel, Oberösterreichisches Landesmuseum, Linz.

In these various museums, our research also benefited from the patient aid and very helpful suggestions of many staff members. We would in this regard like especially to offer thanks to Dr. Erika Patka of the Hochschule für angewandte Kunst; Dr. Hanna Egger, Dr. Angela Völker, Dr. Elisabeth

Schmuttermeier, and Dr. Christian Witt-Dörring of the Österreichisches Museum für angewandte Kunst; Dr. Gunter Düriegl, Dr. Sylvia Wurm, Dr. Regina Forstner, and Dr. Renata Kassal-Mikula at the Historisches Museum der Stadt Wien; Dr. Richard Bösel of the Loos Archiv, Graphische Sammlung Albertina; and Dr. Gerbert Frodl of the Österreichische Galerie.

For their special help both with research and with matters relating to private loans in Vienna, we wish to thank Dr. Paul Asenbaum, Dr. Doris Langeder of the Österreichische Postsparkasse, and Dipl.-Ing. Rainer Pirker of Prof. Hollein's architectural office.

The International Council of The Museum of Modern Art has been a guiding force in our exhibition's organization from the outset. We thank Waldo Rasmussen, Director of the International Program, and Elizabeth Streibert, Associate Director, for their key help in this regard, and we extend special thanks to our Viennese members of the Council, H.S.H. Prinz Karl zu Schwarzenberg and Guido and Stephanie Schmidt-Chiari, for their support and encouragement, as well as Gregor and Beatrix Medinger of New York.

Among the many friends who have helped us in our project, we wish to convey our special thanks to Serge Sabarsky. Both personally and through the Serge Sabarsky Gallery, he has provided valuable information, guidance, and assistance. Not only his knowledge in the field of Viennese art, but also his skills as a diplomat, have been made available to us with the greatest generosity, and we are very appreciative. For special assistance with particular loans, we also thank Furio Colombo, of FIAT, U.S.A. Several knowledgeable dealers in Viennese art have helped us locate and obtain key loans, and have been patient and responsive in the face of countless demands on their time. Jane Kallir of the Galerie St. Etienne, and her co-director, Hildegard Bachert, have been valued guides in the area of paintings and drawings. Wolfgang Ritschka of the Galerie Metropol and Barry Friedman of Barry Friedman, Ltd., have informed us in the field of design, and have helped us gain entrée to numerous collections. Frank Maraschiello of Modernism Gallery has also been helpful. We thank as well Max Protetch of the Max Protetch Gallery and Ian Dunlop of Sotheby, Inc., for their aid in determining object valuations. In Vienna, we wish especially to thank Dr. Paul Asenbaum for his very generous cooperation in obtaining loans, providing photographs, and lending us research materials.

In matters of archival research, William B. Walker and his assistant Patrick Coman of the library of The Metropolitan Museum of Art, and Friederike Zeitlhofer of the Austrian Institute, have kindly facilitated our work. The cooperation and lively support of the Austrian Institute have been important to us from the outset, and we appreciate the work of Dr. Wolfgang Petritsch, Director of the Austrian Information Service, in our behalf.

A very special debt of gratitude is owed to Ronald S. Lauder, a Trustee of this Museum and a dedicated and knowledgeable collector of Viennese art of this period, among his many collecting interests. Without Mr. Lauder's enthusiasm for this project, his determination that it should be realized, and his generous financial support to help make this possible, the exhibition might never have been presented in New York. We are also most grateful to other members of the Lauder family—Jo Carole Lauder, Estée Lauder, and Evelyn and Leonard Lauder—for very graciously and generously assisting this project.

The exhibition is also supported by an indemnity from the Federal Council on the Arts and the Humanities, for which we are deeply grateful.

We thank Mr. and Mrs. Milton Petrie for making possible the concert series of modern Viennese music organized in conjunction with this exhibition. The idea for such a series, in collaboration with the 92nd Street Y, was originally proposed by Ethel Shein, Executive Assistant to the Director. Omus Hirshbein, Director of Performing Arts of the 92nd Street Y, created and expertly planned the exceptional programs.

An extensive educational brochure in newspaper form accompanies the exhibition. The brochure was produced through the great generosity of the *Star-Ledger,* Newark, New Jersey. We wish to acknowledge the special assistance of Virginia Coleman, Director of the Department of Special Events, in the realization of the brochure project and the concert series.

The exhibition's organization has depended upon the extraordinary skill and perseverance of the director of the exhibition in New York, Kirk Varnedoe, Professor of Fine Arts at the Institute of Fine Arts of New York University and Adjunct Curator in the Museum's Department of Painting and Sculpture. With differing versions of the exhibition in three cities and other conflicting loan commitments, the preparation of this exhibition was unusually complex, even daunting. Mr. Varnedoe surmounted these challenges with expertise, sensitivity, and formidable energy. He also found time to write the lucid text of this book and to plan and select its illustrations. We owe him our great admiration as well as our warm thanks.

Finally, however, the crucial contribution to any exhibition is necessarily the generosity of lenders. The many individuals and institutions in Austria and throughout Europe and the United States who graciously lent to this exhibition are listed elsewhere in this book. We are deeply grateful to all of them for consenting to part with their works for a lengthy period. We hope that the final result well justifies the sacrifices involved, and we express to them our most sincere appreciation.

Richard E. Oldenburg
Director, The Museum of Modern Art

· ACKNOWLEDGMENTS ·

I owe much more than can be expressed here to the two people who have worked most closely with me on this project, Diane Farynyk and Gertje Utley. Ms. Farynyk has done a superhuman job of controlling a vast, unwieldy, and often-changing checklist of loans and lenders, entailing back-breaking amounts of correspondence and exceptional tenacity with matters of detail. She has at the same time organized the mammoth photo archive required for the exhibition and for this publication, and has prepared the chronology included here. Mrs. Utley has provided, by dint of her outstanding work as researcher, a substantial part of my contact with the literature on Vienna and Viennese art. Her work is immediately reflected in the annotation of my texts, and she has also prepared the bibliography for this book. Without the self-sacrificing labors, indefatigable good spirits, and general professional excellence of these two collaborators, neither exhibition nor book would have been possible.

I am also grateful to Susan Forster for exceptional efforts in coordinating photographs and for invaluable help with key documentation, to Lisa Kurzner for assistance at a key moment, and to Ruth Priever for countless instances of help with communication and correspondence.

The task of preparing *Vienna 1900* was originally entrusted to me by William Rubin, Director of the Department of Painting and Sculpture, and I have benefited throughout my work from his unfailing support in all matters. He has repeatedly put at my disposal not only the powerful resources of his department but also his store of experience and insight, and I am deeply appreciative. I would like as well to thank Richard Oldenburg, Director of the Museum, for all the work he has done to advance this exhibition project and for his kind personal support. The directors of other departments within the Museum have lent works to the exhibition and have responded generously to my requests for information and assistance. In this regard I convey my gratitude to Arthur Drexler, Director of the Department of Architecture and Design, as well as to Cara McCarty, Assistant Curator in the same department; to Riva Castleman, Director of the Department of Prints and Illustrated Books; to Janis Ekdahl, Assistant Director of the Library of the Museum; and to John Elderfield, Director of the Department of Drawings, who was especially responsive at a key moment in early loan negotiations. Carolyn Lanchner, Curator in Painting and Sculpture, who had been deeply involved with the project for a Vienna exhibition at an early stage, has also given me much-appreciated help. Cora Rosevear, Assistant Curator in Painting and Sculpture, has aided me with special problems of loan arrangements; and Rose Kolmetz, Research Consultant in the Museum's International Program, has provided valuable help with matters of translation.

The handling of loans in such a complex exhibition has required exceptionally dedicated work on the part of all those connected with the transport, protection, and installation of the large and diverse group of objects. Lynne Addison, Assistant Registrar, has been superbly efficient and attentive in this regard, working closely with the Registrar, Eloise Ricciardelli, and with Elizabeth Streibert of the International Program, to make the process move in mercifully smooth fashion. To all of them, deep thanks. The very difficult tasks of arranging lists for funding and indemnity applications, and of overseeing the budgets of the exhibition project, fell to Richard L. Palmer, Coordinator of Exhibitions, who was unfailingly patient with the delays and changes involved; his guiding hand and help with the required procedures have been invaluable, and offered with appreciated calm and good humor. I also thank Marjorie Frankel Nathanson, Curatorial Assistant in Painting and Sculpture, and Lacy Doyle, Grants Officer, for their work in connection with these same applications. The numerous challenges of the complex installation have been in the talented hands of Jerome Neuner, Production Manager, Exhibition Program. Jerry has committed himself to this task with a special intensity and devotion to thoroughness, and his involvement has been not only superbly effective in giving the art its proper environment, but also in inspiring everyone connected with the project. The Department of Conservation is also to be thanked for their work in assuring the proper handling and protection for all the loans entrusted to us. Philip Yenawine, Director of Education, and Emily Kies, Associate Educator, have overseen with characteristic acuity our preparation of exhibition texts, related lectures, and brochures. James Faris, Director of Graphics, has also contributed his considerable talents to these aspects of preparation. And throughout, Jeanne Collins, Director of Public Information, Jessica Schwartz, Associate Director, and Deborah Epstein Solon, Press Assistant, have energetically sought to assure the broadest dissemination of information regarding the exhibition. I wish to thank, too, John Limpert, Jr., Director of Development, for his efforts in behalf of the exhibition.

The preparation of the present publication has been a separate task, often made doubly difficult by the vicissitudes of the exhibition's progress. Louise Chinn, Acting Director of Publications and Retail Operations, has supervised this demanding project, in collaboration with Harriet Bee, Managing Editor, and Tim McDonough, Production Manager. Susan Schoenfeld has skillfully organized the exceptionally complex production process, and James Leggio has been the project editor. Richard Tooke, Supervisor of Rights and Reproductions, and Frances Keech, Permissions Editor, have also had important roles to play, and Kate Keller, Chief Fine Arts Photographer, along with Mali Olatunji, Fine Arts Photographer, contributed to our prepara-

tions. All of these colleagues have worked under very demanding time constraints, and have repeatedly been called on to do the impossible. I am deeply grateful to all of them, and especially to James Leggio, whose keen attention to my texts has saved numerous errors and contributed countless improvements. I would also like to express my admiration and thanks for the work of Steven Schoenfelder, the designer of this book, with whom it has been a great pleasure to work.

Many friends helped my efforts to understand Vienna and its art. Early on, Christianne Crasemann-Collins kindly shared with me the texts of her recent writings on the subject. Carl Schorske has also been tremendously helpful, not only through his excellent scholarship in the field, but also through his personal generosity and encouragement. I appreciate the advice offered by Christopher Wilk, of The Brooklyn Museum, in the area of design. Rosemarie Bletter was kind enough to help with my studies and writing in the areas of architecture and design, and both her suggestions and her encouragement were very valuable to me. I am exceptionally grateful to Mme Nele Haas-Stoclet and to Mme Jacques Stoclet for their superb generosity and hospitality, and for providing the excellent photographic documentation of the Palais Stoclet that adds so significantly to this publication.

A special debt is owed to those who not only made available to me their time and talents, but who provided indispensable personal support. Among those friends already cited in the Foreword, I would in this respect like to redouble the thanks offered to John Sailer, with whom it has been a great pleasure to work, and to Serge Sabarsky and Dr. Paul Asenbaum. Above all, to the small circle that was most directly in touch with the effects of relentless deadline pressures, and that provided constant help with matters of both spirit and intellectual substance, an exceptional acknowledgment: warmest gratitude to my brother, Sam Varnedoe, Jr., to Adam Gopnik, and most especially to my wife, Elyn Zimmerman, upon whose love, forbearance, and counsel I have depended.

K.V.

In this volume, a page reference in parentheses is given for an illustration that does not fall on the page where it is mentioned or on the facing page. In captions, the dimensions of a work of art are given in inches and centimeters; height precedes width, which is followed in sculpture and design objects by depth. Unless otherwise specified, all drawings and prints are works on paper, for which sheet size is given, and all architectural drawings are preparatory studies. Dimensions of illustrated books refer to page size. In captions for photographs of buildings and for architectural drawings, a city is indicated only if the building is not located in Vienna.

Many of the works in this book are not included in the exhibition of the same title; a checklist for that exhibition is available from The Museum of Modern Art.

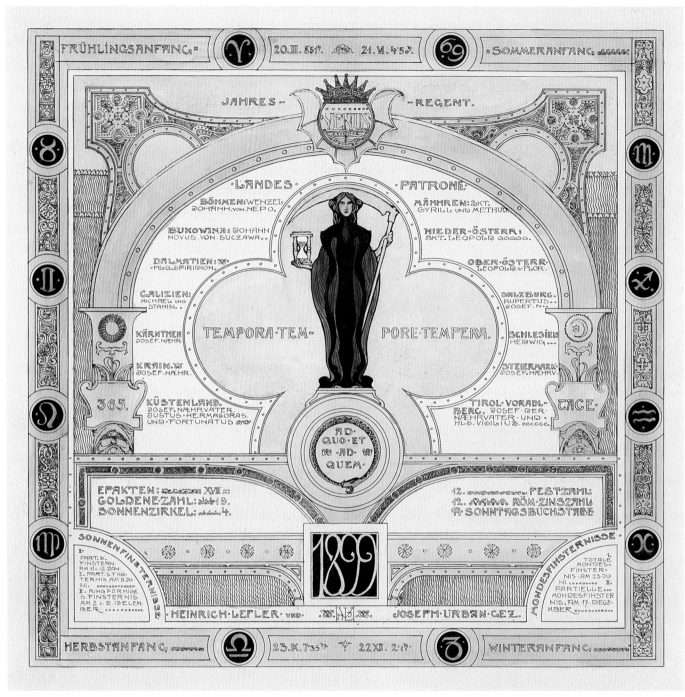

Heinrich Lefler and Josef Urban. Design for a Calendar. 1899. Pencil, ink, watercolor, gouache, and tempera, 15⅝ × 14⅜″ (39.7 × 36.6 cm). Österreichisches Museum für angewandte Kunst, Vienna. In addition to the signs of the Zodiac and a listing of the equinoxes and solstices, the design includes the provinces of Austria-Hungary and their patron saints.

INTRODUCTION

Out of the oil-smooth spirit of the two last decades of the nineteenth century, suddenly, throughout Europe, there rose a kindling fever. Nobody knew exactly what was on the way; nobody was able to say whether it was to be a new art, a New Man, a new morality or perhaps a re-shuffling of society. So everyone made of it what he liked. But people were standing up on all sides to fight against the old way of life. Suddenly the right man was on the spot everywhere; and, what is so important, men of practical enterprise joined forces with the men of intellectual enterprise. Talents developed that had previously been choked or had taken no part at all in public life. They were as different from each other as anything well could be, and the contradictions in their aims were unsurpassable. The Superman was adored, and the Subman was adored; health and the sun were worshipped, and the delicacy of consumptive girls was worshipped; people were enthusiastic hero-worshippers and enthusiastic adherents of the Man in the Street; one had faith and was skeptical, one was naturalistic and precious, robust and morbid; one dreamed of ancient castles and shady avenues, autumnal gardens, glassy ponds, jewels, hashish, disease and demonism, but also of prairies, vast horizons, forges and rolling-mills, naked wrestlers, the uprisings of the slaves of toil, man and woman in the primeval Garden, and the destruction of society. Admittedly these were contradictions and very different battle-cries, but they all breathed the same breath of life. If that epoch had been analysed, some such nonsense would have come out as a square circle supposed to be made of wooden iron; but in reality all this had blended into shimmering significance. This illusion, which found its embodiment in the magical date at the turn of the century, was so powerful that it made some hurl themselves enthusiastically upon the new, as yet untrodden century, while others were having a last fling in the old one, as in a house that one is moving out of anyway, without either one or the other party feeling that there was much difference between the two attitudes.

<div align="right">

Robert Musil, *The Man Without Qualities* (1930)[1]

</div>

With this mingling of remembered passion and gently smiling detachment the Austrian writer Robert Musil, then turning fifty, stirred back to life the reckless faiths of his youth. Yet today when we read Musil, or Stefan Zweig, or the other witnesses of Vienna at the turn of the century, fond nostalgia is inevitably haunted by the sense of a moment not merely past but irreparably destroyed.[2] World War I did not in fact end the urban life of Vienna, or its creative role in Europe. But a confluence of events made it seem that here, more than in any

Josef Divéky. Postcard for Emperor Franz Josef's Jubilee. 1908. Lithograph, 5½ × 3½" (14 × 8.9 cm). Collection Leonard A. Lauder

of the other Western capitals, the discontinuity brought by the war was absolute. The aged Emperor Franz Josef died in 1916, and within two years his army, the centuries-old Hapsburg Monarchy, and the empire all ceased to be. In 1918 Austria-Hungary disappeared from the map of Europe, and Vienna was left at the head of a drastically shrunken Austria, restructured beyond recognition. In the same year four of the men most responsible for the cultural energy of turn-of-the-century Vienna also died: the architect Otto Wagner, the designer Koloman Moser, and the painters Gustav Klimt and Egon Schiele. Certainly Musil and his contemporaries could feel that in this brief span a whole world of old certainties, and also of new energies, had disappeared—and that it could never be replaced in kind.

In retrospect, those who lived on realized that their vanished world had in fact always been one of ambiguities, undermined by disquieting fault lines. The empire itself seemed to have been built from top to bottom on the kind of compromise Musil's reminiscence evokes, of conflicting forces suspended in illusory concert. From the moment Franz Josef had come to the throne, on the heels of the revolution of 1848, he had negotiated his power with an ambitious new middle class determined to operate free of church and throne. By 1860 they had tied him to a constitution and wrested away control of the capital. In 1867 the state's power had then been circumscribed further following Austria's defeat at the hands of Prussia. The resulting treaty was another unwieldy compromise, setting Budapest and Vienna as semiautonomous partners in a dual Austro-Hungarian empire that extended from the Veneto to Russia and embraced eleven national groups with almost as many different tongues.

Size meant instability, not strength, for this ambiguous empire felt itself to be without a soul—deprived of any collective identity determined by blood or geography or tradition. Nothing in the bastardized form of the constitutional monarchy—neither dynastic right nor the "universal" Enlightenment values of the liberal politicians—offered any solid counterweight to the nationalist self-assertion and the emotional, intolerant longing for racial separation which set Germanic against Slavic factions at the end of the century. This conflict, manifest in violent disputes over laws determining the official language of the realm, eventually led the emperor to dissolve the assembly in 1897 and govern by decree.[3]

The one solid presence that seemed to hold everything together was the emperor himself, whose apparently indefatigable longevity the Viennese celebrated repeatedly, in a string of jubilees (1879, 1898, 1908) that it seemed would never end. In the heyday of Musil's remembered optimism, at the turn of the century, it was perhaps not so apparent that even this stability was the most dangerous of illusions, at odds with events in Franz Josef's life as well as his domain. Yet as the autumn parades of 1898 formed, when the emperor was nearing seventy and Musil was still a teenager, the sun of the world they shared had already passed beneath the yardarm. Franz Josef's only son, Crown Prince Rudolf, the heir apparent, had committed suicide with an illicit lover at the royal hunting lodge in Mayerling in 1889; and the Empress Elisabeth, the melancholy "Sissi," was assassinated by an anarchist in 1898, as Franz Josef was preparing for the jubilee ceremonies. "Nothing has been spared me in this life," the emperor said.[4] But there was more, and graver, to come; for, as the events at Sarajevo in 1914 were to prove, the vulnerability of this family, like the volatility of their empire, was not the stuff of local drama but of global tragedy.

In remembering Vienna, Musil and Zweig were haunted by this retro-

spective sense of ill-fated destiny. But when we read these authors today, our pain is doubled by our knowledge of the still worse fate that awaited them with the rise of Hitler and the diaspora of Viennese culture in the 1930s and 1940s. Inevitably we see the one through the other, foreshortening the sequence of history to make 1918 the end of everything: a still darker apocalypse, further intensifying the poignant luster of the epoch it ended. The double optic enlarges and exaggerates. Things that belonged to life everywhere in Europe at the turn of the century—*fin-de-siècle* world-weariness and doubt, hectic exuberance and social unrest, ascendant anti-Semitism—take on special portent in the case of Vienna.

Furthermore, the Nazi era and World War II cast a pall over the academic study of all modern Germanic culture, including Viennese, for a long time after 1945. In this sense, turn-of-the-century Vienna was trebly "lost"; and its intellectual and popular rediscovery in the past two decades has had the excitement of great archaeology—excavating a site that reveals a missing line in the genealogy of modern culture. Studies on Sigmund Freud and the genesis of psychoanalytic theory; on the formation of the philosopher Ludwig Wittgenstein; on the modernist composers Arnold Schönberg, Anton von Webern, and Alban Berg, and the newly revalued Gustav Mahler; and on the plays, poems, and prose of writers such as Arthur Schnitzler, Hugo von Hofmannsthal, and Karl Kraus—all these paths have in recent years converged, producing a new fascination with the city these creators all shared with compatriots as diverse as the founding Zionist Theodor Herzl and the young enthusiast of art and architecture, Adolf Hitler.

Nowhere has this resurgence been more dramatic than in the reevaluation of Vienna's contributions to early modern art. Histories of modern art and architecture conceived before the late 1960s made Paris the master center, with satellites in Berlin and Munich. The Vienna of Gustav Klimt's and Egon Schiele's paintings, or of Otto Wagner's and Josef Hoffmann's architecture, was relegated to the margins, as the pretty but unserious provincial domain of what would politely be referred to as specialized tastes. But in recent years serious studies of all these artists have appeared, coincident with a ground swell of appreciation that has dramatically increased the auction prices for artists such as Klimt and Schiele. Independently and as advertisement for the Vienna vogue, this school of painting has come by now to seem an essential part of the modern tradition. Similarly, the Art Deco revival and, especially, the advent of postmodernist architecture have created a climate of taste in which Vienna's legacy is more widely admired. Adolf Loos, the severe purist among Austrian architects, always had a cult following, but in recent years his detested enemies, Josef Hoffmann and the more decorative designers of the collaborative Wiener Werkstätte (Viennese Workshop), have attracted new devotees.

To the extent that this success of Viennese art is linked to Vienna's new place in the historical imagination, it is a perilous success, precisely because the new idea of Vienna is such a powerful and potentially deforming myth. That lost world, seen through the compound lens of late twentieth-century hindsight, has come to seem the classic fusion of decadence and genius: on the one hand, the guilty pleasures of *fin-de-monde* opulence and sensuality; and on the other, the familiar morality tale of an embattled modernist avant-garde steeled to challenge official order and tradition. "Secession-style," in the art of Klimt and Hoffmann and the other young Viennese artists who banded together against the establishment in 1898, has often been made to mean both things simultaneously. And a subcurrent of lurking, inexorable

Egon Schiele. *Arnold Schönberg.* 1917. Gouache and charcoal, 18⅛ × 11⅝" (46 × 29.5 cm). Private collection

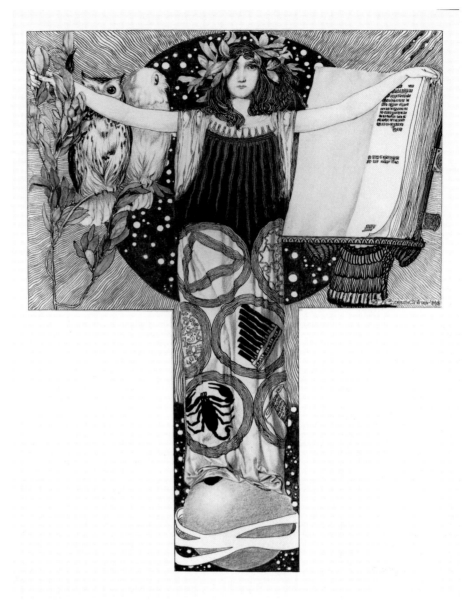

Carl Otto Czeschka. *Knowledge*. 1898. Pen and ink, 16¼ × 12″ (41.3 × 30.4 cm). Historisches Museum der Stadt Wien

fate—the retrospective knowledge that all this would be short-lived and end tragically—lends a Romantic savor to the sensuality, and pathos to the struggle for the new.

These are the elements of folklore, or more bluntly of cliché. Part Athens, part Babylon, Vienna before World War I has become a modern archetype of a doomed society, in which brilliant achievements glowed in the gathering twilight and new music covered distant thunder—the "gay apocalypse" of Hermann Broch, or, as Karl Kraus dubbed it, "a testing-lab for the end of the world."[5] The sentimental Vienna of another generation—the world of Johann Strauss's *Blue Danube,* of the Vienna woods and Linzer torte—has been superseded by its modern equivalent: the world of Richard Strauss's *Also sprach Zarathustra,* of genius and neurosis—a light opera rescripted by Spengler. It is worth noting that this constellation of ideas rose dramatically in American popular consciousness in the 1960s, when Klimt posters began appearing on every dormitory wall. Not only the proto-psychedelic sweet-

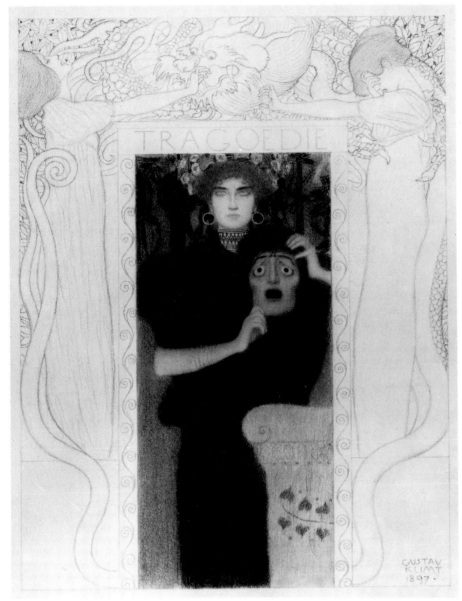

Gustav Klimt. *Tragedy* (for the portfolio *Allegorien, Neue Folge*). 1897. Crayon, pencil, wash, and gold, 16½ × 12⅛″ (41.9 × 30.8 cm). Historisches Museum der Stadt Wien

ness of *The Kiss*, but the whole romance of Vienna—heated sensuality amid swollen materialism, flowered idealism under looming guns—suited the temper of the time.

Within the narrower field of the history of art, pre–World War I Vienna has also become another kind of archetype: the classic instance of the arts intertwined not only with each other, but with their historical, physical, and intellectual setting. The rich concentration of so many innovators in all fields, in such a sharply delimited time and locale, has seemed ideal for an interdisciplinary approach. Indeed, some of the most revealing recent studies of Viennese art have come not from scholars of modern art, but from intellectual historians, joining the work of Klimt, Wagner, et al. to the conditions of Viennese politics or to the concerns of philosophers and poets.[6]

But these studies of art in context have a context of their own. They parallel specific revisionist rebellions within academic art history in the last twenty years, against what was seen as the ahistorical formalism underly-

ing the orthodox, Paris-first view of modern art's progress. And this contextualist vision of turn-of-the-century Vienna, for all that it has illuminated, itself risks becoming yet another cliché—with an artificial, sentimentally pleasing neatness that exaggerates on the one hand and compresses on the other, leveling out profound differences of ambition and of achievement. The "success" of Vienna in these art-historical terms also has its perils, and is in need of reexamination.

Unity was an essential part of the dream of the dead empire—impossible union among all its political and racial factions, and utopian harmony among all its artistic talents in the *Gesamtkunstwerk,* the total work of art. The recent archaeology of Vienna often follows the traces of this dream, and constructs anew—posthumously, conceptually, and in very different terms —the ideal of diverse artists bonded to each other and to the essential character of their time and locale. This is in turn a dream dreamed within another: that of a modern avant-garde art not homeless, but integrated into a real community. Klimt and Wagner and Loos thus become tablemates of Freud and Mahler and Wittgenstein at an imaginary coffeehouse for a shining moment in the city that was "the cradle of modernity." The deeper collaboration here thus may be between our unfulfilled longings and those of the Viennese artists we study.

The original Viennese *Gesamtkunstwerk* was best realized as a dazzling, temporary showpiece; but its limitations were ultimately stifling, in the preference for a perfect local harmony that excluded the incongruous variety of the larger world. The recent popular-historical construct of pre–World War I Vienna shares some of this same kind of excitement, bringing into powerful, if shallow, concert a host of contradictory currents in our popular, academic, and political life of the last decades. It also has this kind of limitation, in that the will to tie all Viennese developments most significantly to each other, and to the local conditions and traditions of the city, risks reimposing an isolating provincialism. The vision of Viennese art that favors proximate contexts over larger ones, and immediate associations over broader judgments—that would pair Klimt with Freud to the exclusion of, say, Rodin—can share this risk.

One of the most important routes to progress in any intellectual endeavor is the displacement of attention from the center of a canon to its margins, or the reestimation of undervalued traditions. In the history of art, we have recently witnessed just this process, in the powerful reconception of the origins and meanings of modernism brought about by a reconsideration of the Northern Romantic tradition.[7] But this kind of shift needs to transform the center, rather than simply fragment the field, before we really get somewhere new. If the new attention given to Vienna finally results only in intellectual Balkanization—in the proliferation of new dominions of Viennophile special interests—something important will have been missed. We have passed through a period of enthusiasm such as Musil remembered, when striking differences—of talent, of ambition, of achievement—have been held suspended in the "shimmering significance" of a new vision of turn-of-the-century Vienna. Now the artificiality of these alliances should become clearer; some of the components are powerful and provocative, while others are shallow, conventional, and overvalued by association with stronger neighbors. The challenge increasingly becomes, not to defend the idea of the "gay apocalypse," but to disassemble it, to learn something more balanced and expansive from its elements. ∎

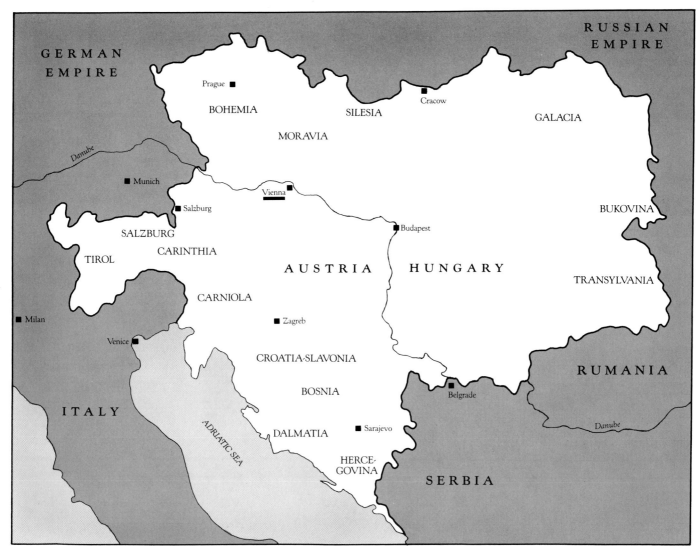

Map of Austria-Hungary in 1914, showing the fourteen major territorial divisions

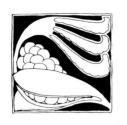

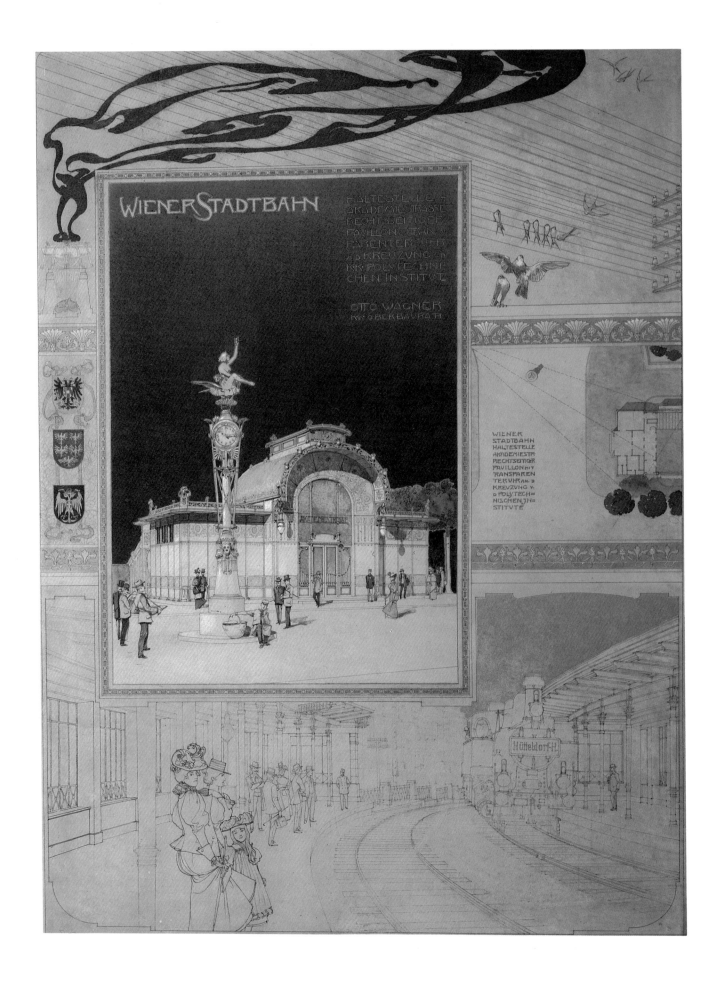

ARCHITECTURE

In talking about early modern architecture, we often look at buildings from the inside out, stressing underlying materials or structures as the pivots on which history turned. But in Vienna the interesting battles are waged on the surface. A concern for façade, symbol, and decoration—exactly those things the Viennese most aggressively claimed to have left in the past—was their special contribution to modernism.

Modernist polemics in Vienna had a particular bogeyman, the Ringstrasse. This broad boulevard circling the inner city was laid out over the old fortification lines around 1860, and then built up with an imposing array of public and private buildings in a hodgepodge of revival styles: neo-Greek Parliament, neo-Gothic City Hall, neo-Baroque apartment "palaces," and so on (p. 26). Such construction continued into the late 1880s, but by then the street had come to be detested. The eclectic façades became a metaphor for the discredited liberal era that spawned them—the token of a worldview based on makeshift pragmatism without unifying ideals, content to pastiche rather than create. Every forward-looking Viennese of the 1890s, for different and often contradictory reasons, found this stultifying.[1]

Their polemics against the Ring generally derived from two credos. First, since the present epoch deserved its own unique, globally consistent style (the Vienna Secession's motto began "To the Age, Its Art"), the old traditions embalmed on the Ring had to be wholly swept away in order for the new to emerge. Second, the new style would not be added on to architecture as a matter of taste, but integrated into it by *necessity*. This *Nutzstil*, the style of usefulness or need, was to be determined by something outside self-conscious art—natural law, the patterns of craft, the demands of structural function—and achieve its form by revealing those origins with transparent honesty. In sum, if tradition were forgotten and stylization eliminated, modern form would emerge inevitably.[2]

Such arguments were to become a familiar aspect of modernism throughout Europe, but nowhere were they more out of tune with reality than in Vienna. It is not just that Viennese buildings lagged behind the rhetoric; more often, they were simply outside it, addressing problems and devising solutions that were not acknowledged by such partisan polemics. For example, though the Ringstrasse was frequently denounced as antiquated, the real problem was that it was *arriviste*. Rather than embodying tradition, it cheapened it, debasing virtually all the great Western styles in a way that left a young artist nowhere to go but Japan or Byzantium. The difficulty

Page opposite: Otto Wagner. Karlsplatz *Stadtbahn* Station. Perspective. 1898. Pencil, ink, and watercolor, 25½ × 18⅛″ (65 × 46 cm). Historisches Museum der Stadt Wien

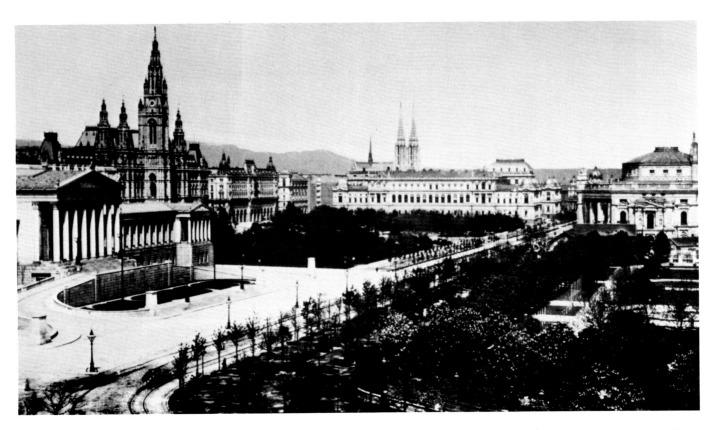

View of the Ringstrasse. c. 1888. From left: Parliament, Rathaus (City Hall), University of Vienna, and Burgtheater.

then lay not in escaping from, but in finding a fresh way back to, these abused traditions. The recurrent search of Viennese architecture was not for a vacant amnesia, but for a valid *Ausgleich*—a standoff, negotiated settlement, or in this case a working partnership—between the new spirit and that of an appropriate older model.

Similarly, the evidence of the buildings suggests that an appropriate style for the new age was not to be determined by unselfconscious honesty, but devised through sophisticated artifice, disjunction, and theatrical gesture. Mask façades and costume styles, the sins of the Ringstrasse, in fact reappear in transformed fashion as key concerns of early twentieth-century building in Vienna. Modernism was addressed as something to be expressed rather than simply revealed, a problem of communication as much as one of inner identity. To distill out of such a history only the moments of orthodox purity is to miss the point. In true Viennese fashion, the ambiguities of the situation are more interesting than the certainties.

Four major architects worked in Vienna between the 1890s and World War I. Two of them, Adolf Loos and Josef Hoffmann, were exact contemporaries and lifelong antagonists; two others, Otto Wagner and Joseph Maria Olbrich, were decades apart in age, but fruitful collaborators. Though the battle between Loos and Hoffmann defines Viennese modernism after 1910, Wagner and Olbrich were the leaders at the turn of the century. Their unlikely coming-together—the union of a born-again technocrat and a youthful Romantic—produced the first modern architecture in Vienna.

In the mid-1890s, they were both at work on the mammoth double commission Wagner had won, for the regulation of the flood-prone Danube Canal (p. 52) and the installation of a new urban rail system, the *Stadtbahn* (pp. 24, 30). This latter project was populist politics' rebuttal to the Ring-

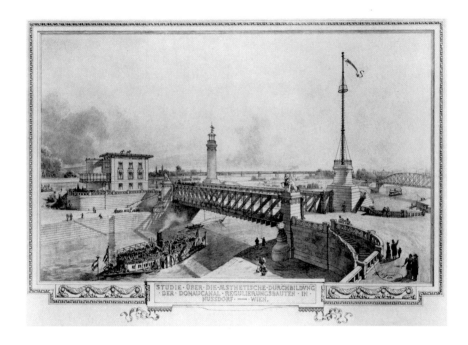

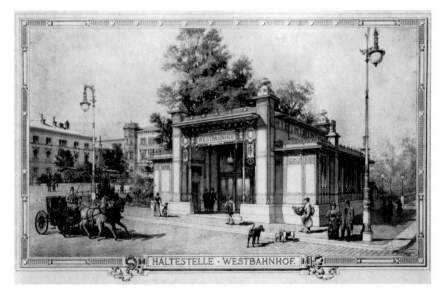

Top: Otto Wagner. Nussdorf Lock, Danube Canal. Perspective. 1894. Pencil, ink, and wash, 17⅝ × 24″ (44.9 × 60.9 cm). Historisches Museum der Stadt Wien

Center: Otto Wagner. Westbahnhof, *Stadtbahn* Station. Perspective. 1895. Pencil and ink, 17⅝ × 24″ (44.8 × 60.8 cm). Historisches Museum der Stadt Wien

Bottom: Otto Wagner. Court Pavilion, Hietzing, *Stadtbahn* Station. Elevation. 1896. Ink, watercolor, gouache, and spray, 17⅞ × 27½″ (45.3 × 69.9 cm). Graphische Sammlung Albertina, Vienna. This station was designed for the exclusive use of the emperor and the royal family.

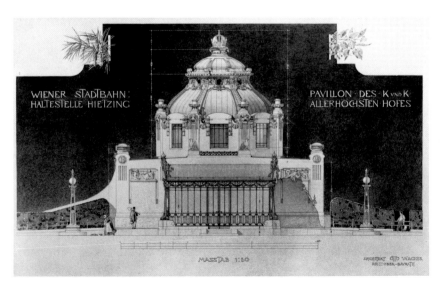

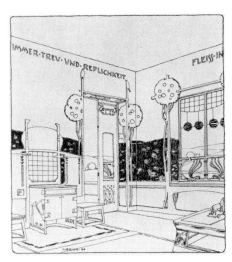

Joseph Maria Olbrich. Villa Friedmann, Hinterbrühl. Perspective of a child's room. 1898. India ink and pencil, 6½ × 5¾″ (16.5 × 14.7 cm). Kunstbibliothek, Staatliche Museen Preussischer Kulturbesitz, Berlin

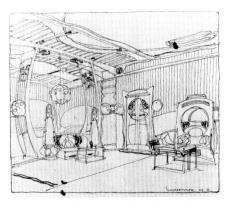

Joseph Maria Olbrich. David Berl House. Perspective of a bedroom. 1899. Ink, pencil, and gouache, 9⅛ × 9″ (23.3 × 23 cm). Kunstbibliothek, Staatliche Museen Preussischer Kulturbesitz, Berlin

strasse, replacing its burgher, inner-city focus with attention to the working suburbs recently incorporated into the municipality. Wagner, despite a substantial career of building in the Ringstrasse mold, had recently gone on record as a convert to more radical modernization, criticizing the Ring's stylistic clutter and its myopic failure to address the problems of the urban area as a whole.[3] Professor at the Akademie der bildenden Künste (Academy of Fine Arts) as of 1894, yet newly youthful in his fifties, he was just the man for the urban renovation job. And he saw that Olbrich was just the assistant he needed—a Prix de Rome student with professional experience, great talent as a draftsman, and reservoirs of enthusiasm.

On paper, however, it was not a natural alliance. Wagner had trained in Berlin, where he was imbued with a lifelong taste for the grandeur of Schinkel's classicism. He saw the new age in terms of a superior rationalism, born from the harmony of industry and new materials on the one hand, and the imperial traditions of imposed order and symmetry on the other. Olbrich by contrast was a product of Vienna's Kunstgewerbeschule (School of Applied Arts), led by the neo-Romantic theorist Camillo Sitte.[4] He favored handwork over industry, and sought to reconnect with the Western tradition not at its crown but at its roots, with forms based in nature rather than in ratiocination. These different temperaments bred potentially incompatible aesthetics: Wagner's more severe geometry, and Olbrich's penchant for florid *Jugendstil* fantasy. Happily, Wagner—who needed some of the younger man's poetry to temper his appetite for mundane efficiency—loved Olbrich like a son, and encouraged his collaboration; and Olbrich in turn appreciated Wagner's discipline as a counterweight to his own tendency toward dreamy decorative extravagance.

Olbrich was doubtless responsible for the characteristic Viennese *Jugendstil* inflections—organic décor trimmed and crisped by geometry—in some of Wagner's *Stadtbahn* stations (p. 30) and in his 1899 Majolikahaus apartment building.[5] But these fashionable trimmings now seem dated, and it is Wagner's integration of that new decorative language into his own sense of tradition that makes for the buildings' more telling modernity. In the two-building complex that includes the Majolikahaus, for example, it is the streamlining of the composite whole—a flattening planarity that wraps the floral tile façade together with its more conventionally swag-decked partner, in continuous bands along the street line—that is finally more forward-looking than the obvious novelties of the décor. The Karlsplatz *Stadtbahn* station (pp. 24, 30) is the most succinct statement of this *Ausgleich* of trendiness and tradition. Juxtapose its spare white and gold symmetry with Hector Guimard's darkly plasmic Paris Métro stations and the Viennese rhythmic clarity leaps to the eye—a modern effect reconciling *Jugendstil*'s dynamic fantasy and the pristine repose of neoclassicism.

Of course, the *Stadtbahn* stations were relatively unconstrained exercises in style. Working independently on unique buildings—Olbrich on the 1898 exhibition building for the Vienna Secession and Wagner on the 1902 competition for the Church of St. Leopold, on the Steinhof (built 1904–07)—these architects faced more complex problems of making architecture that both satisfied unconventional uses and articulated unfamiliar meanings. Working from widely different points of departure, neither arrived at a solution by the direct path—the natural correspondence of new forms and new purposes—they both claimed to follow.

It was simple enough, for example, to make the Secession building *do* what it should, in an appropriately modern way. The Secession was a

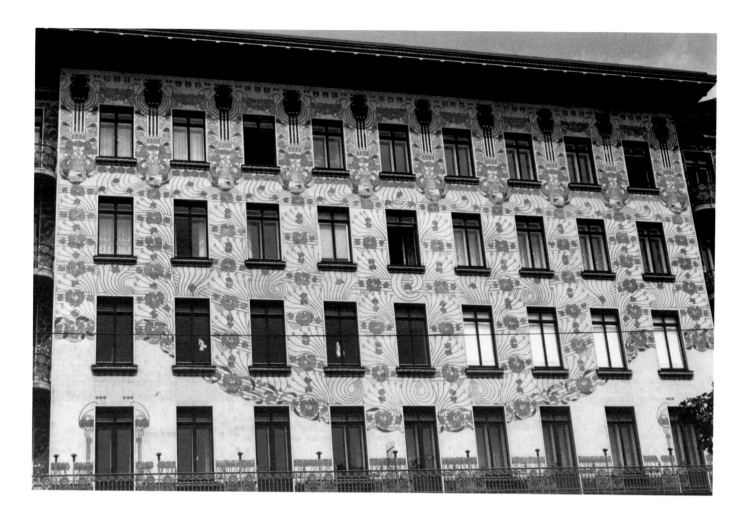

confraternity in defection from the older artists' society, the Künstlerhaus-genossenschaft, that had held a virtual monopoly on art exhibitions in Vienna. The rebel group's program called for more and better shows, and its aesthetic demanded harmony between art objects and surrounding interior environments. To facilitate the changing installation spectacles that would advertise this viewpoint, Olbrich (a founding member) gave them an interior of skylit, flexible space with movable walls.

But it was a different problem to make the building *say* what it should. Originally Olbrich conceived it in the mold of contemporary exposition halls, with banners and ornate high pylons (p. 31)—a logical, legible form for the purposes at hand. But in the end all this garrulous advertisement was compressed into Delphic solemnity, purposely opaque (p. 31). Reacting against the stereotyped codes of Ringstrasse historicism, Olbrich reached for something willfully illegible in terms of Western conventions, the Symbolist mystery of "an enigmatic clue of the lines of feeling."[6] Cryptic suggestion, rather than coded definition, would convey that instinct, not knowledge, was honored here.

Olbrich made the obligatory protestation that this form was found in inner necessity, rather than merely invented. He said he had no thought of style, only the desire "to hear the echo of my own sentiments, to see my warm feelings frozen in cold walls." His reference to artistic tradition was appropriately indirect; he said the "shining and chaste" white walls expressed the *kouros*-like reserve of "a pure dignity that overcame and shook me as I stood alone before the unfinished temple of Segesta."[7]

Above: Otto Wagner. Majolikahaus. Façade. 1899

Below: Otto Wagner. Apartment Building at Linke Wienzeile 38. 1899. Majolikahaus is the adjacent building to the left.

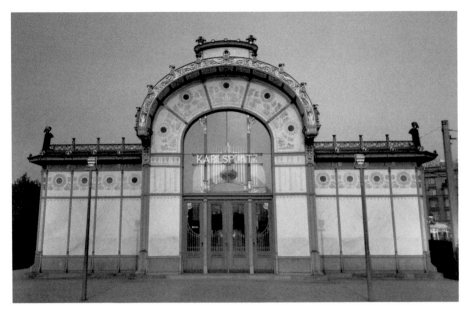

Otto Wagner. Karlsplatz *Stadtbahn* Station. 1898–99

The Secession spirit thus called not for classicism itself, but for the sensation of it; and for self-expression not openly exclaimed, but intoned through an archaic mask—an august and priestly guise to ennoble youthful and quite worldly aspirations. The massing of the façade evoked timeless hieratic certainties (one nickname was "the Mahdi's Tomb"), with only the gilded laurel-leaf dome to suggest that a neurasthenically delicate sensibility dwelled within. The spirit of pragmatic indeterminacy that actually reigned inside this efficient theater of art promotion found no confessing voice. It is this disjunction that really embodies the Secession, in all its unresolved paradoxes. Covering the mutable in the mute, Olbrich's temple epitomizes the attempt to cloak the activity of avant-garde art with the aura of eternal mysteries. As his recollection of the moment of epiphany at Segesta suggests (with ancient nobility reborn from the pathos of private sensations), he also wanted to make concrete a parallel modern myth—heroic depersonalization arising from deep subjectivity.

There was a wide consensus in the nineties that architecture had to guide modern man to something better than the fragmented individualism of the liberal era, and Olbrich's notions of *Jugendstil* unity defined one important point on the compass of possible solutions. He believed each building should be the extension of a unique sensibility. If architecture sprang from deeper within, the idea went, then society would gain cohesion—not by effacing subjectivity but by intensifying it, in order to liberate primal energies.[8] Wagner, though he supported his protégé and the Secession as a whole (he joined in 1899), was headed in a very different direction. For him, the determinants of architecture were to be objective, imposed by the requirements of rational efficiency.

Particularly in his 1895 book *Moderne Architektur,* Wagner made his reputation as a modernist by espousing a ruthless disregard for anything but practicality.[9] (His reaction to the empress's assassination, in 1898, was to propose an immediate reform of the royal crypt, so that spectators could see better and pallbearers would not have to turn corners with the coffin.)[10] He held that the primary focus of the architect should be on satisfying the functional requirements of the building, down to the smallest detail. Materials should be chosen on criteria of cost and ease of maintenance, and

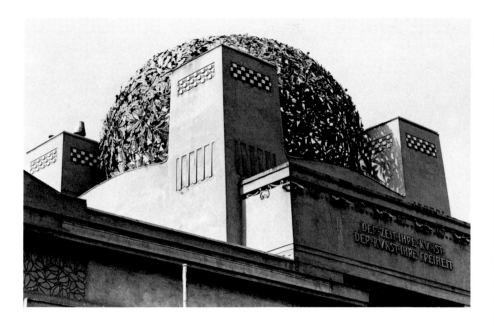

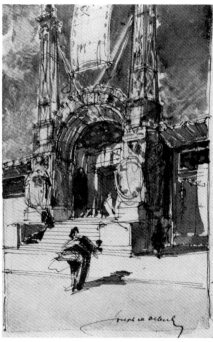

Joseph Maria Olbrich. Vienna Secession Building. 1897–98

Above: Perspective, preliminary design. 1897. Pencil, pen, and watercolor, 7⅜ × 4⅝" (18.7 × 11.6 cm). Kunstbibliothek, Staatliche Museen Preussischer Kulturbesitz, Berlin

Above left: Detail, laurel-leaf dome

Left: Main façade

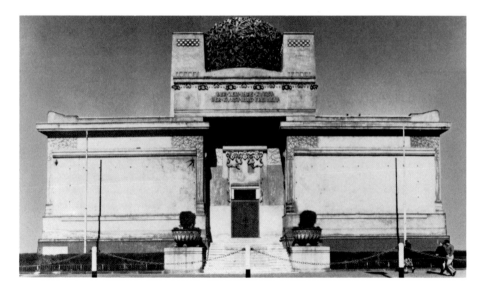

structures should above all be simple and economical. Any thought of form would be a later, and ultimately unnecessary refinement, since buildings made according to these pragmatic, reductive precepts would inevitably, Wagner asserted, be in a style appropriate to modern times. The cohesion of modern society would then come from what he called "uniformity raised to monumentality," and the individual would be a happy cipher in the masses.

The contrast between Olbrich's and Wagner's ideas of stylistic and social unity represents one of the classic oppositions of the epoch: between the utopia of the pulse and that of the piston; between those who would recover the spiritual, ritual bonding of a brotherhood, indicated by the term *Gemeinschaft,* and those who would follow the corporate model of cosmopolitan society, rational and secular, referred to as *Gesellschaft.* Not surprisingly, Olbrich longed above all for communities of small dwellings, close to nature; when the opportunity to build such an ideal colony came in 1899, he left Vienna for the patronage of the Grand Duke of Hesse, at Darmstadt.[11]

Wagner, who thrived on city work for large institutions, went on to win

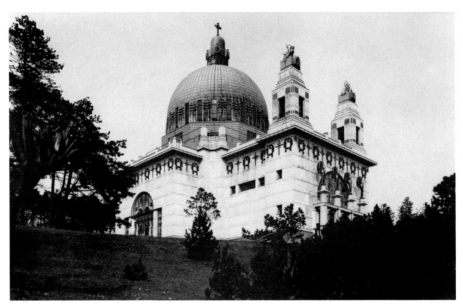

Otto Wagner. Steinhof Church. 1904–07

two major Viennese commissions that were tailor-made to his ambition. The results, however, were not cut from his prescribed patterns. The buildings suggest that Wagner's true talents were as a peacemaker, reconciling things that others found impossibly antagonistic: reason and religion, technology and tradition, honesty and artifice. Such compromises make, rather than muddle, the quality of his modern style.

The first of the commissions involved him once again with the new populist politics, and specifically with the Christian Socialists, a party right-wing in its anti-Semitic appeal but progressive in its attitude toward municipal services. Among the most ambitious of its projects was that for a grand, central sanatorium for the mentally ill, to be located outside Vienna, and—in keeping with the revivified Catholic activism that was one of the party's prime components—to be crowned by a church (St. Leopold, known as the Steinhof church) for the inmate population. The church posed for Wagner an almost perverse architectural challenge: to order the world of the deranged in humane fashion, and to modernize a clerical tradition rationally. He won the commission in 1902, and from it came a total design—furniture and windows as well as walls—that is one of the grandest monuments of collaborative work by early modern Viennese artists (Koloman Moser created the stained-glass windows and Remigius Geyling the mosaics), and a singular demonstration of the way Wagner's aesthetic achieves more than his rhetoric allows (pp. 53–55).[12]

In keeping with Wagner's theoretical tenets, the Steinhof church does have a pointedly efficient functional side, in the overall conception (Wagner had calculated that his interior allowed more views of the high altar per construction schilling than the other major Viennese churches), and especially in carefully planned details, such as rounded edges on the benches to prevent injury and a tilted tile floor for easy cleaning. But it also prominently deploys traditional symbolic elements, most notably in the gilded dome and temple-front portal that call directly on the authority of antiquity and the Renaissance. Its most impressive feature is Wagner's resolution of these two aspects—new practicality and old spirituality—into an environment of modern religio-therapeutic feeling.

The Catholicism he images here is not that of the Ringstrasse era, when

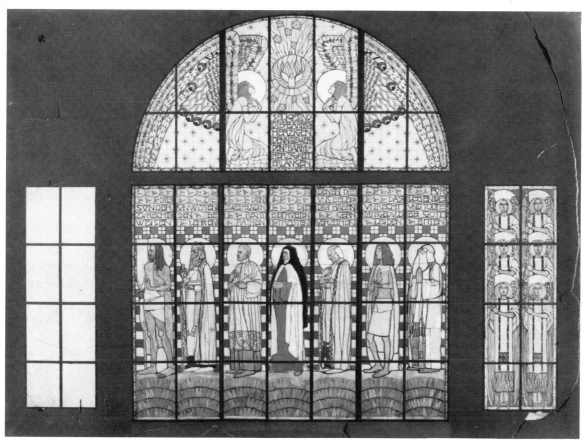

Koloman Moser. Design for Side Windows, Steinhof Church. c. 1905. Pen and ink and watercolor, 33⅞ × 44⅝" (86 × 113.3 cm). Österreichisches Museum für angewandte Kunst, Vienna

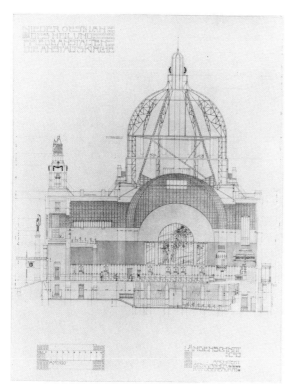

Otto Wagner. Steinhof Church. Longitudinal section. 1904. Pencil and ink, 26¾ × 19¼" (67.8 × 49 cm). Historisches Museum der Stadt Wien

Otto Wagner. Design for Pews and Confessional, Steinhof Church. 1904. Ink and watercolor, 27 × 18⅞" (68.5 × 47.8 cm). Historisches Museum der Stadt Wien

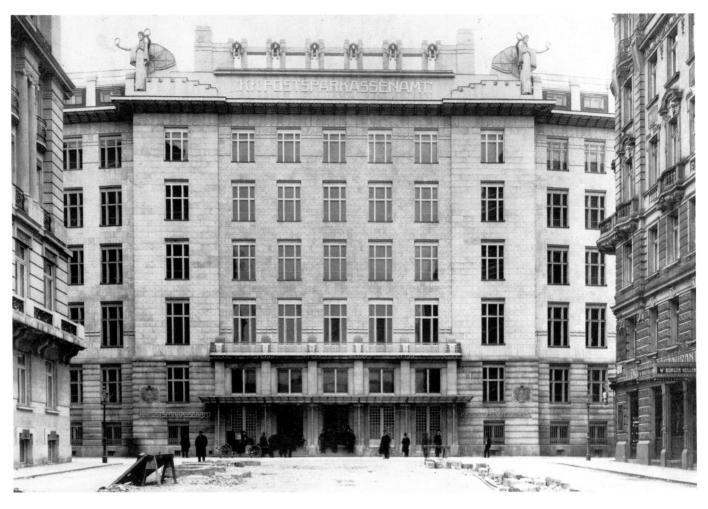

Otto Wagner. Postal Savings Bank. 1904–06

the neo-Gothic of the 1860 Votivkirche was the ecclesial style. It is instead a new recovery of Baroque-Rococo exaltation, distilling the spirit of joyously decorated and illuminated churches designed by eighteenth-century architects like Fischer von Erlach. New building techniques are used to extract, refine, and redefine the elements of this tradition. The noble yet weightless suspended-vault interior (p. 54), with its gold-quilted white envelope of tile walls and ceiling, evokes the confluence of light and purification, of cleanliness and godliness, of rational organization, redemption, and cure—an expression not only of Wagner's fetish of hygiene, but also of his larger faith that modern reason would cleanse all the disfigurements that impair human progress. The Catholic religion is absolved of any taint of dark superstition or autocratic pomposity, and presented in a new light, in lean, gleaming clarity and order, as the ally rather than the enemy of the purifying forces of modern times.

The Steinhof church demonstrated that the style of the past could be accommodated without mere historicism, and Wagner's other major commission, the Postal Savings Bank (built in two stages: 1904–06, 1910–12), followed in this path. Even more clearly than the church, the bank also shows that the style of the present was a problem for imagination as much as engineering, something to be ingeniously created rather than mechanically derived from modern technique. In this quintessentially utilitarian building, contrary to his writings, Wagner worked from the premises that denial was not enough to put history in its place, and honesty was not enough to give modernity its voice.

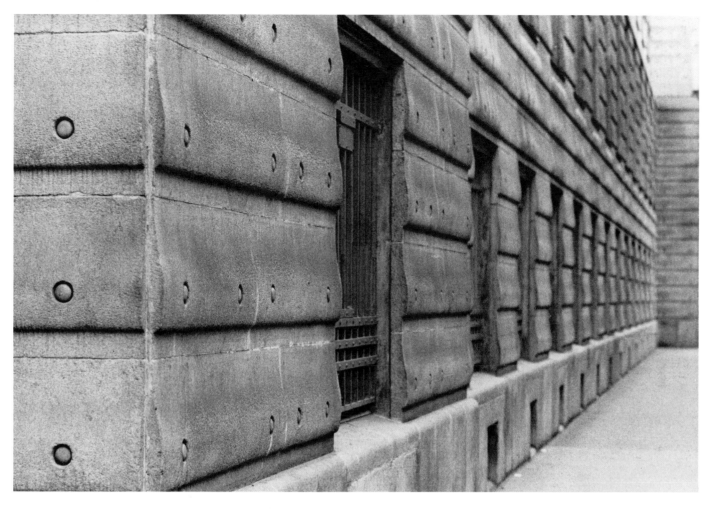

As in the church, where exterior and interior are dressed in obvious veneers of attached marble and tile, the "honesty" of the bank's façade lies not in revealing underlying matters, but in openly declaring the artifice of its mask. By the clear modular division of marble panels and the prominent heads of the bolts attaching them, the cladding is acknowledged as cladding—an overlaid armor of thin chips that lightens the bulk of the structure and studs the surface with a pointillist array of metallic accents. At the bottom of the bank's exterior, muscularly swelling courses of stone recall

Above: Otto Wagner. Postal Savings Bank. Detail of façade. 1904–06

Below left: Otto Wagner. "Postal Savings Bank" Armchair. c. 1906. Wood with aluminum fittings, 30⅜ × 22⅝ × 22⅝" (77.2 × 57.5 × 57.5 cm). Barry Friedman Ltd., New York

Below right: Otto Wagner. Wall Light Fixture for Postal Savings Bank. c. 1906. Metal, 4½" (11.5 cm) diameter × 7¾" (19.7 cm) deep. Private collection

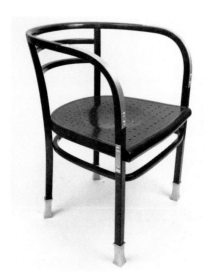

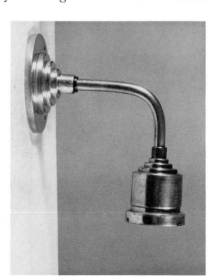

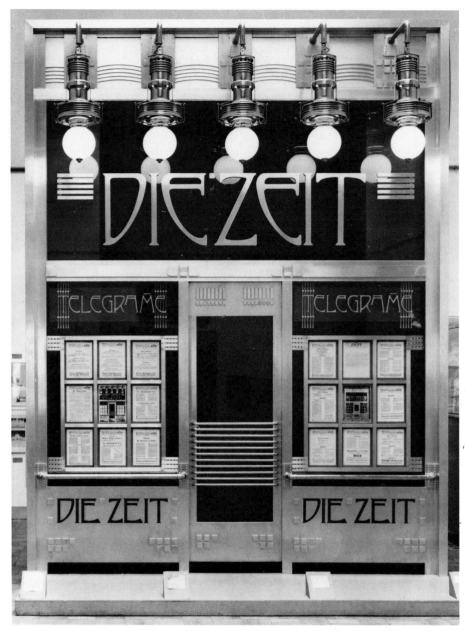

Otto Wagner. Die Zeit Dispatch Bureau. Façade. 1902 (destroyed; full-scale model, 1984–85). Aluminum and glass, 14′9″ × 10′10¾″ (450 × 322 cm). Historisches Museum der Stadt Wien

traditional rustication; but the revealed profiles show that these, too, are only a surface relief of thin facing slabs (p. 35). The deep countersinking of the bolt heads in these lower panels underlines the connotation of massiveness, but does so with the very elements that also belie it: the weight of a rusticated foundation is quoted and cancelled in the same breath.

Wagner thus declared his distance from traditional building, not by simply abandoning its elements, but by expressing them in explicitly denatured form as a skin of style. He countered what he saw as the deceitful costuming of the Ringstrasse not by disregarding the codes of tradition, but by making evident his newly self-conscious, experimental, and transformative relation to them. More surprisingly, the modern elements he used as tradition's counterpoint often entailed equally self-conscious theatrics. Though the bolt heads on the bank's façade supposedly signal structural necessity, they are in fact decorative and symbolic as much as functional. The shafts of the

bolts are not aluminum; the gleaming heads are only enlarged sheathing caps, added to strike the modern note that will be carried through in the aluminum-clad furniture, footings, and hardware inside the building.

Just as in the church, such decisions about structures and materials were based on criteria of expression as much as those of economy. Wagner had used aluminum even more prominently in the 1902 façade of a news dispatch bureau, Die Zeit, where with its protruding rivets it made an aggressively untraditional statement wholly appropriate to an office that trafficked in contemporary events. Both the aluminum and the prominent riveting were carried over into the Postal Savings Bank, but there each was incorporated into a program intended to express as well a reassuring solidity and continuity. Die Zeit's only true offspring is the purely functional hardware of the bank: the no-nonsense bare-bulb light fixtures (p. 35) and most dramatically the remarkable hot-air blowers of the main hall (p. 61)—alumi-

Otto Wagner. Second Villa Wagner. Perspective (detail). 1912. Pencil, pen, colored pencil, and watercolor, 22¼ × 18¼″ (56.5 × 46.4 cm) overall. Historisches Museum der Stadt Wien

num inventions so drastically unconventional that they seem to belong to a world of form still decades in the future.

It would be false to isolate these instances of industrial form, or the train-shed style of the main hall itself (p. 60), as the sole moments of innovation in the vast, impressively coherent hierarchy of material and structure which in fact obtains throughout the bank. What is remarkable about this building is not how these "high-tech" items stand out, but how they fit in. Attention to detail shows not only in the practicalities—built-in heating system to keep the glass roof free from snow, countersunk linoleum in the floors for easier cleaning—but equally in the consistent aesthetic of proportion, shape, and joining technique that unites the furnishings (p. 35) and the building. Once again Wagner's achievement is making happy marriages from unlikely lovers—producing new kinds of meaning by harmonizing into alliance things that narrower ideologues would deem combative. By adding the

Otto Wagner. Apartment Building at Neustiftgasse 40. Perspective. 1909. Pen and ink, 15¾ × 11⅞" (40 × 30 cm). Historisches Museum der Stadt Wien

accents of specifically modern materials to the noble properties and traditional beauty of granite, white marble, and stained wood, Wagner struck just the note he wanted for this modern fortress of finance.

If the Postal Savings Bank does not square with Wagner's own laws for architecture, it is not simply a question of outmoded trappings cluttering a core of rational modernity. Wagner's modernism here is as much a matter of trappings symbolically devised as it is of functional design mechanically derived; this is the building's more problematic and interesting message. Wagner's motto was the chillingly no-nonsense *Artis Sola Domina Necessitas* ("Necessity Is Art's Only Master"); but in his *Nutzstil*, invention is more often the mother of necessity. More in its poetry than in its pragmatics, this giant building represented Wagner's most ambitious attempt to create a grand modern style.

Wagner went on to build more canonically modern buildings after the bank and the church—the severely unornamented apartment block at Neustiftgasse 40 and his second personal villa (p. 37) are among the best-known and most geometrically decisive of these—but he never had the chance again to attempt anything on so grand a scale. The relative meagerness of his late production is partly the fault of circumstance. Many of Wagner's projects, such as his obsession with a city historical museum on the Karlsplatz, were frustrated through the machinations of enemies he had made along

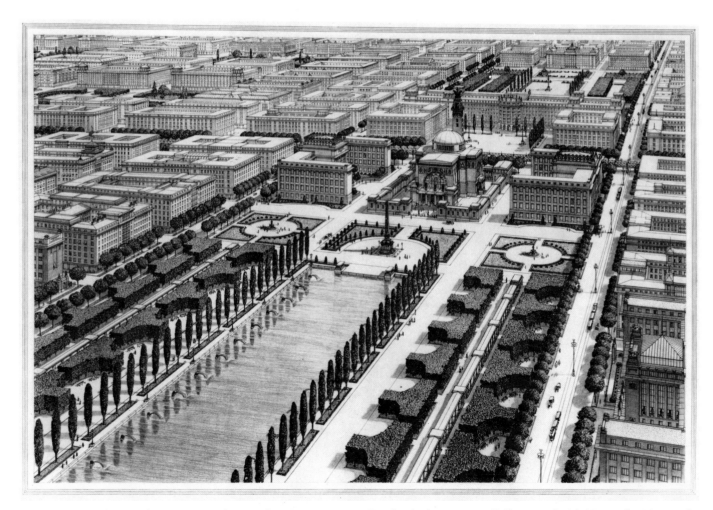

Otto Wagner. Ideal Design for Twenty-second Metropolitan District. 1910–11. Pencil and ink, 23⅞ × 32⅛" (60.5 × 81.7 cm). Historisches Museum der Stadt Wien

his way. He was convinced for example that Archduke Franz Ferdinand, who had acidly slighted the Steinhof church at its dedication ("The style of Maria Theresia is still the best" was the royal nephew's sole comment on the occasion), was personally thwarting him.[13] Wagner was more honored abroad—made president of the International Congress of Architects in 1908, for example—than he was at home. Yet, while one laments the injustice, the unbuilt buildings may be less regretted, since it is clear from the project schemes of the late years that his inspiration was running increasingly dry.

Wagner was one of the last architects of his time to encompass with natural ease both the functionalist faith and its contrary, the recognition that human needs were defined as well in terms of symbols—be they gold Baroque domes or big aluminum bolt heads—that were neither functional nor rational. All of his work tussles with achieving this balance, in different proportions and with very different levels of energy and conviction. In the 1894 Nussdorf Lock (p. 27) he had audaciously and successfully let raw engineering and unapologetic symbolic ornament have their way in open concert, neither belittling the other's strength. It is this kind of vigor, capable of producing such quirkily successful collage, that began to slip away, as both the tradition and the modernity became more attenuated, in his monumental, synthetic tours de force of the Postal Savings Bank and the Steinhof church. After 1910, when the traditional forms became desiccated and the vision of modernity more programmatic, Wagner began to produce a far less appealing blend of dead classicism and totalitarian rationalism. In the "ideal" metropolitan complex he conceived for an architectural gathering at Columbia University in 1911, bureaucracy and megalomania lie down together to dream of never-ending, mediocre uniformity—airy, spacious, rational, and mind-numbing. The memory of Schinkel fades before the premonition of Albert Speer.

Wagner kept planning for yet another, postwar reformation of Vienna, right up to 1917. But his inner compass had gone askew, and the man who prided himself on the sharpest attention to mundane practicality had evidently lost touch with some basic realities. After his wife died in 1915, a grieving Wagner had begun a daily, diaristic correspondence with her. Some measure of his mental insulation may be gathered from the note he inscribed there, reflecting on the consequences of the assassination of Franz Ferdinand in Sarajevo: "I consider that the death of the Crown Prince has removed the greatest single obstacle to the practice and further development of modern architecture in Austria."[14]

Wagner had been for Viennese art what the emperor was for Austria-Hungary, the living embodiment of alliances that without him seemed untenable. Both Josef Hoffmann and Adolf Loos, for example, were great admirers of Wagner; but neither could sustain his blend of imperial classicism and industrial confidence. Needing a rationalism more absolute and less familiar, they looked to sources of inspiration outside the established Western traditions, and wound up marking off enemy sectors in the area of *Ausgleich* that had been the common ground of Vienna's first modern architecture.

Hoffmann and Loos were born within a day of each other in the same region of Moravia, but they charted opposite careers in Vienna. As Wagner's prize student and a founding member of the Secession, Hoffmann had the inside track to early success. Especially after Olbrich's departure

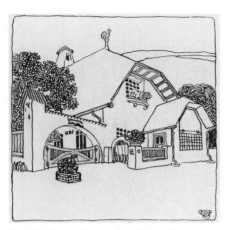

Josef Hoffmann. Project for a House. Perspective. 1899. Pen and ink and colored pencil, 4 × 4″ (10.2 × 10.2 cm). Österreichisches Museum für angewandte Kunst, Vienna

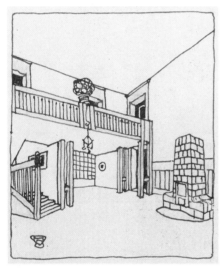

Josef Hoffmann. Project for an Interior. 1899. Pen and ink and colored pencil, 3⅝ × 3⅛″ (9.2 × 8 cm). Österreichisches Museum für angewandte Kunst, Vienna

for Darmstadt, he was the favorite architect of the Secession supporters, and commissions flowed to him from an elite circle of wealthy clients. From his position as professor at the Kunstgewerbeschule (appointed 1899), and later as a founding force in the Wiener Werkstätte design collaborative (see pp. 86 ff.), he became the maestro of all that was fashionable in high Viennese taste.

Loos was by contrast the perpetual loner, born to irritate rather than please. He came to Vienna in 1896, after three years in America, and played the outsider from the start. An early flirtation with the Secession soon soured (his denunciation of the Ringstrasse, titled "Potemkin's City," had been published in the Secession's organ *Ver Sacrum* in 1898), and he turned his journalistic talents against them. Aside from a few early commissions for interiors, he made his name writing cultural criticism rather than building. His circle was literary more than artistic, and his closest associate was the equally mordant critic of Viennese mores Karl Kraus. Emulating Kraus, who published a virtually one-man newspaper of opinion, *Die Fackel* ("The Torch"), Loos once briefly produced a magazine of his own, whose title pithily conveys his stance: it was called *Das Andere* ("The Other") and subtitled "A Publication to Bring Western Culture to Austria."

The temperamental and artistic differences between the two architects were clear, and history has tended to draw them even more sharply. By reading too literally Loos's irresistibly sardonic critiques of the things Hoffmann held dear, later readers have often found it easy to see Loos as the proto-Bauhaus champion of functionalist modernism, and Hoffmann—who had no gift for words and little appetite for theory—as a mere decorative historicist. But such a division does little justice either to the complexity of their individual careers, or to the more telling areas of their disagreement.

For all their differences, Hoffmann and Loos started out in roughly parallel directions, with shared admirations. Both looked to the anonymous products of English and American vernacular as models for a modern form of simplicity. Yet both found themselves caught between these admirations and their clients'—not to mention their own—taste for high refinement, and the authority of ancient architecture. A new respect for the power of anonymous low style pulled on one side, a new sense of elitist individualism on the other. Both men initially set out to resolve this tension by means of the same synthesis: reductive, purified forms that would demonstrate the community of spirit that linked low design and high tradition, combining the best of Anglo-Saxon vernacular with the best of Greco-Roman inheritances. It was on what actually constituted the best in each of these instances, and on how the modern architect should effect the union, that Hoffmann and Loos disagreed absolutely.

Hoffmann was a devotee of John Ruskin and William Morris, and a strong admirer of contemporary English design that had links to the Arts and Crafts movement (C. R. Mackintosh, C. R. Ashbee, H. Baillie Scott, C. F. A. Voysey, et al.).[15] But these interests were tied to larger ambitions. Around 1900, Anglo-Saxon vernacular attracted him as a vein of unselfconscious creativity that touched elemental aspects of architecture. In this key sense the little country house could be seen as something big;[16] and when Hoffmann built four villas in the English rural style for artist friends in 1900–02, he was seeking more than tidy charm. The cool, plain, geometric organization of these dwellings on the Hohe Warte, an area then on the fringe of Vienna, constituted one part of his attempt to devise a radically reductive, all-embracing new style of simplicity.

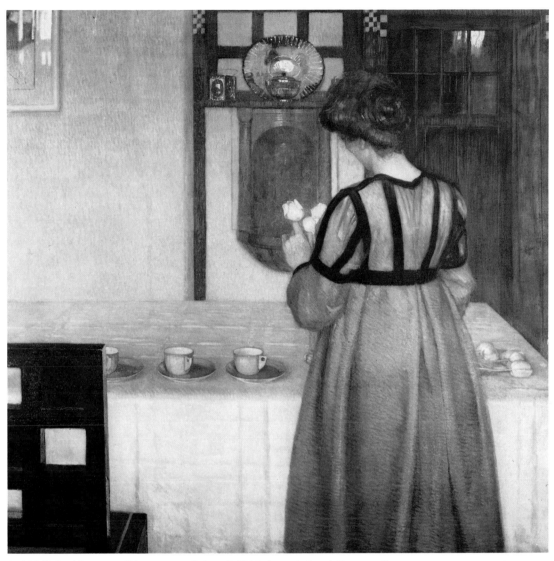

Carl Moll. *Breakfast*. 1903. Oil on canvas, 60½ × 60½″ (153.7 × 153.7 cm). Private collection, courtesy Barry Friedman Ltd., New York. The painting shows the interior of Moll's villa, designed by Josef Hoffmann. The chair at left is by Koloman Moser.

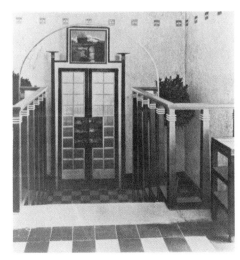

Josef Hoffmann. House for Dr. Hugo Henneberg on the Hohe Warte. View from vestibule to entrance door. 1901–02

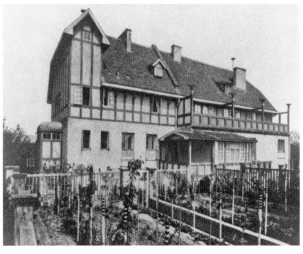

Josef Hoffmann. Double House for Carl Moll and Koloman Moser on the Hohe Warte. Garden façade. 1900–01

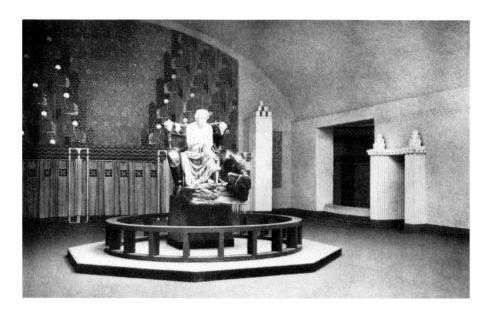

Josef Hoffmann. Installation Design for Max Klinger's *Beethoven* at *Secession XIV.* 1902

Top: Central room (mural: Alfred Roller, *Sinking Night*)

Center: Central room, view toward entrance (mural: Adolf Böhm, *Dawning Day*)

Bottom: Left side room (mural: Gustav Klimt, *Beethoven Frieze*)

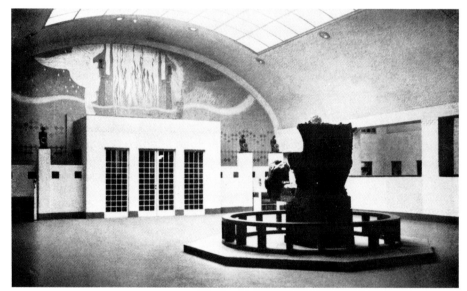

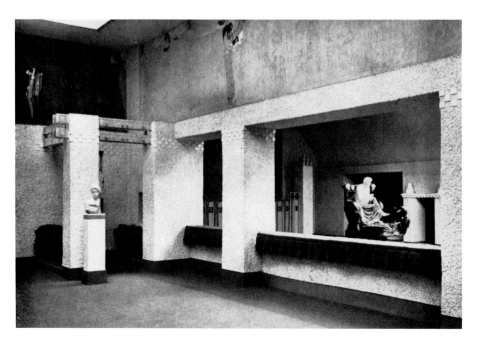

The other part of the equation showed itself at about the same time, in his installation of the Secession's fourteenth exhibition, in the spring of 1902. This was the crowning achievement of the Secession's program for unified design, a collaboration of scenography with painting, sculpture, and music, to provide the proper setting for the Leipzig sculptor Max Klinger's monument to Beethoven.[17] Klinger had enthroned Beethoven in godlike classical nudity, on rocky heights above the eagle's reach, as a triumphant new Prometheus (see p. 155). Hoffmann's design in turn imposed a strict quadratic planarity of snow-white and gold, to express the rarefied atmosphere of this celebration of Olympian genius. In sum and in detail (notably the remarkable over-door reliefs composed exclusively of staggered rectangles),[18] the design raised to featureless monumentality the rectilinear order announced on the Hohe Warte.

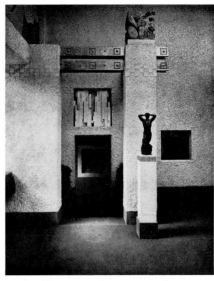

Josef Hoffmann. Installation Design for *Secession XIV.* 1902. Right side room, view toward doorway (sculpture: Max Klinger, *Athlete;* capital carving: Ferdinand Andri; over-door relief: Hoffmann)

The Hohe Warte villas and the *Beethoven* installation together arise from specific aesthetic and social currents of the time. First, they represent Hoffmann's involvement in a broad wave of retrenchment that swept all of Europe in the early 1900s. Rejecting the effulgence of *Jugendstil's* millennial ambitions, this new conservatism favored the bracing and monumental over the warm and intimate, and sought probity in a more "objective" vocabulary of sharply defined form, often explicitly classicist. But Hoffmann's particular inspirational models—English houses and Beethoven—were Northern; his classicizing involved a Germanic imperative to distill cold essences from the forms of the Mediterranean achievement.[19]

Second, the villas and the exhibition also imply two visions of the artist as exemplar in the new order. The Hohe Warte colony speaks for the English view of a workman-artist's life, lived amid well-designed comforts and like-minded friends; while the celebration of Klinger's *Beethoven* honors the Germanic ideal of the uncompromising genius divorced from mundane humanity. The goal of a stylistic simplicity that would merge these two—allying Ruskin and Nietzsche—had a political background, in the attempt to reconcile collective socialism and more anarchic individualism. It also had a potentially noxious side, in the will to make the emotional appeal of folk values and the absolutism of elitist order appear to share a common authority. Reflecting these synthesizing ambitions, Hoffmann's early ideals of unity and purity drew on one of his generation's cultural heroes, the composer Richard Wagner, for the *Gesamtkunstwerk* ideal that empowered the artist to determine every object and aspect of life.

Loos, on the other hand, said no to all of this. Not an idealist by outlook, he clearly saw that the Wagnerian brand of sentimental idealism was potentially oppressive. He wrote satirical attacks, transparently aimed at Hoffmann, on the tyranny of the total-design architect,[20] and sought to delimit, rather than extend, the role of art in shaping life. Where Hoffmann sought to blur boundaries—between the arts, between art and life—Loos wanted to draw more rigid distinctions, keeping the practical functions of buildings and furniture quarantined from the vagaries of aesthetics.

On virtually every point, Loos confronted the same choices and inspirations as Hoffmann, but acted from a wholly different perspective. He too, for example, looked to the commonplaces of the Anglo-Saxon tradition as models for a modern probity in design. But he was emphatically a city man, with no residual Arts and Crafts affections and no patience for ideals of latent grandeur in the rustic. What attracted him in anonymous vernacular was its sense of artless practicality and self-effacing reserve, and he found this spirit not just in quaint country houses but in the modern urban milieu:

London tailoring and American plumbing were among his favorite models.

"The English and the engineers," Loos said, "are the Greeks of our time."[21] As the remark suggests, he wanted, like Hoffmann, to connect the virtues of anonymous Anglo-Saxon practicality with a new understanding of antiquity. But his respect for the classical tradition was more technical than sacral. The notion of Olympian genius was wholly alien to him, and he thought of its cult—indeed, of the notion of inventive originality itself—as showy, narcissistic self-delusion. For him, the Attic spirit survived more in the Englishman's stiff upper lip than in Beethoven's beetled brow. He in fact admired the Romans even more than the Greeks, as prodigious builders who simply appropriated the styles at hand rather than worrying about originality.[22]

Just as he respected craft without sentimentality and antiquity without idolatry, so Loos held a disaffected view of the future. His passive, almost fatalist sense of history saw artists as impediments to, rather than as agents of, modern style. "The language of one's time is not invented," he said; "it happens."[23] In opposition to the cult of new style he saw in the Secession, he argued: "We already possess the style of our time. It may be found wherever the artist . . . hasn't yet stuck his nose in. . . . Can it be denied that leather-goods are in the style of our time? And our cutlery and glassware? And our bathtubs and American washbasins? And our tools and machines? And everything—I repeat everything—which the artists haven't gotten their hands on yet!"[24] This was not a romance of modern design, but a disenchantment with design itself, a distrust of self-conscious creativity that makes of Loos a precursor less of the Bauhaus than of Dada.[25]

The irony is that Hoffmann, with no taste for theory, and a basis in appreciation for humble handwork, was the more inflexible "purist" (woe be to the client who changed a detail in his interiors); while Loos, the dogmatic pundit, was in practice more casual and eclectic in organizing his clients' environments (he often advised them to buy well-designed old furniture rather than commissioning new).[26] If rationalization, in Hoffmann's early ideals, threatened to overextend into tyranny, in Loos's it risked retreating into mere diffidence. Hoffmann's simplicity was born of organized, imposed

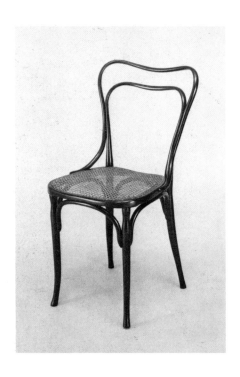

Above: Adolf Loos. "Café Museum" Side Chair. 1899. Wood and caning, 34 × 17½ × 20½" (86.4 × 44.3 × 52 cm). The Museum of Modern Art, New York; Estée and Joseph Lauder Design Fund

Right: Adolf Loos. Café Museum. 1899

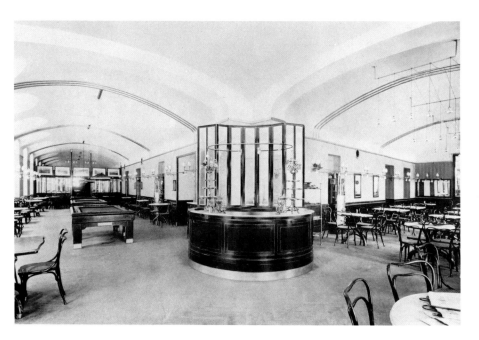

Josef Hoffmann. Purkersdorf Sanatorium. Perspective, preliminary design for west façade. c. 1904. Pen and ink, 4⅝ × 9″ (11 × 23.5 cm). Galerie Metropol, Vienna

Josef Hoffmann. Purkersdorf Sanatorium. 1904–06

Below left: Dining room, second floor

Below: Entrance hall

Bottom: Terrace off reading room, second floor

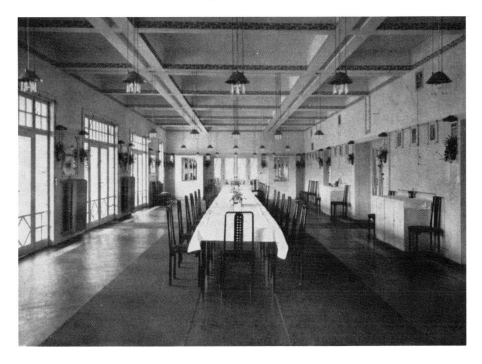

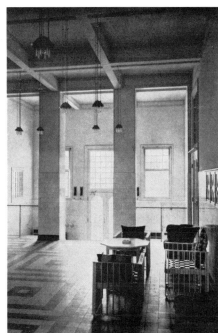

purity, while Loos's issued from pragmatic neutrality. The differences are evident in Loos's Café Museum of 1899 and Hoffmann's Purkersdorf Sanatorium of 1904–06.

The Café Museum was a cold blast of whiteness directly in the face of *Jugendstil* in 1899. Yet, though the bare look of the façade and the strictly uncluttered interior earned this place the nickname "Café Nihilismus," its order came not from simple negation but from recalling a Biedermeier tidiness of Austrian design of the 1830s, and from importing an Anglo-American spirit (one part of the café was hung with Charles Dana Gibson illustrations). The brass-and-wood décor, the bentwood furniture, and the seating pattern itself all drew on these proper urban-bourgeois sources, aiming for neither rural coziness nor aristocratic elegance, but impassive, "correct" civility.

As Loos's adaptation of existing models for the furniture and detailing reflected cynicism about design reform, so Hoffmann's outfitting of the Purkersdorf Sanatorium reflected ambition for total aesthetic control. The austere monumentality of the Purkersdorf building's conception, and the aggressive unconventionality of the décor, are of a wholly different order

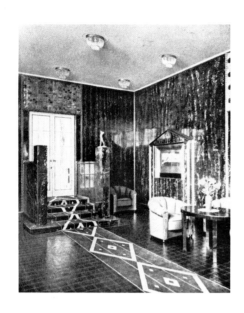

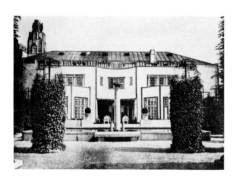

Josef Hoffmann. Palais Stoclet, Brussels. 1905–11

Top: Music room (sculptures: Georges Minne; painting: Fernand Khnopff, *I Close My Door upon Myself*)

Above: Garden façade

Right: Street façade

from Loos's Anglo-Biedermeier bareness. Hoffmann was personally fastidious (he abhorred ugly or dirty hands, and always inspected those of the cooks who served him),[27] and he doubtless felt that the purity of Purkersdorf—the hygienic whiteness of the walls and the simple clarity of the planar massing and of Koloman Moser's furniture designs (p. 83)—were bracingly therapeutic, in line with new vitalist ideologies of health. Though it was more a deluxe health spa (dinners there called for formal attire) than a garrison for the insane, the sanatorium invites comparison with Wagner's contemporary Steinhof church in this respect. The comparison highlights Hoffmann's drastic elimination of familiar architectural elements—starting anew from the "primal" vernacular (there are echoes here of the simple, whitewashed country dwellings he had sketched in Italy), rather than refining down from complex traditions.[28]

Neither Hoffmann's nor Loos's early essays in simplicity could be said to entail *Nutzstil,* as their plainness was involved more with the affirmation of surface than the revelation of underlying structure. Not "necessary" in this sense, these styles were not sufficient in another: in both careers, reduction was a gesture made early and then superseded, a necessary precondition not a final goal. Emphasis on bare surface planes, for example, was part of the new objectivity's rigor, a rejection of the *fin-de-siècle* taste for subaqueous indeterminacy as the sign of inner profundity. But for Hoffmann it was also the starting point of a new kind of decorative play; in his hands, the reduction to geometric module almost immediately released the bare plane to serve as the base unit through which—by its staggering, repetition, or overlay—ornamental richness could be recovered.[29]

The subtle graphic demarcation of planes on the Purkersdorf façade (p. 45) produced a house-of-cards effect in which volume and surface subtly separated; on the exterior of Hoffmann's next major work, the extraordinary house built for Adolphe Stoclet in Brussels, bolder, gilded moldings delineated an array of white rectangles whose seemingly weightless interplay recalled the over-door reliefs from the *Beethoven* exhibition of 1902. In the passive stateliness of what Eduard Sekler calls this "sliding and gliding . . .

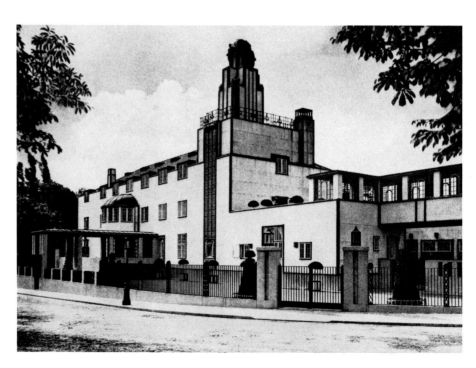

glissando"[30] of the Stoclet façade, the crisp rigor of Purkersdorf yielded to dreamy refinement. The ideal of classicism had abandoned the Northern, brute and rational, to comingle with the Eastern, precious and mystic. Whatever its starting point in contemporary English notions, ultimately the conception of the Palais Stoclet looked not to Anglo-Saxon vernacular, but to Oriental splendor. (The Greek goddess of wisdom, Pallas Athene, stood over the entrance to the house; Ganesha, the elephant-headed Indian deity, was at the eastern end.)[31]

A new luxury is affirmed in the Stoclet interior (pp. 64–73), in unparalleled fashion. Given carte blanche by his wealthy young art-loving client, Hoffmann here brought to bear a collaboration of the best decorative talents in his newly founded design workshop, the Wiener Werkstätte, and an extraordinary range of luxury materials. From the marquetry floors and specially loomed carpets through the kid-suede covering of the chairs and the variegated marble, onyx, and malachite inlays of the walls gleaming beneath crystal chandeliers, this was a tour de force of symphonic orchestration (pp. 67, 70). Yet no gaudiness obtruded: all the richness of the inlays and innate patterns in the stones and woods was restricted to the smooth, flat planes of nobly proportioned and logically arranged sequences of spaces. Hoffmann's goal was to articulate an ideal of high luxury for a clientele repelled by the gross heaviness of the Ringstrasse generation's décor, just as he would interpret the classical heritage for tastes formed by the rejection of historicism. Purkersdorf had been the requisite first step, the formation of a new basic vocabulary through which such enrichments, formerly denied, could then be restated.

Something changed, however, in the translation. The Palais Stoclet's opulence banished any trace of brash confidence in favor of a reticent interiority. While Athene stood for antique dignity outside the chaste façade, two presiding works of art inside were icons of late Symbolist solipsism: the self-embracing adolescent of Georges Minne, and Fernand Khnopff's *I Close My Door upon Myself* (which was enshrined in an altar-like structure in the music room; p. 68). And the crowning image, the fabulous stone-and-glass mosaic Gustav Klimt designed for the dining room, evoked an ecstatic fulfillment to be found in the Persian-garden tendrils of love's intimacy (pp. 70–73). When one imagines the Stoclets providing the final touch by carefully selecting the color of their evening accessories to coordinate with the décor,[32] the dream of an exclusive, inward-turning harmony of life and art is impeccably sealed.

Against such aestheticism, Loos set himself up as a modernist Savonarola, preaching ascetic reserve as the proper faith of modern man. His most notorious essay, "Ornament and Crime" of 1908 (written with the Stoclet building in progress), mounted a barrage of moral, economic, and evolutionary charges against decoration.[33] Loos saw the death of traditional ornamental crafts, and the absence of appropriate new decorative styles, as historical inevitabilities, to be embraced rather than lamented. His was not simply an argument for the virtues of impoverishment, but a challenge to the moneyed vanguard, to dress themselves and their lives in accordance with the English-tailored stoicism he saw as the most cultivated attitude toward the inevitabilities of history. Ornament was permissible for peasants who had no other pleasures, but modern urbanites with access to the fine arts had no need of it. "Whoever goes to the Ninth Symphony and then sits down to design a wallpaper pattern," he said in a jab recalling the Secession's 1902 Beethoven extravaganza, "is either a rogue or a degenerate."

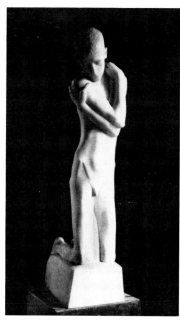

Georges Minne. *Kneeling Youth.* n.d. Marble (after original plaster of 1898), 31⅜″ (79.6 cm) high. Whereabouts unknown

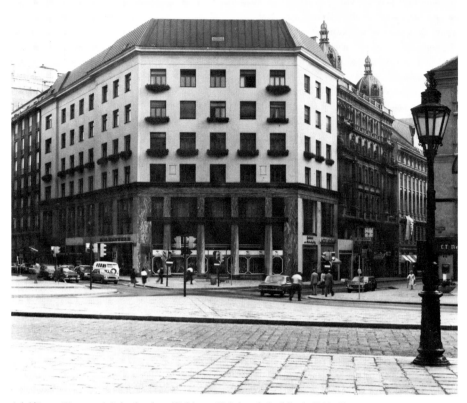

Adolf Loos. Haus am Michaelerplatz (Goldman & Salatsch Building). 1909–11

Such lines make wonderful reading, but are incomplete as guides to what Loos actually did as an architect. Inevitably confrontations with high luxury and high classicism marked his development, as well as that of his nemesis. And if we compare the 1899 Café Museum with his 1907 Kärntner Bar, we see that his development in fact followed a trajectory not dissimilar to Hoffmann's. In this vest-pocket interior, the Anglo-Americanism of the stand-up bar, an item distinctly foreign to Vienna, is joined to a more self-conscious classicizing reference (the coffered ceiling) and realized in more lavish materials. All this, and especially the space-extending multiplication by mirrors, illustrates the way Loos, too, could rebound directly from stripped-down modular simplicity to expansive complexity.

More evidently with Hoffmann but just as certainly with Loos, the faith of reason and the seduction of extravagance played out a complex amour. Loos's attraction to bare smoothness was as much sensual as rational; he savored rich leather, variegated stone, and highly grained wood as much as he loathed the excrescences of applied ornament.[34] Loos buildings that are puritanical in some respects may thus be luxuriantly appointed in others, and his Spartan rhetoric is belied by deluxe designs that range from the quietly expensive elegance of tailor's shops, like the still intact Kniže store (1909–11) on Vienna's Graben, to the Roman pomp of the remade Villa Karma in Switzerland (1904–06).[35]

Loos's infamous Haus am Michaelerplatz—the apartment block and store for the English-style tailoring firm, Goldman & Salatsch, that was his first commission for a complete building—is an almost diagrammatic example of the intersection of the reductive and the rich. Attention is usually focused on the astringent spareness of the stucco upper stories (and their implicit nose-thumbing at the ornate Imperial Residence, across the square). This

part seems the most uncompromisingly modern, even though Loos protested that its plaster plainness was true to older, indigenous building types in Vienna. But what is more characteristic of Loos is the juxtaposition of this strict blankness with the lavishly veined stone of the lower, classically columned entrance façade (into which is slotted, to complete the complexity of references, an English bay-window system).

Loos insisted that the heterogeneity of the Haus am Michaelerplatz façade—emphasized by the break between the lower, commercial and upper, residential parts—was the sign of its resolute urbanity; this kind of building, he argued, could exist only in a metropolis, where diverse functions, ages, and classes constantly intermingled.[36] In this love of the big city, Loos would seem to follow Otto Wagner as confirmed boulevardier. But where Wagner thought of the big city's impersonality as happily homogenized— "uniformity raised to monumentality" —Loos's vision was newly psychological, and reckoned impersonality as the correct public mask for the fragmented, and by implication alienated, individual personalities that shared the city space.[37]

Loos nonetheless had his own kind of sentiment, in constant tension with his haughty asceticism. All the Romantic emotion he excluded from buildings and objects poured with surplus into his heated vision of painting. He wanted from art a savage, confessional honesty that would compensate for its opposite, the stoic facelessness he prescribed for modern design. Clothes and buildings should be silent, but paintings should shriek; his greatest admiration went to Oskar Kokoschka.

Even within architecture, he drew a sharp distinction between the façade, which he felt must present a "dumb" face to the street; and the interior, where the wealth of individual personality, fantasy, and emotion could have free rein.[38] His interiors thus show not only a more sophisticated play of spatial relations than would be suspected from the outside, but also a remarkable staginess: entrance halls with trappings of ceremonial pomp, English fireplaces and inglenooks for hearthside coziness, and bedrooms suggestive of hothouse eroticism (his wife's own bedroom was carpeted with thick-shagged white fur rugs).[39] The mute severity of the skin-tight surface he used to cover the volumes of works like the Steiner House or the Scheu House (p. 51)—radically denuded, unconventional forms—should in this respect be compared with the floating marble planes of Hoffmann's Palais Stoclet. Each architect enjoins silence and denies access to interior life, but in very different ways—Hoffmann by cultivating a patrician, late Symbolist classicism; Loos by aggressively embracing an essentially schizophrenic modern existence.

Loos's constructions were far from functional simplicity. On the contrary, his complex stacking and interlocking of interior volumes, and his insistence on specific luxury materials, posed terrible difficulties for contractors, and made the interiors potentially onerous to inhabit. Nor was he against tradition; he constantly stated his allegiance to inherited ways of Austrian building, as well as to antiquity. Nonetheless his buildings, especially those of the teens, were sufficiently bereft of ornament and unfamiliar in form to attract the admiration of nascent functionalists, to his benefit and chagrin. In the crucial buildings of the early teens, such as the Steiner House and especially the Scheu House, Loos actually seems in important respects to have retraced his steps, back toward the flat-roofed, planar look of, for example, Hoffmann's Purkersdorf building of 1904–06. In earlier work he had not balked at the open show of classical elements, notably in the essentially

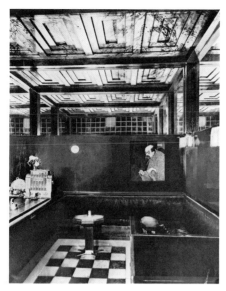

Adolf Loos. Kärntner Bar. 1907. A photomontage by Loos, collaging to the rear wall the 1908 portrait of Peter Altenberg by Gustav Jagerspacher. Loos Archiv, Graphische Sammlung Albertina, Vienna

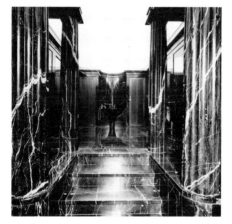

Adolf Loos. Villa Karma, Montreux. Bathroom, first floor. 1904–06

Adolf Loos. Fireplace and Inglenook from Loos's Apartment. 1903 (reconstructed). Historisches Museum der Stadt Wien

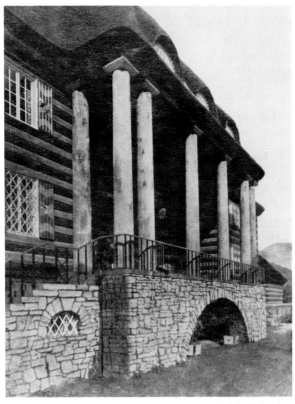

Josef Hoffmann. Primavesi Country House, Winkelsdorf, Czecho-
slovakia. 1913–14

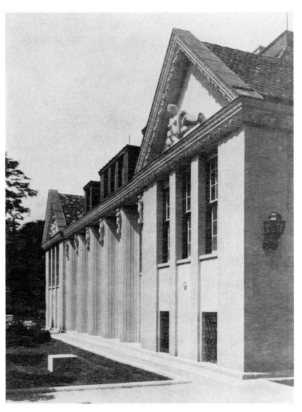

Josef Hoffmann. Villa Skywa-Primavesi, Hietzing. 1913–15

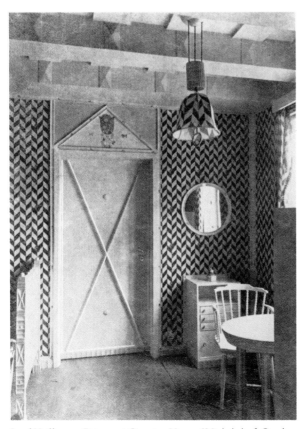

Josef Hoffmann. Primavesi Country House, Winkelsdorf, Czecho-
slovakia. Bedroom. 1913–14

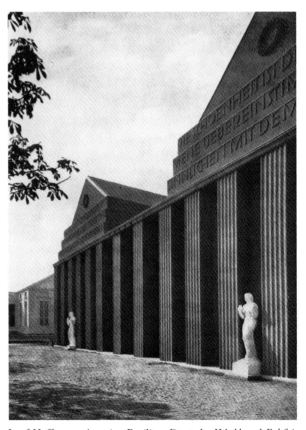

Josef Hoffmann. Austrian Pavilion, Deutsche Werkbund Exhibi-
tion, Cologne. 1914

ornamental columns of the Haus am Michaelerplatz and the Paestum-like Doric arcades of the Villa Karma. But in the Scheu House, he turned, as Hoffmann had much earlier, to the idea of deeper assimilation, and to the model of Mediterranean vernacular—in this case, Algerian terraced houses, symptomatic of a broader wave of modernist interest, during the teens, in North Africa.

Hoffmann, meanwhile, moved in the opposite direction, away from plainness and toward overt historicism. In the Stoclet garden he enthroned a freestanding Doric column as a fountain (p. 46)—a token of his willingness to abandon the search for featureless synthesis, and return to the legible quotation of classical style. After that his progression—from the pavilion for the Wiener Werkstätte's exhibition in Rome and the Villa Ast (both 1911) to the Austrian pavilion at the Deutsche Werkbund exhibition in Cologne and the sumptuous Villa Skywa-Primavesi (both 1914)—shows the emergence of a sharply mannered neo-Greek style. Radical, monumental simplicity—overscale, flat columns without base or capital meeting acute-triangular pediments—combines with graphic geometrical repetition to produce Art Deco before its time. Here and in Hoffmann's further work of the teens, geometry is increasingly engaged in a punning play between abstraction and quotation—a development that has more and more to do with Cubism.

This new, mannered classicism finds its converse in Hoffmann's increasing affection for a more picturesquely obvious folk style. The huge country house built in Moravia in 1913 for Otto Primavesi was the most impressive example of this serious flirtation with the reactionary style of the hearth and homeland known as *Heimatstil*. The log-look exterior with its sharply pitched roof was matched on the inside by rooms busily decorated in flowered and geometric patterns borrowed from folk ornament—a style couched in the vocabulary of expressionism, with gaudy coloring and restless shapes conveying a world of active fantasy and emotion.

Previously, both Hoffmann and Loos had dreamed of an architecture of unity, whose simplicity would join classicism and the vernacular, and whose appearance would be an integral expression of the new, modern spirit of its inhabitants' lives. The disjunction of the liberal era's Ringstrasse, with its polyglot historicism and applied "costume" façades, would be eliminated. These ideas of unity had corresponded to larger intellectual and political aspirations in Austria. The desire to merge high, rational style with rougher folk forms had paralleled the longing for an empire that would reconcile the forces of cosmopolitan progress, implied by the word *Zivilisation,* with the values of rural solidarity, implied by the word *Kultur.* And the wish that a building communicate directly the life lived within had reflected the deeper urge for cohesion within the modern personality, between the private, psychological and the public, social spheres of existence. The failure of these ideals of a new unity thus portended something more complex than just the return of the Ringstrasse. The splitting up of Hoffmann's style into mannered urban rationalism on the one hand, and emotive *völkisch* décor on the other, suggests not simply the return to historicist eclecticism, but the advent of a degree of polarization, reflecting a more ominous breakdown in the notion of the state. And Loos's insistence on the blank, uncommunicating façade, divorced from interior life, was not just a simple regression to costuming. It radically reformulated the casual hypocrisies of the Ringstrasse's disjunction between private and public expression, as the most bitter of modern truths. ∎

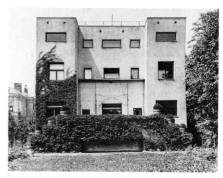

Adolf Loos. Steiner House. 1910

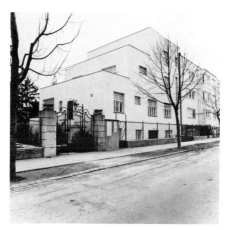

Adolf Loos. Scheu House. 1912

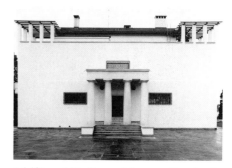

Adolf Loos. Villa Karma, Montreux. East façade. 1904–06

Otto Wagner. Project for Quaysides of Danube Canal with Aspern Bridge and Ferdinand Bridge. 1897.
Pencil, ink, and watercolor, 38⅞ × 28¼″ (98.7 × 71.8 cm).
Historisches Museum der Stadt Wien

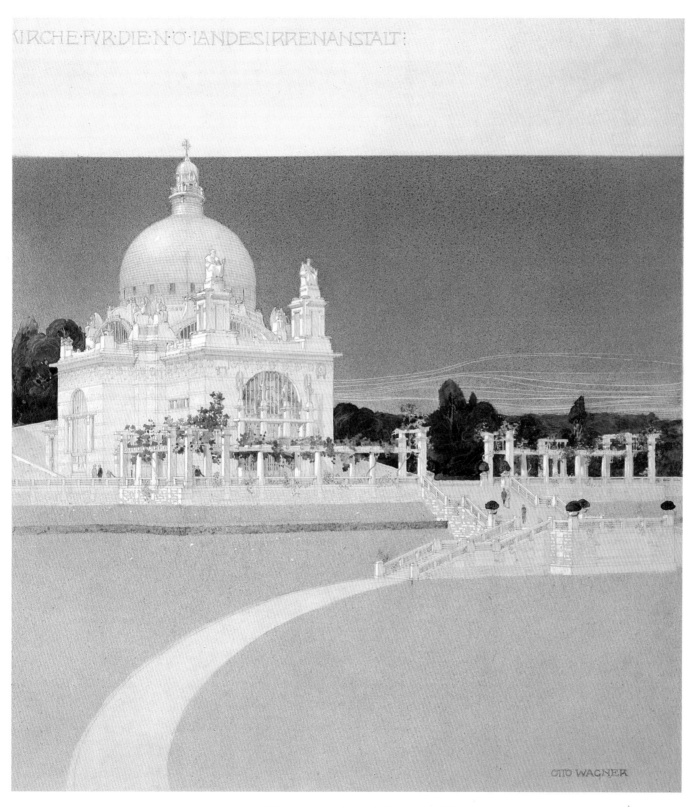

Otto Wagner. Steinhof Church. Perspective. 1902.
Pencil and watercolor, 21⅞ × 18½″ (55.8 × 47 cm).
Historisches Museum der Stadt Wien

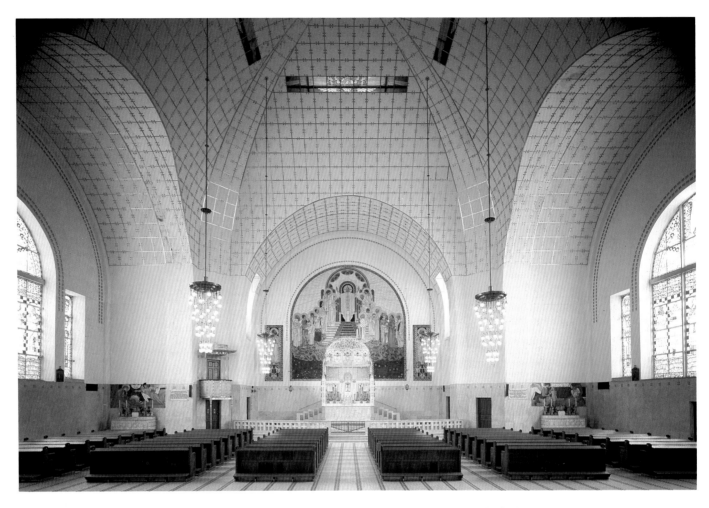

Otto Wagner. Steinhof Church. 1904–07 (apse mosaic: Remigius Geyling)

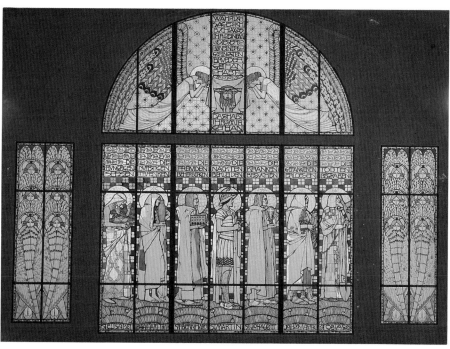

Koloman Moser. Design for Side Windows, Steinhof Church. c. 1905.
Pen and ink and watercolor, 40½ × 54¾″ (103 × 138 cm).
Österreichisches Museum für angewandte Kunst, Vienna

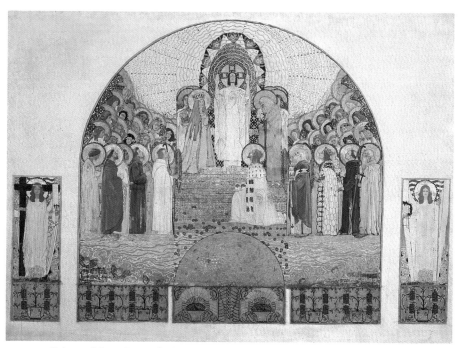

Koloman Moser. Design for Apse Mosaic, Steinhof Church (not executed). c. 1905.
Oil on canvas, 33⅞ × 44″ (86 × 113.5 cm).
Österreichisches Museum für angewandte Kunst, Vienna

Koloman Moser.
Study of Angels for Window,
Steinhof Church. c. 1905.
Watercolor, 16½ × 8″ (41.9 × 20.3 cm).
Österreichisches Museum für
angewandte Kunst, Vienna

Joseph Maria Olbrich. Vienna Secession Building. Entrance hall. 1897–98 (circular window: Koloman Moser)

Koloman Moser. Design for Circular Window, Vienna Secession Building. 1898.
Watercolor, 6⅞″ (27.5 cm) diameter.
Österreichisches Museum für angewandte Kunst, Vienna

Joseph Maria Olbrich. Vienna Secession Building. Exhibition room. 1897–98

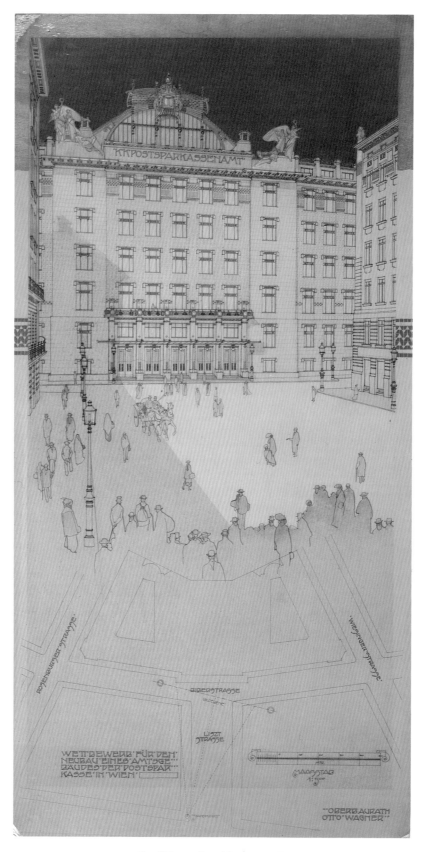

Otto Wagner. Postal Savings Bank.
Competition design, perspective from Ringstrasse. 1903.
Pencil and ink, 33¾ × 16⅞″ (85.7 × 41.8 cm).
Historisches Museum der Stadt Wien

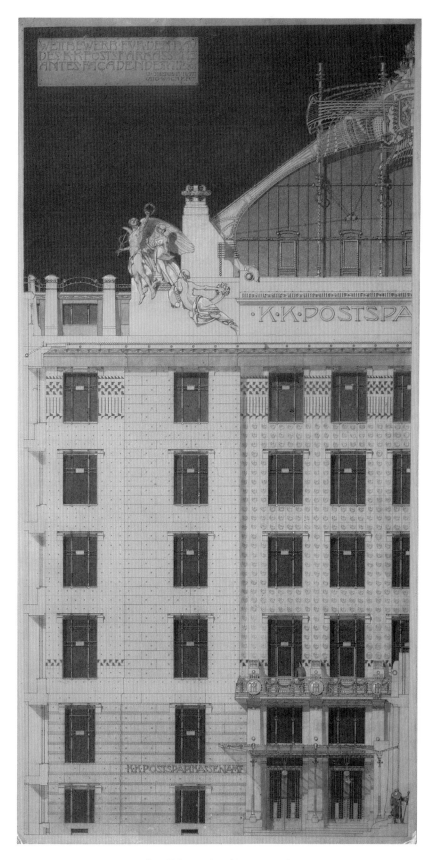

Otto Wagner. Postal Savings Bank.
Competition design, detail of façade. 1903.
Pencil, ink, and watercolor, 33⅝ × 16⅜″ (85.5 × 41.5 cm).
Historisches Museum der Stadt Wien

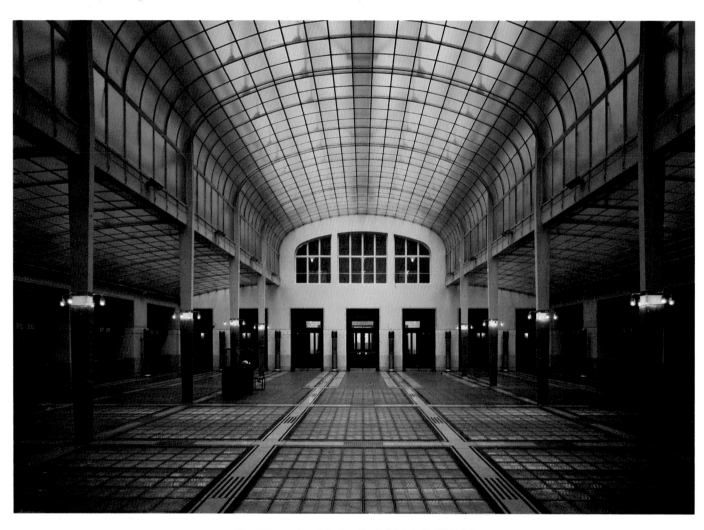

Otto Wagner. Postal Savings Bank. Main hall. 1904–06

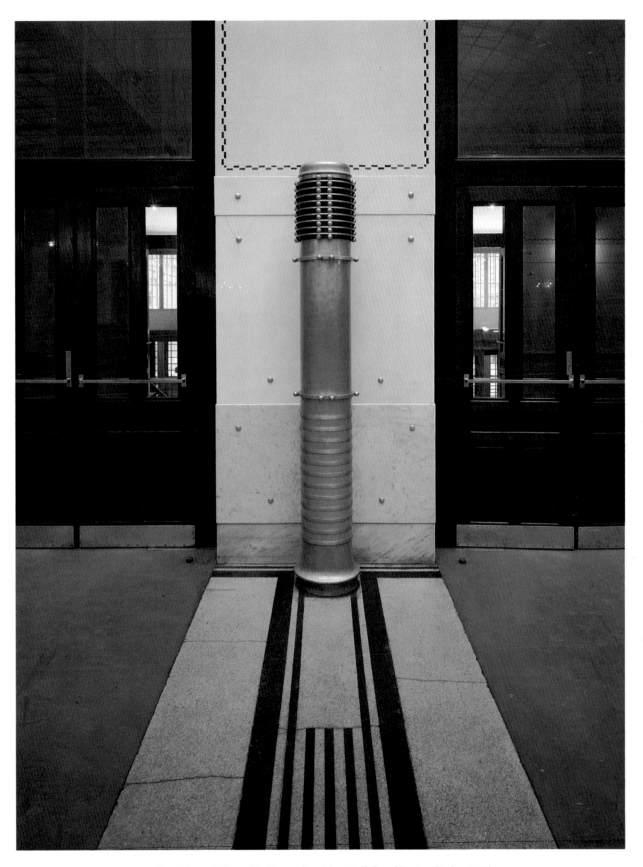

Otto Wagner. Warm-Air Blower from Main Hall, Postal Savings Bank. c. 1906.
Aluminum, 8′ 2½″ (250 cm) high.
Österreichische Postsparkasse, Vienna

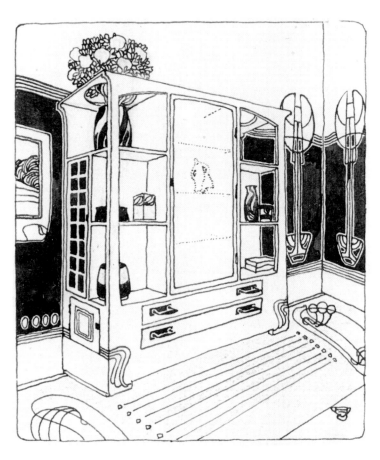

Josef Hoffmann. Project for an Interior. 1899.
Pencil and ink, 5 × 4¼″ (12.7 × 10.8 cm).
Österreichisches Museum für angewandte Kunst, Vienna

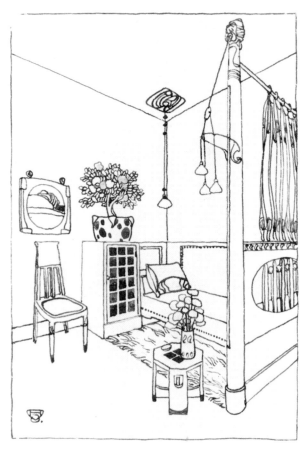

Josef Hoffmann. Project for an Interior. 1899.
Pencil and ink, 6¼ × 4⅛″ (15.9 × 10.5 cm).
Österreichisches Museum für angewandte Kunst, Vienna

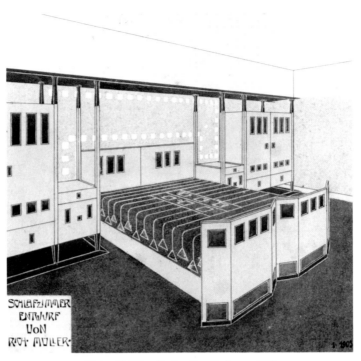

Richard Müller. Project for a Bedroom. 1903.
Ink and watercolor, 8½ × 8⅝″ (21.5 × 22 cm).
Österreichisches Museum für angewandte Kunst, Vienna.

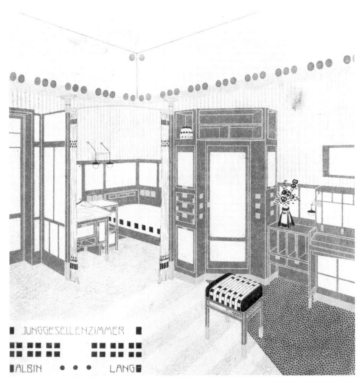

Albin Lang. Project for a Bachelor's Room. c. 1903.
Pencil, ink, and watercolor, 10⅞ × 9″ (27.6 × 22.9 cm).
Österreichisches Museum für angewandte Kunst, Vienna
This and the drawing above, design exercises by
Josef Hoffmann's students at the Kunstgewerbeschule, were shown in the
exhibition of Austrian crafts at the St. Louis World's Fair, 1904.

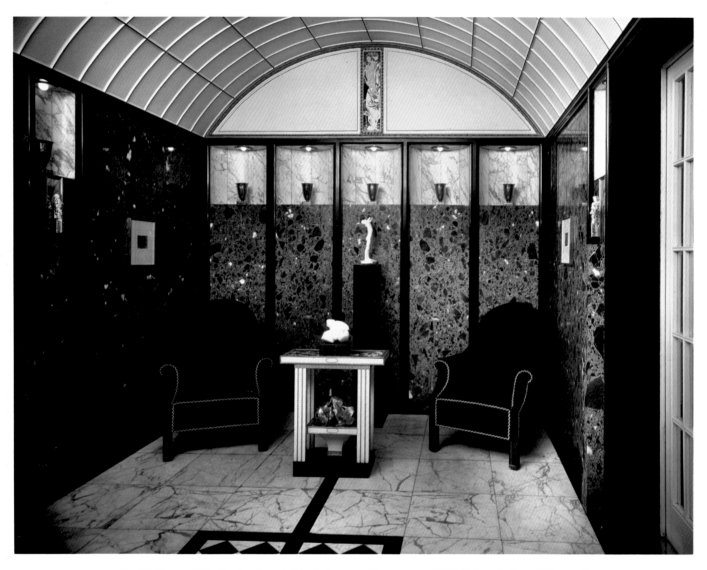

Josef Hoffmann. Palais Stoclet, Brussels. Vestibule, as seen from entrance. 1905–11 (mosaic: Leopold Forstner)

Above:
Josef Hoffmann. Palais Stoclet, Brussels. Plan of first floor. c. 1905.
Ink and pencil, 13⅜ × 16½″ (34 × 41.8 cm).
Museum moderner Kunst, Vienna

Right:
Leopold Forstner. Artist's Replica of Female Figure for Vestibule of Palais Stoclet. c. 1910.
Glass and ceramic mosaic, 30 × 6½″ (76.3 × 16.5 cm).
Fischer Fine Art, London

Josef Hoffmann. Palais Stoclet, Brussels. Interior perspective. c. 1905.
Ink and pencil on graph paper, 13 × 8″ (33 × 20.5 cm).
Museum moderner Kunst, Vienna

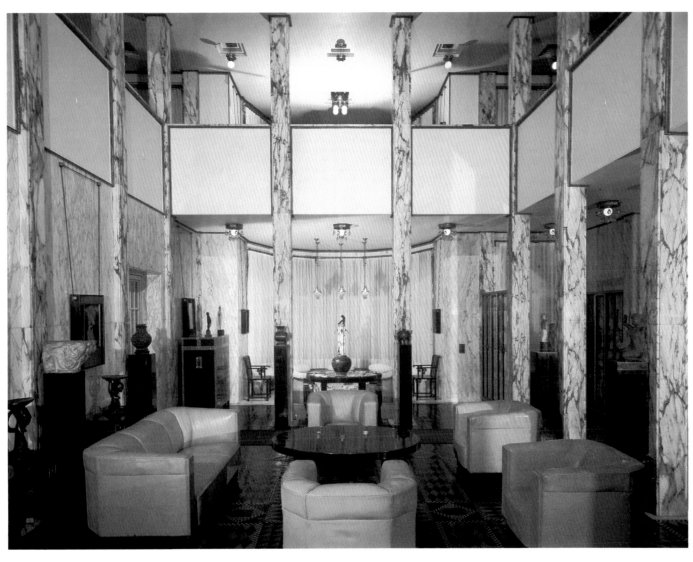

Josef Hoffmann. Palais Stoclet, Brussels. The Great Hall, view toward fountain alcove. 1905–11

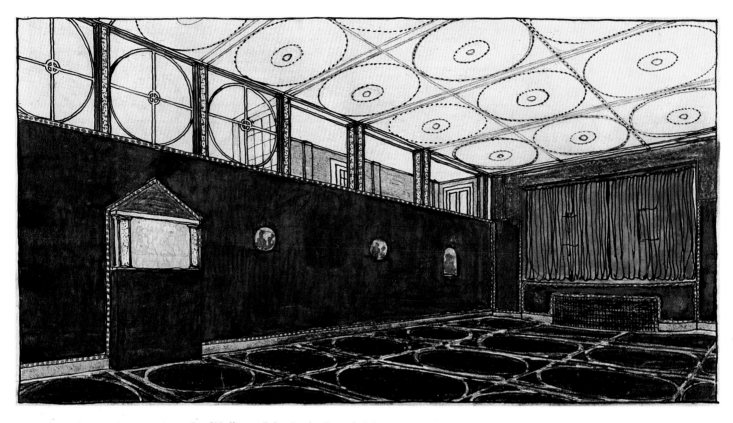

Josef Hoffmann. Palais Stoclet, Brussels. Music room, interior perspective. c. 1905.
Pencil, ink, watercolor, and gold, 4⅞ × 10⅛″ (12.5 × 25 cm).
Museum moderner Kunst, Vienna

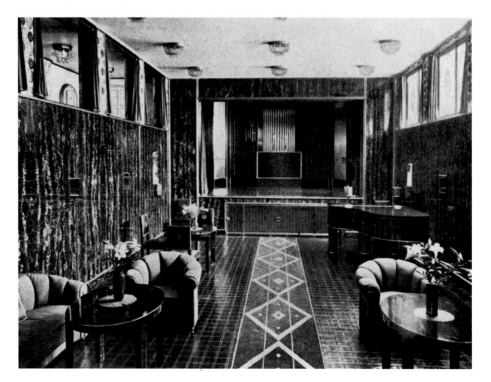

Josef Hoffmann. Palais Stoclet, Brussels. Music room. 1905–11

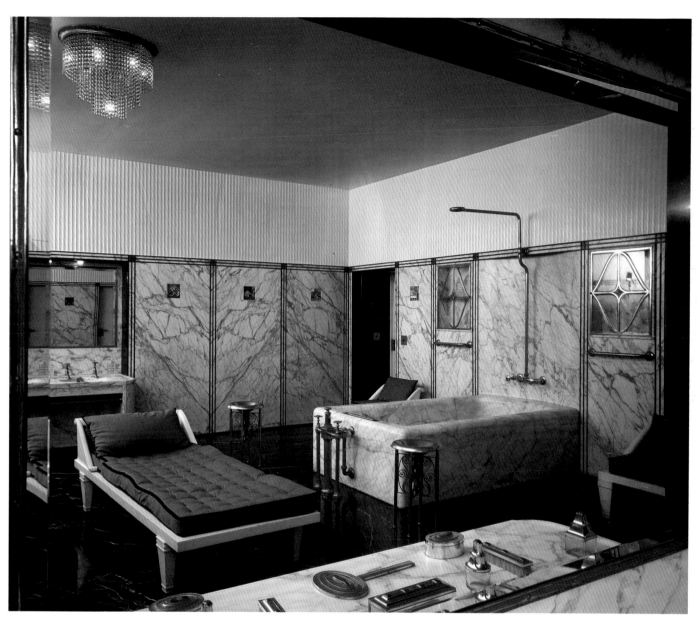

Josef Hoffmann. Palais Stoclet, Brussels. Master bathroom. 1905–11

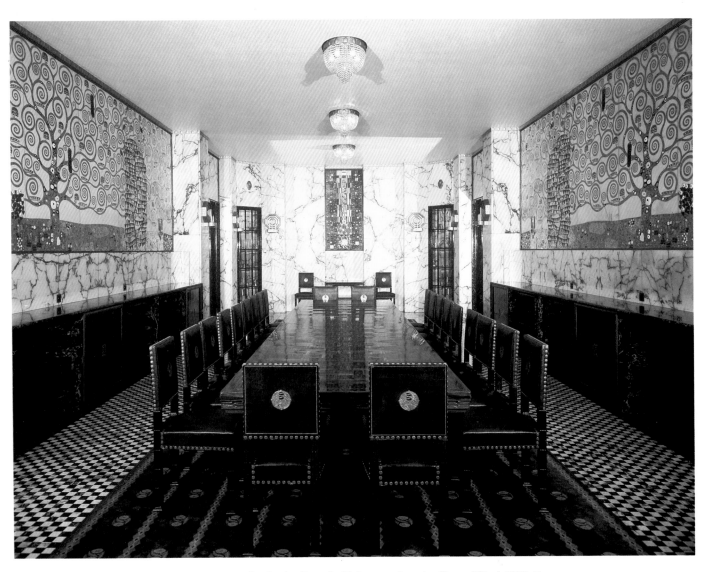

Josef Hoffmann. Palais Stoclet, Brussels. Dining room (mosaics: Gustav Klimt). 1905–11

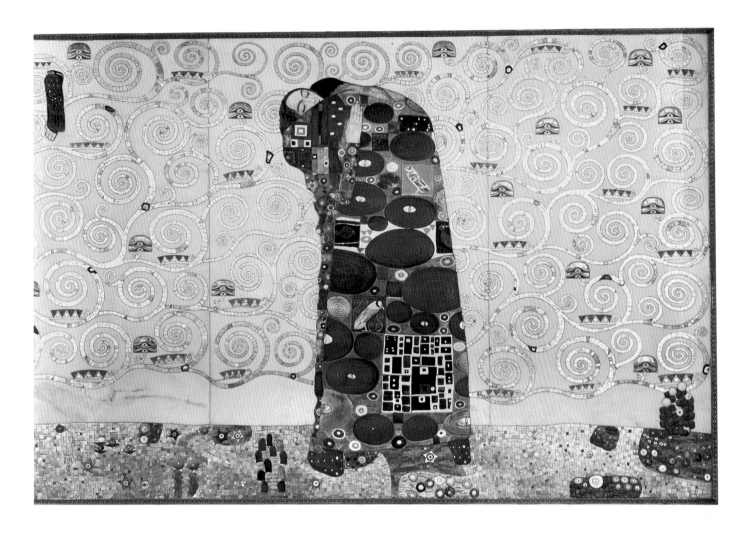

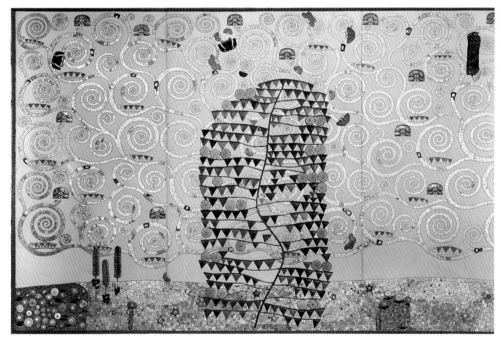

Gustav Klimt. *Fulfillment*. c. 1910.
Mosaic of marble, glass, and semiprecious stones (executed by Leopold Forstner).
Palais Stoclet, Brussels.
Top: Detail of right end, embracing couple
Above: Detail of left end, rosebush

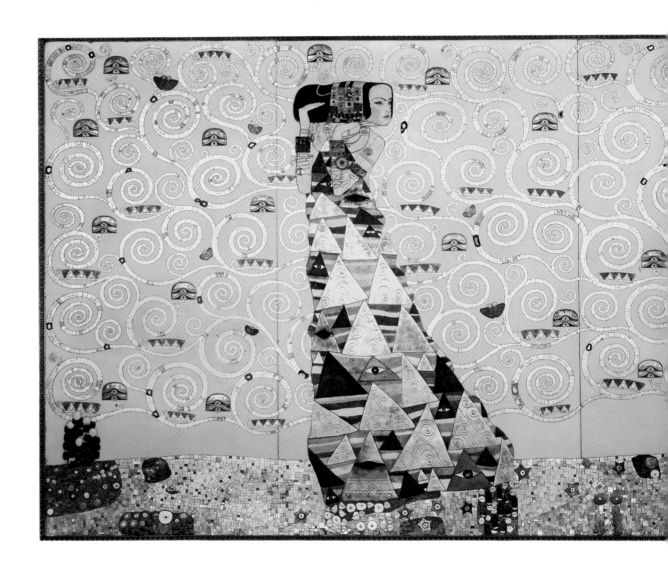

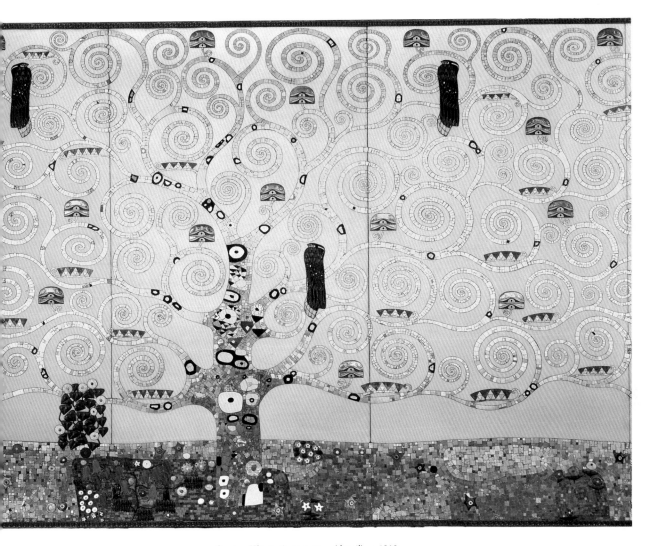

Gustav Klimt. *Anticipation* (detail). c. 1910.
Mosaic of marble, glass, and semiprecious stones (executed by Leopold Forstner).
Palais Stoclet, Brussels

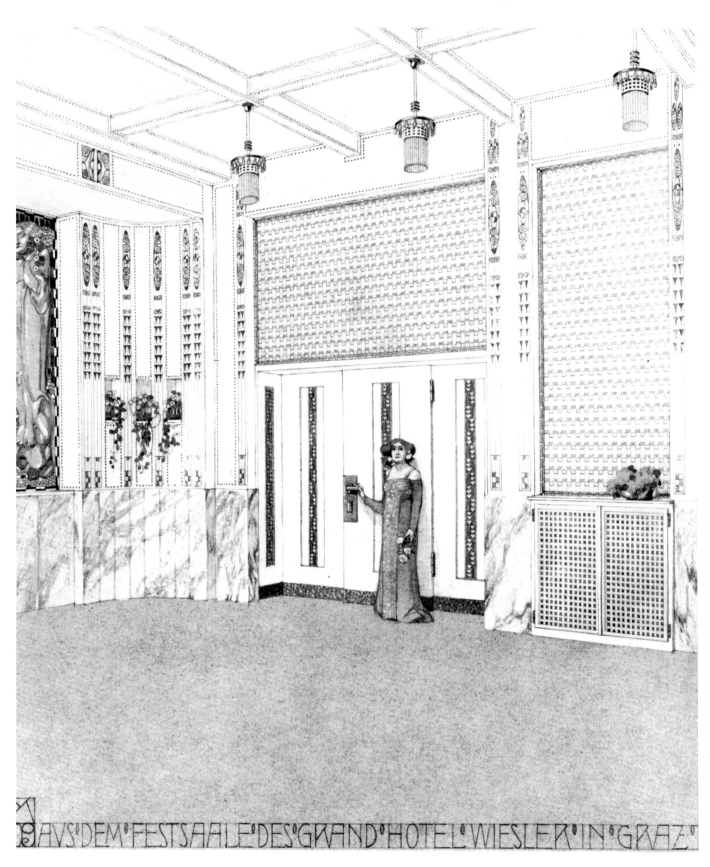

Marcel Kammerer. Project for Reception Hall, Grand Hotel Wiesler, Graz. 1909.
Pencil, pen and ink, watercolor, and gouache, 14¼ × 12¼″ (37.5 × 31 cm).
Private collection

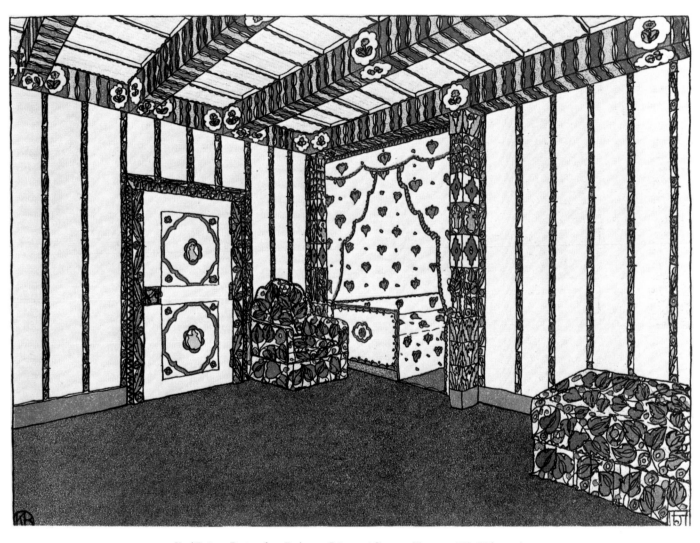

Karl Bräuer. Project for a Bedroom, Primavesi Country House. c. 1913. Lithograph.
Whereabouts unknown

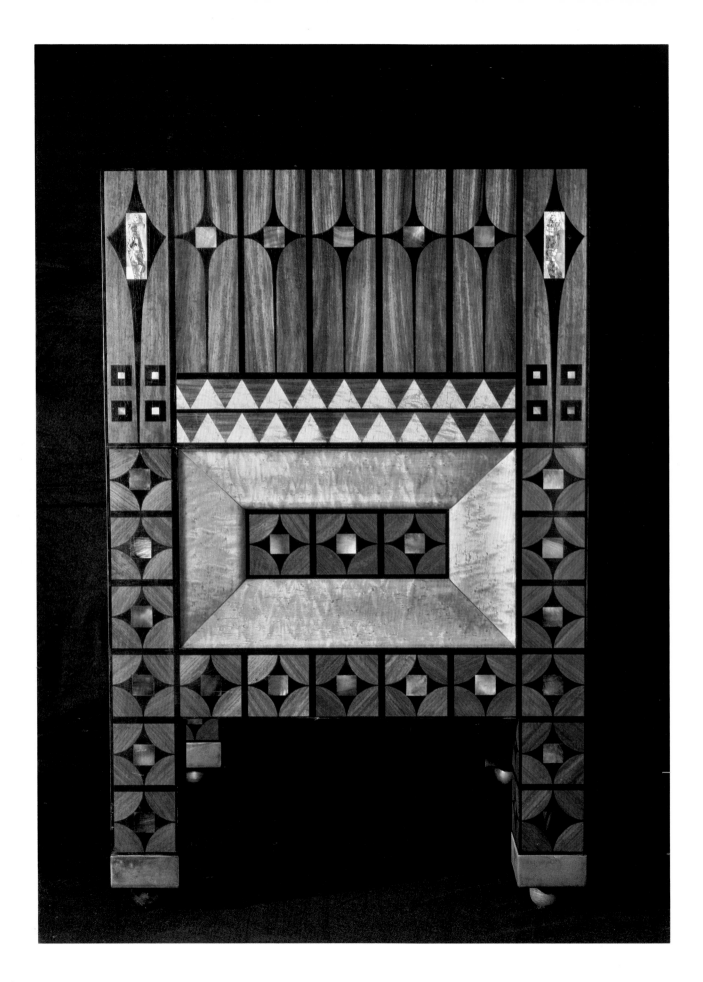

DESIGN

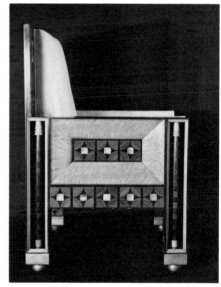

Koloman Moser. Armchair. 1903. Wood with mother-of-pearl inlay, 43 × 28 × 28″ (109.2 × 71.1 × 71.1 cm). Private collection, Vienna

Above: Side view

Page opposite: Back view

ipe and abundant decoration seems as Viennese as the waltz, and a hallmark of the city's legendary frivolity. But in early modern Vienna, the decorative arts were a serious matter. All over Europe around 1900, artists were concerned to get art off its easels and pedestals and out into a broader role in life; and it seemed that the further art moved from the imitation of nature, the more naturally it would once again be subsumed into the forms and purposes of architecture. The notion of the "decorative" thus came to seem a central progressive ideal.[1] Elsewhere this ideal led to a focus on public art; but in Vienna the concern was for the betterment of private life, in the design and fabrication of books, furniture, ceramics, silverware, and so on. Viennese ethics and aesthetics concurred in assigning to these minor arts a central role as agents of reform and signs of social health.

This concern was not simply a matter of nostalgia, but also of labor reform, and of Austria's ambitions in international commerce. The government was anxious to sustain skilled handworkers whose traditional rural bases and aristocratic clientele were disappearing with modern capitalization. The first major initiatives in this field were the founding of the Österreichisches Museum für Kunst und Industrie (Austrian Museum for Art and Industry, 1864) and the Kunstgewerbeschule (School of Applied Arts, 1868). Like numerous similar institutions across Europe, both were to a significant extent inspired by the pioneering role of the industrialized British in promoting modern decorative arts (especially the innovative South Kensington Museum, now the Victoria and Albert, founded 1852).

But by the later nineteenth century the failure of such liberal-progressive initiatives had become evident, and the hoped-for happy marriage of Art and Industry had failed to materialize. Instead, mass-produced ornament had come to be synonymous with nouveau-riche philistinism, and a disgruntled artisanry had come to be associated with volatile, resolutely anti-modern strains in socialism and reactionary populism. The next impetus to reform thus came not from above but below—from syndicalist movements among designers and craftsworkers, such as the English Arts and Crafts movement of William Morris. Drawing on the theories of John Ruskin and Morris, such guild-like collectives preached that good design was essential to the moral as well as the economic well-being of a nation, and that responsible, individual handwork could save the soul of machine-age man. For these large ideals, small organizations were thought best: communal workshops that would appeal directly to private patronage, independent of official or industrial concerns.

Josef Hoffmann. Page from *Ver Sacrum* with Poem by Rainer Maria Rilke. 1898. Lithograph, 11⅝ × 11″ (29.6 × 28 cm). The Museum of Modern Art, New York

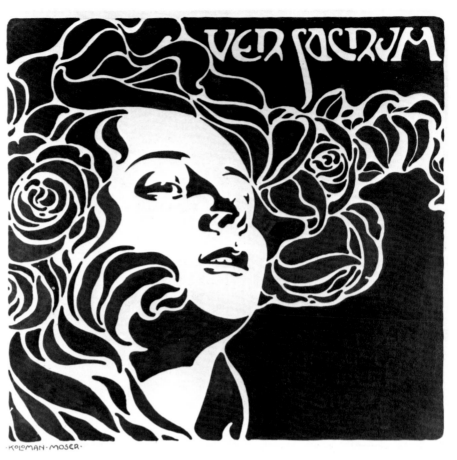

Koloman Moser. Design for Cover of *Ver Sacrum*. 1899. Pen and ink, 16⅝ × 16½″ (42.2 × 41.8 cm). Historisches Museum der Stadt Wien

In these turn-of-the-century endeavors, designers or architects were characteristically the leaders; but the issues involved were by implication those of the historical, ethical, and practical justification for art itself, in a modern society where the purpose and audience of art seemed undefined. The fate of the major and minor arts seemed crucially intertwined, for better or for worse: for the promise of a newly powerful, all-embracing coordination of talent, extending the domain of art to include every aspect of life; or for the threat of the growing irrelevance and superfluousness of individual labor. It was in this spirit, part crisis-anxiety and part utopian enthusiasm, that virtually every leading artist in turn-of-the-century Vienna —painters, sculptors, and architects, as well as men and women engaged in all the handcrafts—was vitally concerned with the question of the unity of the fine and the applied arts.

This idea of unity was at the center of the Secession's program, in the notions of collaborative design and the ideal of the *Gesamtkunstwerk* or total work of art, in which furniture, rugs, walls, and every useful object were to be symphonically coordinated with paintings, sculptures, and architectural conception. But the group's primary collective achievements were less in carrying out the idea than in advertising it. Their applied design focused on public-relations activities: the exhibition installations which were their hallmark; the exceptional series of posters for these exhibitions (pp. 106–09); and the deluxe periodical *Ver Sacrum* (pp. 112, 113). These productions set a standard of lavish orchestration few clients could hope to afford (the deluxe quality of *Ver Sacrum* itself soon declined, bowing to financial realities). But

Koloman Moser. "Vogel Bülow" Fabric Sample (detail). 1899. Fabric, 50⅜ × 37″ (128 × 94 cm) overall. Österreichisches Museum für angewandte Kunst, Vienna

Koloman Moser. Vignette from *Ver Sacrum.* 1901

Otto Wagner. "Sunflowers" Carpet Design for Postal Savings Bank. c. 1906. Watercolor, 23 x 15″ (58.4 × 39.4 cm). Collection Joh. Backhausen & Söhne, Vienna. Copyright Joh. Backhausen & Söhne

high-level official patronage almost immediately lent its support to these "rebel" attempts to stimulate new markets for Austrian crafts—as witness the appointments of the pioneer Secessionists Josef Hoffmann and Koloman Moser to the faculty of the Kunstgewerbeschule (in 1899 and 1900) and the Secession's participation in the Austrian display at the Paris world's fair of 1900.

The Secession's hallmark was a special brand of *Jugendstil,* inflected in a way that reveals an urge toward monumentality. While much of the curvilinearity widespread in the later 1890s writhed in restless, weedy whiplashes, the Viennese favored more sober symmetry and repetition that suggested order directing natural energies. This variant organicism is typified by one of the favorite motifs of Joseph Maria Olbrich, Otto Wagner, and other Viennese designers—the sunflower, a plant whose rigid, light-seeking verticality and mathematically organized face made it a proper emblem for a stricter, Northern spirit (as opposed to the murky exoticism of plants like the water lily, favored elsewhere). The same interests contributed to the popularity in Vienna of the Swiss Symbolist painter Ferdinand Hodler, whose prominent rhythmic patterning (based on a pseudoscientific theory of "parallelism" underlying nature) eventually came to impress itself on Gustav Klimt.[2]

One of Hodler's greatest devotees was the member of the Secession who was by background and talent most solidly grounded in the decorative arts: Moser. He drew his curvilinear *Jugendstil* forms directly from pliant natural life—mushrooms, fish, swan's necks, and so on. But then he interlocked

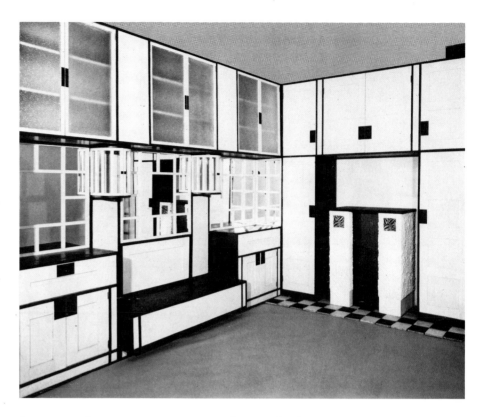

Right: Koloman Moser. Sideboard and Fireplace for Moser's Guest Room. 1902. Wood, glass, mirror, and ceramic tile, 71½″ × 11′ 2″ × 25″ (181.6 × 340.4 × 63.5 cm) and 71½″ × 6′ 8½″ × 25″ (181.6 × 204.5 × 63.5 cm). Collection Julius Hummel, Vienna

Below: Josef Hoffmann. Stool for Koloman Moser. 1898. Lacquered wood, 18½″ (47 cm) high × 16½″ (41.9 cm) diameter. Österreichisches Museum für angewandte Kunst, Vienna

Bottom: Josef Hoffmann. Table for Carl Moll. c. 1904. Painted wood with marble, 15⅞ × 15⅜ × 15⅜″ (40.5 × 39 × 39 cm). Hochschule für angewandte Kunst, Vienna

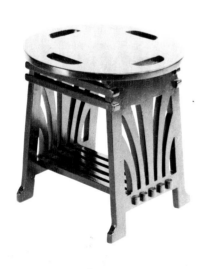

them in airless repeating patterns that made the vague and viscous dynamism of Art Nouveau dance to a stroboscopically intense beat (pp. 81, 114, 115). A hint of the ordered cadence that so altered Klimt's work around 1902 was already present in these exceptional designs, which anticipate by decades the pseudo-Surrealist M. C. Escher's figure-ground reversing schemes.[3]

Moser's firsthand knowledge of diverse craft skills and his experience with commercial art (from his early work as an illustrator) made him a leader in the Secession. He shaped the look of *Ver Sacrum* and imposed a style of exhibition installation whose uncluttered elegance was widely influential. His special graphic talent and sense of rhythmic proportion also made a providential match with Hoffmann's more rigid architectural logic. From their first collaborations in the Secession shows until they parted ways in 1907, this partnership was the driving force of progress in Viennese decorative arts.

Working so harmoniously that it is often difficult to distinguish one man's work from the other's, Moser and Hoffmann were primarily responsible for the black-and-white geometric style that banished the cozy curves and wood stains of *Jugendstil,* and made Vienna's most radical contribution to early modern design. One need only compare the lacquered stool Hoffmann designed for Moser's studio in 1898 with the small cubic table he made for the painter Carl Moll's villa in 1904 to measure the change. The interior cabinetry of Hoffmann's 1902 villa for Moser on the Hohe Warte—furniture thought to be by Moser himself—is one of the most striking early announcements.

Looking back on the changes in Viennese design, one critic said in 1908 that "the main event" of the preceding years had been "the conquest of applied art by architecture."[4] This new tectonic rigor came from the vocabulary of modular, geometric design that Hoffmann, Moser, and like-minded colleagues worked out around 1902–04—an all-purpose vocabulary that,

depending on scale, had the ability to give small forms monumentality (pp. 120, 121) and major constructions an almost precious lightness. The absolutes of geometry could give brute, cubic authority to a chair's form, and at the same time—repeated as pattern on the surface—dissolve its bulk into rich graphic planes (pp. 78, 79, 117). A metal plant stand could have both the look of a visionary skyscraper and a gauze-like airiness (p. 116). The dominant form was the impersonal and scaleless square, and the most pervasive motifs were the grid and checkerboard—as basic as the graph paper on which Hoffmann sketched out his floor plans, façades, and furniture.

The fact that rectilinear symmetry and square motifs had already appeared in Secession design of the late 1890s does not diminish the significance of this shift to simplification.[5] Part of the drama came from the way the new look realigned a whole constellation of things, old and new, exotic and indigenous. Much has been made of British influences, and certainly Hoffmann's admiration for the work of Ashbee, Mackintosh, and others is indisputable. The bony, monochrome rectilinearity of Mackintosh's Glasgow Art Nouveau, brought to Vienna for the eighth Secession exhibition (p. 84), was well received, not least because of the moral authority he and the other British designers brought with them from the cold island.[6] But, aside from some early transfer of Gothic proportions and rude English stolidity (p. 123), the simplicity Hoffmann and Moser wrought in their objects was more decisive, and more broadly synthetic.

The new Viennese reductiveness reflected a reimagining of the lessons of plainness in Japanese design, in opposition to the gaudier 1890s *japonisme* of France,[7] and an insight that such distant and exotic models were in harmony with humble things that lay close to hand. Those local models included simple forms of homespun, which is hardly surprising. But they also included, in a way that seems more peculiar to Austria, the middle-class style of the *Vormärz* period (literally, "before March," meaning before the revolution of 1848), the derivative of neoclassicism known as Biedermeier.

The decades prior to 1845, dominated by Metternich's efforts to restore a pre-Napoleonic order, have often been derided as a low ebb of creative imagination in Central Europe, an interlude of garden-tending burgher complacency. But for Hoffmann and Moser, and others of their generation, this

Josef Hoffmann. Vase. c. 1905. Painted sheet metal, 9⅝″ (24.5 cm) high. Private collection

Josef Hoffmann. Designs for Three Chairs. 1904. Pen and ink, 13½ × 18⅛″ (20.6 × 34.3 cm). Österreichisches Museum für angewandte Kunst, Vienna

Koloman Moser. "Purkersdorf" Armchair. 1902. Painted wood with dyed fiber webbing, 27¾ × 25⅞ × 25½″ (70.5 × 65.8 × 64.8 cm). Galerie Metropol, New York

seemed to have been a special moment in the history of middle-class taste, after the domination of the aristocracy and before the errors of historicism. In the plain façades of its buildings, and in the unadorned shapes of its metalwork and furniture, the bourgeoisie of the 1830s seemed to have begun a modern tradition—betrayed by the imitative puffery of the Ringstrasse

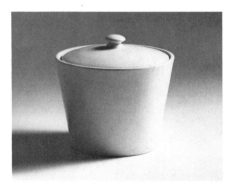

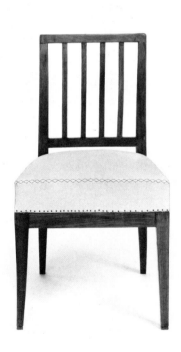

Top: Charles Rennie Mackintosh and Margaret Macdonald-Mackintosh. Room Designed for *Secession VIII.* 1900

Above: Designer Unknown. Sugar Bowl. c. 1825. Glazed porcelain, 4⅛″ (10.5 cm) high. Private collection

Right: Designer Unknown. Side Chair. c. 1810. Wood and fabric, 34⅝ × 18⅞ × 18⅛″ (88 × 48 × 46 cm). Private collection

generation and now to be recovered. The Biedermeier style's sedate authority offered just the remedy, too, for those withdrawing from the more anarchic ambitions of *Jugendstil*.[8]

Hoffmann nonetheless scorned the copying of forebears, however admirable, and by the early 1900s he found himself at odds with the Austrian Museum for Art and Industry, which used its exhibitions to encourage revivals of styles like Biedermeier. As he made clear in the 1901 essay "Simple Furniture," Hoffmann wanted to draw on the spirit, not the formal details, of his sources, to produce something unmistakably modern.[9] A design like his remarkable armchair of that date—one curved plane and one binding bentwood bar, with select aluminum detailing—pays homage to, yet maintains distance from, *Vormärz* furniture.

The design shift around 1901 was primarily reductive and purgative; the chairs often have the denuded look of armatures stripped of padding and upholstery (p. 83). Yet what appeared to be reductive, functional design was

Josef Hoffmann. Armchair. 1901–02. Wood with aluminum fittings, 31¼ × 23⅝ × 25″ (79.5 × 60 × 63.5 cm). Collection Julius Hummel, Vienna

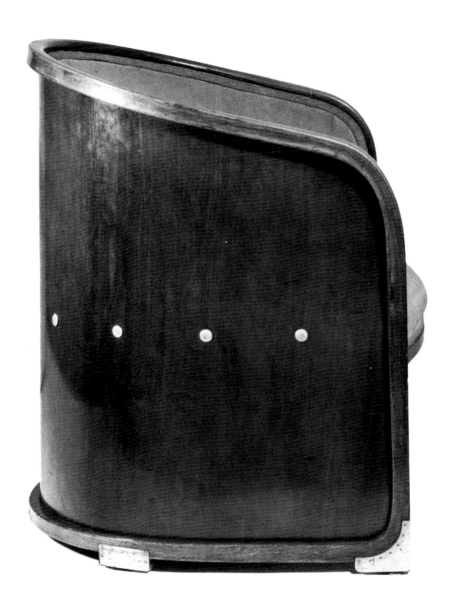

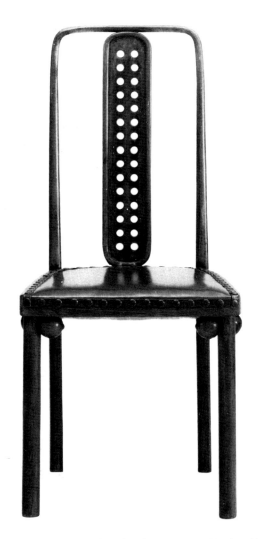

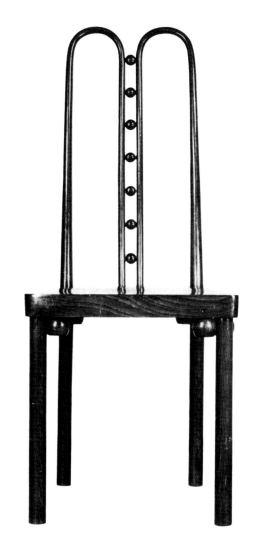

Josef Hoffmann. "Purkersdorf" Side Chair. c. 1904. Wood and leather, 39⅜ × 17¾ × 16⅞" (100 × 45 × 43 cm). The Museum of Modern Art, New York; By exchange

Josef Hoffmann. "Seven Ball" Side Chair. 1906. Wood, 44 × 16½ × 16" (111.8 × 41.9 × 40.7 cm). Collection Tim Chu

Josef Hoffmann. Inkwell. c. 1906. Hammered, silver-plated white metal, 3⅝ × 3¼ × 4⅝" (9.3 × 8.4 × 11.7 cm). Private collection

Koloman Moser. Cruets and Stand. c. 1904–05. Silver and glass, 6¾" (17.2 cm) high. Private collection

often governed equally by decorative intent. In the Purkersdorf side chair and other early Hoffmann furniture, for example, the stabilizing element at the juncture of the legs and seat was insisted upon as an autonomous, spherical form, a ball that quickly became a stylistic accent separate from, or even opposed to, structural logic. Here, as with Otto Wagner's use of oversize bolt heads, stripping down to the declared function excised one kind of decoration but prepared the way for another. In early modern Viennese design, classic structural simplicity and mannerist formal play often interlocked in this fashion, within the same period or even the same object.

For Hoffmann and Moser the challenge from the outset was to recover richness from reduction—to rephrase simplicity with a reticent elegance that would render superfluous the conventional luxuriance they were eliminating. Even in their sparest years, they were engaged in finding ways to make cheaper, unornamented materials and less flashy handwork produce objects and environments that would feel precise, cared for, and appealing— rather than merely deprived. Classic instances are their characteristic basketwork and hammered-metal objects (pp. 120–23). Without disturbing the conceptual clarity of forms, their busy surface liveliness makes explicit a kind of insistently anti-virtuoso hand labor, and readmits decorative enrichment. The impulse behind such design reform was after all not asceticism, but the redefinition of material pleasure, purified of the gross vulgarity of historicist bourgeois taste.

It was hardly coincidental that hammered- and punched-metal objects were the hallmark early productions of the artists' design collaborative Hoffmann and Moser founded in 1903, the Wiener Werkstätte (Viennese Workshop). For the Werkstätte, this dialogue between the simple and the sophisticated was a matter of business as much as aesthetics; one of its primary goals was to translate the innate moral strength of good design and craft into commercial appeal. The working manifesto Hoffmann and Moser wrote for the Werkstätte was notably free of the mythological and spiritualist trappings of the Secession, and dealt in more down-to-earth terms with matters of product value.[10]

Yet the manifesto exhorted as it advertised, and was as much sermon as sales pitch. Appealing to the sons and daughters of the Ringstrasse generation to give back to middle-class taste its progressive force, the authors invoked the historical destiny of artistic leadership yet to be fulfilled by the modern bourgeoisie. What was at issue was the ideal that avant-garde values and middle-class values should be partners, not enemies. The founding premise of the Werkstätte was that at its best, the bourgeois spirit— with its combination of pleasure-affirming worldliness and a disciplined work ethic—was close to the soul of the new age. Materialism need not remain confused with crass, sensual complacency, but could be as forward-looking, as refined, and as disciplined as these clarified new objects of enjoyment. It was in this spirit that Hoffmann and Moser urged patrons to shun the vulgar seductions of raw-material value or mere applied ornament, and to treasure instead the deeper qualities of conception and fabrication they would offer. In jewelry, for example, they pleaded that well-wrought silver and semiprecious stones should outshine gold and diamonds in the eye of the true connoisseur (pp. 140–45).

They did succeed in persuading some of the leading Viennese furniture, glass, and textile firms that modern design was marketable. The textile manufacturer Backhausen, having embraced Moser's talent early on, went

Wiener Werkstätte. Postcard. 1909. Lithograph, 5½ × 3½" (14 × 18.9 cm). Fischer Fine Art, London

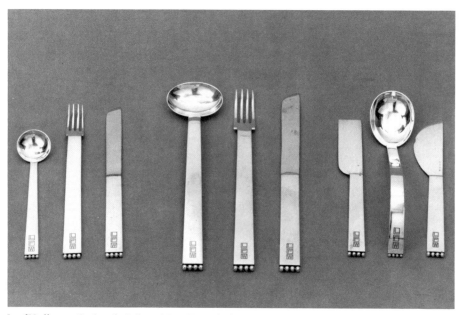

Josef Hoffmann. Cutlery for Lilly and Fritz Wärndorfer. c. 1906. Silver; middle group: spoon, 8⅝" (21.8 cm) long; fork, 8½" (21.6 cm) long; knife, 8½" (21.5 cm) long. Österreichisches Museum für angewandte Kunst, Vienna

Josef Hoffmann. "Notschrei" Fabric Sample (detail). c. 1903. Fabric, 59 × 19⅝" (150 × 50 cm) overall. Collection Julius Hummel, Vienna

on to produce not only Hoffmann's special carpets for the Palais Stoclet but also a range of innovative textile patterns for the broader market (p. 119). The glass firms of Bakalowits and Lobmeyr similarly engaged Werkstätte designers, on a more limited basis. And perhaps the most striking interchange took place between avant-garde designers and one of the city's most distinctive industries, the manufacture of bentwood furniture. Wagner, Hoffmann, Moser, and Loos (the last, of course, no friend of the Wiener Werkstätte) all admired the simple clarity of the unpretentious, mass-produced work of the Thonet firm; in turn, they designed furniture very much in this spirit (pp. 44, 86), for specific clients and also for general production both by Thonet and by the rival bentwood fabricator J. & J. Kohn.[11]

The Werkstätte itself, however, never succeeded in establishing the broad clientele or effecting the widespread design reform initially envisioned. In practical if not in moral terms, the ideals were set too high to be long maintained. The whole endeavor was only made possible through the underwriting generosity of Fritz Wärndorfer, the Anglophile scion of a wealthy textile-manufacturing family who was a patron of Mackintosh as well as Hoffmann.[12] His initial financial support allowed Hoffmann and Moser to design exemplary working premises, gather the best talents, and accumulate top-quality raw materials and equipment. As with the design workshops of the Arts and Crafts movement on which it was partly modeled (notably C. R. Ashbee's in London and Mackintosh's in Glasgow), this operation was intended to be self-sustaining; but that would have required extraordinary commercial success and very good management, neither of which was achieved. Overspending and litigated debt were chronic problems, periodically relieved by infusions of money from a handful of wealthy supporters.

Eventually even Wärndorfer's deep pockets were emptied, and the enterprise came to be a shareholding arrangement with a board of directors made up of major clients. In this fashion, the Wiener Werkstätte continued, and even flourished, long after its founders had lost their creative roles and its products had changed beyond recognition; it finally closed only in 1932.[13]

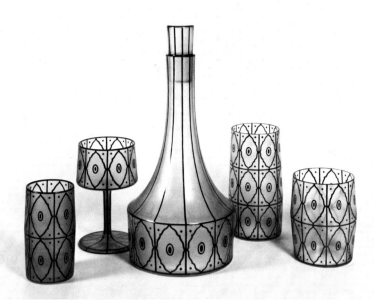

Josef Hoffmann. Decanter, Wine Glass, and Tumblers. c. 1910. Blown crystal; decanter, 10⅞″ (27.6 cm) high. Collection J. & L. Lobmeyr, Vienna

Thonet Brothers and Marcel Kammerer. Table. 1904. Wood, 31″ (78.7 cm) high × 23″ (58.4 cm) diameter. Collection Miles J. Lourie

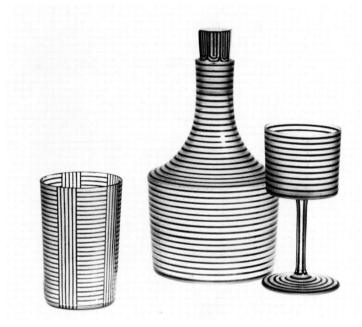

Josef Hoffmann. Decanter and Wine Glass, 1913, and Tumbler, 1910. Blown crystal; decanter, 8½″ (21.6 cm) high. Collection J. & L. Lobmeyr, Vienna

Michael Thonet. Side Chair. 1859. Wood and caning, 36⅜ × 16½ × 19⅞″ (92.5 × 42 × 50.5 cm). Private collection

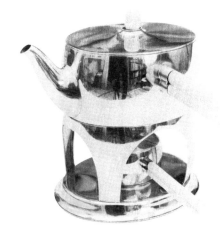

But the special character of the first few years' production, when real commercial need did not yet impinge and Hoffmann and Moser balanced idealism and elegance, was never regained.

This period, about 1904 to 1906, witnessed the transition from bare geometry to more sophisticated stylization. Hoffmann works like the table made about 1905 for Hermann Wittgenstein (a cousin of the philosopher), or the silver pieces that shed foursquare English influence for a suaver play of ovals and rectangles (p. 124), present an exemplary melding of simplicity and subtlety, matched by excellent crafts execution. Similarly, the early interiors on which Hoffmann and Moser collaborated—the Purkersdorf Sanatorium (p. 45), the fashion salon for Klimt's friend Emilie Flöge (p. 100), and the first Wiener Werkstätte displays abroad—have exceptional grace and clarity. But the character of Werkstätte production shifted strongly after 1907. In that year, Moser quit the enterprise, unhappy with the administration (and particularly angry at a surreptitious attempt to solicit financial support from his wife).[14] With his departure, and a new cast of leading designers, production became more scattershot, as the Werkstätte was buffeted by a different set of influences and ambitions.

Above left: Josef Hoffmann. Samovar with Stand and Burner. c. 1905. Silver and ivory; samovar, 8½″ (21.5 cm) high × 9½″ (24 cm) diameter. Private collection

Below: Josef Hoffmann. Table for Hermann Wittgenstein. c. 1905. Wood and marble, 26 × 43½ × 26″ (66 × 110 × 66 cm). Österreichisches Museum für angewandte Kunst, Vienna

Page opposite, top: Josef Hoffmann. Covered Bowl. c. 1903–05. Hammered silver, 3⅝″ (9.2 cm) high × 8″ (20.3 cm) diameter. Private collection

Page opposite, center: Josef Hoffmann. Design for Covered Bowl. 1903. Pencil, 7¾ × 12⅞″ (19.7 × 32.8 cm). Österreichisches Museum für angewandte Kunst, Vienna

Page opposite, bottom: Josef Hoffmann. Eggcup and Spoon. 1905. Silver; eggcup, 2⅝″ (6.8 cm) high × 4½″ (11.3 cm) diameter. Private collection

Bertold Löffler. Envelope for Kabarett Fledermaus. c. 1908. Lithograph, 2 × 3″ (5.1 × 8.9 cm). Historisches Museum der Stadt Wien

In 1907 the Werkstätte, rich with the combined support of Wärndorfer and Stoclet (who, rather ill-advisedly, had begun by advancing money on his open-ended building budget),[15] conceived and commissioned for themselves a theater-bar, the Kabarett Fledermaus (pp. 128, 129). Sparked by the model of artistic cabarets in Paris and Munich, the Fledermaus was intended to extend the group's cultural mission into the performing arts and provide an informal headquarters for the Viennese avant-garde. The announcements of the opening boasted of the superior combination of artistic purposes and creature comforts that would be provided, including—a typical Werkstätte concern—scrupulous attention to "the practical and hygienic needs of the audience." As Werner Schweiger points out, the critic Karl Kraus (an ally of Loos and enemy of the Werkstätte) wrote a column "reporting" a debate over whether these needs would best be served by using friendly critics' reviews as toilet paper, or by having the bathroom attendant wear a Hoffmann dress; in the end, he wrote acidly, the aestheticians of the Werkstätte deemed that white paint and a checkerboard imprint on the commode would be the most harmonious solution.[16]

The cabaret was an apt monument to the openly *mondain* spirit of the Werkstätte, so opposed to the Symbolist solemnity that had ruled the *Ver Sacrum* years. Where art had previously adopted the airs of cultish elitism, here it would rub elbows with popular entertainment. The tenor is evident in the program of the first season—which mixed avant-garde dance, semi-surreal masked plays, and odd fairy-tale projection shows with marionette plays, old military songs, and grotesqueries[17]—and in the décor of the bar. In the (unprofitably small) downstairs theater room, Hoffmann had used gray and white marble that prefigured the deluxe feel of the Stoclet interior (pp. 67–70); but in the bar, thousands of randomly sized ceramic tiles covered the walls with a loud crazy-quilt of jokes and decorative caprices.

This so-called "paperhanger's nightmare" was commissioned by the Werkstätte from an affiliate, the Wiener Keramik, formed in 1906 by Bertold Löffler and Michael Powolny. Early on these two had produced work with a strikingly simple architectonic look (p. 118), but the pictorial tiles for the Fledermaus were of another order. Their jocular chaos exploded the subservience of decoration to architectural order, and their gaudy styliza-

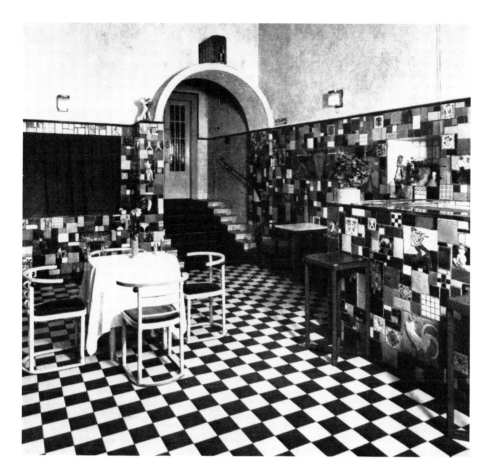

Above: Bertold Löffler. Design for Wiener Keramik Logo. c. 1910. Ink and gouache, 2 × 2" (5 × 5 cm). Historisches Museum der Stadt Wien

Left: Barroom of Kabarett Fledermaus, with Wiener Werkstätte wall tiles designed by Michael Powolny and Bertold Löffler. 1907

Below left: Josef Hoffmann and Wiener Werkstätte. Theater room of Kabarett Fledermaus. 1907

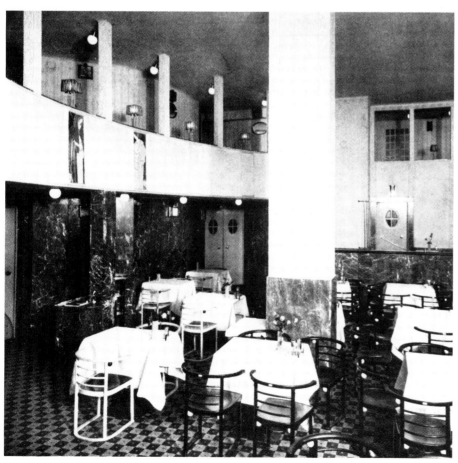

tions abandoned classicizing dignity for the earthier world of woodcuts, popular broadsides, and humorous illustrations. Simple club-spirit frivolity accounts to some extent for this aspect of the Fledermaus tiles, but the décor also reflects the broader emphasis on figural fantasy that, through the appearance of new talents, was then beginning to assert itself in Viennese art.

Chief among these new talents was a twenty-one-year-old prodigy, still enrolled at the Kunstgewerbeschule: Oskar Kokoschka. The first week of performances at the Fledermaus included Kokoschka's only partially successful attempt to project the sequence of images for his "Indian fairy tale," *The Speckled Egg,* and in a matter of months he had assumed a leading role in the Viennese avant-garde. His success was that of the *enfant terrible.* In works like his illustrated fable *Die träumenden Knaben* ("The Dreaming Youths"; p. 130), Kokoschka's stream-of-consciousness nursery-rhyme narrative style, and his quirky magic-garden vision—in which schematic figuration and bluntly stylized organic form floated in uncertain fields of space—seemed in direct communication with the uncorrupted resources of a child's imagination.

Children's creativity had been a subject of intensified scrutiny for educational reformers and psychologists throughout the later nineteenth century; like Matisse and many other avant-garde artists in Europe, the circle of the Werkstätte shared this interest.[18] It was part of a larger search in which early modern artists, frustrated by what they felt was the fatigued decadence of naturalism, sought "raw" sources of inspiration. The same appreciation of the naïve and untutored fostered a new attention to folk art, for, like rural culture itself, folk styles were seen as harmonizing unselfconscious individualism and uninterrupted tradition—free from both the conformist monotony and the forced stylishness of "civilized" expression.

This interest in folk culture, which was connected to the larger phenomenon of "primitivism" in Europe, also had broader counterparts in Austrian society. With the long-awaited advent of universal male suffrage in 1907, and the increasing power of the conservative heir apparent, Franz Ferdinand (who was resolutely anti-British and anti-French), the rural minorities of the empire came to greater prominence. From the picturesque peasant brigades of the emperor's jubilee parades of 1908 to the aggressively anti-urban polemics of leading writers, *Provinzkunst* (art drawn from, and devoted to, the provinces) was ascendant.[19]

As *völkisch* admirations intertwined with nationalism, local and particular truths were valued over so-called universal ideals. Thus the conception of the heroic and epic, previously centered on the iconic reserve of Attic deities, shifted toward the darker drama of Northern sagas. One of the most impressive of the many works conceived by Wiener Werkstätte artists for children was the illustrated *Die Nibelungen* made in 1908 by Kokoschka's professor at the Kunstgewerbeschule, Carl Otto Czeschka, for the publisher Gerlach's Youth Library (p. 131). Its epic archaism is remote from the vagaries of adolescent sexuality recounted in *Die träumenden Knaben.* Yet both books exemplify the fascination with fairy tales, enchantment, and folk myth that, from the edges of Europe (Scandinavia and Russia especially), came in the early 1900s to challenge Western art's traditional basis in Mediterranean culture (and captured, among others, the Russian painter Kandinsky in his Munich years).[20]

These primitivizing currents, crucial sources for emergent expressionism, could lead in widely divergent directions. On the one hand, they promoted a sharp conservatism associated with reactionary politics and *Heimatstil*—

the conformist, anti-modern art of home and hearth, marked by thatched-roof revivalism. But they also opened the way to a new appreciation of more radical energies in popular art, and allowed for some unusual stylistic hybrids. At issue was a basic reimagining of art's sources. Moser and others of his generation had followed Ferdinand Hodler in supposing that there was an objective, regular order in nature beyond the vague impressions of our senses, and in using art to reveal this order by imposing the timeless high abstractions of geometry. But to a younger generation that set greater store by subjective intuition, crude exaggeration and unmodulated hues seemed better suited to express the primal basis of art's activity. Such odd companions as the archaic (in saga style and neo-Viking ornament) and the comic (in caricature and cartoons) became parallel instances of the way imagination's power, free from tutored imitation, acted to shape the world in bolder form. The Fledermaus programs, and the large production of Wiener Werkstätte postcards around 1908, show just this kind of dance between peasant style and *Punch* style (p. 132).[21]

Previously, with classicism as their high ideal, Hoffmann and other

Carl Otto Czeschka. Two-Page Illustration from *Die Nibelungen* (Vienna: Gerlach & Wiedling, 1920; original ed., 1908). Lithographs, each 5⅞ × 5⅜″ (14.8 × 13.5 cm). Collection Ronald and Hilde Zacks, Hamden, Connecticut

designers had looked to the vernacular for instances of tectonic simplicity. Around 1907, though (partly with a reevaluation of antiquity itself, based on Minoan and Mycenaean rather than Attic models),[22] folk style and Northern archaism came to be synonymous with elaborate, dense surface decoration. Energy was preferred to clarity: the static neutrality of the square was supplanted by woodcut-like spikes and looping whorls, and the regularity of the checkerboard by the fragmentation of mosaic. Line took on a new physiognomic density, and architecture was supplanted as a source of inspiration by handwork such as embroidery and old manuscript illumination.

Naturally, these were not overnight changes; many of the elements that moved to the fore around 1907 had been present much earlier (notably in the work of Czeschka), pushed into the margins by the temporary dominance of the geometric style. In large part, the new look was a consequence of Moser's departure, and of Hoffmann's subsequent loosening of his grip on Werkstätte design, as his own work fell from dominance and came under the

Page opposite, top: Oskar Kokoschka. *Stag, Fox, and Magician,* Plate 1 (with border design by Carl Otto Czeschka) from Program I, Kabarett Fledermaus. 1907. Lithograph, 9½ × 9¼″ (24.2 × 23.4 cm). The Robert Gore Rifkind Center for German Expressionist Studies, Los Angeles County Museum of Art; Purchased with funds provided by Anna Bing Arnold, Museum Acquisition Fund and Deaccession Funds. Believed to have been one of the images projected as part of *The Speckled Egg* at Kabarett Fledermaus in 1907.

Page opposite, center: Hubert von Zwickle. Wiener Werkstätte Postcard for Emperor Franz Josef's Jubilee. 1908. Lithograph, 5½ × 3½″ (14 × 8.9 cm). Private collection

Page opposite, bottom: Oskar Kokoschka. Title-Page Vignette for *Die träumenden Knaben* ("The Dreaming Youths," 1908; issued, Leipzig: Kurt Wolff, 1917). Lithograph, 9½ × 11⅜″ (24 × 28.9 cm). The Museum of Modern Art, New York; The Louis E. Stern Collection

Josef Hoffmann. *Kunstschau Wien 1908* Exhibition Pavilion. Façade. 1908

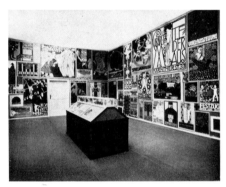

Bertold Löffler. Installation of Prints and Posters, *Kunstschau Wien 1908* Exhibition Pavilion. 1908

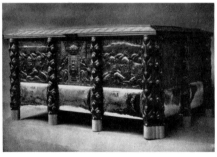

Carl Otto Czeschka. Silver Box Commemorating the Emperor's Visit to the Skoda Factory, Pilsen. 1905–06. Gilded silver and precious stones, 11 × 20⅞ × 14¾" (28 × 53 × 37.5 cm). Österreichische Nationalbibliothek, Vienna

influence of other members of the group. But by any account the Fledermaus ensemble, with its sophisticated mixture of the refined and the raucous, represented a turning point in the development of the Werkstätte's style. The shift was fully confirmed in the following year, with the landmark exhibition *Kunstschau Wien 1908.*

There had been a split within the Secession in 1905, and the core of original leaders had followed Gustav Klimt in departing. This had left the most progressive wing of Viennese art without any regular exhibition space, and the *Kunstschau*—staged on leased land in a temporary set of pavilions devised by Hoffmann and associates—was the solution to this problem. The collaboration of the "Klimt Group" and the Wiener Werkstätte shaped the giant production, which included Moser's installation of a major Klimt retrospective exhibition, a garden theater, a complete two-story cottage by Hoffmann ready to sell, and rooms devoted to theater arts, art for and of children, and Werkstätte objects. The ensemble was at once the most complete advertisement Viennese artists ever mounted for the notion that artistic design should shape every corner of life, and also the announcement —in the savagery of Kokoschka's talent, which here first reached a broad public—that modern art might henceforth be a much more disquieting endeavor.[23]

In a room whose walls were accented by vertical panels of lace-like linear ornamentation, the Werkstätte display featured, among other objects of decorous elegance, the flowered ceramics and fruit-bearing cherubs of Powolny (p. 136). The center of the room was given over to Czeschka's incredible wrought-silver showcase, two years in the making. The dominance of Hoffmann and Moser was thus definitively set aside, and a new Romantic, eclectic individualism brought to the fore. For several of the Werkstätte's designers, this was doubtless liberating, but one does not have to be a rigorous purist to feel something important had been lost. Moser complained on leaving the Werkstätte that it had begun to scatter its energies too widely, and shape its work too trivially, in order to win over a fashionable clientele. In the *Kunstschau* extravaganza, between the thin, mannered elegance of the wall décor and the chubby charm of Powolny's gaily colored Baroque-revival putti, one can measure the justice of his judgment.

Czeschka's work, too, pointed in a problematic direction. This artist's tightly woven stylizations, effective on the printed page and in jewelry, became heavier and more lavishly ornate when translated to objects like the "grail-style" vitrine, or the box he designed in 1905 as the Werkstätte's gift to the emperor. The problem was a symptomatic one, not unique to him. Up to about 1907, Werkstätte production had been dominated by architectural principles. But from the advent of Kokoschka onward, the new and influential talents were essentially atectonic and pictorial; and the Werkstätte's signature works were increasingly printed matter, fabrics, and applied surface ornament. The early dialogue of surface plane and structural form was abandoned, in favor of more sculptural and often more precious formal inventions, and more complex plays of all-consuming pattern (p. 137).

With the new emphasis on pattern, Western logic yielded to quasi-Oriental splendor. In these revolts against structure it sometimes looked as if the luxuriance of *intimiste* painting—the wallpapered world of early

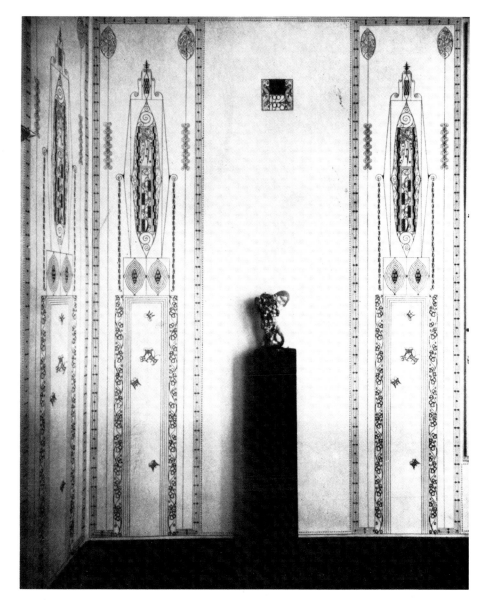

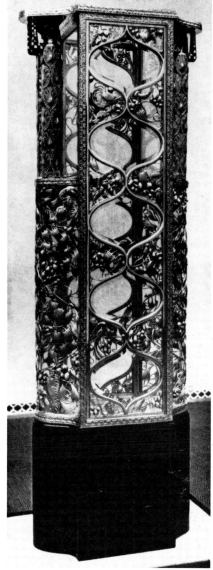

Above: Carl Otto Czeschka. Vitrine. 1906–08. Silver with semiprecious stones, enamel, and ivory, 63 × 24 × 12½″ (160 × 61 × 31.8 cm). Private collection

Above left: Josef Hoffmann. Detail of Wiener Werkstätte Room, *Kunstschau Wien 1908* Exhibition Pavilion. 1908 (ceramic figure by Michael Powolny, illustrated p. 136).

Left: Josef Hoffmann. Wiener Werkstätte Room, *Kunstschau Wien 1908* Exhibition Pavilion. 1908. The vitrine by Carl Otto Czeschka illustrated above is in the center of the room.

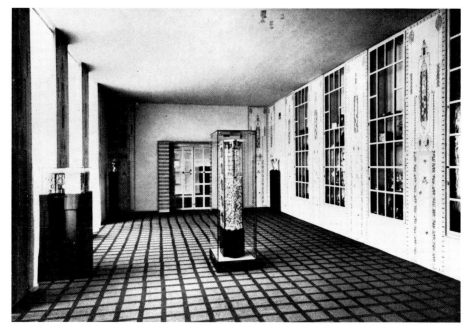

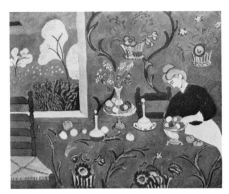

Henri Matisse. *Harmony in Red.* 1908. Oil on canvas, 69¾ × 7′ 1⅞″ (177.2 × 218.2 cm). The Hermitage Museum, Leningrad

Josef Hoffmann. Anniversary Table (with china figures by Richard Luksch) for the Wiener Werkstätte Exhibition *Der gedeckte Tische* ("The Laid Table"). 1906

Vuillard and Bonnard, and ultimately of Matisse's *Harmony in Red*—had spilled over into interior design. It would be facile and prudish simply to dismiss this development as a self-indulgent retreat from earlier tough-mindedness, for it was in touch with an aesthetic of pleasure that had its own radical potential. From its beginnings, Werkstätte design had been linked—notably in exhibitions like *Der gedeckte Tisch* ("The Laid Table") of 1906—with the championing of material pleasure and the gratification of the senses as necessary parts of the fulfillment of life's potential. A connection with *Harmony in Red* would thus not be a mere coincidence; it would reflect a shared belief in the radical force of the decorative ideal within the new, affirmative conception of modern materialism on which the Werkstätte was founded. In opposition to the otherworldliness of Symbolism and the ascetic severity of German classicism, this was originally a progressive and liberating impulse; the imposition of flat pattern over spatial illusion and tectonic reason had an important affirmative aspect. But unchecked by a countervailing distaste for slack indulgence, it risked degenerating into picturesque and shallow amusement. This balancing of extravagance and restraint was the challenge with which Matisse continually confronted himself, and the one that was gradually abandoned in Vienna. In design, as in Klimt's work, Fauvist ideas came late, and were lacking in some essential strengths.

The loss of tectonic logic bespoke the demise of the early reform spirit of the Werkstätte enterprise. The chic frivolity that characterized the Fledermaus took over, degenerating into fashionable aestheticism of a more banal sort. The *Kunstschau* was a swan song. It marked the end of an epoch that had begun with the founding of the Secession, an epoch in which the decorative arts had been central to all that was progressive and ambitious in the modern movement. After 1908, these minor arts once again became minor, responding to taste more than shaping change; and the Wiener Werkstätte became, more and more, simply a business built on embellishment.

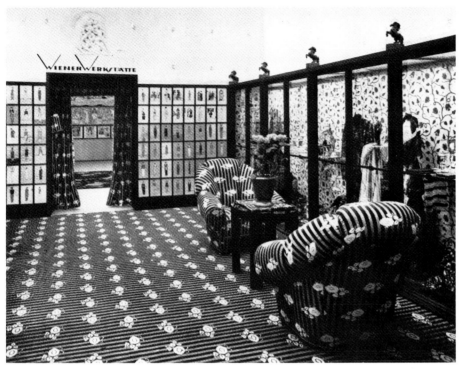

Eduard Josef Wimmer-Wisgrill. Wiener Werkstätte Room, Austrian Pavilion, Deutsche Werkbund Exhibition, Cologne. 1914

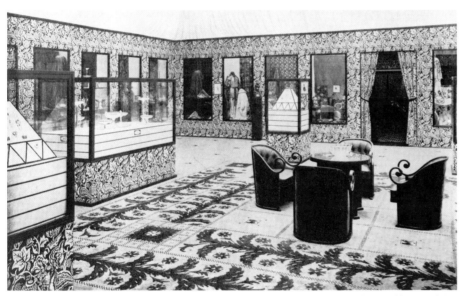

Karl Witzmann. Exhibition Room for Decorative Arts, Austrian Pavilion, Deutsche Werkbund Exhibition, Cologne. 1914

The years following the 1908 *Kunstschau* saw the Werkstätte extend its international reach, by exhibitions in Rome (1911) and Cologne (1914), and by participation in the larger Deutsche Werkbund (founded 1907). But a severe retrenchment followed, as World War I drastically cut back activities and obliged an exclusive focus on design that was recognizably Germanic in character, without French or English taint. This provincialism had its strongest effect on the newest of the Werkstätte's departments (and one of its most successful commercial endeavors), the fashion department, founded in 1910.[24]

Fashion and art had intertwined earlier in Vienna, in the friendship

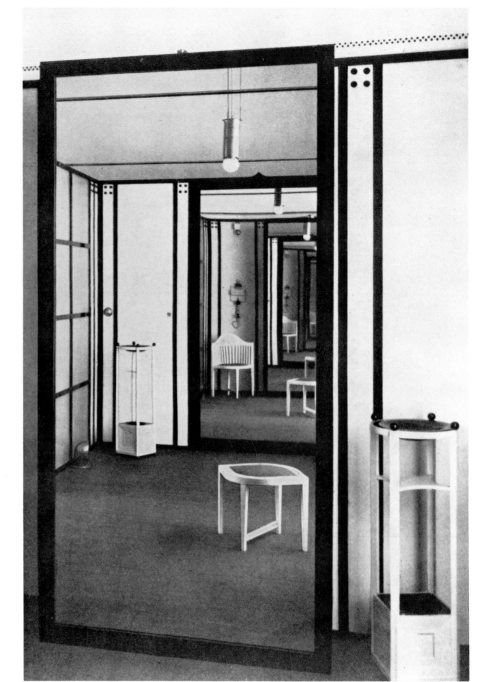

Josef Hoffmann and Koloman Moser. Interior of Casa Piccola, Flöge Sisters' Fashion Salon. 1904

Above: Emilie Flöge wearing "Concert" dress designed by Gustav Klimt and pendant by Josef Hoffmann; before 1907. (Pendant illustrated p. 140)

Right: Gustav Klimt. Sheet of Labels for Casa Piccola (detail). c. 1906. Silk, 26¾″ × 9′ 3⅞″ (68 × 284 cm) overall. Collection Dr. Wolfgang Fischer, Vienna, for Fischer Fine Art, London

between Klimt and Emilie Flöge (p. 198). Flöge, who with her sister ran a leading Viennese fashion salon (whose quarters were designed by the Wiener Werkstätte), had around the turn of the century designed gowns so close to the spirit of Klimt's art that it is hard to say whether he or she was ultimately responsible for them. She had also amassed an impressive collection of peasant lacework and embroidery from the eastern provinces and Rumania, and incorporated fragments of these directly into her designs well before folk style was fashionable. But more important, her early works represented a moment when fashion, along with the other applied arts, became an integral part of avant-garde ambitions for the larger reform of life.

At the end of the nineteenth century, the issue of women's clothing involved the larger issues of feminism.[25] The fashionable silhouette of the bustled and corseted ladies of the 1880s was regarded in progressive circles as criminal, a constricting and unhealthy deformation of the body; all whalebone and laces were to be discarded, and dresses were to fall away from the body in smock-like fullness that permitted freedom of movement. This kind of garb, known as the Reform dress, was for a long while the exclusive domain of earnest and resolutely unfashionable feminists. What designers like Flöge realized, with the help of Paul Poiret's fashion innovations in Paris, was that this look could be made appealing on other than just orthopedic grounds. The breakthrough came in merging the plain, straight lines of the Reform dress with a redefined classicism, either in Empire revival (another instance of Biedermeier-epoch resurgence) or in more boldly "antique" designs. In this manner, "natural" freedom and the strict artificiality of simple lines were jointly satisfied, and a look that had been considered styleless and marginal for decades was repackaged, in the early years of the century, as the latest development of taste—the so-called Rational dress of Flöge and Klimt.[26]

The next step leading toward an official Wiener Werkstätte fashion undertaking came with the establishment of a textile workshop in 1905. Hoffmann and Moser had already worked successfully with the textile firm of Backhausen & Söhne for carpets and upholstery, but set up the in-house operation to focus on more lavish hand-printed and painted silk designs.[27] With such luxury cloth, manufactured in literally thousands of patterns constantly replenished by the Werkstätte's leading artists—Hoffmann, Czeschka, et al.—Vienna first made its mark on the international fashion scene.

Hoffmann had always regarded textiles as an essential part of the total aesthetic control of an interior design; by legend, it was the realization that a client's clothing could disturb this complete harmony that prompted the founding of the fashion department. But, though Hoffmann contributed designs, the talent that really shaped Wiener Werkstätte fashion was that of the founding director, Eduard Josef Wimmer-Wisgrill. Wimmer-Wisgrill was regarded as the Viennese answer to Paul Poiret, and a review of his designs (pp. 102, 103) as well as those of his colleagues shows a constant dialogue with Paris fashion and Poiret's designs in particular.[28] Poiret, who visited Vienna in 1912 and was a great admirer of Hoffmann, in turn repaid the compliment by purchasing quantities of fabric from the Werkstätte.

Wimmer-Wisgrill's and the Werkstätte's outstanding success in Germany and Austria—to take nothing away from innate talent or quality of execution—owed much to the social need to beat Paris at its own best game. Nowhere was Paris's dominance more overbearing than in fashion design, and thus nowhere was it more imperative—or more difficult—to respond to

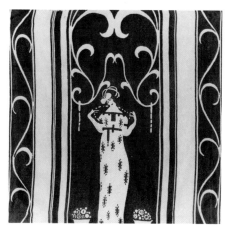

Arnold Nechansky. "Pompey" Fabric Sample. c. 1913. Silkscreened silk, 14½ × 14½" (37 × 37 cm). Collection James May

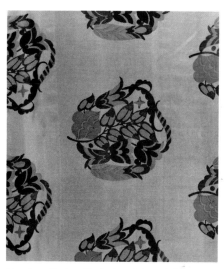

Dagobert Peche. "Rosenkavalier" Fabric Sample (detail). c. 1918. Silkscreened silk, 15⅜ × 25⅛" (39 × 64 cm) overall. Collection James May

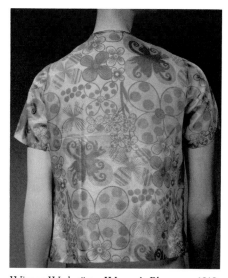

Wiener Werkstätte. Woman's Blouse. c. 1918. Printed silk. The Metropolitan Museum of Art, New York; Gift of Mrs. Friedericke Beer-Monti, 1964

Above left: Eduard Josef Wimmer-Wisgrill. Design for "Bubi" Suit. 1912. Pencil and watercolor, 11¾ × 7″ (29.7 × 17.8 cm) sight. Österreichisches Museum für angewandte Kunst, Vienna

Above center: Eduard Josef Wimmer-Wisgrill. Design for "Franziska" Suit. 1912. Pencil and watercolor, 11¾ × 7″ (29.7 × 17.8 cm) sight. Österreichisches Museum für angewandte Kunst, Vienna

Above right: Wiener Werkstätte. Dress. c. 1915. Silk. The Metropolitan Museum of Art, New York; Gift of Mrs. Friedericke Beer-Monti, 1964. Made of the same patterned silk seen in Mrs. Beer-Monti's portrait by Gustav Klimt, at right.

Right: Gustav Klimt. *Friedericke Maria Beer.* 1916. Oil on canvas, 66⅛ × 51⅛″ (168 × 130 cm). Collection Markus Mizné, Rio de Janeiro, on extended loan to The Metropolitan Museum of Art, New York

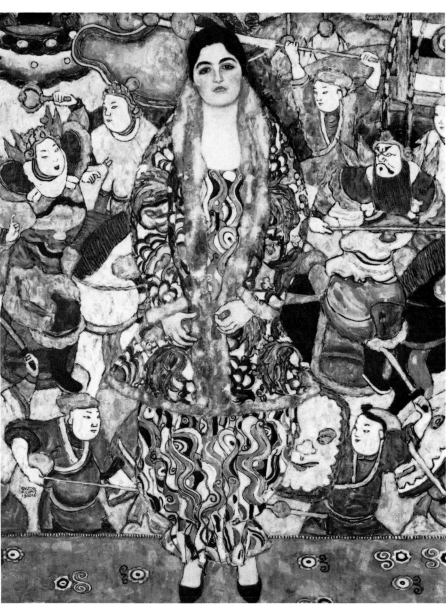

the cry *"Los von Paris!"* ("Away from Paris!") when the war came. All the stores that had advertised themselves as *maisons pour robes* were obliged to hurriedly tape over their signs, and the Werkstätte was expected to take the lead in redefining the properly Germanic mode.[29] In the folio of approved designs published for 1914–15, the representations neatly switched from the elegant linearity of previous years to a suitably rough woodcut look, and a certain un-Gallic heaviness was incorporated into every type of dress. Orientalism, in the Scheherazade mode of Léon Bakst, was still permissible, as witness the Turkish-pajama outfit in Wiener Werkstätte silk worn by Friedericke Maria Beer in her 1916 portrait by Klimt.

The stress on things German, and the emotional resonance of the woodcut look, doubtless figured as well in the initial popularity of the one major new designer who emerged from the war years, Dagobert Peche. Peche was twenty-nine when he entered the Werkstätte in 1915, and was fated to die before he reached forty. His was an idiosyncratic stylistic temperament, refined to a point of nervous perversity (p. 104); but it was not discordant with Wimmer-Wisgrill's talent, and perfectly in tune with Hoffmann's tendency in the teens toward mannered and attenuated elaboration. Hoffmann was immediately impressed, and influenced: Peche's spiky style quickly became the hallmark of the Werkstätte's look, in posters, in fabrics, and in exhibition design. Its angular stylization drew on German Expressionism; but, like so much of the Werkstätte design of the teens, it was already racy, brittle Art Deco in spirit. In harmony with the particular feminine luxuriance that had become the Werkstätte's stock-in-trade, it was essentially a mode of filigree, and worked best on paper, in fabrics, and in jewelry.

The Wiener Werkstätte would rebound strongly after the war and play an international role, operating in America and figuring prominently in important design exhibitions such as the one in Paris in 1925. But standards of quality declined, and an unmistakable element of kitsch marked too many of its productions. Ironically, it is this least innovative, most facilely decorative aspect of later design that has come to be most broadly associated with the Werkstätte, while the work of the enterprise's early years has been brought back to public admiration only in the last two decades.

Page opposite: Carl Moll. *White Interior.* c. 1908. Oil on canvas. Whereabouts unknown. The furniture and interior shown in the painting are by Josef Hoffmann.

Right: Dagobert Peche. Jewelry Box. 1918. Silver, 16¾ × 7⅝ × 4⅞″ (42.5 × 19.5 × 12.5 cm). Private collection

Below right: Dagobert Peche. Poster for Wiener Werkstätte Lace Department. 1918. Lithograph, 22⅜ × 17⅞″ (57 × 45.5 cm). Österreichisches Museum für angewandte Kunst, Vienna

Below: Dagobert Peche. Embroideries. c. 1916. Lace; each, 5⅞ × 5⅞″ (15 × 15 cm). Collection James May

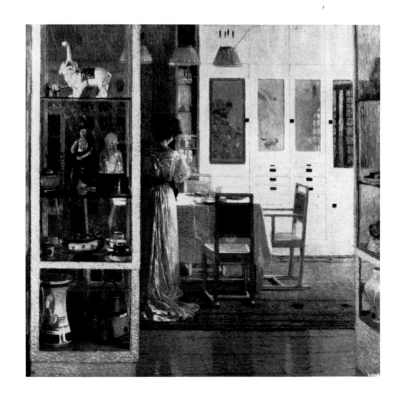

On balance, it would be difficult to call the Werkstätte a success in the terms it set for itself. Citing the ideals of John Ruskin and William Morris, the founders envisioned an alliance between collaborative artists dedicated to the notion that handwork was morally fulfilling, and an educated bourgeois clientele that would value enduring quality over fickle fashion. Through this alliance the talents of the best designers would be supported in their desire to produce functional objects of grace and quality, accessible to a broad spectrum of society. The Werkstätte's own production, however, never really established itself on a mass-market basis. While the best work was reserved for lavish, one-of-a-kind commissions such as that for Stoclet, the enterprise was allowed, at the other end of the scale, to dilute the authority of its imprimatur by producing trivia. The ideal of reforming the life of the common man through better design remained a paper promise.

Unfortunately, the very nature of the Werkstätte's ideals partially doomed its heritage. Its founders intended their work to be seen in contrapuntal ensembles, with materials and styles played off against each other in balanced interiors. With the one extraordinary exception of the Palais Stoclet (still remarkably preserved, in excellent condition), nothing now survives but the fragmentary components of that intention. The temptation, then, is to choose sides and forge outside alliances: either to isolate the geometric work and insist upon its proto-Bauhaus severity and functionality; or to embrace the aspects of rich and flowery eclecticism as prophetically postmodern, in the fashion of the historicizing design or of the pattern-and-decoration painting of recent years. But in the best productions of the Werkstätte, the strict simplicity and luxuriant complexity were complementary, not opposed, principles—ways of emptying out and filling up that would banish vulgarity and define a modern sense of material pleasure. ∎

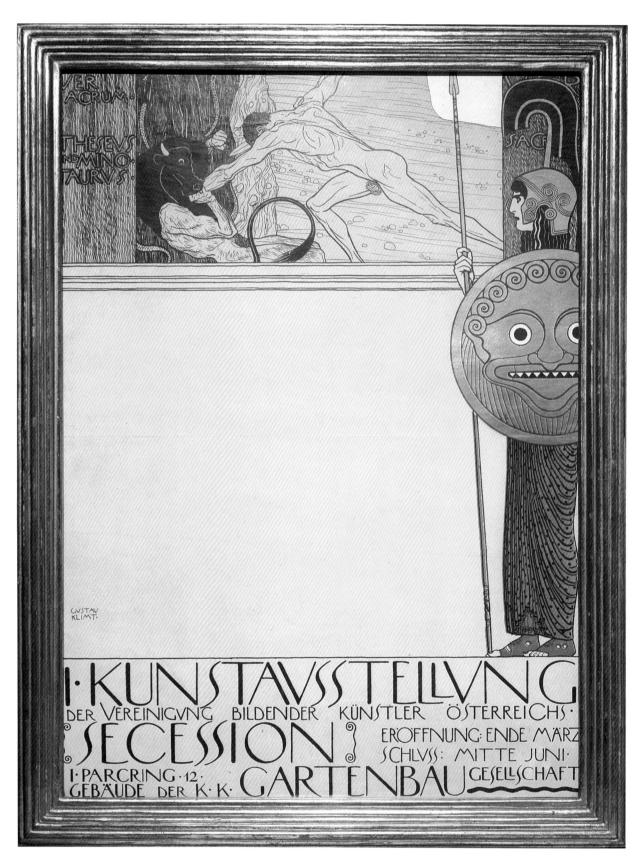

Gustav Klimt. Poster for *Secession I* (before censorship). 1898.
Lithograph, 24¼ × 17¼″ (61.6 × 43.9 cm).
Private collection, courtesy Barry Friedman Ltd., New York

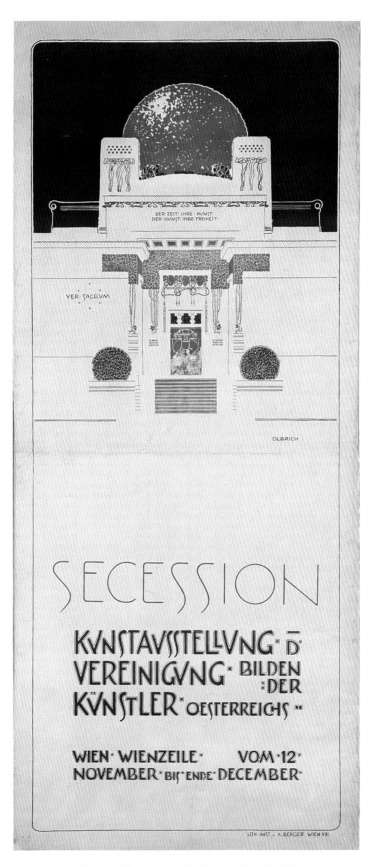

Joseph Maria Olbrich. Poster for *Secession II and III*. 1898–99.
Lithograph, 33⅝ × 19⅞" (85.5 × 50.5 cm).
Collection Mr. and Mrs. Leonard A. Lauder

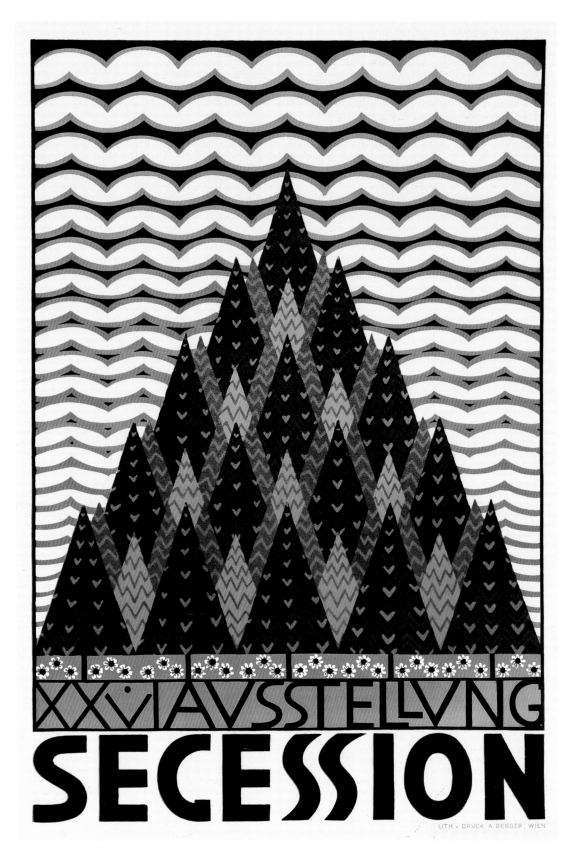

Ferdinand Andri. Poster for *Secession XXV.* 1906.
Lithograph, 37 × 24½″ (94 × 62.2 cm).
Collection Mr. and Mrs. Leonard A. Lauder

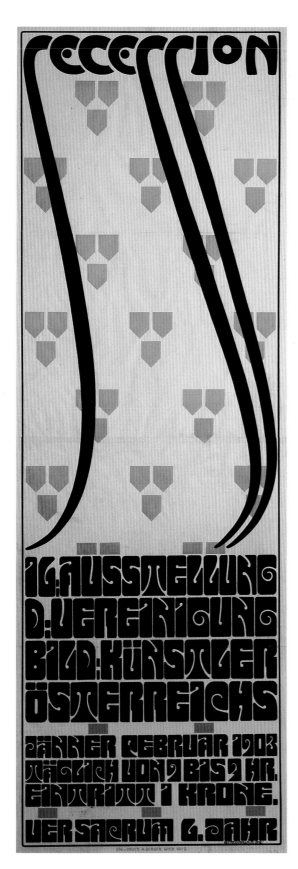

Alfred Roller. Poster for *Secession XVI*. 1903.
Lithograph, 6′ 2⅜″ × 25″ (188.9 × 63.5 cm).
Private collection, courtesy Serge Sabarsky Gallery, New York

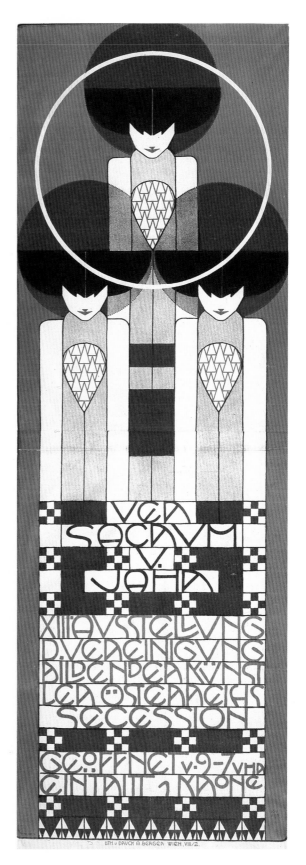

Koloman Moser. Poster for *Secession XIII*. 1902.
Lithograph, 69¾ × 23½″ (177.2 × 59.7 cm).
Private collection, courtesy Barry Friedman Ltd., New York

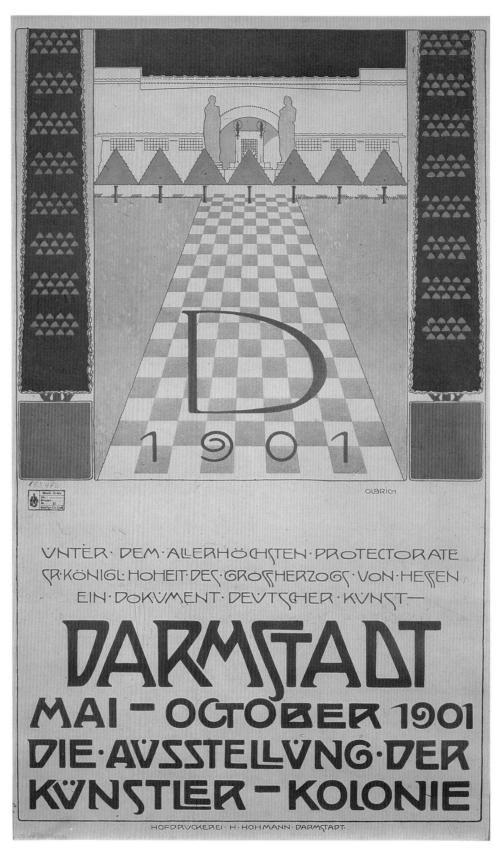

Joseph Maria Olbrich. Poster for the Exhibition *Ein Dokument deutscher Kunst,* Darmstadt. 1901.
Lithograph, 32 × 19¼" (81.3 × 48.9 cm).
Private collection, courtesy Barry Friedman Ltd., New York

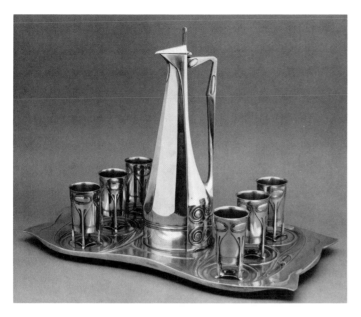

Joseph Maria Olbrich. "Peacock" Schnapps Service.
Pitcher, tray, and six goblets. c. 1901.
Pewter, 13½ × 17½ × 10¼″ (34.3 × 44.5 × 26 cm) overall.
Collection Miles J. Lourie

Joseph Maria Olbrich. Plate. c. 1901.
Pewter, 10¼ × 10½″ (26.1 × 26.7 cm).
Private collection, courtesy Barry Friedman Ltd., New York

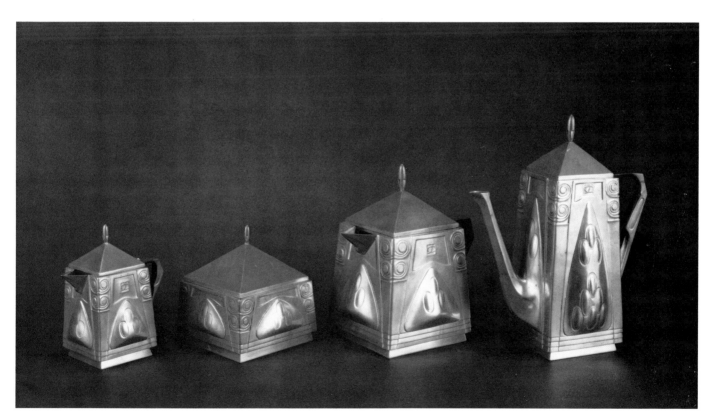

Joseph Maria Olbrich. Creamer, Sugar Bowl, Teapot, and Coffeepot. c. 1904.
Pewter; coffeepot, 9½″ (24.2 cm) high.
Private collection, courtesy Barry Friedman Ltd., New York

Alfred Roller.
Cover of *Ver Sacrum*. 1898.
Lithograph, 11⅝ × 11⅛" (29.5 × 28.2 cm).
The Museum of Modern Art, New York

Koloman Moser.
Cover of *Ver Sacrum*. 1898.
Lithograph, 11⅝ × 11⅛" (29.5 × 28.2 cm).
The Museum of Modern Art, New York

Otto Wagner.
Cover of *Ver Sacrum*. 1899.
Lithograph, 11⅛ × 11" (28.2 × 27.9 cm).
The Museum of Modern Art, New York

Alfred Roller.
Cover of *Ver Sacrum*. 1898.
Lithograph, 11⅝ × 11⅛" (29.5 × 28.2 cm).
The Museum of Modern Art, New York

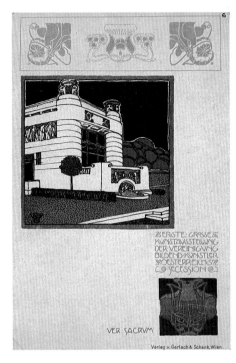

Josef Hoffmann and Joseph Maria Olbrich.
Postcard of Designs for *Ver Sacrum*. 1898.
Lithograph, 5½ × 3½″ (14 × 8.9 cm).
Collection Leonard A. Lauder

Koloman Moser.
Postcard of Designs for *Ver Sacrum*. 1898.
Lithograph, 5½ × 3½″ (14 × 8.9 cm).
Collection Leonard A. Lauder

Adolf Böhm.
Postcard of Designs for *Ver Sacrum*. 1898.
Lithograph, 5½ × 3½″ (14 × 8.9 cm).
Collection Leonard A. Lauder

Koloman Moser and Joseph Maria Olbrich.
Postcard of Designs for *Ver Sacrum*. 1898.
Lithograph, 5½ × 3½″ (14 × 8.9 cm).
Collection Leonard A. Lauder

Koloman Moser. "Palm Leaf" Fabric Sample (detail). 1899.
Fabric, 15¾ × 12⅛″ (40 × 31 cm) overall.
Österreichisches Museum für angewandte Kunst, Vienna

Robert Örley. "Cosmic Fog" Fabric Sample (detail). 1900.
Fabric, 50 × 38⅛″ (127 × 97 cm) overall.
Österreichisches Museum für angewandte Kunst, Vienna

Koloman Moser. "Mushrooms" Fabric Sample (detail). 1900.
Fabric, 44⅛ × 35⅞″ (112 × 91 cm) overall.
Österreichisches Museum für angewandte Kunst, Vienna

Koloman Moser. "Poppy" Fabric Sample (detail). 1900.
Fabric, 51⅛ × 48¾″ (130 × 124 cm) overall.
Österreichisches Museum für angewandte Kunst, Vienna

Koloman Moser. Plates from the Moser Issue of *Die Quelle* ("The Source"; Vienna and Leipzig: Verlag M. Gerlach, 1901–02).
Lithographs, each 10 × 11¾″ (25.4 × 29.9 cm). Hochschule für angewandte Kunst, Vienna

Koloman Moser (attrib.). Plant Stand. c. 1903.
Painted wood and metal, 33½ × 17¾ × 17¾″ (85 × 45 × 45 cm).
Collection Julius Hummel, Vienna

Koloman Moser. Plant Stand. c. 1904.
Painted sheet metal,
62½ × 22 × 22″ (158.8 × 55.9 × 55.9 cm) high.
Collection Nelson Blitz, Jr.

Wiener Werkstätte Exhibition at Galerie Miethke. 1905.
The installation was designed by Koloman Moser and Josef Hoffmann; plant stands designed by Moser are at left and right.

Koloman Moser. "Zuckerkandl" Armchair. c. 1904.
Wood, 27½ × 23½ × 23½" (69.2 × 59.7 × 59.7 cm). Collection Nelson Blitz, Jr.

Koloman Moser. Sewing Box. c. 1904.
Wood, 10½ × 17¼ × 11" (26.7 × 43.8 × 28 cm). Collection Nelson Blitz, Jr.

Leopold Bauer. Cup and Saucer. c. 1902.
Stoneware, 2″ (5.1 cm) high, overall.
Collection Julius Hummel, Vienna

Bertold Löffler. Candlestick. 1905.
Glazed ceramic, 5½″ (14 cm) high.
Collection Julius Hummel, Vienna

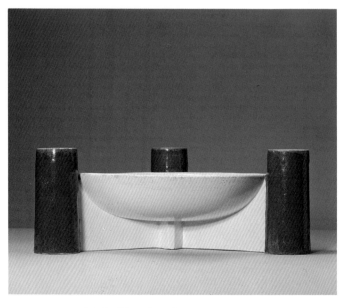

Bertold Löffler (attrib.). Bowl. c. 1905.
Glazed ceramic, 9⅝″ (24.8 cm) diameter.
Collection Julius Hummel, Vienna

Michael Powolny. Flower Bowl. 1903.
Glazed ceramic, 4¾″ (12 cm) high × 11¾″ (30 cm) diameter.
Collection Julius Hummel, Vienna

Josef Hoffmann. "Vineta" Fabric Design. 1904.
Watercolor, 23¾ × 16¾″ (60.4 × 42.6 cm).
Collection Joh. Backhausen & Söhne, Vienna.
Copyright Joh. Backhausen & Söhne

Josef Hoffmann. "Long Ears" Fabric Design. 1902.
Watercolor, 6⅛ × 6⅛″ (15.7 × 15.7 cm).
Collection Joh. Backhausen & Söhne, Vienna.
Copyright Joh. Backhausen & Söhne

Josef Hoffmann. "Mushrooms" Fabric Sample (detail). 1902.
Fabric, 36 × 46½″ (91.5 × 118.2 cm) overall.
Collection Joh. Backhausen & Söhne, Vienna.
Copyright Joh. Backhausen & Söhne

Karl Johann Benirschke. "Flower" Fabric Sample. 1901.
Fabric, 10½ × 14″ (26.7 × 35.6 cm).
Collection Joh. Backhausen & Söhne, Vienna.
Copyright Joh. Backhausen & Söhne

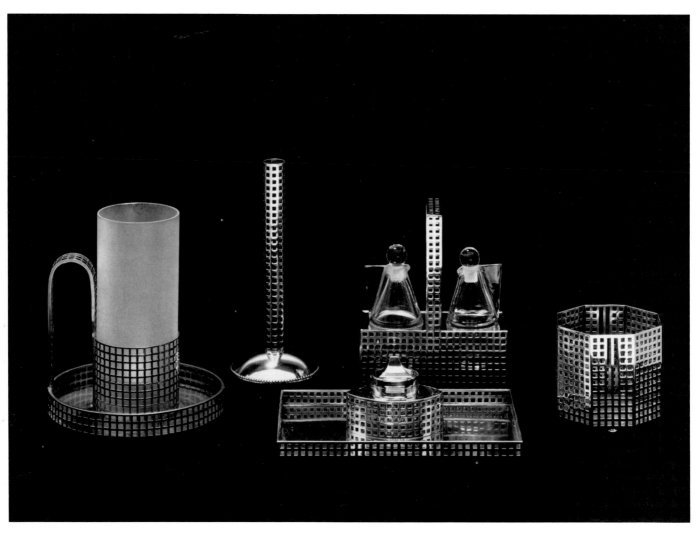

Josef Hoffmann. Candle Holder (left), Planter (right). c. 1904–05.
Silver; candle holder, 7⅝″ (19.5 cm) high. Private collection

Koloman Moser. Bud Vase, Inkstand, and Cruets and Stand. c. 1904–05.
Silver; vase, 8½″ (21.6 cm) high. Private collection

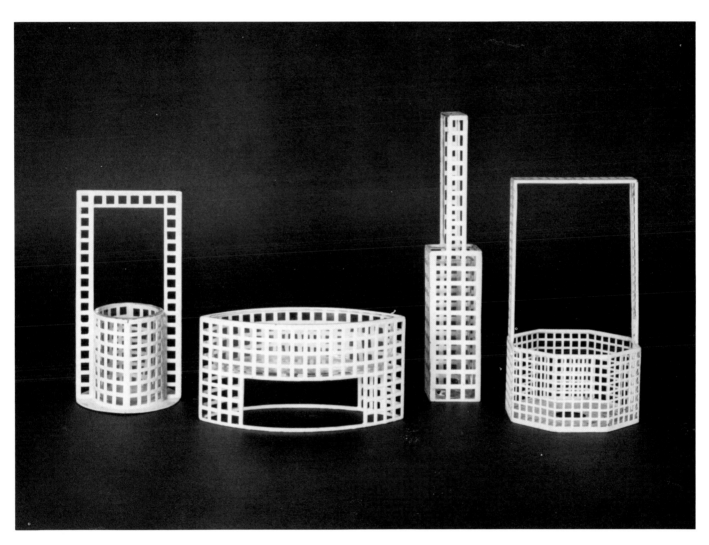

Josef Hoffmann. Planter, Centerpiece, Vase, and Planter. c. 1905.
Painted sheet metal; vase, 9⅝″ (24.5 cm) high.
Private collection

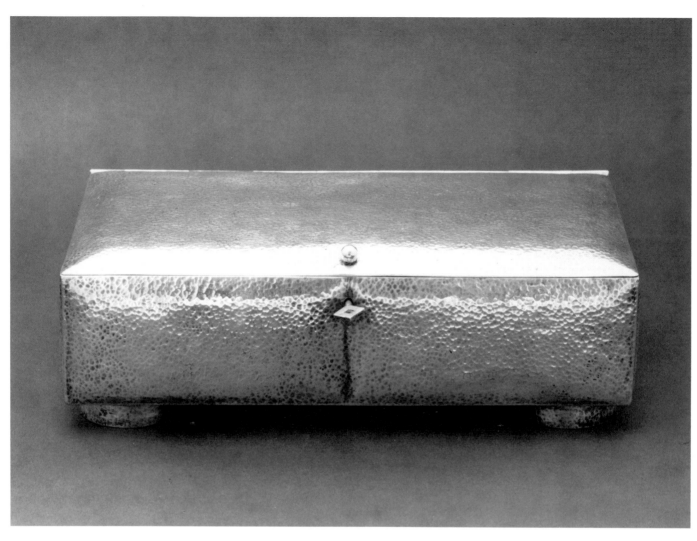

Josef Hoffmann. Box. 1904.
Hammered silver, 4 × 12⅞ × 6⅞" (10.2 × 32.7 × 17.5 cm).
Collection Nelson Blitz, Jr.

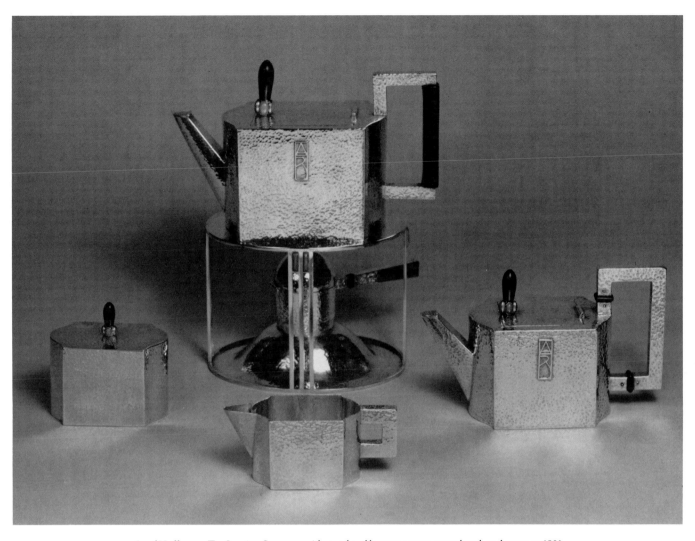

Josef Hoffmann. Tea Service. Samovar with stand and burner, teapot, sugar bowl, and creamer. 1903.
Hammered silver, coral, wood, and leather; samovar, 10⅝" (27 cm) high.
Österreichisches Museum für angewandte Kunst, Vienna

Josef Hoffmann. Design for Tea Service. 1903.
Pencil and charcoal, 8¼ × 13⅜" (21 × 34 cm).
Österreichisches Museum für angewandte Kunst, Vienna

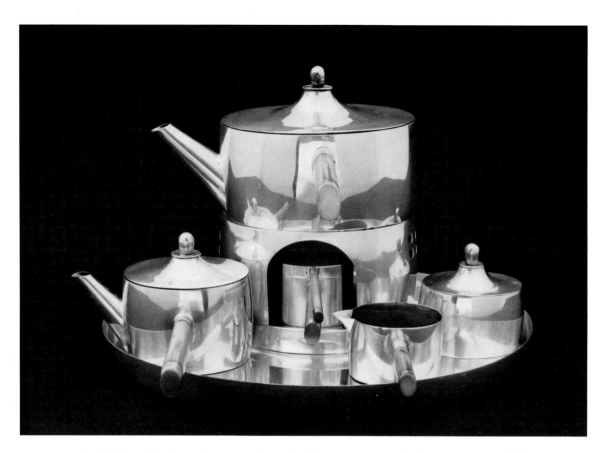

Josef Hoffmann. Tea Service. Samovar with stand and burner, teapot, sugar bowl, creamer, and tray. 1904.
Silver-plated brass and wood, 8½″ (21.6 cm) high × 13½″ (34.3 cm) diameter, overall.
Collection Miles J. Lourie

Josef Hoffmann. Design for Teapot. 1904.
Pencil, 7⅜ × 11¼″ (18.8 × 28.6 cm).
Österreichisches Museum für angewandte Kunst, Vienna

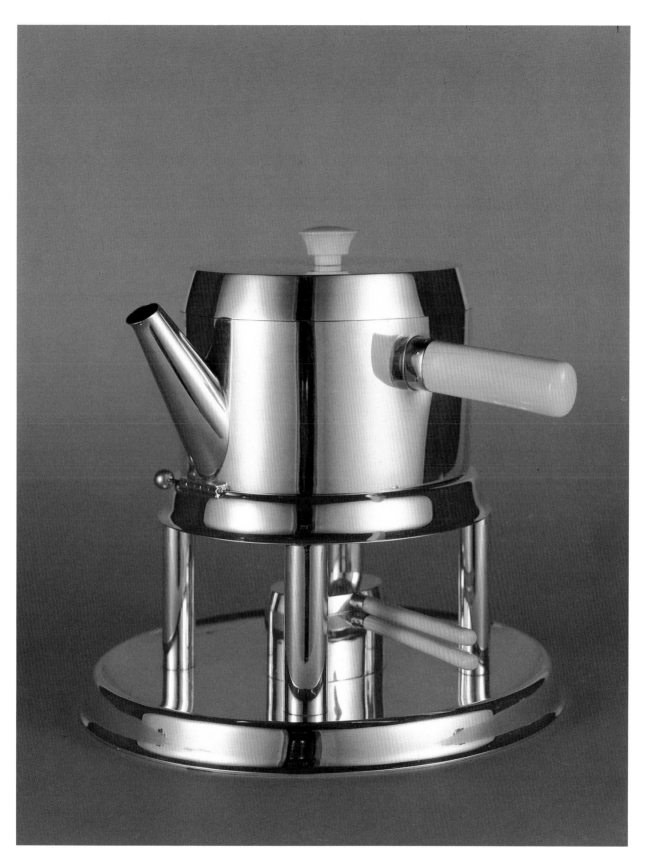

Josef Hoffmann. Samovar with Stand and Burner. 1909–10.
Silver and ivory; samovar, 11⅜″ (29 cm) high.
Österreichisches Museum für angewandte Kunst, Vienna

Josef Divéky (attrib.). Postcard for Kabarett Fledermaus. 1908.
Lithograph, 5½ × 3½″ (14 × 8.9 cm). Collection Leonard A. Lauder

Emil Hoppe. Project for Design of *Kunstschau Wien 1908* Exhibition Pavilion. 1908.
Pencil, colored pencil, pen and ink, crayon, and gouache, 12¼ × 10″ (31.2 × 25.4 cm).
Fischer Fine Art, London

Bertold Löffler. Poster for Kabarett Fledermaus. 1908.
Lithograph, 24¾ × 17⅛" (63 × 43.5 cm).
Historisches Museum der Stadt Wien

Bertold Löffler. Fan for Kabarett Fledermaus. 1907.
Cardboard and printed paper, 8¼ × 15⅛″ (21 × 38.4 cm) open. Historisches Museum der Stadt Wien

Carl Otto Czeschka. Cover of Program I, Kabarett Fledermaus. 1907.
Lithograph, 9½ × 9¼″ (24.2 × 23.4 cm).
The Robert Gore Rifkind Center for German Expressionist Studies,
Los Angeles County Museum of Art;
Purchased with funds provided by Anna Bing Arnold,
Museum Acquisition Fund and Deaccession Funds

Fritz Zeymer. Untitled (Woman with Diaphanous Cape),
Plate 3 (with border design by Carl Otto Czeschka)
from Program I, Kabarett Fledermaus. 1907.
Lithograph, 9½ × 9¼″ (24.2 × 23.4 cm).
The Robert Gore Rifkind Center for German Expressionist Studies,
Los Angeles County Museum of Art;
Purchased with funds provided by Anna Bing Arnold,
Museum Acquisition Fund and Deaccession Funds

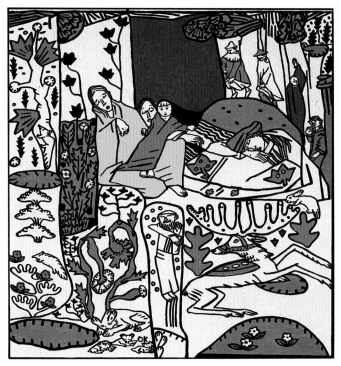

Oskar Kokoschka. Four Illustrations from *Die träumenden Knaben* ("The Dreaming Youths," 1908; issued, Leipzig: Kurt Wolff, 1917).
Lithographs, each 9½ × 11⅜″ (24 × 28.9 cm).
The Museum of Modern Art, New York; The Louis E. Stern Collection

Carl Otto Czeschka. Two-Page Illustration from *Die Nibelungen* (Vienna: Gerlach & Wiedling, 1920; original ed., 1908).
Lithographs, each 5⅞ × 5⅜″ (14.8 × 13.5 cm).
Collection Ronald and Hilde Zacks, Hamden, Connecticut

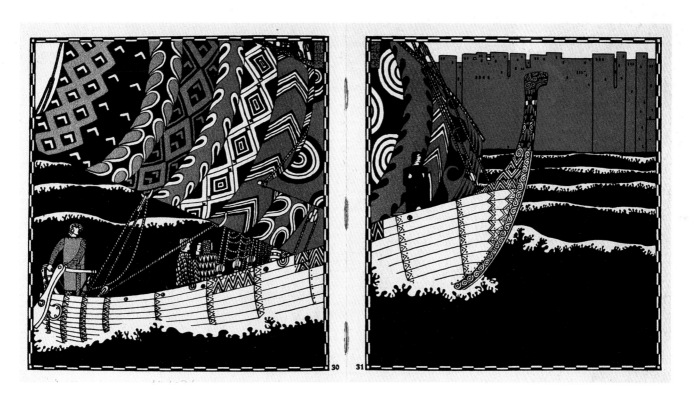

Carl Otto Czeschka. Two-Page Illustration from *Die Nibelungen* (Vienna: Gerlach & Wiedling, 1908).
Lithographs, each 5⅞ × 5⅜″ (14.8 × 13.5 cm).
Historisches Museum der Stadt Wien

Hans Kalmsteiner. Postcard (Puppet Show). c. 1909.
Lithograph, 5½ × 3½″ (14 × 8.9 cm).
Collection Leonard A. Lauder

Hans Kalmsteiner. Postcard (Puppet Show). c. 1909.
Lithograph, 5½ × 3½″ (14 × 8.9 cm).
Collection Leonard A. Lauder

Oskar Kokoschka. Postcard (Reclining Woman). c. 1908.
Lithograph, 5½ × 3½″ (14 × 8.9 cm).
Collection Leonard A. Lauder

Oskar Kokoschka. Postcard (Rider). n.d.
Lithograph, 5½ × 3½″ (14 × 8.9 cm).
Collection Leonard A. Lauder

Bertold Löffler. Poster for *Kunstschau Wien 1908*. 1908.
Lithograph, 26⅝ × 37¾″ (68 × 96 cm).
Private collection, courtesy Barry Friedman Ltd., New York

Rudolf Kalvach. Poster for *Kunstschau Wien 1908*. 1908.
Lithograph, 37 × 22½″ (94 × 57.2 cm).
Private collection, courtesy Barry Friedman Ltd., New York

Oskar Kokoschka. Poster for *Kunstschau Wien 1908*. 1908.
Lithograph, 36¾ × 24″ (93.4 × 61 cm).
Private collection, courtesy Barry Friedman Ltd., New York

Michael Powolny. Candy Jar. c. 1912–13.
Glazed ceramic, 4¾″ (12 cm) high × 3⅜″ (8.6 cm) diameter.
Historisches Museum der Stadt Wien

Michael Powolny. Putto with "Spring" Flower Basket. 1908.
Glazed ceramic, 14¾″ (37.5 cm) high.
Österreichisches Museum für angewandte Kunst, Vienna

Josef Hoffmann. Dance-Card Holder. 1909.
Brass and leather, 5⅝ × 4⅝″ (14.2 × 11.8 cm).
Historisches Museum der Stadt Wien

Carl Otto Czeschka. Covered Goblet. 1909.
Gilded silver and lapis lazuli, 10″ (25.5 cm) high x 5⅛″ (13 cm) diameter.
Österreichisches Museum für angewandte Kunst, Vienna

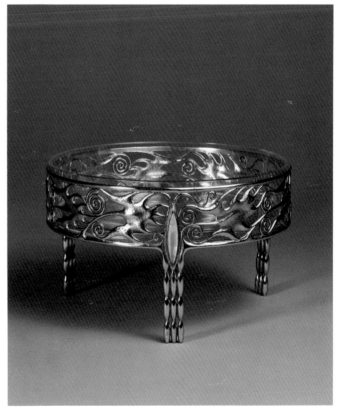

Carl Otto Czeschka. Centerpiece. c. 1906.
Silver, lapis lazuli, and glass inset, 3⅞″ (10 cm) high.
Österreichisches Museum für angewandte Kunst, Vienna

Mela Köhler. Postcard of Dress Design. n.d.
Lithograph, 5½ × 3½″ (14 × 8.9 cm).
Collection Leonard A. Lauder

Mela Köhler. Postcard of Dress Design. n.d.
Lithograph, 5½ × 3½″ (14 × 8.9 cm).
Collection Leonard A. Lauder

Josef Divéky. Postcard of Dress Design. n.d.
Lithograph, 5½ × 3½″ (14 × 8.9 cm).
Collection Leonard A. Lauder

Erich Schmal. Postcard of Dress Design. n.d.
Lithograph, 5½ × 3½″ (14 × 8.9 cm).
Collection Leonard A. Lauder

Josef Hoffmann. Wallet. c. 1915.
Gold-tooled goatskin, 3⅛ × 5⅛″ (8 × 13.2 cm).
Österreichisches Museum für angewandte Kunst, Vienna

Josef Hoffmann. Writing Case. 1910–15.
Gold-tooled goatskin, 11¾ × 9⅛″ (29.3 × 23.3 cm).
Österreichisches Museum für angewandte Kunst, Vienna

Designer Unknown. Two Pairs of Ladies' Shoes. c. 1914.
Silk and leather.
Historisches Museum der Stadt Wien

Koloman Moser and Josef Hoffmann. Necklace. c. 1904–06.
Gold with black opals, 63¾" (162 cm) long.
Private collection

Josef Hoffmann. Necklace with Heart-Shaped Pendant. 1905.
Silver, mirror, and two opals;
necklace, 30⅞" (78.5 cm) long; pendant, 2⅛" (5.4 cm) long.
Collection Dr. Wolfgang Fischer, Vienna, for Fischer Fine Art, London.
Formerly collection Emilie Flöge

Koloman Moser. Necklace for Emilie Flöge. 1905.
Silver, ivory, and carnelian beads, 18⅞″ (48 cm) long.
Collection Dr. Wolfgang Fischer, Vienna, for Fischer Fine Art, London

Carl Otto Czeschka (attrib.). Bracelet. c. 1905.
Gold and moonstone, 8″ (20.4 cm) long.
Private collection

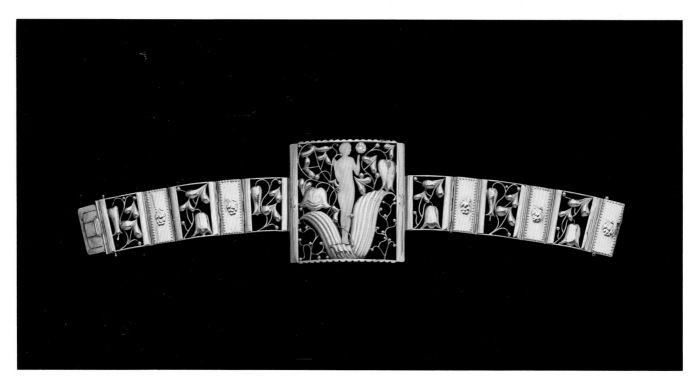

Josef Hoffmann. Bracelet. c. 1914.
Chased gold, ivory, and diamond, 2 × 7¾″ (4.8 × 19.8 cm).
Private collection

Josef Hoffmann. Belt Buckle. c. 1907.
Gilded copper and enamel, 2½ × 2½″ (6.5 × 6.5 cm).
Private collection

Josef Hoffmann. Brooch. 1908.
Silver, partially gilded, with lapis lazuli, coral, opal, almandite,
turquoise, chrysoprase, agate, moonstone, and carnelian,
2⅛ × 2⅛″ (5.5 × 5.5 cm).
Private collection

Josef Hoffmann. Brooch. n.d.
Silver, malachite, lapis lazuli, moonstone, cabochon, and coral,
1¾ × 1¾″ (4.5 × 4.5 cm).
Collection Christa Zetter, Galerie bei der Albertina, Vienna

Josef Hoffmann. Neck ... c. 1904–06.
Gilded silver and citrines, 21″ (53.4 cm) long.
Private collection

Josef Hoffmann. Pendant. c. 1915.
Chased gold and opal, 2¾″ (7 cm) high.
Private collection

Otto Prutscher. Necklace and Earrings. 1908.
Platinum and pearls; earrings each 1⅜″ (3.5 cm) high.
Private collection

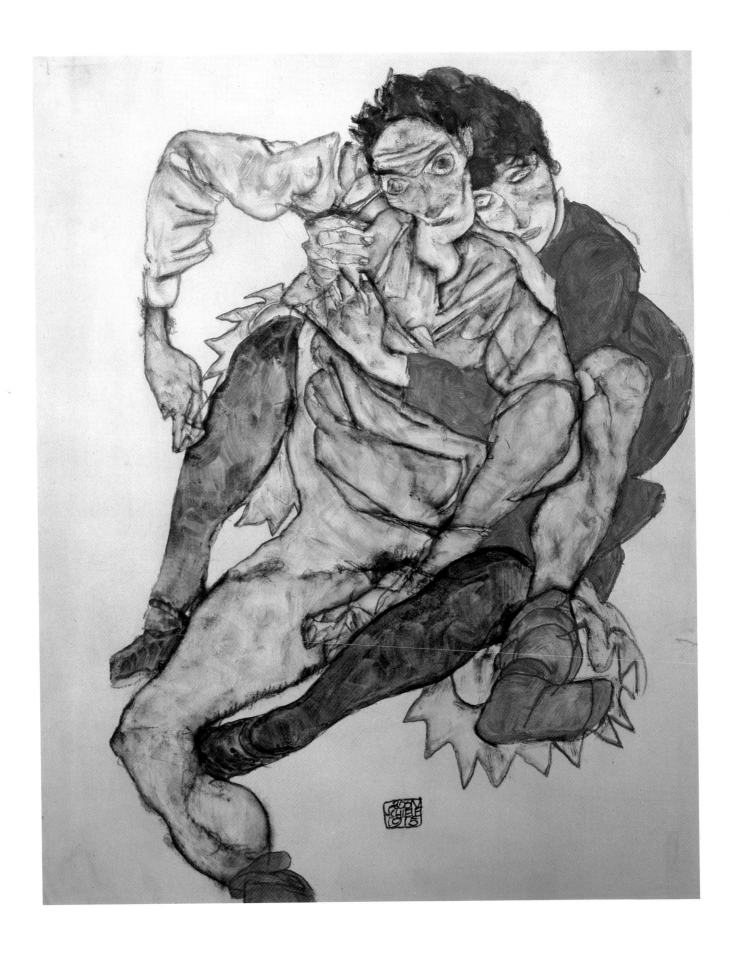

·PAINTING· &·DRAWING·

Until 1908–09, and the first exhibitions of Oskar Kokoschka and Egon Schiele, architects and designers were the primary movers in modern art in Vienna. The one exception to this rule was the painter Gustav Klimt, a culture hero whose stature transcended matters of medium or style. Yet Klimt's ascendancy in the first years of the twentieth century has often been noted with reservations. The eroticism and elegance of his art seem guilty pleasures of mere glamor, allegedly redeemed only by their being rooted in the dark soil of Freudian impulsion, and by Klimt's engagement with such morbidly primal human subjects as aging, death, and—the quintessential Viennese affliction—anxiety. Kokoschka and Schiele have just as often been portrayed as modern avenging angels, for stripping away the gilded refinements of Klimt's world to expose deeper truths, painful and raw.

This vision of Viennese painting, even though it accords with the pronouncements of some Viennese artists and critics themselves, seems inadequate on several counts. It implies prior assumptions that sensual pleasure is sister to shallow decadence, and that modern truth must wear suffering on its sleeve. Such an account slights some of Klimt's most personal and coherent work while elevating more earnest but less original efforts, and tends to miss the complex strategies in expressionism, far less direct than the straightforward baring of the soul. It may in fact be a reversed view—of subjective veracity in Klimt, and artificial theatrics in expressionism—that opens up more telling areas of interest, and more accurately locates the most creative achievements. As in Viennese architecture in which the separate screen of the façade was crucial to modern expression, so in Viennese painting, insight and overlay, matters of depth and matters of surface, were complexly intertwined.

At the turn of the century, Klimt embodied both authority and rebellion. Born in 1862 as a goldsmith's son, he became a professional decorative artist in his teens, and in one instance executor for the designs of the "prince" of Viennese art in the Ringstrasse era, Hans Makart (p. 150). After Makart's death Klimt, regarded as his "heir," became a favored painter for the ceilings of the later Ringstrasse buildings.[1] As an honored young professional, Klimt thus commanded special respect, in the 1890s, from forward-looking artists' clubs like the Siebener (the Seven) of Josef Hoffmann and Koloman Moser.[2] But as an aging prodigy who had spent too many hours on scaffolds satisfying institu-

Page opposite: Egon Schiele. *Seated Couple.* 1915. Pencil and gouache, 20¾ x 16¼″ (52.5 × 41.2 cm). Graphische Sammlung Albertina, Vienna

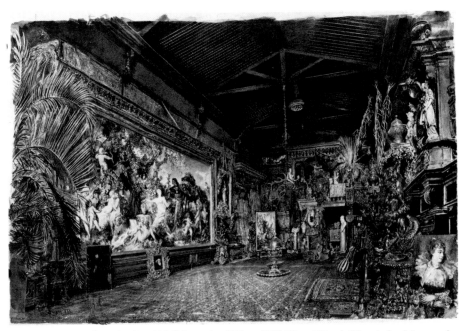

Rudolf von Alt. *Makart's Studio.* 1885. Watercolor, 27⅛ × 42½″ (69 × 108 cm). Historisches Museum der Stadt Wien

tional tastes (and who had been passed over for a professorship in history painting), he was ripe to be converted to their idea that modern art had something better to offer.[3] In two major instances in the later 1890s—the paintings commissioned from him for the ceiling of the University of Vienna's Great Hall, and the formation of the Secession—Klimt decided to leave the path of his "correct" career, and cast his lot with youth and change. This *exemplum virtutis,* in combination with his fraternal artisan's spirit, gave him a certain secular sainthood, enhanced by the "martyrdom" he suffered at the hands of critics.. His beard, sandals, and studio smock enhanced this image of piety, so piquantly incongruous with his reputation as a womanizer and with the hothouse sensuality of his work. Klimt was part Francis of Assisi, part Rasputin.

He was elected first president of the Secession more for his personality than for his painting. When the Secessionists defected from the major artists' society, the Künstlerhausgenossenschaft, they had new policy goals (especially with regard to showing more foreign artists), but no focused aesthetic program. As the pages of their magazine *Ver Sacrum* show, aggressive *Jugendstil* stylists and straightforward naturalists at first coexisted happily within the membership; Klimt's election was matched by the honorary presidency accorded the venerable *plein-air* watercolorist Rudolf von Alt.[4]

In any event, Klimt had not firmly defined his style by 1897. His successes as a decorator had been based on his eclectic ability to evoke a range of historical manners, from Florentine to Egyptian, and his private production of portraits and allegories showed mixed influences from German, English, and Belgian painters of the day. The one constant factor was a substructure of specific naturalism: both a bald accuracy about the look of the material world and a special eye for the specific physiques and physiognomies of contemporary Viennese.[5] Even in its most reportorial form, this particular realism gave an odd artificiality to his early *Auditorium of the Altes Burgtheater, Vienna,* and, paradoxically, it came to play an increasingly key role as Klimt moved against its grain, into decorative Symbolism. Thus in alle-

gorical works closer to 1900, like the *Pallas Athene* (p. 188) or *Judith I* (p. 189), underlying realism produced an uncomfortable immediacy, as if idealist visions were being staged as costumed *tableaux vivants* (even the little "statue" of *nuda veritas* in Athene's hand has been given disturbingly specific corporeality).[6] This marriage of dream and flesh was something that appeared in Klimt's work first as a quirk, and then became, when manipulated more aggressively, an essential part of his special success.

More than just indecisive in style, Klimt at age thirty-five was as yet relatively unproductive; a scattering of portraits and some small-scale allegories were all he had to show for his independent (nondecorative) work. His grander ambitions as a painter first announced themselves after 1899, in the fulfillment of his commission for the ceiling of the university building. Here he determined to transform the locus of the old Klimt, the dutiful historicist decorator, into the birth-site of the new Klimt, avant-garde allegorist of the human condition. The resulting huge canvases, lost to fire in the last days of World War II[7] (pp. 152, 153), were held to be breakthroughs for the artist and for Viennese art in general. But in retrospect we may question whether they are not to be honored more as emblems—illustrations for an epoch— than as artistic achievements; and whether Klimt's ambitions and his abilities were truly in concert here.

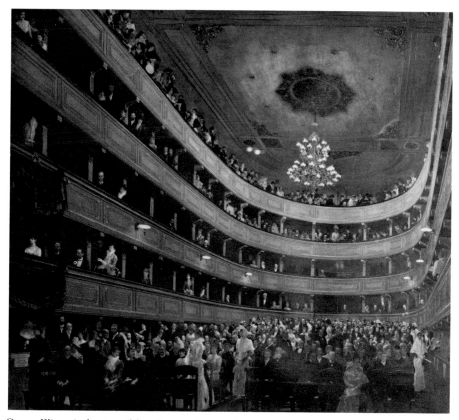

Gustav Klimt. *Auditorium of the Altes Burgtheater, Vienna.* 1888. Gouache, 32¼ × 36¼″ (82 × 92 cm). Historisches Museum der Stadt Wien

Certainly their story is a rich one, beginning in 1898 with the conditional approval of sketch studies for allegorical images of *Philosophy, Medicine,* and *Jurisprudence,* and ending with Klimt, discouraged by widespread hostility to the final canvases, buying back the commission in 1905. In between, the sequential emergence of the three paintings at three Secession exhibitions (*Philosophy* in spring 1900, *Medicine* a year later, and the unfinished *Juris-*

Above left: Gustav Klimt. *Philosophy.* 1899–1907.
Oil on canvas, 14′ 1¼″ × 9′ 10⅛″ (430 × 300 cm).
Destroyed

Above right: Gustav Klimt. *Medicine.* 1900–07.
Oil on canvas, 14′ 1¼″ × 9′ 10⅛″ (430 × 300 cm).
Destroyed

prudence in 1903) tangled the artist in controversy. Carl Schorske has masterfully shown how government cultural policy worked initially in Klimt's favor in these years, and then turned against him, and how the support and abuse accorded the paintings divided along lines symptomatic of deeper fissures in Viennese society.[8] The prominent role of untempered nudity in these works, and the charges of obscenity leveled against Klimt, have also been seen as linking the artist's emphasis on the erotic with the contemporary work of Sigmund Freud, itself decried and rejected by Viennese society. In this fashion, the mammoth university paintings have grown even larger than life. They have come to epitomize the painful eruption into modern thought of the unconscious in all its disturbing power, and the scandal surrounding their rejection has seemed an index of the final failure of liberal culture in Vienna.[9] Yet, though these paintings may be an essential part of the history of Viennese culture, their part in the history of early modern art, and indeed their position in a critical assessment of Klimt's own oeuvre, is more marginal.

The first two university paintings, *Philosophy* and *Medicine*, were not particularly original conceptions, and the shock they caused in 1900–03 is more a measure of Vienna's artistic provinciality than of Klimt's creative daring. The device of a nonspecific allegory, based on a tangle of nudes of all ages, had become common coin in late Symbolism; and the crepuscular vision of humanity proffered by *Philosophy* and *Medicine*, with self-absorbed sensuality amid unutterable grief, was a familiar one, already being displaced

elsewhere in Europe by the sunshine and vigor of vitalism.

One of the most evident sources for Klimt's overall imagery and individ-ual figures dates back to the 1880s: Rodin's *Gates of Hell*. Rodin was one of the Secession's most admired artists, and much of his work—the unconven-tional poses of extreme compression and extension, the special sensual aban-don, and the libertine freedom of the later drawings—left a profound mark on Klimt. What Klimt added was a distinctive mood of subaqueous torpor. Where Rodin's figures in the *Gates* are driven from within, spasmodically thrusting and clutching in every direction, the crowds in Klimt's *Philosophy* and *Medicine* float upward like molten forms in viscous suspension. Other turn-of-the-century artists, such as the Norwegian sculptor Gustav Vige-land, similarly constructed pillars of humanity from Rodin's model, but were drawn, by contrast, to exaggerate his already strenuous physicality.[10] In Klimt's Baroque illusionism, gravity—the condition of mortality exagger-ated in Last Judgment scenes, and the energizing opponent of Rodin's suf-ferers—is disavowed. The cycle of human helplessness is re-imagined in Eastern terms as groundless transience, passively adrift in the realm of dreams.

All these effects were more or less true to Klimt's initial sketch con-ceptions, even if the literalness of the nudity and the spatial detachment of the foreground figures became more unsettling in the final versions. But by the time Klimt turned to the third and final allegory, *Jurisprudence*, radical changes had taken place. Here the naturalism and ornament that had been

Above left: Auguste Rodin. *The Gates of Hell*. 1880–1917 (detail). Bronze, 18′ × 12′ × 33″ (548.6 × 365.8 × 83.8 cm) overall. Kunsthaus Zurich

Above right: Gustav Klimt. *Jurisprudence*. 1903–07. Oil on canvas, 14′ 1¼″ × 9′ 10⅛″ (430 × 300 cm). Destroyed

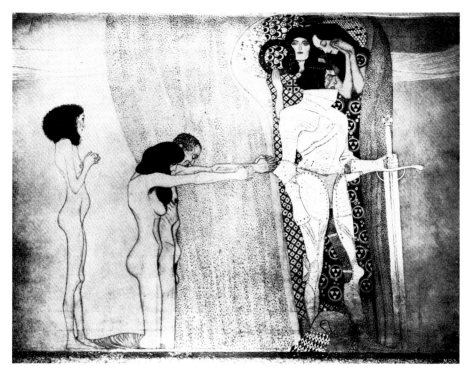

Gustav Klimt. *Beethoven Frieze.* Detail from "The Longing for Happiness." 1902 (before restoration). Casein, gold leaf, semiprecious stones, mother-of-pearl, gypsum, charcoal, pastel, and pencil on plaster, 7′ 1″ × 45′ 2½″ (216 × 1378 cm) overall. Österreichische Galerie, Vienna

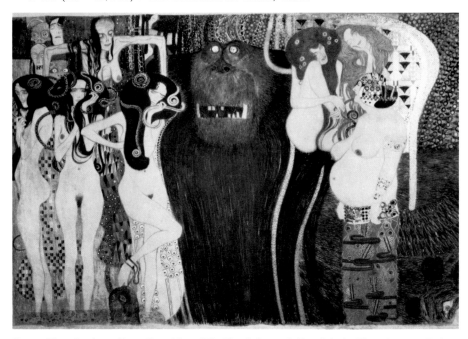

Gustav Klimt. *Beethoven Frieze.* Detail from "The Hostile Powers" (from left: the Three Gorgons; Typhon, the Giant; Debauchery, Unchastity, and Excess). 1902 (after restoration). Casein, gold leaf, semiprecious stones, mother-of-pearl, gypsum, charcoal, pastel, and pencil on plaster, 7′ 1″ × 20′ 10⅜″ (216 × 636 cm) overall. Österreichische Galerie, Vienna

apparent years before (in the overlay of golden fabric decoration in *Medicine,* for example) became polarized. The realism was more trenchant, the nude bodies characterized in bony specificity, while the abstraction was at the same time more insistent: the chiaroscuro fog of *Philosophy* had been replaced by snaking rhythmic masses. A frontal confrontation between figures and viewer had also supplanted the suave Baroque perspective of the previous two images; space was layered and disjunctive rather than cloudily

indefinite. The image's severity, reinforced by a palette of black and gold, was in keeping with the harshness of its conception of justice. This Dantesque vision set remote and unfeeling law high above a punishment scene whose protagonists, a sagging old man and three sinewy women with the bruised eyes of cabaret vampires, conjured a physical and psychic anxiety from which innocence was no defense (p. 153).[11]

Yet for all the effort toward portentous gloom, there is something unconvincing about this conceit. The repulsive yet decorative polyp and the stylish demonism of the knobby-kneed studio harpies have their own odd power, but neither this nor the other allegorical paintings have aged well as embodiments of grand ideas. Here, with the weightless poetry of the earlier allegories banished, we are more aggressively aware of the clumsiness of Klimt's self-consciously earnest symbolic apparatus.

Klimt doubtless felt this kind of monumental expression should be his highest goal. A frustration with what were seen as the limitations of easel painting similarly goaded other ambitious European painters around 1900, longing for art to take on transcendent themes in grander forms. It remains an open question whether the very goal they pursued, of an art public in scale and ambition yet determinedly individual in inspiration and style, was itself feasible; but it seems clear that where many tried—Munch, Gauguin, and Signac among them—few succeeded in the way they had hoped. Klimt was nonetheless drawn, not just by the hazard of commissions but independently, to the notion that by wedding itself to architecture in a new way, his painting could aspire to the status of great mural art of the past, and he could work in the nobler atmosphere of philosophy.[12]

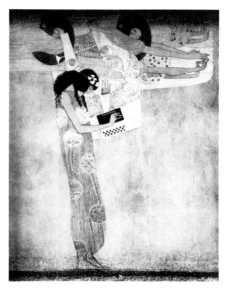

Gustav Klimt. *Beethoven Frieze.* Detail from "Poetry." 1902 (before restoration). Casein, gold leaf, semiprecious stones, mother-of-pearl, gypsum, charcoal, pastel, and pencil on plaster, 7′ 1″ × 32′ 2¼″ (216 × 981 cm) overall. Österreichische Galerie, Vienna

Klimt's most elaborate testament to such ambitions is the large frieze he painted on plaster (*al secco*) for the 1902 Secession exhibition organized around Max Klinger's monument to Beethoven (p. 42). Klinger's sculpture itself had a grandiose iconographic program (spelled out in the reliefs on its bronze throne), which wedded Greek and Christian motifs in a cycle of suffering and salvation appropriate to Beethoven as redeeming *Übermensch*.[13] In the adjacent side hall, Klimt—apparently drawing heavily on Richard Wagner's exegesis of Beethoven's Ninth Symphony—set out a cycle in three major episodes: the weak implore the intervention of the strong (represented by the knight, on the left wall) against the Hostile Powers (Debauchery, Excess, Sickness, Madness, and others, on the front wall), while the longings of mankind fly over these to find solace in Poetry—all leading to a climactic chorus, a choir surrounding an embracing couple representing "this kiss for the whole world" (right wall; p. 197).[14]

A reverent mythology, and an accompanying hagiographic literature, has grown up around this "legendary" frieze (only recently restored and returned to view after decades of inaccessibility). But in all the ink consecrated to the numerous iconographic and stylistic models on which Klimt drew, and to the meaning of the work, there has been surprisingly little critical comment on its more problematic aspects.[15] The basic program involves a play of sentimentality and power-worship that should at least give pause; the man in armor now appears as much *Führer* as white knight (an intimation reinforced by the overall exhibition setting; see the discussion of Hoffmann's installation design, p. 43). Moreover, the expression of the idea seems to fall short of either the threat or the promise intended. The pearly-eyed ape and his cohorts project more camp extravagance than evil, and the angelic choir seems thinly smug rather than exultant. What is more to be lamented here, the idea or the execution? Does the cycle fail to move us

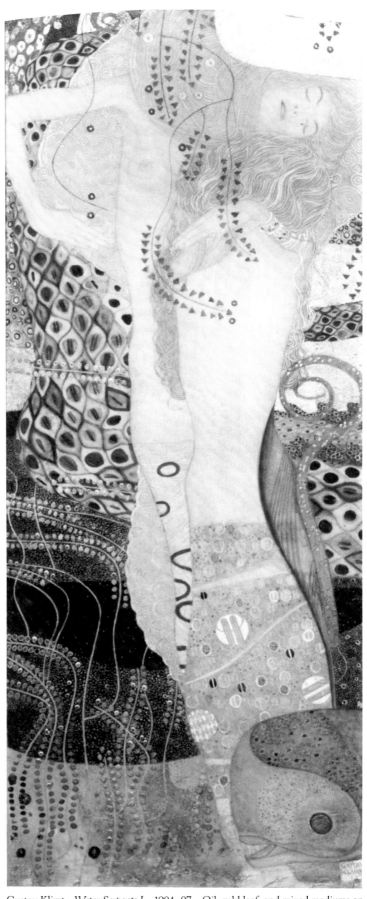

Gustav Klimt. *Water Serpents I.* 1904–07. Oil, gold leaf, and mixed mediums on parchment, 19⅝ × 7⅞″ (50 × 20 cm). Österreichische Galerie, Vienna

Gustav Klimt. *Adele Bloch-Bauer I* (detail). 1907. Oil on canvas, 54¼ × 54¼" (138 × 138 cm) overall. Österreichische Galerie, Vienna

because it represents Klimt's retreat from the public ambitions of the university allegories, into a vision of art as solace, and sexuality as enclosed and globally consuming?[16] Or because it embodies his persistence in the attempt to force lesser means—the melded visions of illustrative talents such as Félicien Rops, Aubrey Beardsley, and Jan Toorop, for example—to yield a monumental painting of programmatic sublimity?

The strained seriousness of the *Beethoven Frieze,* and of *Jurisprudence,* might arguably be seen as a regression, drily and coldly against the grain of the unsettling erotic languor that emerged as a personal note in Klimt's art in the first university canvases, and in smaller works like *Judith I,* around 1900. Working through the influences of lesser illustrators, and of major figures such as Rodin and Munch, Klimt found a way to put his finger squarely on a certain nerve in the Viennese, and indeed the larger human, psyche—in an area of fantasy where the desires of lust and luxury mingle with the passive *Angst* of ennui, melancholy, and fear of transience. This poetry that flirts with soft pornography, in gilded visions of lithe women adrift in musky, droopy-lidded lassitude, strikes an original and complex note. But when he constrained this vision to express certainties rather than ambiguities—when Evil and Good and Life and Art were at issue—the music went tinny and the poetry cloyed.

Klimt's imagination came alive not on the chilly heights of idealism, but in watery depths—less among the Nibelungen than among the *nymphéas.* As so often at the end of the century, the primal was conceived, in the first two university paintings, in terms of the fluidity of invertebrate life. Just as the thickets of parallel trunks in Klimt's forest paintings (p. 192) suggested Hodler's notion of objective order in nature,[17] so this underwater curvilinearity, drifting into and out of the framed field, became Klimt's metaphor for the subjective world, submerged in sensuality. The extreme instance of this vision is the *Water Serpents* of 1904–07, a parchment miniature of Persian surface exquisiteness, feverishly disorienting in its plasmic merger of organic and inorganic life.

The *Water Serpents* demonstrates how Klimt brought into powerful concert specific naturalism and expressive distortion, spatial illusion and elaborate surface ornament. The bodies of the lesbian lovers are confusingly overlapped (two arms and one head visible for the two bodies), and selectively obscured by flowing bands of veils, hair, and fabric. Similarly the pale, silverpoint modeling of body forms, in conjunction with the vividness of fields of scaly pattern, causes the image to oscillate constantly in figure-ground reversals. Our reading of this image repeatedly collapses the recognition of each woman's separate integrity into the illusion of one bonelessly

Constantin Brancusi. *The Kiss*. 1907–08. Stone, 11″ (28 cm) high. Muzuel de Artă, Craiova, Rumania

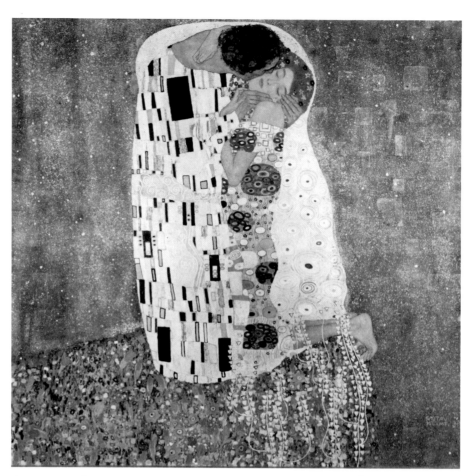

Gustav Klimt. *The Kiss*. 1907–08. Oil on canvas, 70⅞ × 70⅞″ (180 × 180 cm). Österreichische Galerie, Vienna

distended, biomorphic organism—an object of desire that moves between the world of Ingres's odalisques and that of Picasso's reveries of the 1930s.

This kind of confusion and ornamental richness does not embellish the content of Klimt's art, it *is* the content. For Klimt the maintaining of irre-solution—between figure and ground, flatness and depth, object and image—was a key way to heighten the experience of art.[18] It evoked the privileged state of a dreamlike floating in which fantasy liquifies the world, tinting and bending it to its own desires. (It is in this strategy that Klimt's paintings have affinities with psychedelic imagery of the 1960s.) The most extreme statements of this willed decorative disorientation lie in the "golden" phase of Klimt's work, from 1906 to 1909. In those works, metallic leaf appliqués and embossed designs determined a collage-like surface life, assertively independent of figural content (p. 157). They also drew on a repertoire of ancient and exotic decorative motifs to assemble a vocabulary of *Ur*-forms of geometry and biology—spirals, rectangles, lozenges, triangles, etc.—intended to evoke primal associations of male and female, mind and nature.[19]

These are the same combined goals—an anti-illusionist play directly on the viewer's sensorium, and an abstract formal language attuned to universal expression—that led other European artists in these same years to decisive certainties of sharp reduction and synthesis. In Klimt they gave rise to elaboration and ambiguity. While others looked to sources in archaic and exotic art for a new economy of volume and line, Klimt saw in the same sources the heightened splendor of complexity—not only the blunt

empiricism of a head by Giotto, but that head and its flat golden halo together; not only the woodcut simplicity of Hokusai's form, but that simplification overprinted with multipatterned kimono forms; not the white purity of Greek art at Segesta, but the rich ornament of the recent Mycenaean finds. For him, the exotic, archaic, and primitive arts bore evidence of a primal human love of proteiform brilliance—the doubled intensity of earthy observation joined with fertile abstract invention and lust for materials. This was the common ground that, from nomadic metalwork to Byzantine mosaics, shaped a tradition of spiritually charged art he sought to recover.

We might in this regard consider the best-known image in Klimt's decorated manner, *The Kiss*, in contrast with Brancusi's roughly contemporary version of the same theme. Both artists were steeped in enthusiasm for archaic and Eastern folk art, and both wanted to supplant mere naturalism with a stronger spiritual intensity they found in such sources. Both, too, were affirming the post-Symbolist elevation of the erotic; Klimt, in contrast to the gloomy and dangerous sexuality of his works around 1900 (for example, *Judith I*; p. 189), here sought to embody a newly positive faith in the fusing power of love. But where Brancusi aphorized the fusion of opposites in the abrupt and vigorous terms of caricature, Klimt envisioned their subtle, ambiguous melding in an enervated luxuriance that dissolved physicality even as it overloaded sensuality. The extravagant ornamental style was integrally a part of the play between certainty and uncertainty, opposition and union, individuality and universality that constituted the meaning of *The Kiss*. Yet in the painted version (p. 202) the final result was also mixed in less positive senses, its dreamy lyricism nearly overwhelmed by the lavish richness of the formal means. Only in the harder, more assertively abstract forms of the Stoclet mosaic *Fulfillment* (p. 71) did Klimt project his originality with full intensity. In the archaic splendor of its irregular relief and gem-like colors, the *Stoclet Frieze* (pp. 70–73) defined a modern Byzantinism that rivaled Matisse without replicating him, and opened up a fantasy domain of zoomorphic geometry later to be explored by Klee. Nowhere are the tensions in Klimt's art—between representation and abstraction, between high art and artisanry, between the dreamlike and the concrete— more powerfully exercised than in the obsessive, whorling brilliance of this celebration of love as fusion and dissolution.

Though evidently the stuff of dreams, the golden style was first, and in several instances most impressively, tied to portraiture. The 1902 portrait of Klimt's longtime companion Emilie Flöge (p. 198) really initiated the new manner, scattering a shower of reflective motifs in a skein of linear designs. The "sacred" glitter of visionary efforts like *The Kiss* was thus from the outset interwoven with a feel for chic (Flöge was a dress designer; see pp. 100–01). And it was in women's portraits, where the sitter's individual presence introduced a saving anchor against dissolving extravagance, that this phase of Klimt's work yielded some of its best results. In the Flöge portrait, the sinuous rhythms of *Jugendstil*, the dark, featureless surroundings, and the confinement of ornament to the gown only partially realize the potential. This peacock finery had first to revert to swan-like chasteness—in the blend of lacy and lapidary, Whistler and Werkstätte that marks the 1905 *Margaret Stonborough-Wittgenstein* (p. 199)—before it could reemerge in the more complete brilliance of *Fritza Riedler* and *Adele Bloch-Bauer I* (pp. 200, 201).

These portraits are not flattering in any conventional sense. Klimt's idea

of beauty was always a strange one; his emaciated body types and lantern-jawed features, like the Botticellian style of femininity favored by the English Pre-Raphaelite painters who influenced him, were initially received as curious, even ugly, before they imposed their particular, morbidly unrobust appeal. Similarly, he did not beautify his sitters' physiognomies, or couch their poses in conventions of grace. Their faces are unlovely, and their hands lie or twine in oddly ill-at-ease distraction. But the profusion of flecked, leafed, incised, and embossed whorls, scallops, squares, and squiggles, in the shadowless metallic light of rose, silver, pearl, and gold, armors them in mandarin splendor. These paintings redefined the recurrent Viennese dream of an Eastern splendor beyond reason—an imperial opulence that beggared ordinary aristocracy. Such gilded elegance has often been held up as the archetypal imagery of decadence—the vision of a narcissist upper class encasing itself in futile aestheticism, and the emblem of Klimt's disappointing retreat from the world of pioneering, responsible ambition into that of slack privilege.[20] Yet in all Klimt's oeuvre there is little that can match this portrait series—for its insights into the character and aspirations of a particular stratum of Viennese society and for the obsessive complexity of its formal innovations. Absolutely of their time, they are still the least dated of his works.

A similar exoticism, but now far more literally tied to the Viennese taste for *chinoiserie*, appears in his later portraits (pp. 102, 204), where perceptual plays of space and depth, figure and ground, the animate and the inanimate are carried out in painted pattern alone. These are luxurious pictures, softer and in better humor than the more tautly strung portraits of 1905–08; but they are emptied of both the hard elegance and the high fantasy that set the golden pictures apart. In the later period, which began roughly with the *Kunstschau* of 1908, Klimt's work fell off in intensity. Within Vienna, younger men with a very different vision began to assert themselves; and within Klimt's work, the influence of styles from abroad appeared more markedly.

In landscapes he returned to an early interest in the spaceless play of fields of broken-stroke pattern, loosely derived from Neo-Impressionism. In Viennese painting around 1900, a Divisionist tendency had been a feature both of moody Symbolism (pp. 190, 191) and of experiments in nascent abstraction, but the scientific spirit of Neo-Impressionist color theory found no rigorous

Gustav Klimt. *The Park*. 1910. Oil on canvas, 43¼ × 43¼″ (110 × 110 cm). The Museum of Modern Art, New York; Gertrud A. Mellon Fund

Adolf Böhm. *Landscape*. 1901. Oil on canvas, 39⅜ × 33⅛″ (100 × 84 cm). Historisches Museum der Stadt Wien

adherents in Vienna. Klimt seems to have been more attracted to the stippled, carpet-like effect of countless evident, regular strokes, and to have found it especially effective in evoking diffuse, shadowless fields of flowers and shrubs (pp. 194, 195). After 1910, the landscapes became occasionally marked by thicker color and more agitated rhythms. These flattened, often horizonless quilts of flecked color were vacation work, done primarily during Klimt's summers on the Attersee. As a rule placid in feeling, they began, in the teens, to show more disruptive energies of stroke, color, and spatial stacking that evidence Klimt's attention both to the more expressive nature-feeling of van Gogh, and also to Egon Schiele's landscapes (pp. 171–73).

One might similarly call the late portrait and figure pictures "expressionist," but there the influences seem less Northern, more to do with the

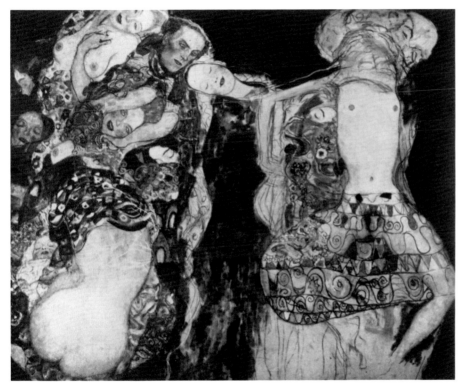

Gustav Klimt. *The Bride*. 1917–18. Oil on canvas, 65⅜″ × 6′ 2¾″ (166 × 190 cm). Private collection

palette and patterns of the Nabis and Matisse. Klimt's idea of pleasure began to take on a more exclusively feminine tone, relinquishing the sexual polarities, with their intimations of *Angst* and implicit fear of loss of self, that attended his earlier images of male/female confrontation. Undisguised voyeurism and oceanic, sated voluptuousness are the hallmarks of two major symbolic efforts of the teens, *The Maiden* of 1912–13 (p. 205) and the unfinished *Bride* of 1918, his final year. The ambiguous, self-absorbed gestures of the university paintings' nudes are here replaced by splayed female figures with the angular body rhythms of Oriental dancers, heraldically pinioned open to the possession of the viewer. The parceling up of partial bodies—severed heads, free-form sections of buttocks, legs, and torsos—creates a congealed, charnel-house fantasy in place of the glycerine sleekness of the *Water Serpents* (p. 156). At the very end, in the depths of World War I, with Austria falling quickly apart, an unsettling note crept into the work, not only in the oddly cool and oversweetened phantasmagoria of *The*

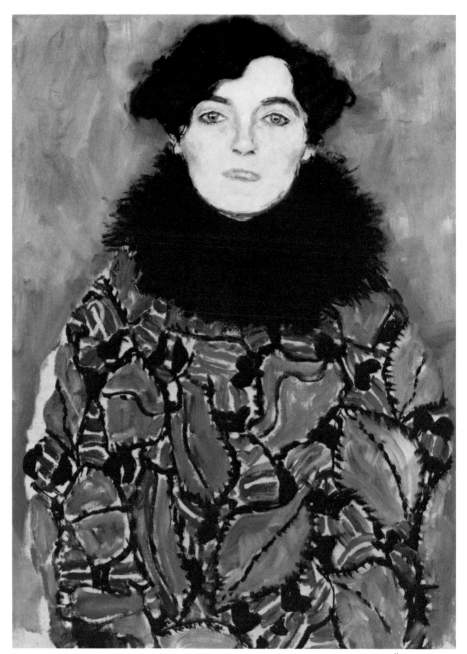

Gustav Klimt. *Johanna Staude.* 1917–18. Oil on canvas, 27½ × 19¾" (70 × 50 cm). Österreichische Galerie, Vienna

Bride, but also in the uncharacteristically disheveled, numbly distraught image of *Johanna Staude.* Here the shaky dissolution of the picture structure and surface differs disturbingly from the energized ambiguities of the past: something was crumbling at the core.

The years from 1906 to 1910, the apogee of Klimt's golden manner, were years of sharp transition in the culture of the visual arts in Vienna. Nineteen hundred and five saw the development of a decisive rift within the Secession, between the more conservative elements—largely naturalist painters with a bent toward land-rooted *Heimatkunst*—and the "stylists" who recognized Klimt as their flag bearer. In this same year that he led the "Klimt Group" in defection from the Secession, Klimt also renounced trying to see his university paintings

mounted, and bought back the commission—a gesture that reflects his perception that official policy was becoming cooler toward the avant-garde. Otto Wagner's difficulties in the same period confirm such a retrenchment. With this conservative turn both in the artists' exhibition society and in government support, private galleries gained an increasingly prominent role, precisely at the moment when forward-looking dealers in all the major capitals of Europe were beginning to commit themselves to more challenging work by young modernists. In Vienna, one of the arguments that split the Secession was waged over the affiliation of the Klimt faction with a local gallery.[21] But even more important, the new market situation fostered the ascendancy of Berlin and Munich, where dealing in modern art was more active, and men like Herwarth Walden of the Der Sturm gallery (Berlin) were eager to find new talent in Central Europe. The dominant new art in these cities was to be expressionism; the Brücke group, with artists such as Ernst Ludwig Kirchner and Emil Nolde, had just moved from Dresden to Berlin, in 1908.

Vienna did not have the artistic bohemia, characterized equally by messianic utopianism and deep social cynicism, that helped make Berlin the capital of this new art. On the Danube, artists and patrons alike still held the reassuring notion, sustained by the Secession and *Kunstschau* exhibitions, that Vienna was above all the capital of good taste in Central Europe. The coterie of industrialists and art lovers around Klimt and Hoffmann had honored craftsmanship, and the extension of good design into all the appurtenances of life; but by 1908, it seemed to many that this attitude had degenerated into a shallow aestheticism that relegated art to the status of complacent décor. Reviewing the 1908 *Kunstschau* in Karl Kraus's newspaper *Die Fackel*, one critic complained succinctly, "Our art is being ruined by good taste."[22] Those who shared this opinion, and who formed the circle of critics and patrons around Egon Schiele and Oskar Kokoschka, were predominantly a stratum of Viennese professionals, intellectuals, writers, and musicians separate from the milieu of the Secession or the Wiener Werkstätte. Their leading figures were men prone to decisive radicalism, less given to communitarian fellowship than to loner exclusivity, and more loyal to the ethos of criticism, theory, and the life of ideas than to aesthetic traditions. They supported work that they felt confronted matters of high seriousness, to the exclusion of any decorative appeal. In such an art they valued not skilled craftsmanship but its opposite, the deforming marks of rough impulse or even willful ugliness, as the indices of an inner necessity that propelled the artist past the stifling conventions of mere taste. They cared much less about the role of art in life and much more about the intensity of life in art.

These new attitudes and artistic circles can already be seen in the relationship between the painter Richard Gerstl and the composer Arnold Schönberg.[23] Gerstl, a well-to-do young man, had entered the Academy of Fine Arts at fifteen, but he was difficult, antisocial, and little suited to academic training. His entry into high Viennese culture came instead through music, of which he was a passionate devotee. While Gustav Mahler was artistic director at the Imperial Opera, Gerstl attended constantly, and there came into contact with Schönberg and his circle. In 1907 and 1908 Gerstl summered with the Schönberg family, painting radically unstructured and heavily impastoed portraits of them (p. 164), and leading Schönberg himself, who had no artistic training, into experiments in painting (p. 165). This "false dawn" of Viennese Expressionism was short-lived,

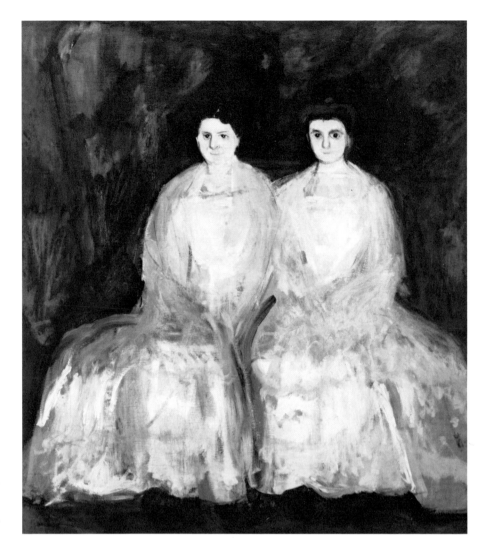

Right: Richard Gerstl. *Two Sisters (Karoline and Pauline Fey)*. 1905. Oil on canvas, 68⅞ × 59⅛″ (175 × 150 cm). Österreichische Galerie, Vienna

Below right: Richard Gerstl. *The Arnold Schönberg Family*. c. 1908. Oil on canvas, 34⅝ × 43″ (88 × 109 cm). Museum moderner Kunst, Vienna

Below: Richard Gerstl. *Laughing Self-Portrait*. 1908. Oil on canvas, 15¾ × 12⅛″ (40 × 31 cm). Österreichische Galerie, Vienna

as Gerstl, following an affair with Schönberg's wife, committed suicide in the autumn of 1908.

The Gerstl-Schönberg episode yielded a small and problematic body of art that was tangentially connected to fully developed Viennese Expressionism, by sociological similarities in the supporting milieu and by common sources. Gerstl was perhaps the first painter in Vienna to register the impact of the key exhibitions of work by Vincent van Gogh (at the Secession in 1903, and the Galerie Miethke in 1906) and Edvard Munch (at the Secession in 1904). Yet his ambitions, for all the echoes of these powerful inspirations in his heavy-handed brushwork and occasionally strident hues, were never fully focused into images with the biting tension of full-blown German or Viennese Expressionism. Though often violently antinaturalistic, his pictures still have the loose liquidity of sketches, rather than the sense of a world thoroughly restructured along new lines. More than his achievement, it was Gerstl's aggressive attitude, particularly in his more extreme nude and seminude self-portraits, that looked forward remarkably.

Schönberg's art is even less easily categorized, as it wanders between caricature, naïve realism (primarily in a series of bluntly confrontational self-portrait heads), and more visionary, quasi-abstract imagery known as "gazes."[24] These small drawings and oils were championed by Wassily Kandinsky, who admired all untutored art as a pure expression of inner psychic necessities.[25] The works were shown in a Viennese gallery in 1910 and published in the *Blaue Reiter Almanach* in 1912. Though they were an independent form of expression, it is doubtful these works would have found such notice had their author not been the musician he was. They have a *faux-naïf* feeling that, however fascinating for students of the composer, places them among the marginal curiosities of early modern art—in the company of the "proto-abstractions" of numerous naïve theosophist artists of this period, or with the oils of another "proto-expressionist," August Strindberg.[26] Schönberg provided the best rationale for this work

Arnold Schönberg. *Gaze.* 1910. Oil on canvas, 11 × 7⅞" (28 × 20 cm). Collection Lawrence A. Schoenberg, Los Angeles

Arnold Schönberg. *Critic I.* 1910. Oil on wood, 17¼ × 11¾" (44 × 30 cm). Collection Lawrence A. Schoenberg, Los Angeles

when he wrote, in 1911, "I believe art is born of 'I must,' not of 'I can.'"[27]

The first, and arguably the best, achievements of a fully formed new aesthetic in Vienna were the oil portraits painted by Oskar Kokoschka in 1909–11. In his début, at the 1908 *Kunstschau,* the rebellious young Kokoschka had revealed an unconventional sense of erotic fantasy (p. 130); the violent tenor of his originality was made still more evident by the stark and bloody play, *Mörder Hoffnung der Frauen* ("Murderer, Hope of Women"), he staged in the outdoor theater at the *Kunstschau* of 1909 (pp. 185, 214, 215).[28] These showings, perhaps in conjunction with Kokoschka's lack of training as a painter, convinced Adolf Loos that this was an artist temperamentally predisposed to portray the inner agitation Loos saw as a truth of the modern human condition. Loos took Kokoschka under his wing and promoted his career. Signficantly, one of the first sittings Loos arranged was that for the portrait of the writer Ludwig Ritter von Janikowsky, then confined in the Steinhof Asylum (p. 207).[29] On the evidence of aggressively unflattering early works like the Janikowsky portrait and that of Father Hirsch (p. 206), where the livid intensity echoes van Gogh, there would seem to have been few artists less suited to the task of society portraiture. Yet Loos was sufficiently dedicated to this prospect to set Kokoschka up in Alpine resorts and sanatoria, to make his way painting the aristocracy who came there for therapeutic retreat from city life.[30] Through Loos's contacts, Kokoschka wound up setting onto canvas the images of a strangely mixed society, from prominent scientists and scholars (like the art historian Hans

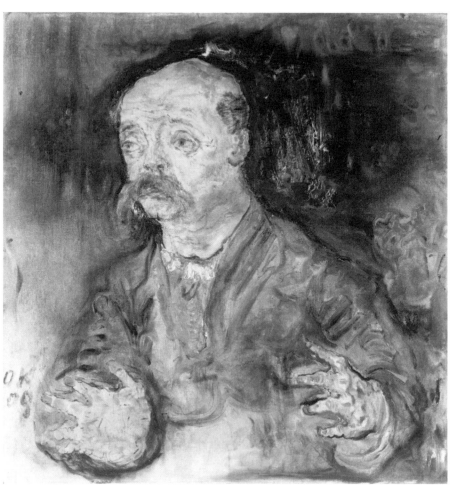

Oskar Kokoschka. *Peter Altenberg.* 1909. Oil on canvas, 29⅞ × 28″ (76 × 71 cm). Private collection

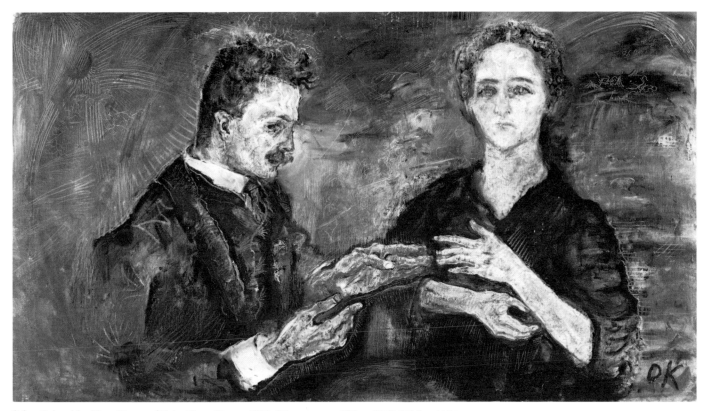

Oskar Kokoschka. *Hans Tietze and Erica Tietze-Conrat.* 1909. Oil on canvas, 30⅛ × 53⅝" (76.5 × 135.2 cm). The Museum of Modern Art, New York; Abby Aldrich Rockefeller Fund

Tietze and his wife, in an exceptional double portrait) to unkempt eccentrics such as the Viennese writer Peter Altenberg, a mainstay of the Kraus-Loos coterie, to elegantly dissipated counts and countesses who seem to belong to a rarefied world frequently compared to that of Thomas Mann's *The Magic Mountain,* where keen refinement and nervous pathology intertwine.

Yet all these individuals were brought by Kokoschka's brush into a distinctly unified, and disturbed, family of the spirit. Partly from the "magnetic fields" of rhythmically organized strokes that often surround van Gogh's self-portraits, and partly from a parallel belief in the spiritual energies individuals may broadcast, Kokoschka surrounded many of these sitters with a charged, glowing aura; he set them in dark atmospheres brought cracklingly alive with scumbled and scraped surface incident. In the best early portraits the sitters' skin is often rendered as thin, venous, and on the edge of dissolution; the edgy electricity of the surrounding atmosphere conveys a nimbus of nervous energy that consumes the sickly physicality of the subject.

This tendency to divorce sitters from mundane surroundings, in order to focus on character alone, is also evident in the portraits Egon Schiele made around 1910. Emerging from under the benign but smothering influence of Klimt, Schiele stripped away the decorative surroundings that marked his first portrait attempts.[31] But in place of the teeming fullness of Kokoschka's tangled atmospheres, he set figures such as Dr. Erwin von Graff (p. 168) and Eduard Kosmack (p. 208) in blank vacuums, so that the energy of their gestures was compressed rather than radiated outward. Schiele also reduced his sitters to taut sinew and bone, in contrast to the melting flesh of Kokoschka's figures; he exaggerated their scarecrow-like ungainliness with a

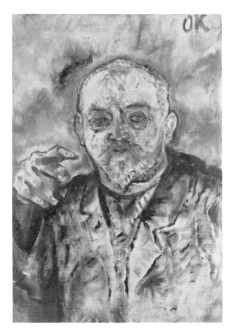

Oskar Kokoschka. *Paul Scheerbart.* 1910. Oil on canvas, 27½ × 18½″ (70 × 47 cm). Private collection, courtesy Serge Sabarsky Gallery, New York

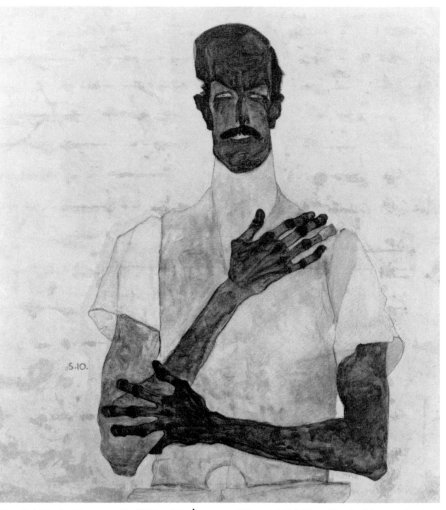

Egon Schiele. *Dr. Erwin von Graff.* 1910. Oil on canvas, 39⅜ × 35⅜″ (100 × 90 cm). Private collection

talent that was more graphic than painterly, and as much influenced by Toulouse-Lautrec as by van Gogh. Kokoschka's subjects produce perturbations that agitate the world around them, but the language of gestures and the silence of emptiness in Schiele's best portraits evoke a different kind of nervous pathology: the cramping confinement of alienation.

The metaphors that commonly surround the discussion of this new expressionist portraiture are those of surgery: stripping away disguises, probing into private verities. Where Klimt's art would be alleged in these terms to have been concerned with superficial appearances, the expressionist vision is said to lay truth bare—the joint truth, both of other individuals' inner states mercilessly exposed and of the artist's own psyche invested without mediation in every act of art-making.

But this account does not seem to fit the pictures. Far from defining the uniqueness of each of their individual sitters, the best early portraits made by both Kokoschka and Schiele seem highly consistent, bearing a strong family resemblance in their special, heightened intensities. The bodily grimaces, the charged voids and bare backgrounds, all impose visions of shared states of being, as a foil against which individual idiosyncrasies appear. One of Kokoschka's foremost biographers long ago saw that his portrait vision began in the categorical typologies of his fantasy characters, before it consid-

ered the features of his contemporaries; his tendency, she observed, was "to transform familiar individuals into fundamental human types . . . always searching for the common factor in the human beings he came across."[32] The version of individual truth involved in such work was filtered through a new, global sense of both the inner essence and the outer expression of a modern human condition: an inner life of disturbed energies not accessible to control, and a separate exterior life of conscious and unconscious gesture that communicated through performance.

It hardly seems coincidental that Kokoschka's first oil portrait was of an actor (*The Trance Actor*, 1908), and that one of Schiele's closest associations was with a mime (Erwin Dom Osen, or Mime van Osen, as he called himself).[33] Both artists amplified the activity of gesture, even to the point of implying narrative, as a way of suggesting internal states. The entire body, especially the hands, participated in their portrait characterizations. Their subjects slump, twist, grasp, and gesticulate semaphorically, acting out their identities in compressed dramas of frailty and tension, impulse and stasis, self-loss and self-consciousness, rather than simply addressing the viewer in a poised and resolved state of being. The bare stage of the cabaret, more than the surgeon's chamber, seems the proper home of this vision.

This theatricality is an essential aspect, too, of the artists' self-presentation. Both these young men were role-players from the start and became more concerned with adopted guises as their careers developed. Early on, Kokoschka shaved his head in the fashion of a criminal, to dramatize his bad-boy role as the enemy of bourgeois complacency. After his exposure to Berlin—where Herwarth Walden had him attired in high style and introduced him to an international elite of the avant-garde—this self-presentation as outlaw took on an even more sardonic air. The self-image of these years was set forth in a poster, where a torso wound (like Christ's) of blasphemous "martyrdom" was indicated with a grotesquely swaggering grimace. But it was only when Kokoschka returned to Vienna and entered into a stormy affair with Gustav Mahler's widow, Alma Mahler, that his self-portraiture developed most vigorously. Challenged and threatened by this affair with a powerful and worldly woman some years his senior, Kokoschka projected himself into epic roles as hero/victim, in a series of illustrations for narratives of his own devising.[34] The high points of this period of self-concern came at the conclusion of the affair, in two painted allegories: the *Knight Errant* (p. 170), in which he assumed the role of a fallen cavalier (premonitory, in light of wounds he would incur in World War I);[35] and *The Tempest* (p. 170), which conjured a vision of the artist and Alma Mahler swept up in the turbulence of their passion. Both canvases are marked by the nocturnal palette and thicker brushwork that after 1912 replaced the early portraits' spidery, heated tremulousness, and by a parallel shift in rhetorical tone, toward more evident pathos.

Kokoschka's sense of his own originality, and his later image of himself as epic hero, seem to reflect the solid confidence he retained from his upbringing. From his respected father, a descendant of Prague goldsmiths, Kokoschka had gained pride, a strong ethical education, and critical social awareness.[36] By contrast Schiele (whose stern, stationmaster father had died insane, from syphilis, when Egon was fourteen) shaped his sense of self from sharply different experience. He had passed a more difficult, self-enclosed childhood marked by an unnaturally close bonding with his younger sister Gertrud.[37] Vienna posed two quite different challenges for these young men. When Kokoschka strutted as a young skinhead renegade, Schiele

Oskar Kokoschka. "Vortrag O. Kokoschka": Poster for a Kokoschka Reading at the Akademischer Verband für Literatur und Musik. 1912. Lithograph, 37¾ × 24¾" (95 × 62.9 cm). The Museum of Modern Art, New York; Gertrud A. Mellon Fund

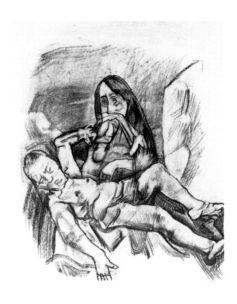

Oskar Kokoschka. *Pietà—It Is Enough.* 1914. Charcoal, 18¾ × 12½" (47 × 31.2 cm). Collection Werner Blohm, West Germany

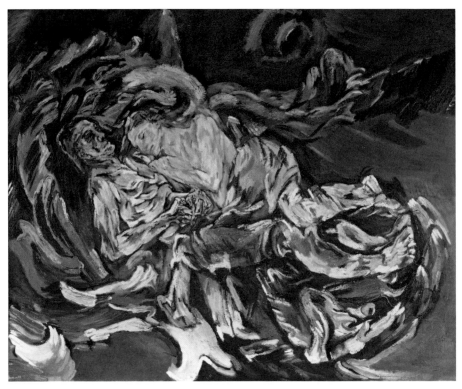

Oskar Kokoschka. *The Tempest (Die Windsbraut).* 1914. Oil on canvas, 71¼" × 7'3" (181 × 221 cm). Öffentliche Kunstsammlung, Kunstmuseum Basel

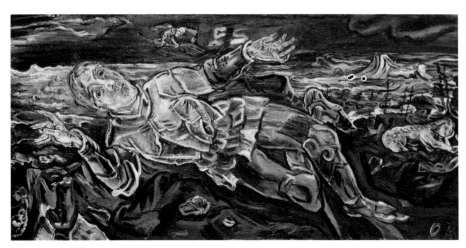

Oskar Kokoschka. *Knight Errant.* 1915. Oil on canvas, 35⅜ × 70⅞" (90 × 180 cm). The Solomon R. Guggenheim Museum, New York

sought to be an impeccably proper artistic dandy, fashioning white collars from paper when he had no cloth ones. The older Oskar moved easily as a loner in Viennese night life, but Egon cherished ideals of artistic brotherhood (reflected in his role in forming the Neukunstgruppe—New Art Group—in 1909) as a buffer against relatively poor social success. When Kokoschka went to Berlin, Schiele began to spend more time in provincial towns; when Kokoschka was creating scandal in Vienna by his involvement with one of the city's most prominent ladies of culture, Schiele was being imprisoned in a country jail on charges stemming from his alleged seduction of a runaway minor.[38] More frustrated and more easily wounded by life, and far less at ease with the disparities between his ideals and his situation,

Schiele devised a different gamut of fictional selves for his art.

Schiele cloaked himself in the guise of a monk or a cardinal (p. 210), less for the idea of private transcendence that led Kokoschka to the Catholic tradition than for the ideal of spiritual fraternity as a model for the artistic life he desired. (The other "monk" in the major works of this series is by appearance and symbolic role almost certainly Schiele's artistic "abbot," Klimt.)[39] He also allegorized his relations with women in a different way. *Death and the Maiden* (p. 211), in which a numb, distraught Schiele is clutched by his model and mistress Wally Neuzil, was painted at the time Schiele's marriage to the more properly bourgeoise Edith Harms was destroying his studio ménage with Wally.[40] The picture was roughly contemporary with Kokoschka's valedictory to his affair with Alma, *The Tempest.* The differences in crypto-religious emotional tone—Schiele's like a Station of the Cross, Kokoschka's like an Ascension—do not obviate the similar strategies of borrowing guises and inventing symbolic fictions as the means of self-presentation.

Schiele's penchant for symbolic representation recurs in devices such as

Egon Schiele. *Four Trees.* 1917. Oil on canvas, 43½ × 55½" (110.5 × 141 cm). Österreichische Galerie, Vienna

the wilted sunflower he used as an attribute (in the Kosmack portrait, p. 208) and self-image. In later landscape work as well, he infused bare, autumnal trees with a pathos that looked back, beyond the softer moods of German landscape painting around 1900, to the Romantic nature symbolism of Caspar David Friedrich (p. 172).[41] There were models close to hand for such imagery, notably in the work of Klimt and Hodler, but both the specific motifs of flowers and trees and the general feeling for self-projection into nature doubtless owe as well to van Gogh. While Schiele does not seem to have been as immediately marked as Kokoschka by the style of van Gogh's paintings, he may have shared a deeper affinity, in the obsession with the self as a central subject, encountered directly or by transposition into landscape,

Egon Schiele. *Autumn Sun (Sunrise)*. 1912. Oil on canvas, 31⅝ × 31¾″ (80.2 × 80.5 cm). Private collection, courtesy Galerie St. Etienne, New York

imagined narrative, and the surrogates of surrounding objects. Schiele's small view of his room, painted in 1911 in the provincial town of Neulengbach, affirms this respect for van Gogh, though the spindly furniture shapes, the spatial flattening of the chamber, and the scumbled thinness of the color betray a sensibility far more delicate. The rough-hewn structure of *The Artist's Bedroom at Arles* has here become a collage of cards and sticks.

The acute perspective and crude peasant colors of van Gogh's *Bedroom*

Above: Vincent van Gogh. *The Artist's Bedroom at Arles*. 1888. Oil on canvas, 28⅝ × 36⅛″ (72.7 × 91.8 cm). The Art Institute of Chicago; Gift of Frederic Clay Bartlett as addition to Birch-Bartlett Collection

Left: Egon Schiele. *The Artist's Room in Neulengbach*. 1911. Oil on wood, 15¾ × 12⅜″ (40 × 31 cm). Historisches Museum der Stadt Wien

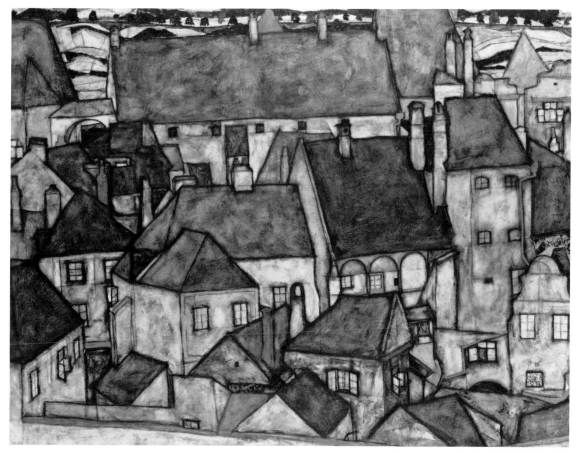

Egon Schiele. *Yellow City.* 1914. Oil on canvas, 42¼ × 55″ (110 × 140 cm). Fischer Fine Art, London

reflect the urgency of his longing to make over his troubled spirit in the
model of what he saw as the hearty, unselfconscious naturalness enjoyed by
those who lived closer to the land. The wan and rickety tentativeness of
Schiele's room suggests a different spirit altogether. As the tormented image
of monastic fraternity in *Agony* conveys (p. 210), Schiele's longing for human
bonding was countered by a fear of being smothered by associations with
others.[42] Similarly, his recurrent imagery of the higgledy-piggledy jumble of
Austria's provincial towns might be thought to be in tune with the then
current nostalgia for the "organic," accretive nature of rural life and tradi-
tions. But the odd mood of these townscapes—empty yet claustrophobic,
poised between the world of Hänsel and Gretel and that of Dr. Caligari—
points to the artist's ambivalence about the closed-in stiltedness of provincial
society, appealing to his ideals yet alien to his nature. It was this disjunction
between city self and country society that produced the most traumatic
event in Schiele's brief career, his imprisonment in Neulengbach in the
spring of 1912. Local objections to what were seen as his licentious life and
pornographic art led the provincial judge not only to incarcerate Schiele on
dubious charges, but also to burn one of Schiele's drawings in the court-
room. This series of events produced some of the artist's most histrionic self-
portraits (p. 174).[43]

It would be wrong, however, to draw too direct a line from Schiele's
biography to his art. In the first place, it is clear from the testimony of friends
that a vast gap existed between the strange and frenetically disturbed
Schiele we seem to see in his art and the well-dressed and relatively

unprepossessing young man they knew in life.[44] Nor will it do to fall back on the simple affirmation that the art presents the true self laid bare, without the disguises of ordinary society. This is the rhetoric of expressionism we have already found faulty, and nowhere does it seem less useful than in the area where it would seem most appropriate—in the unique series of nude self-portraits that are the outstanding hallmark of Schiele's art. Leaving behind obvious disguises and symbolic surrogates—strategies he shared not only with Kokoschka but with many other modern artists—Schiele here did something far more personal and original. He invented a surrogate self housed in his own body, a self as *poseur* in both literal and figurative senses, to play out an identity acknowledged to be acted as much as experienced. What seems most tellingly modern about these works is not the directness of their communication, but its obliqueness; not the sense of revelation, but the sense of performance.

After a few tentative and stylish early efforts at self-definition, Schiele began in 1910 to produce the series of painted and drawn self-portraits that are among the most extraordinary works of early modern Viennese art (pp. 176, 212). Again and again, he depicted himself as a scrawny and scrofulous nude, in hues of red, fiery orange, ochre, and occasionally bruised purple-blue, tangled and foreshortened into a contortionist's repertoire of strenuous poses. The nudity here is not the sign of ideal truth, but of studio artifice. Schiele and the women who sometimes appear with him are explicitly depicted as models, with no symbolic pretext or tempering idealization added to dissemble that role (pp. 148, 213). The subject of the artist and his model was of course not a new one, and depiction of the behind-the-scenes apparatus of the studio pose, in order to undercut the false idealism of nudity, dates back at least to the generation of Seurat and Lautrec.[45] But the artist's adoption for himself of the nakedness and staged stances of the model adds a distinctly modern twist. The artist is presented not as a detached perceiver, but as part creator, part creation of the studio world, living through assumed poses.

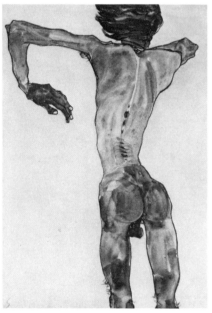

Egon Schiele. *Standing Male Nude, Back View.* 1910. Chalk, watercolor, and gouache, 17⅝ × 12⅛" (44.8 × 30.8 cm). Private collection, courtesy Serge Sabarsky Gallery, New York

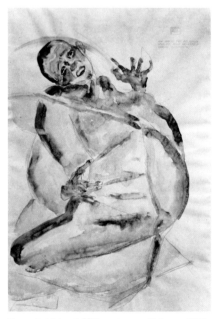

Egon Schiele. *Self-Portrait as a Prisoner.* 1912. Pencil and watercolor, 19 × 12½" (48.2 × 31.8 cm). Graphische Sammlung Albertina, Vienna

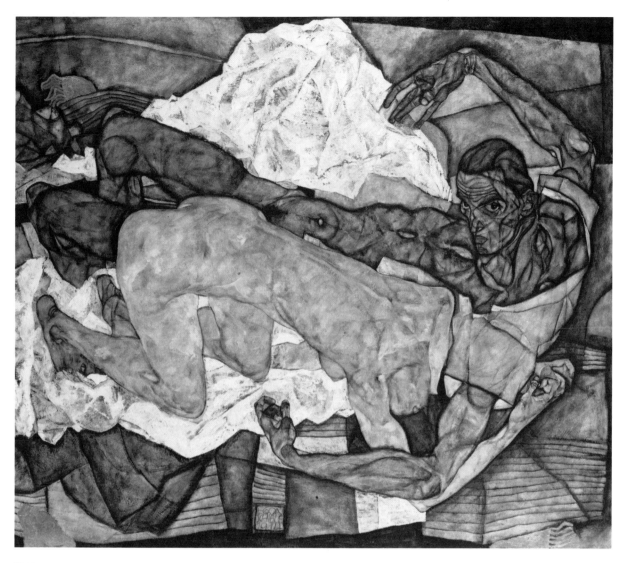

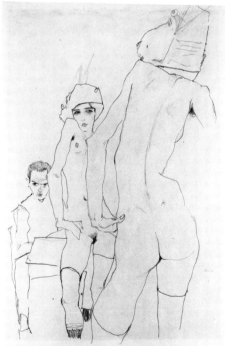

Above: Egon Schiele. *Man and Woman (Liebespaar)*. 1914. Oil on canvas, 46⅞ × 54⅜″ (119 × 138 cm). Private collection, courtesy Serge Sabarsky Gallery, New York

Left: Egon Schiele. *The Artist Drawing Nude Model Before Mirror*. 1910. Pencil, 21¾ × 13⅞″ (55.2 × 35.3 cm). Graphische Sammlung Albertina, Vienna

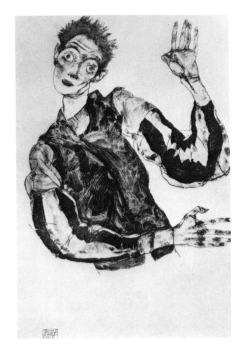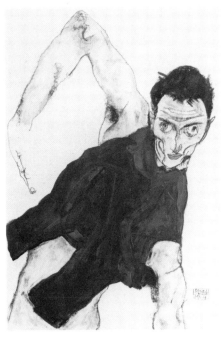

Both Schiele's and Kokoschka's works are theatrical. But Schiele's most arresting self-portraiture is more specifically a theater of the marionette. These are images not of the direct, cathartic revelation of interior life, but of gesticulation in private codes, and surrender to disarticulated muteness, that profoundly internalize the alienation first glimpsed in Schiele's early portraits. The authenticity of such work lies less in discarding artifice than in exacerbating our sense of it. Schiele took the very forms that had been the privileged symbolic locus of verity—the nude and by implication the mirror—and made them convey a deep-seated falseness. As so often in Viennese art, as in the work of Loos, for example, the opaque barrier that divided inner life from social communication was here stressed as an inescapable modern condition.

Schiele portrayed himself in two different aspects of the marionette. On the one hand, we see an exaggerated show of posturing grimaces that go well beyond the normal tradition of artists studying their own extreme expressions (as Rembrandt did, for example). With his friend the mime van Osen, Schiele seems to have sought a new alphabet of universal gestural communication, based on pseudoscientific study of the pathology of human movements and expressions,[46] and to have exaggerated these unconventional signs of distress in his private theater of self-imaging. In this sense, his work belongs to the broader study of expressive movement that activated the experiments of modern dance in the early twentieth century.[47]

On the other hand, in many of these images Schiele portrays himself inert and expressionless, literally a dummy, with blank eyes and disjointedly mechanical poses (pp. 148, 213). The same button-eyed, doll-like flaccidity appears recurrently among his female models, blurring the line between lay figures and living ones.[48] In these instances, Schiele associates himself with another world—that of the mannequins which became familiar personae, in the work of de Chirico among others, around World War I. These hollow men came to symbolize a deep pessimism about communication, and a decisive rejection of the ideal of a private, interior life that had been so crucial to the imagery of the human condition at the turn of the century.

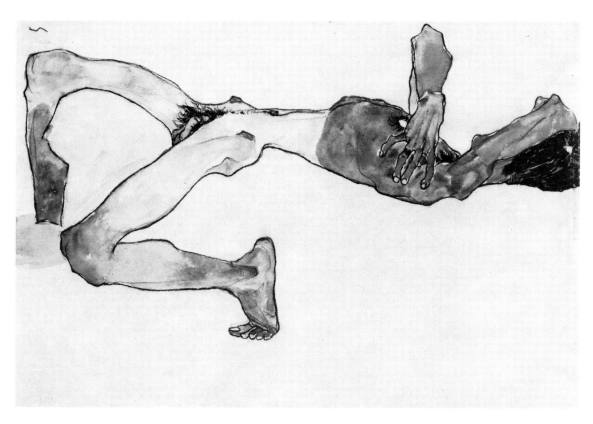

Egon Schiele. *Reclining Male Model with Yellow Cushion.* 1910. Pencil, watercolor, and gouache, 12¼ × 17⅞″ (31.1 × 45.4 cm). Private collection, courtesy Serge Sabarsky Gallery, New York

Egon Schiele. *Two Girls Lying Entwined (Two Models).* 1915. Pencil and gouache, 12½ × 19″ (31.9 × 48.2 cm). Graphische Sammlung Albertina, Vienna

DRAWING

rawing was not a secondary or subservient art in Vienna. Linearity dominated much of the best early modern painting, and *Flächenkunst* (the art of the plane, or roughly what we would call graphic design) was of paramount importance in all phases of the decorative arts, from books to fabrics and furniture. Draftsmanship also frequently assumed a self-sufficient or even primary role. The oeuvres of Alfred Kubin and Klemens Brosch consist primarily of drawings, while those of Klimt, Kokoschka, and Schiele all contain bodies of graphic work that were conceived independently of their paintings.

Max Klinger, the Leipzig sculptor honored by the Secession in 1902 (see pp. 42, 155), had argued in the 1890s that drawing should be a separate form of expression, reserved for a specific range of subjects and attitudes. His essay *Malerei und Zeichnung* ("Painting and Drawing," 1891) held that color should be reserved for objective images of nature, or for ideal visions, while graphic mediums were better able to express a critical view of reality, or embody the distorted world of fantasy and dream.[49] His own cycles of socio-critical and fantasist etchings, especially the fetish tale *Paraphrase on the Finding of a Glove* (1882), were not the kinds of dreams favored by Klimt and the Secession circle.[50] They left a deep impression, however, on both Kubin and Brosch.

Kubin arrived very early at a complete, strikingly personal vision. His freshest works date from the very first years of the twentieth century, especially around his first Berlin exhibition in 1902, and up to the time of the publication of his fantasy novel *Die andere Seite* ("The Other Side") in 1908.[51] They conjure a twilight world of impossible humanoid beasts and plants, with a note of reverie, usually cruel and often violent, that struck a responsive chord in German Expressionist circles. Born in Bohemia, Kubin made his career more in Germany than Vienna; he was an illustrator for the magazine *Simplicissimus,* and was involved with Kandinsky in the circle that formed the Blue Rider group.

His imagery and style echo the work of a panoply of other graphic artists, from Rops and Redon to Bosch and Breughel. The underlying ideas were also very likely shaped by the fascination with dreams and the unconscious that pervaded Germany and Austria-Hungary in Freud's formative years.[52] Yet for all the patchwork eclecticism, Kubin had a genuine poetic gift which was not borrowed; he did not, however, have reliable control over it, as witness his inability to sustain the level of creativity evident in the early images.

The uncanny resists defining by formula, and it is hard to spell out the strategies by which Kubin succeeded: erotic deformation, incongruities in scale, and eerie nocturnal lighting all play their part within the general fabric of uncomfortably specific rendering. His early ink-wash scenes have the seamless tonalities of fine aquatint or lithography, and their images seem to have been seized whole, with the unity of a photograph. (Kubin had in fact worked in photography as a boy.) It is somewhat easier to say where this vision goes awry. Kubin's sense of grotesque tangibility easily shaded over into the merely vulgar or pornographic, abandoning the residual lyricism

Above left: Alfred Kubin. *Primeval Mud.* 1904. India ink, wash, spray, and charcoal, 15½ × 12¼" (39.5 × 31.2 cm). Graphische Sammlung Albertina, Vienna

Top right: Alfred Kubin. *Africa.* 1902. Pencil, pen, brush, and spray, 12⅜ × 15⅜" (31.3 × 39 cm). Graphische Sammlung Albertina, Vienna

Above: Alfred Kubin. *War.* c. 1916. Pen and ink, wash, and spray, 12¼ × 15½" (31.2 × 39.4 cm). Graphische Sammlung Albertina, Vienna

Left: Alfred Kubin. *Self-Consideration.* 1902. Pen and ink, wash, and spray, 8⅞ × 9" (22.5 × 22.7 cm). Graphische Sammlung Albertina, Vienna

Klemens Brosch. *Birches, Barbed Wire, Fallen.* 1914. Ink and ink wash, 8⅛ × 10⅜" (20.6 × 26.2 cm). Oberösterreichisches Landesmuseum, Linz

Klemens Brosch. *Airship over Linz.* 1911. Pencil, pen and ink, and ink wash, 13 × 8" (33 × 20.3 cm). Oberösterreichisches Landesmuseum, Linz

Klemens Brosch. *Swallows over the South Shore.* 1912. Ink and ink wash, 13¾ × 16⅛" (35 × 41.4 cm). Oberösterreichisches Landesmuseum, Linz

Klemens Brosch. *Memories of the Vienna Skating Rink.* 1915. Ink and ink wash, 12⅜ × 17¾" (31.4 × 45.1 cm). Oberösterreichisches Landesmuseum, Linz

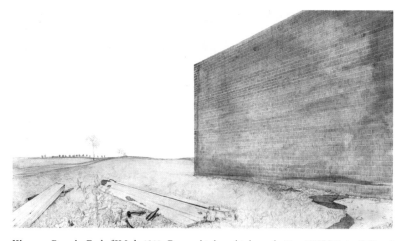

Klemens Brosch. *End of Work.* 1912. Pen and ink and ink wash, 11 × 19¼" (28 × 48.9 cm). Oberösterreichisches Landesmuseum, Linz

that lent his luridness its savor. Moreover, he was better as a tonal imagist than as a true draftsman, and once he abandoned the chiaroscuro of the early work for a shaggy, more overtly expressionist style of line rendering, the magic dissipated.

Klemens Brosch had a far shorter career than Kubin's (committing suicide at thirty-two, in 1926), and has remained virtually unknown outside Linz, where he was born, and Vienna, where he studied at the Academy of Fine Arts.[53] Like Kubin, he was a prodigy who began producing accomplished, personal work quite suddenly, as a teenager. Their sources, too, are not dissimilar; Goya greatly affected Brosch's bitterly ironic scenes of World War I, and Klinger's bare, sharply etched realism pervades all his imagery. But Brosch drew with a clear-eyed sense of daylight dreaming wholly distinct from Kubin's phantasmagoria.

What sets Brosch apart is his cinematic vision: a combination of mobile perspective, icy, relentless detail, and *japoniste* asymmetry of space, that seems to link the world of Caspar David Friedrich with that of Alfred Hitchcock. Particularly striking for their dates (just before the innovations of Sergei Eisenstein and Dziga Vertov in Russian film) are Brosch's peculiar abstracting viewpoints, from steeply above or below, and a focus that pulls together the mundane and random specifics of near and far into scenes whose emptiness suggests an absent narrative. Kubin's eye lived within another world, but Brosch stood just outside this one, looking in with the numb accuracy of post-traumatic detachment. His most haunting creation is the view of a barren hospital ward, seen through his own reflection in a glass door. In this ghostly self-portrait, a disquieting fly is poised over the artist's eye.

For all the interest of such independent, pictorial draftsmanship, however, the predominant drawings of the epoch in Vienna were the figure studies of the major painters. Of the senior master, Klimt, one writer could

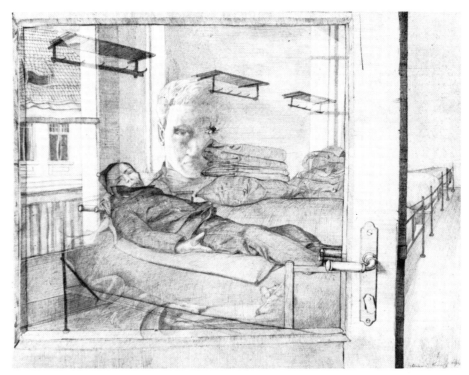

Klemens Brosch. *View Through the Glass Door.* 1915. Pencil, 9⅞ × 13⅜″ (25 × 34 cm). Stadtmuseum Linz

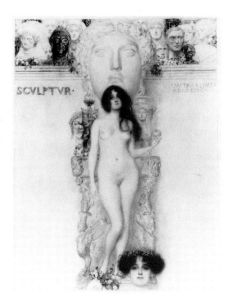

Gustav Klimt. *Sculpture* (for the portfolio *Allegorien, Neue Folge*). 1896. Black crayon, pencil, wash, and gold, 16½ × 12⅜″ (41.8 × 31.3 cm). Historisches Museum der Stadt Wien

Carl Otto Czeschka. *Nude with Drapery.* 1909. Pencil, 24⅛ × 18⅛″ (61.2 × 46 cm). Graphische Sammlung Albertina, Vienna

say in 1944: "The Byzantine pomp and theatrical symbolism of his greatest compositions do not appeal to present-day taste, [but] his really masterly and very sensuous drawings will always rank among the best of their kind. And it was as a draughtsman that he had a beneficial influence on the young artists of Vienna."[54] Yet today, Klimt's graphic work seems far less imposing, and that of Kokoschka and Schiele more independent of his lessons.

It is surprising that the taut and sensuous linearity we associate with Klimt is so absent from his drawings. His early allegorical drawings show a suave, but essentially painterly and tonal talent (p. 19). In the studies for the university ceiling panels (p. 196) his foreshortened figures provided more dramatically swelling linear rhythms, but he only partially fixed these contours. Here, as throughout Klimt's career, his linear control was more assertive in the paintings themselves than in the preparatory studies. Numerous drawings exist for the major portraits, but even the definitive preparatory studies show only general, loosely stroked indications of the forms. The love of taut decorative pattern, so characteristic of the paintings, rarely appears in Klimt's drawings as evidently as it does in, for example, those of Czeschka.

Klimt is in any event best known as a draftsman, not for such ancillary works, but for his more independent studies of nude models. In this large body of work, he shows women, separately or in couples, in an extraordinary variety of informal poses, often explicitly erotic. Such works have long been seen as an essential part of Klimt's reputation as a sensualist, and of Vienna's image as a hotbed of indulged Eros. But important aspects of these drawings are imported. In 1900 at the Paris world's fair, and doubtless on other occasions, Klimt had the opportunity to see the innovative drawings Rodin had begun making in the later 1890s: studies of nude models in unusual poses of motion, frequently voyeuristic in their concentration on the erotic, rendered swiftly in simplified pencil contours, and often washed with watercolor. These bold drawings had a lasting impact on many artists coming to maturity around 1906 (such as Matisse), and they were certainly important for Klimt. However, Klimt was more interested in the play of wandering line than in the binding of sculptural volumes; the grassily stroked atmospherics of artists such as Anders Zorn and Giovanni Boldini also left their mark. Unlike either Rodin before him or Schiele afterward, he was little inclined to make an issue of athletic strenuousness of gesture, or of the graphic placement of the figural silhouette on the page. His drawings thus have a casual quality in their often disconnected lines, and even when obscene their appeal is that of light, boudoir intimacy.

The early figure drawings of Kokoschka and Schiele seem to have taken their point of departure, not from the plump sensuality of these later nude studies of Klimt, but from the emaciated elongation of his previous female types (p. 197). In Klimt this slenderness had been the expressive form of a morbidly attenuated, and by implication "hungry," sexuality associated with the fatal woman. In Kokoschka and Schiele it became the property of adolescence, under the influence of the gothicized youths of Georges Minne's sculptures (p. 47). Both Kokoschka and Schiele were attracted to street-urchin girls who bore both the social pathos of a marginal existence and the disturbing fascination of prepubescent eroticism (p. 184). (The same appeals motivated the Brücke painters' adoption of a circus child, Franzi, as a studio "mascot.") These waifs' raw-boned physiques satisfied the artists' preference for an unconventional nudity, beyond the domain of professional models, and suited their desire to develop a tougher line quality that would leave

Gustav Klimt. *Nude Figure*. n.d. Pencil, 14½ × 22⅜″ (37 × 57 cm). Historisches Museum der Stadt Wien

Auguste Rodin. *Reclining Female Nude*. c. 1900. Pencil, 12⅛ × 8″ (31 × 20 cm). Musée Rodin, Paris

Gustav Klimt. *Reclining Nude*. c. 1913–14. Blue pencil, 14⅝ × 22″ (37.1 × 55.8 cm). Historisches Museum der Stadt Wien

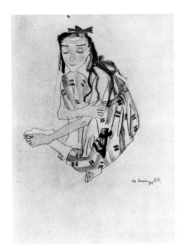

Oskar Kokoschka. *The Lunatic Girl.* c. 1909. Pencil and watercolor, 17¼ × 12¼″ (44 × 31 cm). Historisches Museum der Stadt Wien

Oskar Kokoschka. *Herwarth Walden.* c. 1910 (from *Der Sturm,* vol. I, July 28, 1910)

Oskar Kokoschka. *Karl Kraus.* c. 1910 (from *Der Sturm,* vol. I, May 19, 1910)

Right: Oskar Kokoschka. *Young Girl in Three Views.* 1908. Pencil, 17¾ × 12¼″ (45 × 31 cm). Graphische Sammlung Albertina, Vienna

behind the suave smoothness of *Jugendstil* curves. The taboo sexuality—illicit by social convention, but true to a new psychological awareness of precocious libido—added to the appeal of the subject.

Kokoschka's most impressive early drawings, however, originated in fantasy rather than in study from life, as illustrations for the crudely schematic, ritualized drama of blood-lust and desire he premièred at the *Kunstschau* of 1909, *Mörder Hoffnung der Frauen.* The poster advertising the performance was stunning in its macabre play between the imagery of a consoling Pietà and that of a devouring, death's-head female; the compressed twist of a livid, flayed male corpse against the lunar blue of the ground made the shock all the more raw (p. 215). But the pen-and-ink illustrations later published in *Der Sturm* convey the violent cruelty at least as vividly, by a combination of

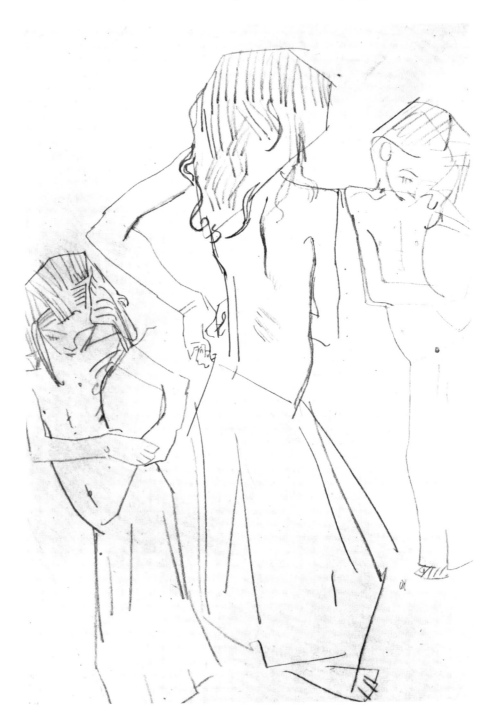

stiff schematization and expressive distortion, but also by the spiny bristle of semi-independent calligraphic inventions. Splintered dagger and asterisk forms, often based on exaggerations of conventional graphic codes such as the parallel hatching used to define volumes, suggest tribal scarification or wounds on the figures themselves, and activate the scenes with crackling, conflicted energies. These drawings shift sharply away from the naïve solidity of contour in Kokoschka's immediately preceding illustrations from imagination, such as *Die träumenden Knaben* (p. 130) and related tales. They seem to anticipate later work by Picasso, such as the studies related to *Guernica;* when the same linear inventions are used to break up an individual's face into a mutilated field of comets and stars, the work seems equally premonitory of aspects of Surrealist automatism. This expressive calligraphy

provided a point of departure for the scraped surfaces of some of Kokoschka's early painted portraits (p. 167). But after his style of painting changed, the influence reversed: the broader manner of the paintings of the teens was brought back into Kokoschka's drawings as a thickened stroke, visible in the series of illustrations made for lithography from about 1912 onward (p. 170). The woodcut-like bite of the pen gave way to the cooler and softer look of chalk and crayon.

Of all these draftsmen, it is certainly Schiele who produced the most richly varied and consistently arresting work. His line runs the gamut from a frail and spidery brittleness to rough, barbed fragmentation, and the use

Above left: Oskar Kokoschka. Drawing for *Mörder Hoffnung der Frauen* ("Murderer, Hope of Women") I. c. 1908. India ink, 10⅞ × 7⅞" (27.5 × 20 cm). Private collection

Above: Oskar Kokoschka. Drawing for *Mörder Hoffnung der Frauen* ("Murderer, Hope of Women") IV. c. 1908. India ink, 10⅞ × 10⅞" (27.5 × 27.5 cm). Private collection

Above: Egon Schiele. *Seated Nude in Shoes and Stockings.* 1918. Charcoal, 18⅜ × 11¾″ (46.7 × 29.9 cm). The Metropolitan Museum of Art, New York; Bequest of Scofield Thayer, 1982

Above right: Egon Schiele. *Reclining Nude with Yellow Towel.* 1917. Tempera and black chalk, 12¼ × 19″ (31.1 × 48.3 cm). Private collection

Page opposite: Egon Schiele. *Reclining Nude, Half Length.* 1911. Watercolor and pencil, 18⅞ × 12⅜″ (47.9 × 31.4 cm). Private collection, courtesy Serge Sabarsky Gallery, New York

of color washes similarly embraces both liquid delicacy and a leathery, scumbled toughness. Schiele had what Klimt did not: a virtually unfailing ability to command the sculptural complexity of anatomy twisted and fore-shortened in every conceivable way. Moreover, unlike Klimt, Schiele was able to see these bodily forms simultaneously as volumes in space and as graphic shapes on the page, and to realize both aspects with equal power. His line seems relentlessly specific, and tied to lived experience, as it tracks the unidealized particularities of skin, hair, bone, and clothing. Yet this same line, and the seemingly unforced power of his framing of the forms, yields a rich decorative sense. Followed through the drawings, the line breaks and returns, passes through flurries and swelling leaps, hesitates in wavering thinness, and bears down with flattened fullness, in a life of its own, semi-independent of the things described. The smocks and towels, petticoats and garters, shoes and stockings function not just as fetish accessories, but as occasions for color and pattern that lend racy stylization to his charac-teristically sullen figures. Similarly, the emaciated bodies splay themselves across the pages in ways that suggest a mobile, never-complacent viewpoint and a constant resistance to an enclosing volume of proximate space. In all these respects, Schiele's powers as an observer are integrally linked to his instincts as a designer.

These drawings have since Schiele's lifetime been notorious for their pornographic aspects, and it is a reputation well deserved. The sexuality of their voyeurism is usually far tougher, more heated and challenging than the plush, harem steaminess of Klimt. In Schiele eroticism often seems to have lost its link to pleasure, and to have associated itself with spasmodic suffer-ing; both the self-abandon and self-enclosure of the splayed-leg models are disturbingly affecting. Yet these willfully scurrilous and often notably anti-sensual nudes are also almost unfailingly elegant as designs. This elegance was a reflex for Schiele; his eye for unusual style was as personal as his feeling for the unconventional psychology of the body. It is the marriage in Schiele between the shocking and the chic, between the lure of depravity and suffering and the urge to stylishness, that determines the particular quality of the drawings. The sultry mingling of morbidity, voluptuous ugliness, and high fashion that Klimt had first defined as a *fin-de-siècle* Viennese sensibility, Schiele modernized into a brutal and denuded glamor. ∎

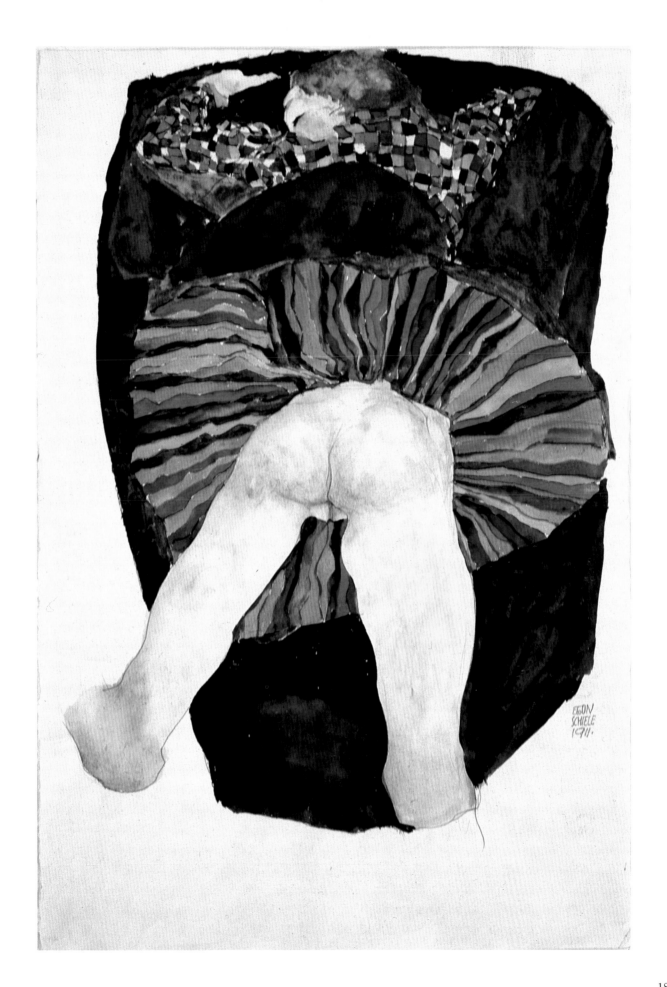

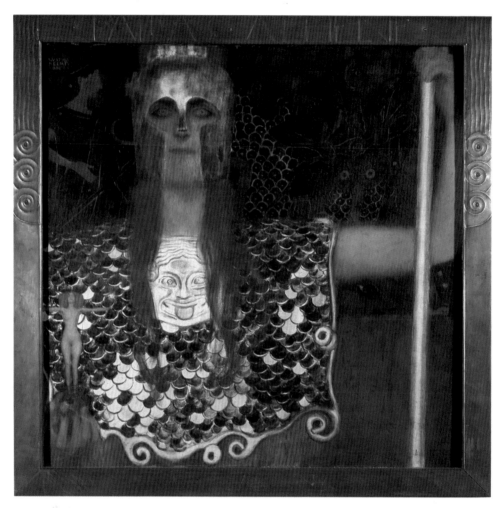

Gustav Klimt. *Pallas Athene.* 1898.
Oil on canvas, 29½ × 29½" (75 × 75 cm).
Historisches Museum der Stadt Wien

Opposite:
Gustav Klimt. *Judith I.* 1901.
Oil on canvas, 33 × 16½" (84 × 42 cm).
Österreichische Galerie, Vienna

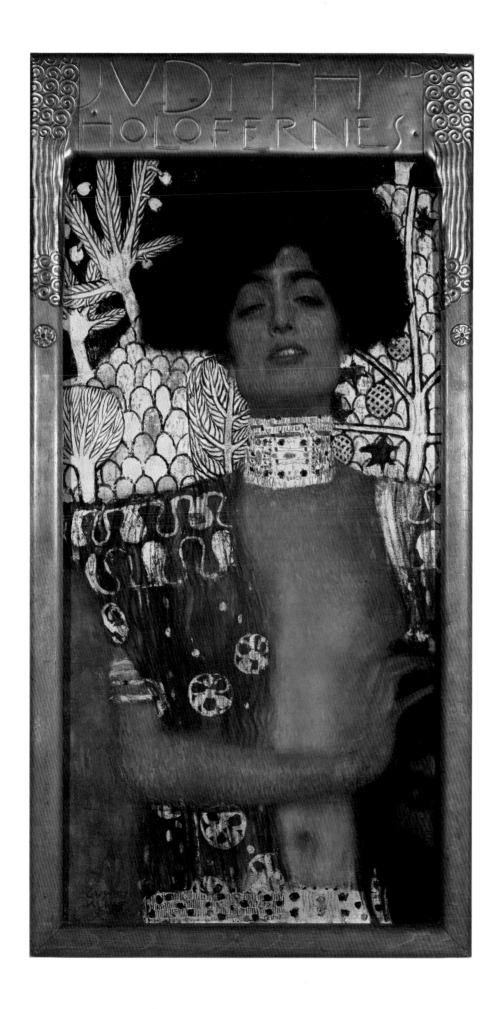

Carl Moll. *Twilight*. c. 1900. Oil on canvas, 31½ × 37¼" (80 × 94.5 cm). Österreichische Galerie, Vienna

Gustav Klimt. *Island in the Attersee.* c. 1901.
Oil on canvas, 39⅜ × 39⅜″ (100 × 100 cm).
Estate of Dr. Otto Kallir, courtesy Galerie St. Etienne, New York

Gustav Klimt. *Beech Forest I*. c. 1902.
Oil on canvas, 39⅜ × 39⅜″ (100 × 100 cm).
Staatliche Kunstsammlungen Dresden, Gemäldegalerie Neue Meister

Walter Sigmund Hampel. *Evening.* c. 1900.
Oil on canvas, 39⅜ × 43⅜″ (100 × 110 cm).
Collection Bernard Goldberg

Gustav Klimt. *Garden Landscape (Blooming Meadow)*. c. 1906.
Oil on canvas, 43¼ × 43¼" (110 × 110 cm).
Private collection

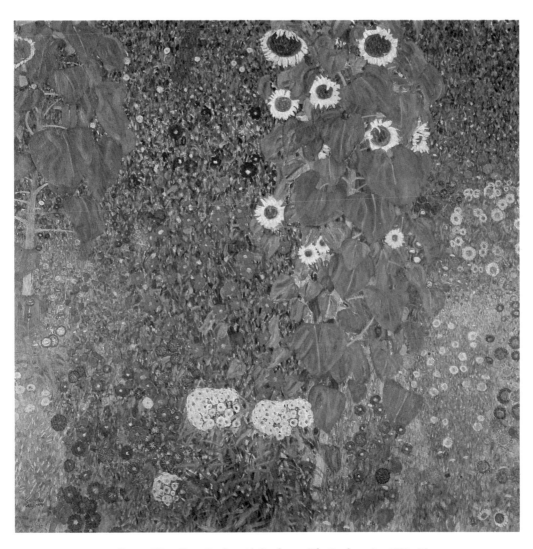

Gustav Klimt. *Farm Garden with Sunflowers (The Sunflowers)*. c. 1905–06.
Oil on canvas, 43¼ × 43¼″ (110 × 110 cm).
Österreichische Galerie, Vienna

Gustav Klimt. Study for *Medicine*. c. 1900.
Pencil and crayon, 33⅞ × 24⅜″ (86 × 62 cm).
Graphische Sammlung Albertina, Vienna

Gustav Klimt. Study for *Philosophy*. c. 1898–99.
Pencil and crayon, 35¼ × 24⅞″ (89.6 × 63.2 cm).
Historisches Museum der Stadt Wien

Gustav Klimt. Study of Suspended Female Figure for
Medicine. c. 1898. Chalk, 16⅜ × 10¾″ (41.5 × 27.3 cm).
Graphische Sammlung Albertina, Vienna

Gustav Klimt. Study of Nude Figure for *Medicine*. c. 1898.
Chalk, 17 × 11⅜″ (43 × 28.9 cm).
Graphische Sammlung Albertina, Vienna

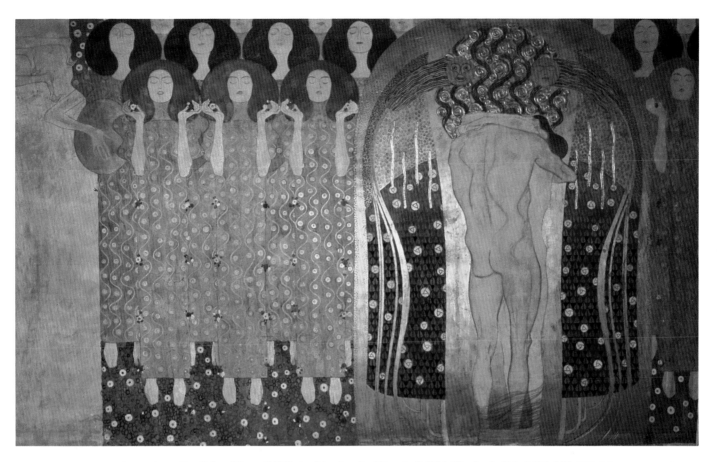

Gustav Klimt. *Beethoven Frieze*. Detail from "Poetry" ("Choir of the Angels of Paradise"; "This Kiss for the Whole World"). 1902 (after restoration).
Casein, gold leaf, semiprecious stones, mother-of-pearl, gypsum, charcoal, pastel, and pencil on plaster, 7′1″ × 32′ 1¼″ (216 × 981 cm) overall.
Österreichische Galerie, Vienna

Gustav Klimt. Study of Left Figure of Three Gorgons
(Reversed) for *Beethoven Frieze*. 1902.
Black chalk with partial wash, 17⅝ × 12⅝″ (44.9 × 32 cm).
Graphische Sammlung Albertina, Vienna

Gustav Klimt. Study of Composition "This Kiss for
the Whole World" for *Beethoven Frieze*. 1902.
Black chalk, 17¾ × 12⅛″ (45 × 30.8 cm).
Graphische Sammlung Albertina, Vienna

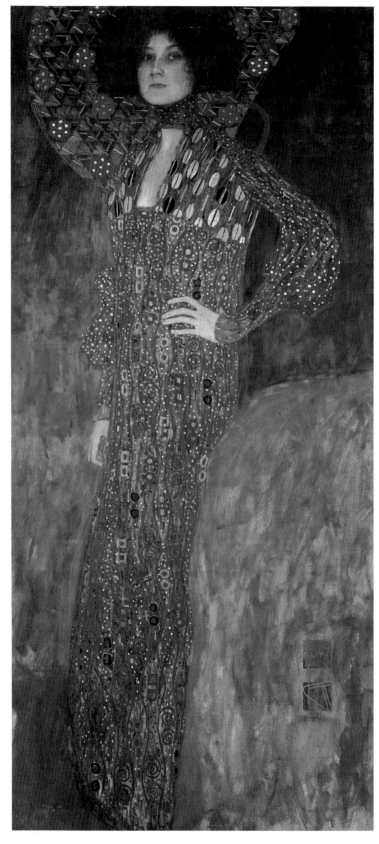

Gustav Klimt. *Emilie Flöge.* 1902.
Oil on canvas, 71¼ × 33″ (181 × 84 cm). Historisches Museum der Stadt Wien

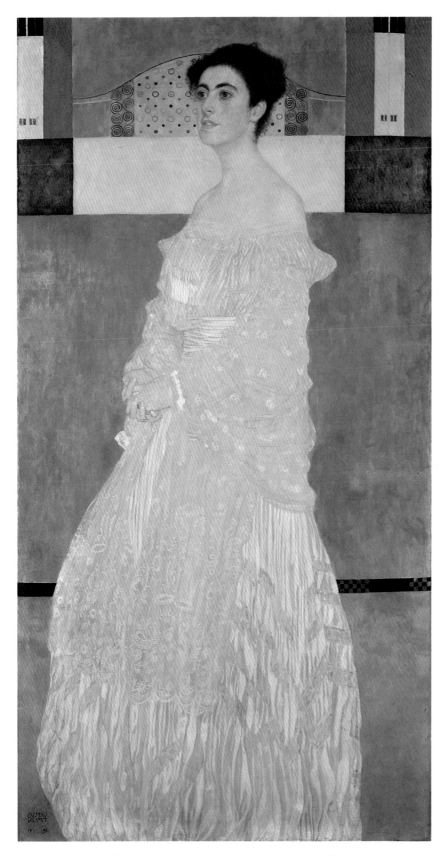

Gustav Klimt. *Margaret Stonborough-Wittgenstein*. 1905.
Oil on canvas, 70⅞ × 35⅜″ (180 × 90 cm).
Bayerische Staatsgemäldesammlungen, Neue Pinakothek, Munich

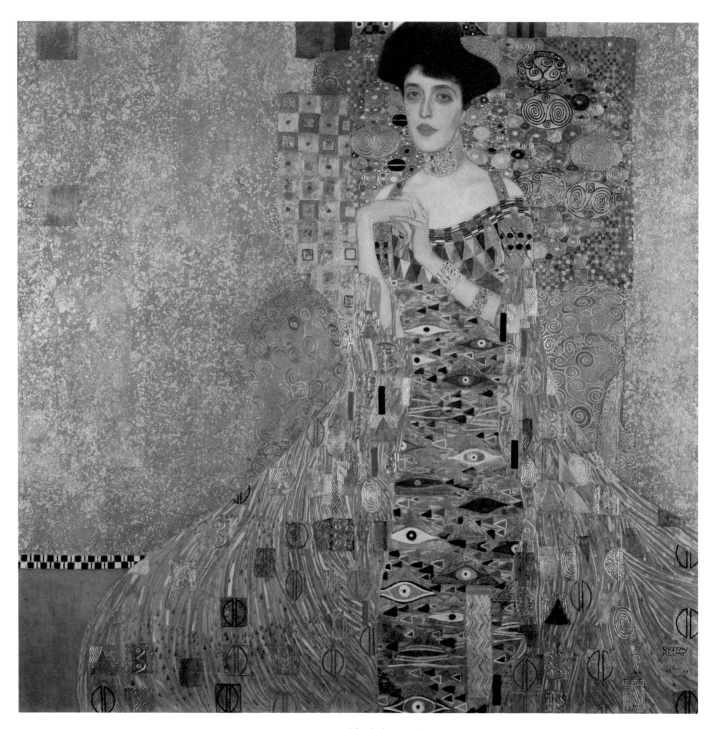

Gustav Klimt. *Adele Bloch-Bauer I.* 1907.
Oil and gold on canvas, 54¼ × 54¼″ (138 × 138 cm).
Österreichische Galerie, Vienna

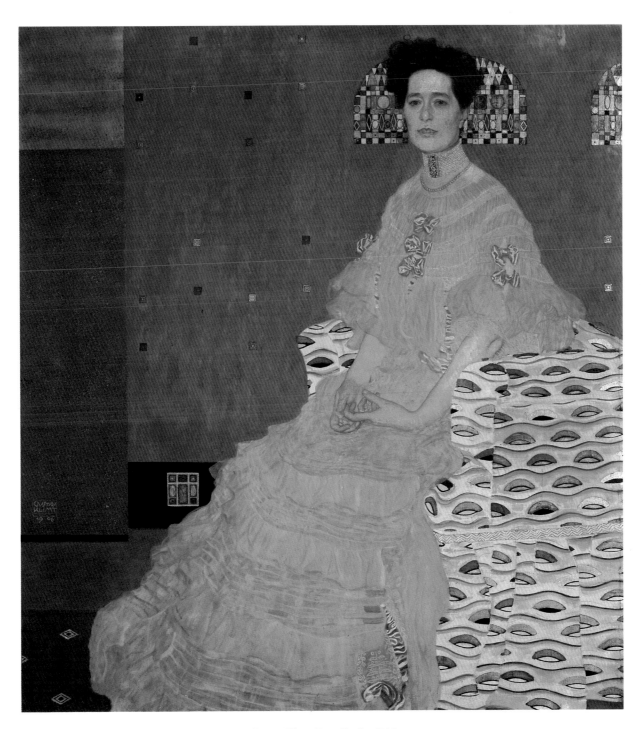

Gustav Klimt. *Fritza Riedler*. 1906.
Oil on canvas, 60¼ × 52⅜″ (153 × 133 cm).
Österreichische Galerie, Vienna

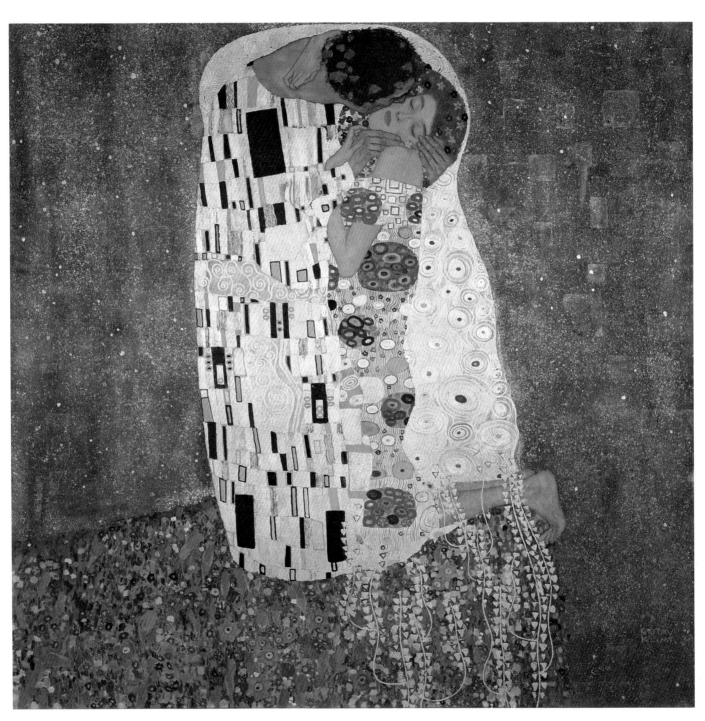

Gustav Klimt. *The Kiss.* 1907–08. Oil and gold on canvas, 70⅞ × 70⅞″ (180 × 180 cm).
Österreichische Galerie, Vienna

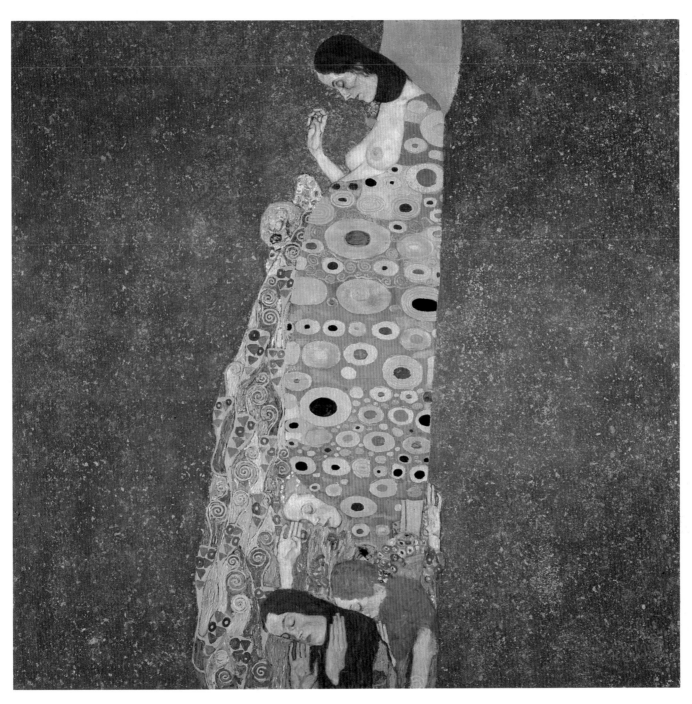

Gustav Klimt. *Hope II.* 1907–08. Oil and gold on canvas, 43½ × 43½″ (110.5 × 110.5 cm).
The Museum of Modern Art, New York; Mr. and Mrs. Ronald S. Lauder and Helen Acheson Funds, and Serge Sabarsky

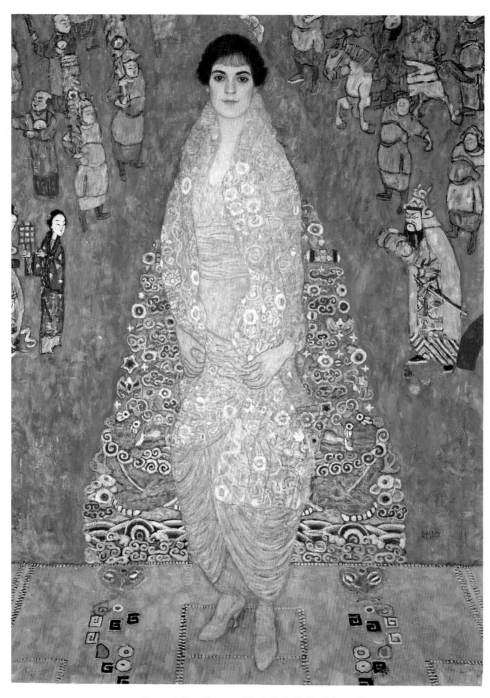

Gustav Klimt. *Baroness Elisabeth Bachofen-Echt.* c. 1914.
Oil on canvas, 70⅞˝ × 50⅜˝ (180 × 128 cm).
Private collection

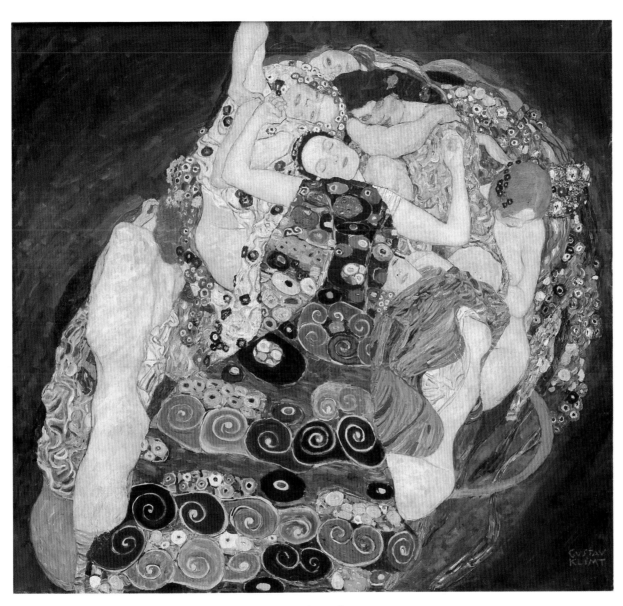

Gustav Klimt. *The Maiden.* 1912–13.
Oil on canvas, 6′ 2¾″ × 6′ 6¾″ (190 × 200 cm).
The National Gallery, Prague

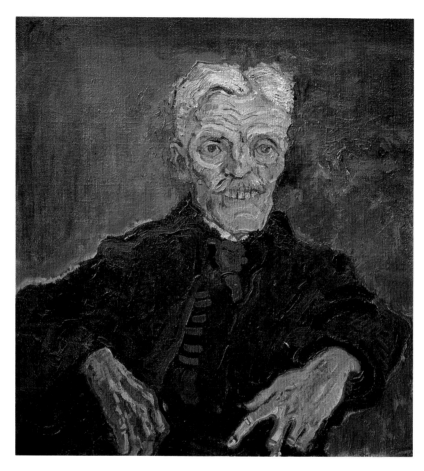

Oskar Kokoschka. *Portrait of an Old Man (Father Hirsch).* 1907.
Oil on canvas, 27¾ × 24⅝″ (70.5 × 62.5 cm).
Neue Galerie der Stadt Linz/Wolfgang-Gurlitt-Museum, Linz

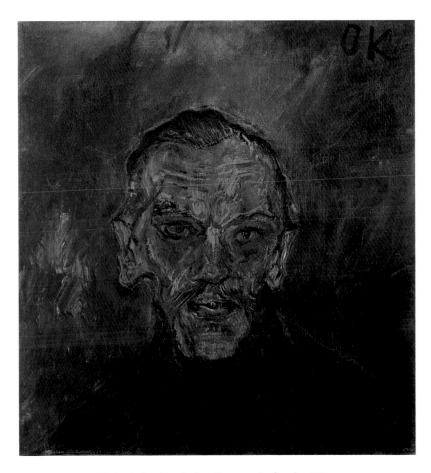

Oskar Kokoschka. *Ludwig Ritter von Janikowsky.* 1909.
Oil on canvas, 23⅝ × 22½″ (60 × 57 cm).
Private collection

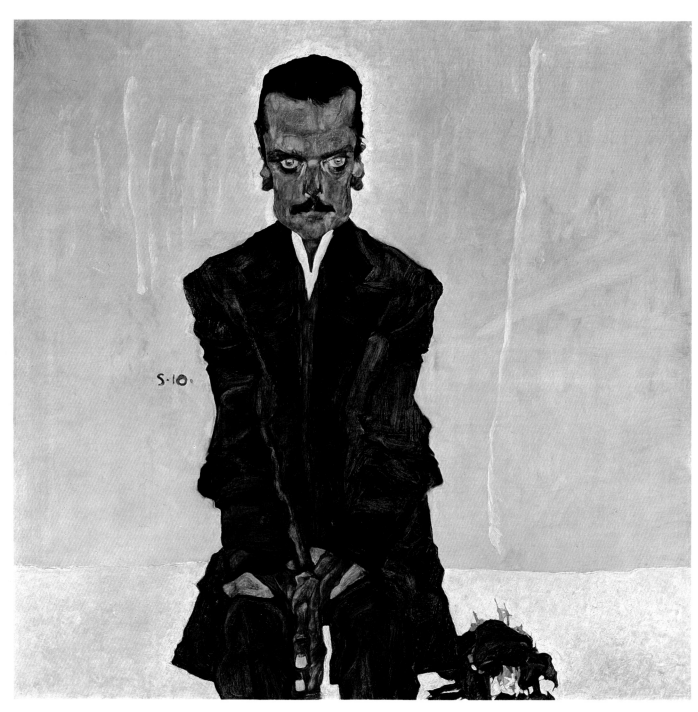

Egon Schiele. *Eduard Kosmack*. 1910.
Oil on canvas, 39⅜ × 39⅜″ (100 × 100 cm).
Österreichische Galerie, Vienna

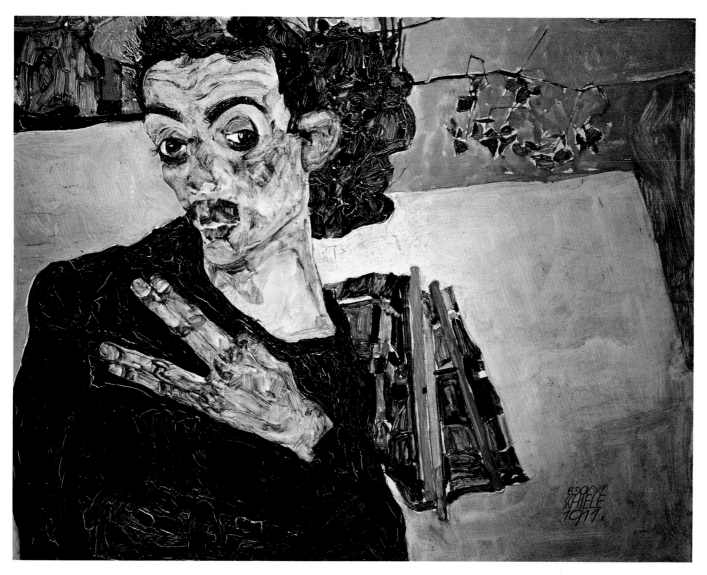

Egon Schiele. *Self-Portrait with Black Vase (Self-Portrait with Spread-Out Fingers)*. 1911.
Oil on wood, 10⅞ × 13⅜" (27.5 × 34 cm).
Historisches Museum der Stadt Wien

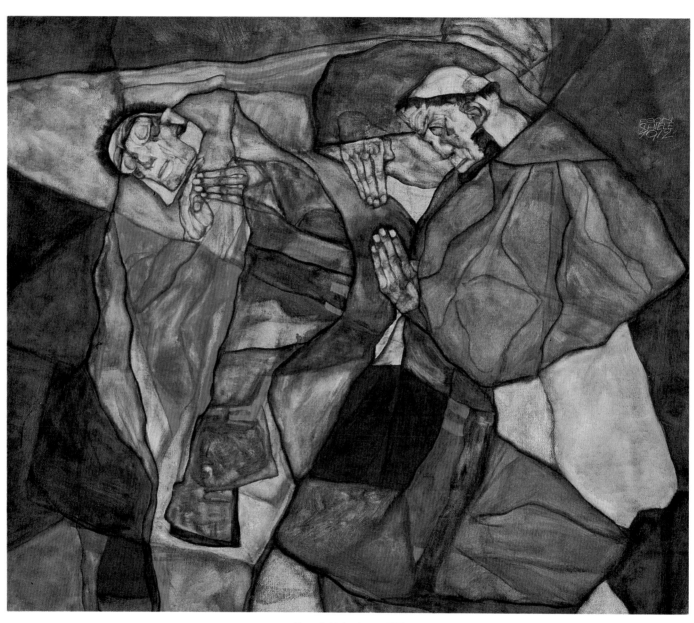

Egon Schiele. *Agony.* 1912.
Oil on canvas, 27½ × 31½″ (70 × 80 cm).
Bayerische Staatsgemäldesammlungen, Neue Pinakothek, Munich

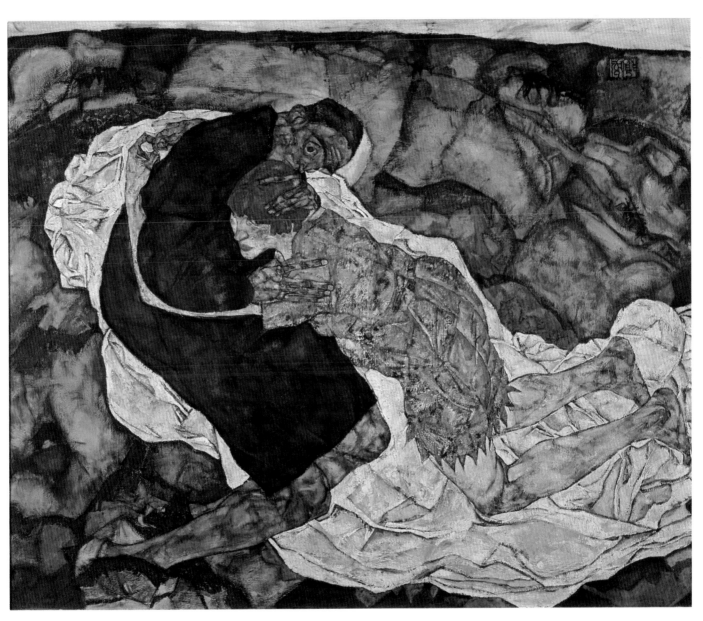

Egon Schiele. *Death and the Maiden*. 1915.
Oil on canvas, 59 × 70⅞″ (150 × 180 cm).
Österreichische Galerie, Vienna

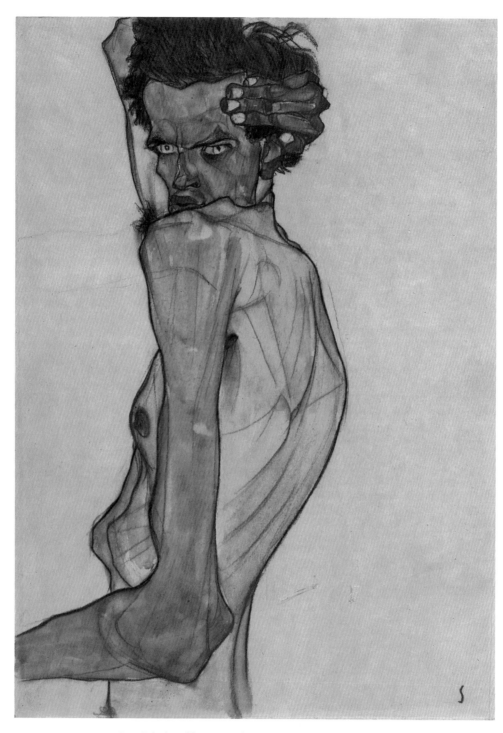

Egon Schiele. *Self-Portrait with Arm Twisted Above Head.* c. 1910.
Charcoal and wash, 17¾ × 12½" (45.1 × 31.8 cm).
Private collection

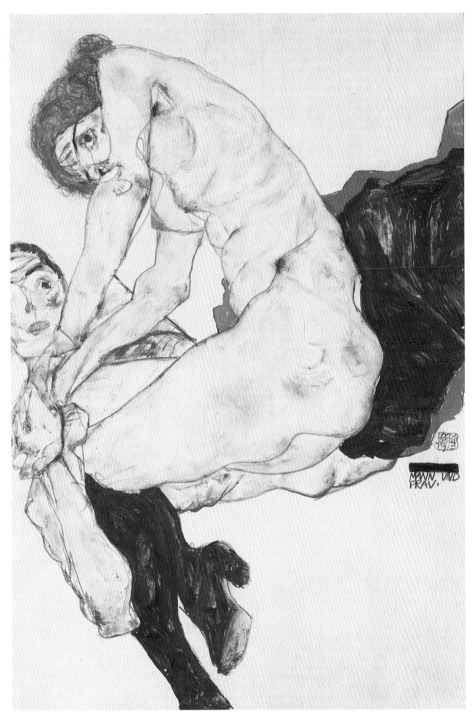

Egon Schiele. *Man and Woman*. 1913.
Pencil, watercolor, and tempera, 31 × 18¾″ (78.7 × 47.6 cm).
Private collection

Oskar Kokoschka. *Frauenmord* for *Mörder Hoffnung der Frauen*
("Murderer, Hope of Women"). 1908–09.
Pencil, ink, and watercolor, 12 × 10⅛″ (30.8 × 25.8 cm).
The Robert Gore Rifkind Center for German Expressionist Studies;
Los Angeles County Museum of Art

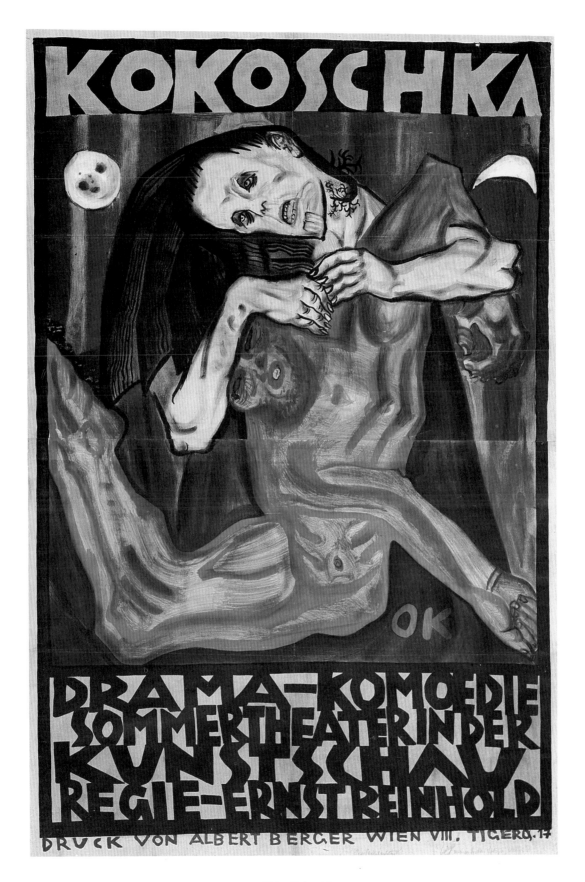

Oskar Kokoschka.
"Kokoschka: Drama-Komödie": Poster for *Mörder Hoffnung der Frauen* ("Murderer, Hope of Women"). 1909.
Lithograph, 46½ × 30″ (118.1 × 76.2 cm).
The Museum of Modern Art, New York; Purchase

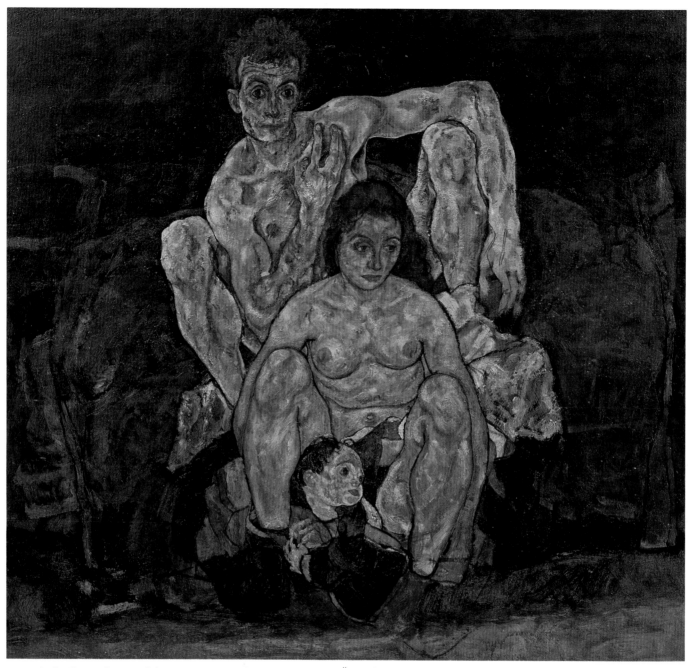

Egon Schiele. *The Family*. 1918. Oil on canvas, 58⅞ × 63″ (149.7 × 160 cm). Österreichische Galerie, Vienna

[CONCLUSION]

chiele painted *The Family* at the age of twenty-eight, the year he died. Though the male subject is Schiele himself, this is not a domestic self-portrait; he had no children, and the woman here is not his wife.[1] A personal allegory of the artist as father, the picture could also be said to end the childhood of Viennese modern art. It no longer dwells on the disruptive energies of youth or adolescence as challenges to established culture. Instead Schiele turned to procreation as a primal metaphor of continuity, a way of imagining the legacy of one generation to another. Klimt's early works on the related theme of motherhood had been haunted by *fin-de-siècle* forebodings of death-in-life, and the loss of self in the roundel of fate. The despair in Schiele's picture is less Romantic, and more troubling. Huddled in mutual disregard in the cold darkness of an empty studio, these three, and especially the artist in his primal, simian crouch, have a numbed passivity that betrays neither fear nor hope. In a year of death, this imagination of birth raised, yet left barrenly open, the questions Schiele would not live to answer: What of the future? What is our legacy?

In a more confident and happier time, in 1898, Koloman Moser had incorporated into his huge stained-glass window for the Secession building (pp. 56, 57) a motto born of joy in the present, not fear of transience: "The Artist Shows His World of Beauty, Born with Him, That Never Was Before nor Ever Will Be Again." The artists who passed under that window believed that their community could make its own world, and that historical change was their natural ally. But in 1918, time's scythe cut with its other edge—Klimt, Wagner, Moser, Schiele himself, and the empire all belonged to history before the paint had dried on *The Family*. What *then* of the world this community envisioned, of the beauty that was born with them? The questions Schiele seems to pose are still ours to answer: What of legacy? What was bequeathed to us by Vienna?

It seems crucial that we ask these questions specifically with regard to the Viennese visual arts, for two main reasons. First, many other cities, such as Berlin, Prague, or Munich, produced great writers, philosophers, and scientists, and raised social issues of enormous consequence. Many of these cities also had important artists and active Secession movements. But Vienna set itself apart by the eruption of talent in *all* the visual arts, and by the particular Viennese sensibility, the *Lebensgefühl* associated with those achievements. The quality of this art is central to the fascination of the city, and the specific elements of pleasure and pain in Viennese aesthetics inevitably color our vision of all the intellectual upheavals that took place there.

But there is a second reason why we should focus on the visual arts of

EINFACHE MÖBEL FÜR EIN SANATORIVM

Above: Koloman Moser. Design for Cover of Wiener Werkstätte Brochure *Einfache Möbel für ein Sanatorium* ("Simple Furniture for a Sanatorium"). c. 1903. India ink on cardboard, 9⅞ x 9⅞" (25 × 25 cm). Hochschule für angewandte Kunst, Vienna

Page opposite: Bertold Löffler. Design for Wine List for Hotel Savoy. c. 1908. Tempera and India ink on cardboard, 7⅛ × 3⅞" (18 × 10 cm). Hochschule für angewandte Kunst, Vienna

Vienna, and it is at least as pressing. Their place is a distinct and special one that needs separating from the larger field of Vienna's legacy in science, literature, music, and so on. Put simply, Klimt was not Freud, and Schiele was not Schönberg. That is to say, there were innovators in early modern Vienna who took enormous leaps of invention and transformed their given fields in ways that reverberated, with profound consequence, throughout the culture of the Western world—but none of the visual artists were among them. No matter how attractively we package our image of the "gay apocalypse," this discrepancy will not, and should not, be disguised. If we study the circumstances that united creators as diverse as Wittgenstein and Kraus and Loos and Altenberg and Wagner and Musil, without discerning the differences in power and originality that separated them, then we cheat something crucial. Similarly, if we leave Viennese art attached to the coat-tails of Freud's psychoanalysis, Schönberg's atonal compositions, and the other radical products of Viennese culture, we risk reducing it to mere illustrations for the epoch, and avoid the hard questions about why the art itself did not become an equally radical force in modern culture at large. To ask seriously of Viennese early modern art the question, What is the legacy?, is not simply to ask which beauties were born, but also why some died as they did: not just to delight in the successes, but also to ask what went wrong.

One underlying problem in Vienna, put in admittedly crude and schematic terms, was that of the balance between plain and fancy. Many writers have seen that this balance was not maintained, but have disagreed on the reasons and the consequences. An orthodox modernist account elevates the

moments of plainness—the sober, rational, geometric style of Hoffmann and Moser around 1902–04, for example—and bemoans fancy frippery as a fatal Viennese disease. Only Loos survives as a true hero to this vision, accompanied in an ambiguous way by the other enemies of aestheticism, Kokoschka and Schiele. On the other hand an opposite view, associated with postmodern taste, argues that the fanciness of Vienna was its particular joy—the decorative richness of Klimt, and the eclectic ornamentalism of the later Wiener Werkstätte—and that this fun was suppressed by more dour, canonical international modernism. Neither account does much justice to either side of the balance, or sheds much light on what pushed the equilibrium askew.

Fancy Vienna, for example, was a lot more than just fun. Poised on the edge where Europe met the East, the Viennese had a special feel for Oriental splendor, not only in high Byzantine lavishness, but also in the intricate exuberance of Slavic folk design. In Moser and Klimt, in Czeschka and Peche, we find again and again a delight in the confusions of dazzling pattern. But this delectation of the eye was also a part of the Viennese mind, in a crucial way. A new estimation of the decorative arts was key to emergent modern ideas of human nature and history.

Two key aspects of early modernism were entwined with the study of decorative arts: the assertion of the mind's powers, as above the biological laws that had dominated much of nineteenth-century thinking about man; and the disavowal of Greco-Roman antiquity and the High Renaissance as the summits of art. In the 1890s, as human representations came to be valued more for what they revealed about the mind than for what they showed of

nature, ornament came to be regarded as equal or superior to figurative art, as an index of a society. The major pioneer in this regard was the Viennese art historian Alois Riegl, whose work on late Roman decorative arts was epoch-making in its focus on will, rather than skill, as the significant shaping force of art. His new valuation of minor art forms previously thought merely debased and derivative had the effect not only of turning art history upside down, but also of turning notions of culture around—by insisting that anonymous, unselfconscious patterns were the surest markers of an epoch's energies.[2] The antipositivist implications of Riegl's studies were radical, and they found an echo not only in Viennese artists' push to break down the hierarchy that divided the fine from the minor arts, but also in the tastes of Klimt, Czeschka, and others for "decadent" ornament as a way out of naturalism.[3]

What seems still more characteristic of Vienna, though, is not just the love of ornament, but the specific taste for disorienting, eye-befuddling patterns. Beyond the pleasurable sense of dislocation and dreamy suspension, this kind of fanciness also has its intellectual side. As Werner Hofmann has noted in discussing Klimt, the condition of reading figure and ground interchangeably—frequently experienced in Klimt's work (p. 156) and central to the effect of many Moser designs (p. 115)—was crucial to the radical study of perception that became known as Gestalt psychology.[4] Psychologists pointed to the oscillating instability of such patterns as evidence that the forms of man's experience were not grounded exclusively either in sensory data or in mental constructs, and thus that inconstancy had to be considered irreducible in any account of our relation to the world.[5] As with the case of Riegl and Klimt, so with Moser and Gestalt theory: the Viennese penchant for decoration was early on in harmony with some of the most radical developments in the modern rethinking of the human mind and of cultural history—not by simple influence, but by virtue of parallel pursuit of similar notions, against the grain of positivist naturalism.

This attraction to decorative pattern led in two very different directions. On the one hand, the perceptual confusion of dense ornament could be seen, as the art historian Wilhelm Worringer saw it in a classic treatise of 1908, as the sign of spiritual distress.[6] Worringer's premise was both symptomatic of and influential on the art of his day in the Germanic lands. It held that the harmonious naturalism of the Renaissance was shallow, whereas the tangled *horror vacui* of Gothic and Celtic decorative patterning (the kind that attracted Czeschka particularly) was characteristic of more spiritually exalted ages, in which man's fear-filled psyche emptied itself out in world-denying antinaturalist forms.

On the other hand, for many Viennese artists, especially after 1908, abundant decoration satisfied an affection for the late Baroque and Rococo, and a desire for a pleasurable, sensual confusion. For this taste, covering the world in pattern meant overriding the divisions between volume and plane, between the functional and the useless, to dissolve the boundaries of an environment into a heightened, more oceanic aesthetic experience (p. 99). Decoration was to offer more elaborate sensory stimulation, not project inner anxiety.

The basic problem was not only that these two positions were opposed, but that neither restrained its dream of the fancy with some saving anchor in the plain. Each made a virtue of excess, which pushed Czeschka's talent into ponderous Gothicism, while it set some of the work of Hoffmann, Peche, and others on the road to airy triviality. In high moments such as

Klimt's Stoclet mosaic, there was the promise of a powerful intrusion of Eastern splendor into Western art, aiming for the kind of synthesis between decorative pattern and a feel for the natural world that produced many of Matisse's most potent early works. But viewed as a whole, and especially after 1908, the Viennese love for the fancy is often drily, heartlessly frivolous; its later achievements seem to belong to a lesser strain of modernism, more in tune with the world of Dufy.

The fate of the plain in Vienna is as complex as this history of the fancy, and shows similar bifurcation. Unadorned simplicity started out around 1902 as an ideal of a high order, platonic and world-affirming at the same time. Hoffmann and Moser started producing what they boasted of as *einfache Möbel* ("simple furniture"), and the other spare geometric objects of the Wiener Werkstätte, in order to increase the sum of human pleasure. They thought that the spiritual rewards of proud individual craft labor could be harmonized with the sensual requirements of an elite new middle class, to the literal profit of all involved. The lightened touch of decoration and the clarity of geometry were intended to open up a newly refined form of pleasure in material life.

This simplicity was not sustained, as the Werkstätte's clients soon tired of the noble notion of good basic designs for all, and began to demand more obvious forms of luxuriance to suit their sense of privilege. The kind of plainness that did endure in Vienna, Adolf Loos's, was altogether different. His insistence on banning ornament was an odd mirror-reversal of Klimt's love of decoration. Loos, too, looked to the East (he put *yin* and *yang* symbols on the main doors of his Villa Karma), but primarily for lessons in austere simplicity (as from Japanese houses) and for a certain strain of philosophy. His fatalistic sense of history and his ironic diffidence were in touch with a world-denying ethic, consistent with his sense of a mandarin superiority to the tawdry messiness of common lives (he showed up for the war in a specially tailored uniform).[7]

He also explicitly affirmed what Klimt apparently understood intuitively, that art was originally, at its sources in ornament, directly linked to the erotic.[8] But he would have none of the dreamy confusion that Klimt courted, and his engagement with science was nearly the opposite of the Gestalt challenge to the stability and constancy of experience. Like his friend Karl Kraus, in Kraus's restrictive view of language, Loos had a sense of the plain that was involved with strict reductionism and the delineation of hard boundaries. These men prided themselves on drawing polar distinctions in areas where others saw overlap and permitted flexibility.[9] Theirs was scientism of a delimiting kind, enjoining strictest caution and discounting all that could not be grounded in certainty. As Allan Janik and Stephen Toulmin pointed out, Loos's attitudes had a certain traffic with the efforts of Wittgenstein to circumscribe a reduced field for philosophy;[10] they had perhaps even more in common with the self-styled scientific spirit of the later Viennese philosophical school of logical positivism. In both cases, a militant sterility was advanced as the proper condition of modern expression.

Now, again, the problem is not just that the two forms of the plain were irreconcilable, but that neither one came to any satisfactory or enduring engagement with the fancy. The Wiener Werkstätte's early simplicity had no base in what later would have seemed natural to its forms, a true functionalist aesthetic or one focused on machine manufacture; it either crumbled under applied decoration, or inverted itself from reductive to

Above: Otto Wagner. Alphabet, c. 1858. Pen and ink, 15 × 16¼″ (38 × 41.2 cm). Kupferstichkabinett, Akademie der bildenden Künste, Vienna. As a student exercise, Wagner developed a repertoire of styles, the typographical equivalent of the eclecticism of the Ringstrasse.

Page opposite: Artists' Monograms, from the catalogue of *Secession XIV*, 1902. Left to right, top row: Ferdinand Andri, Josef Hoffmann, Maximilian Lenz, Emil Orlik; second row: Joseph Maria Auchentaller, Rudolf Jettmar, Wilhelm List, Alfred Roller; third row: Rudolf Bacher, Gustav Klimt, Elena Luksch-Makowsky, Othmar Schimkowitz; fourth row: Leopold Bauer, Friedrich König, Koloman Moser, Ernst Stöhr; bottom row: Adolf Böhm, Maximilian Kurzweil, Felician von Myrbach, Leopold Stolba

expansive geometry, eventually feeding directly into Art Deco. The parallel with the fate of fanciness, from potent beginnings to dissipation, is striking. But it is the enduring success of Loos's austerity, rather than the failings of the Werkstätte, that truly gives pause, for it opens onto a broader issue of communication.

The plain façade was for Loos, like the impeccably inconspicuous tailoring he favored, a form of mask, a cloak of anonymity. When he said that a building should be "dumb" on the outside, and only reveal its wealth in the interior,[11] he was insisting not just on a division between private and public lives, but, by extrapolation, on an impermeable barrier between inner essence, the wealth of the individual psyche, and outer expression, the depersonalized muteness of social demeanor. The connection seems clear between this ethic of abstinence and the dilemma evoked in one of the most famous documents of early modern Vienna, Hugo von Hofmannsthal's fictional, but also confessional, "Letter of Lord Chandos" of 1902.[12] The author of the letter describes how, as his experience of the world in its every aspect came to be ever more unbearably rich, his despair over the inadequacy of words became more profound, and he ceased to write at all. The sign of his heightened life is his mask of silence.

The predicament of Hofmannsthal's Lord Chandos is of course a basic creative dilemma, but it has a particular resonance in the world of Loos and Kraus, where architectural and linguistic expression were defined by the sharpest curtailment of the outward play of imagination, and by veneration of self-effacement (Kraus's antiwar masterwork, *The Last Days of Mankind*, was assembled entirely from texts of others). Loos's support of untutored, savagely deforming painting as the proper realm of art, combined with the strict, mute "dumbness" of his buildings, is symptomatic of the failures of compromise that could lead to the assertion of passive silence as a badge of modern honor, and uncommunicativeness as a sign of understanding. Here as with the dissipation of decoration into triviality, what is missing is a comfortable, enduring middle ground between the two poles of abdication:

the giddy and the sullen. Something difficult to name—a heartiness, a spontaneous sense of conviction, an unselfconscious directness—seems absent from much of the Vienna artistic enterprise, in its vacillation between dreams and high ideals on the one hand and pinched dryness on the other. The most focused energies wound up being those of self-conscious negation and self-chastisement (as in Loos or Schiele), while the liveliest physicality was pathological (as with Kokoschka).

Viennese artists did not lack for will and enthusiasm at the outset; however, in thinking back over all the ephemeral projects (especially the exhibition installations) on which they expended so much energy, it is fair to ask whether they spent this coin well—and whether the collaborative efforts they so valued were destined to best serve the artists' individual development. Nor did they lack for support; it is hard to think of another avant-garde so consistently buttressed not only by official aid but also by the active participation of a moneyed bourgeoisie. It seems fair to ask, too, whether this support was a springboard for achievement or a seductive cushion to fall back on.

The salient characteristic of the most consequential early modern art elsewhere in Europe was that it solved Lord Chandos's problem. It was able to hammer together, from neglected sources in noncanonical traditions, from marginal art forms, and from intuition, a language of expression that was decidedly private and unfamiliar—and yet widely disseminated and quickly accepted, as capturing something previously inexpressible about modern experience. In the early years of the twentieth century, up to around 1907, it seemed as if all the elements were in place for this pattern to take hold in Vienna. Instead, the relation to tradition decayed into eclectic play in the pattern-book of history, and such carnival masking found its counter either in the dumb show of depersonalized architecture or in the critical theatrics of expressionism. Though the Viennese did not fuse a wholly new language of art, they became masters of the façade; they found the rich, modern possibilities—still fascinating and troubling—in an art of artifice. ■

INTRODUCTION

1. Quoted from Robert Musil, *The Man Without Qualities,* trans. Eithne Wilkins and Ernst Kaiser (New York: Perigee, 1980), p. 59. Originally published as *Der Mann ohne Eigenschaften,* vol. 1: part 1, "Eine Art Einleitung," and part 2, "Seinesgleichen Geschieht" (Berlin: Rowohlt, 1930); vol. 2: part 3, "Ins tausendjährige Reich (Die Verbrecher)" (Berlin: Rowohlt, 1932); vol. 3: the unfinished conclusion with selected chapters from the manuscript of part 4, edited by Martha von Musil (Lausanne: Imprimerie centrale, 1943).

2. See Stefan Zweig, *Die Welt von Gestern: Erinnerungen eines Europäers* (Stockholm, 1942), translated as *The World of Yesterday: An Autobiography* (New York: Viking, 1943; reprint, Lincoln, Nebr.: University of Nebraska Press, 1964). See also Hermann Broch, *Hugo von Hofmannsthal and His Time: The European Imagination, 1860–1920,* ed. and trans. Michael P. Steinberg (Chicago: University of Chicago Press, 1984), drawn from Hermann Broch, *Schriften zur Literatur,* vol. 1, *Kritik* (Frankfurt am Main: Suhrkamp Verlag, 1975).

3. On the language crisis, and especially the bill put forward by Count Casimir Badeni to require bilingual Czech-German transactions throughout the Czech civil service, see Edward Crankshaw, *The Fall of the House of Habsburg* (New York: Penguin, 1983), pp. 300–02.

4. Albert von Margutti, *Kaiser Franz Joseph* (Vienna, 1921), p. 86; cited in Crankshaw, *The Fall of the House of Habsburg,* p. 342.

5. The phrase "gay apocalypse" comes from Broch, *Hugo von Hofmannsthal and His Time;* see for example p. 59. The phrase "testing-lab for the end of the world" is from Karl Kraus's obituary of Franz Ferdinand, quoted in Werner Hofmann, *Experiment Weltuntergang: Wien um 1900,* exhibition catalogue (Hamburg: Kunsthalle; Munich: Prestel Verlag, 1981), p. 7.

6. Foremost among these recent works, in its effect on my own thinking, is Carl E. Schorske's *Fin-de-Siècle Vienna: Politics and Culture* (New York: Knopf, 1980). My admiration for Professor Schorske's work is matched by my gratitude for his kind generosity both on a scholarly level and personally. See also Allan Janik and Stephen Toulmin, *Wittgenstein's Vienna* (New York: Simon & Schuster, 1973). Two other books have addressed themselves specifically to art in Vienna: William J. McGrath, *Dionysian Art and Populist Politics in Austria* (New Haven and London: Yale University Press, 1974); and James Shedel, *Art and Society: The New Art Movement in Vienna, 1897–1914* (Palo Alto, Calif.: Society for the Promotion of Science, 1981). Finally, see also the more encyclopedic treatment of Austrian culture in William M. Johnston, *The Austrian Mind: An Intellectual and Social History, 1848–1938* (Berkeley, Los Angeles, and London: University of California Press, 1972), especially the chapter "Aestheticism at Vienna."

7. See Robert Rosenblum, *Modern Painting and the Northern Romantic Tradition: Friedrich to Rothko* (London: Thames & Hudson; New York: Harper & Row, 1975).

ARCHITECTURE

1. For the fullest documentation of the Ringstrasse project, see Renate Wagner-Rieger, ed., *Die Wiener Ringstrasse: Bild einer Epoche,* 11 vols. (Vienna, Cologne, and Graz: Verlag Hermann Böhlaus, 1969–70; Wiesbaden: Franz Steiner Verlag, 1972–). Carl E. Schorske has brilliantly analyzed the place of the Ring project in Viennese history, and the nature of the reaction against it, in the classic study, "The Ringstrasse, Its Critics, and the Birth of Urban Modernism," in his *Fin-de-Siècle Vienna: Politics and Culture* (New York: Knopf, 1980).

2. See for example these words from the Viennese writer and pundit Hermann Bahr, in *Secession* (Vienna: L. Rosner, 1900), p. 109, cited in Ian Latham, *Joseph Maria Olbrich* (New York: Rizzoli, 1980), p. 13: "The styles of yesterday no longer please; those palaces, decorated like ones from the Renaissance or from the Baroque are no longer effective. We demand to live in the ways that match our requirements, just as we dress in the ways that match our requirements. We don't want costumes any more, neither do our houses. If we go over to the Ring we find ourselves in a right cheap carnival. Everything is hidden, everything is disguised, everything is masked. But life has become just too serious for that. We want to look life in the face. We use the catchphrase of a 'realistic architecture.' By this we mean that the building should serve its purpose, it should not conceal it but express it distinctly. Whoever has the strength to give constructive solutions to his forms is our artist. To hide them behind strange forms seems foolish and ugly to us. Previously one would first demand that a building should 'look like something.' We demand that it should be something. We are ashamed when the present day working people live like the princes or patricians of yesterday and the day before yesterday. We feel that it's a swindle. From the building one should see what it is, what is the profession of whoever lives in it and how he lives. We are not Baroque people, we don't live in the Renaissance; why should we act as if we did? Life has changed, fashions have changed, every thought, every feeling and the whole art of

the people has changed, so the people's buildings must change, to express their new tastes and deeds."

3. On Otto Wagner and the Ringstrasse, see Schorske, *Fin-de-Siècle Vienna*, pp. 72 ff.

4. On Camillo Sitte, see George Collins and Christiane Crasemann Collins, *Camillo Sitte and the Birth of Modern City Planning*, Columbia University Studies in Art History and Archaeology, no. 3 (New York: Columbia University Press, 1965). See also Schorske, *Fin-de-Siècle Vienna*, pp. 62–72.

5. For Wagner, see Heinz Geretsegger and Max Peintner, *Otto Wagner, 1841–1918: The Expanding City and the Beginnings of Modern Architecture*, trans. Gerald Onn (New York: Rizzoli, 1979). On Olbrich, see Robert Judson Clark, "Joseph Maria Olbrich and Vienna" (Ph.D. dissertation, Princeton University, 1974); for Olbrich's role in the city railway project and in the apartment buildings, see especially pp. 39–45 and 54–55. For further entries on Wagner and Olbrich, see the Architecture section of the Bibliography, by artist.

6. Joseph Maria Olbrich, "Das Haus der Secession," *Der Architekt* (Vienna), 5 (January 1899), p. 5; translated in Latham, *Joseph Maria Olbrich*, p. 18: "With what joy did I give birth to this building! It arose from a chaos of ideas, an enigmatic clue of the lines of feeling, a confusion of good and bad, not easy! There were to be walls, white and shining, sacred and chaste. Solemn dignity should pervade. A pure dignity that overtook and shook me as I stood alone before the unfinished temple at Segesta. . . . I wanted to invent neither a 'new style,' nor 'Modern,' nor even the 'latest.' . . . No, I wanted to hear only the echo of my own sentiments, to see my warm feelings frozen in cold walls. Subjectivity, my beauty, my building, as I had dreamed, I wanted and had to see."

7. Ibid. The reference to the temple at Segesta is telling. This exceptional monument in Sicily had been a place of pilgrimage described by Goethe; by virtue of the radical simplicity of its unfluted Doric columns, it had been a source of inspiration for architects of the past also seeking a purified *Ur*-form of classicism. See the discussion in Robert Rosenblum, *Transformations in Late Eighteenth-Century Art* (Princeton: Princeton University Press, 1967), pp. 121 and 147; Rosenblum cites Goethe's drawings of Segesta reproduced in Gerhard Femmel, ed., *Corpus der Goethezeichnungen: Goethes Sammlungen zur Kunst, Literatur, und Naturwissenschaft*, vol. 2 (Leipzig, 1960). My thanks to Gertje Utley for pointing out these last references to me.

8. Olbrich's patron Hermann Bahr expressed this notion, dear to the Secession, most directly in 1898: "A room . . . should express something of the soul. . . . Above the door a verse should be written: the verse of my being, and what this verse is in words, so should all the colors and lines have to be, and

again every door, every wallpaper, every lamp, always the same verse. In such a house I would see my soul as in a mirror everywhere." Bahr, *Secession*, p. 33; cited in Eduard F. Sekler, *Josef Hoffmann: The Architectural Work—Monograph and Catalogue of Works*, trans. John Maas (Princeton: Princeton University Press, 1985), p. 33. This is an interesting *fin-de-siècle* turnaround on the familiar Romantic-realist premise associated with Balzac's observation that the room is the character, the character the room.

9. Otto Wagner, *Moderne Architektur: Seinen Schülern ein Führer auf diesem Kunstgebiet* (Vienna, 1895). The fourth edition was retitled *Die Baukunst unserer Zeit: Dem Baukunstjünger ein Führer auf diesem Kunstgebiet* (Vienna: A. Schroll, 1914; reprint, Vienna: Löcker Verlag, 1979).

10. See Geretsegger and Peintner, *Otto Wagner*, p. 25.

11. On the larger opposition between *Gemeinschaft* and *Gesellschaft* in a generation greatly influenced by the thought of Richard Wagner, see William J. McGrath, *Dionysian Art and Populist Politics in Austria* (New Haven and London: Yale University Press, 1974).

For Olbrich's dream of an artists' colony to be established in a great, open field outside Vienna, see Clark, "Joseph Maria Olbrich and Vienna," p. 135.

12. On Otto Wagner's Steinhof church, see: Massimo Cacciari, *Dallo Steinhof: Prospettive viennesi del primo novecento* (Milan, 1980), pp. 50–58; Vittoria Girardi, "La chiesa am Steinhof," *L'architettura cronache e storia* (Rome), 4, no. 35 (1958), pp. 332–37; Peter Haiko, Harald Leopold-Löwenthal, and Mara Reissberger, " 'Die weisse Stadt': Der 'Steinhof' in Wien—Architektur als Reflex der Einstellung zur Geisteskrankheit," *Kritische Berichte* (Hamburg), 9, no. 6 (1981), pp. 3–38; Ludwig Hevesi, "Otto Wagners moderne Kirche (29. November 1899)," in *Acht Jahre Sezession (März 1897–Juni 1905): Kritik, Polemik, Chronik* (Vienna: Verlagsbuchhandlung Carl Konegan, 1906; reprint, ed. Otto Breicha, Klagenfurt: Ritter Verlag, 1984); Otto Schönthal, "Die Kirche Otto Wagners," *Der Architekt* (Vienna), 14 (1908), pp. 1–5, and in *Bildende Künstler* (Jena), 7 (1911), pp. 342–44; Manfred Tafuri, "Am Steinhof: 'Centrality' and 'Surface' in Otto Wagner's Architecture," in Gustav Peichl, ed., *Die Kunst des Otto Wagner*, exhibition catalogue (Vienna: Akademie der bildenden Künste; Wiener Akademie-Reihe, 1984). Wagner's ideas on church building were outlined in "Die Moderne im Kirchenbau" (1898), in connection with his project for the parish church in Währing; published in Otto Wagner, *Einige Skizzen: Projekte und ausgeführte Bauwerke*, vol. 3 (Vienna: A. Schroll, 1906).

13. See Geretsegger and Peintner, *Otto Wagner*, p. 20.

14. Ibid.

15. On Hoffmann, see the indispensable study: Sekler, *Josef Hoffmann*. On broader questions of relations between England and Vienna, see: Hermann Bahr, "Der englische Stil," *Ver Sacrum* (Vienna), 1 (July 1898), pp. 3–4; Roger Billcliffe and Peter Vergo, "Charles Rennie Mackintosh and the Austrian Art Revival," *The Burlington Magazine* (London), 119 (November 1977), pp. 739–44; Horst-Herbert Kossatz, "The Vienna Secession and Its Early Relations with Great Britain," *Studio International* (London), 181 (January 1971), pp. 9–21; Stefan Muthesius, *Das englische Vorbild* (Munich: Prestel Verlag, 1974), especially chapter 9, pp. 151 ff.; Eduard F. Sekler, "Mackintosh and Vienna," *The Architectural Review* (London), 144 (December 1968), pp. 455–56.

16. Alfred Lichtwark, a writer Hoffmann admired, wrote on the "sober, simple mass" of country-house walls, and held that "the smallest old hut appears more monumental than any urban palace"; see his "Palastfenster und Flügeltür" (Berlin, 1899), in Wolf Mannhardt, *Alfred Lichtwark eine Auswahl seiner Schriften*, vol. 1 (Berlin: B. Cassirer, 1917), pp. 227–336; cited in Muthesius, *Das englische Vorbild*, p. 174.

17. On the Beethoven exhibition, see especially the contemporary review by Joseph August Lux, "XIV. Kunst-Ausstellung der Vereinigung bildender Kuenstler Oesterreichs-Secession 1902: Klingers Beethoven und die moderne Raum-Kunst," *Deutsche Kunst und Dekoration* (Darmstadt), 10, no. 1 (1902), pp. 475 ff. See also Marian Bisanz-Prakken, "The Beethoven Exhibition of the Vienna Secession and the Younger Viennese Tradition of the *Gesamtkunstwerk*," in Erika Nielsen, ed., *Focus on Vienna 1900: Change and Continuity in Literature, Music, Art and Intellectual History*, Houston German Studies, no. 4 (Munich: W. Fink, 1982). See also the same author's "Der Beethovenfries von Gustav Klimt in der XIV. Ausstellung der Wiener Secession (1902)," in *Traum und Wirklichkeit: Wien, 1870–1930*, exhibition catalogue (Vienna: Historisches Museum der Stadt Wien; Eigenverlag der Museen der Stadt Wien, 1985), and her larger work on Klimt, *Der Beethovenfries: Geschichte, Funktion, Bedeutung* (Salzburg: Residenz Verlag, 1977; enlarged ed., Deutscher Taschenbuch Verlag, 1980).

18. On the exceptional relief and the question of its relation alternatively to architectural decoration and to modern abstract art, see Dieter Bogner, "Die geometrischen Reliefs von Josef Hoffmann," *Alte und moderne Kunst* (Vienna), 27, nos. 184/185 (1982), pp. 24–32.

19. On the issue of monumentality within *Jugendstil*, see Richard Hamann and Jost Hermand, "Die Volkhaft monumentale Phase," in *Stilkunst um 1900*, vol. 4 of their *Deutsche Kunst und Kultur von der Grün-*

derzeit bis zum Expressionismus (Berlin: Akademie Verlag, 1967).

20. Adolf Loos, "Vom armen reichen manne," *Neues Wiener Tagblatt* (Vienna), April 26, 1900; reprinted under the title "Von einem armen reichen manne," in Adolf Loos, *Ins Leere gesprochen, 1897–1900* (Paris: G. Crès, 1921; reprint, Vienna: G. Prachner, 1981), and in *Adolf Loos: Sämtliche Schriften,* ed. Franz Glück (Vienna and Munich: Verlag Herold, 1962); translated as "The Poor Little Rich Man," in *Adolf Loos: Spoken into the Void—Collected Essays, 1897–1900,* ed. Joan Ockman, trans. Jane O. Newman and John H. Smith (Cambridge, Mass.: MIT Press, 1982).

21. "Is there anyone left, in our time, who works in the same way as the Greeks? Oh yes! The English as a people, the engineers as a class. The English and the engineers are the Greeks of our time. We owe our culture to them. . . . The Greek vases are beautiful in the same way as a machine is beautiful, as a bicycle is beautiful." Adolf Loos, "Glas und Ton," *Neue freie Presse* (Vienna), June 26, 1898; reprinted in Loos, *Ins Leere gesprochen;* cited by Benedetto Gravagnuolo in *Adolf Loos: Theory and Works,* trans. C. H. Evans (New York: Rizzoli, 1982). See also Roland L. Schachel, "Adolf Loos, Amerika und die Antike," *Alte und moderne Kunst* (Vienna), 15, no. 113 (1970), p. 7.

22. Loos's contempt for invention is discussed in Gravagnuolo, *Adolf Loos;* see for example p. 22 ("We have enough original genius. Let's repeat ourselves *ad infinitum*"), and pp. 35–37 for a discussion of the Romans as builders.

23. Cited in Gravagnuolo, *Adolf Loos,* p. 20.

24. Ibid.

25. Gravagnuolo discusses this connection; see his consideration of Loos's "disenchantment" and "sarcastic indifference" in *Adolf Loos,* p. 56.

26. On Loos's early practice as a designer of interiors and his use of existing furniture models, see: *Traum und Wirklichkeit: Wien, 1870–1930,* p. 440; Mara Reissberger and Peter Haiko, " 'Alles ist einfach und glatt': Zur Dialektik der Ornamentlosigkeit," in Paul Asenbaum, Stefan Asenbaum, and Christian Witt-Dörring, eds., *Moderne Vergangenheit: Wien, 1800–1900,* exhibition catalogue (Vienna: Künstlerhaus; Gesellschaft bildender Künstler Österreichs, 1981), p. 16; Christian Witt-Dörring, "Schein und Sein: Form und Funktion 1800—Das moderne Möbel 1900," in Asenbaum, Asenbaum, and Witt-Dörring, *Moderne Vergangenheit,* p. 36; Peter Vergo, *Art in Vienna, 1898–1918: Klimt, Kokoschka, Schiele and Their Contemporaries* (Oxford: Phaidon, 1975), p. 165. For Loos's ideas on furniture, see his essay "Möbel" (1898), reprinted in his *Ins Leere gesprochen* and in *Adolf Loos: Sämtliche Schriften.*

27. On Hoffmann's special attention to hands, see Sekler, *Josef Hoffmann,* p. 232.

28. On the Purkersdorf project, see Sekler, *Josef Hoffmann,* pp. 67–72.

29. Sekler masterfully analyzes this play between reduction and new formal interplay, between the Purkersdorf and Stoclet buildings; see *Josef Hoffmann,* p. 72.

30. Ibid.; see especially pp. 82–85, where the comparison with the Beethoven exhibition *sopraporta* is made: "In Hoffmann's building, where any virtual movement occurs it is not in the nature of a clearly defined dynamism, but a passive motion, a sliding and gliding of elements which leads to an effect of 'passive dematerialization,' recalling a similar tendency in paintings by Gustav Klimt, where forms and bodies seem to float past each other, not driven by their own volition but as if in a trance. . . . With all due caution in making comparisons from one field of creativity to another, one is also reminded of the glissando effects so typical of the avant-garde music of the period" (p. 85).

31. Ibid., p. 89.

32. Ibid., p. 98.

33. Adolf Loos gave a talk entitled "Ornament und Verbrechen" in Munich in 1908, and in Berlin and Vienna (at the Akademischer Verband für Literatur und Musik) in 1910; again in Vienna on February 21, 1913 (at the Akademischer Architektur Verein), according to Roland L. Schachel in "Adolf Loos, der dem Zeitgeist die geringsten Zugeständnisse machte," in Robert Waissenberg, ed., *Wien, 1870–1930: Traum und Wirklichkeit* (Salzburg and Vienna: Residenz Verlag, 1984), p. 223, n. 31. The essay was published in 1910 in Herwarth Warden's journal *Der Sturm: Wochenschrift für Kultur und die Künste* (Berlin), Jg. 1, vol. 6, p. 44; republished in French, in *Cahiers d'aujourd'hui* (Paris), no. 5 (1913), pp. 247–56, and again in *L'esprit nouveau* (Paris), no. 2 (1920), pp. 159–68; reprinted in Loos's *Trotzdem, 1900–1930* (Innsbruck: Brenner Verlag, 1931), and in *Adolf Loos: Sämtliche Schriften.* An English translation appears in Ludwig Münz and Gustav Künstler, *Adolf Loos, Pioneer of Modern Architecture,* trans. Harold Meek (New York: Praeger, 1966). See the astute analysis of the essay in Reyner Banham, "Ornament and Crime: The Decisive Contribution of Adolf Loos," *The Architectural Review* (London), 121 (February 1957), pp. 85–88.

34. On Loos's love for the beauty of materials, see Gravagnuolo, *Adolf Loos,* p. 23; one critic spoke of the "feminine grandeur of Loos," p. 82.

35. See Dietrich Worbs, "Adolf Loos in Vienna: Aesthetics as a Function of Retail Trade Establishments," *Architects Yearbook* (London), 14 (1974), pp. 181–96; Jacques Gilber and Gilles Barbet, "Loos' Villa Karma," *The Architectural Review* (London), 145 (March 1969), pp. 215–16; and the discussions of the Kniže store and Villa

Karma in Gravagnuolo, *Adolf Loos,* pp. 106, 134.

36. "My building in the Michaelerplatz may be beautiful or ugly, but one characteristic even its detractors must recognize: it is not provincial. It is a building that can stand only in a metropolis [*in einer Millionenstadt*]." From Loos's essay "Heimatkunst" (1914), in his *Trotzdem* and in *Adolf Loos: Sämtliche Schriften;* translated in Gravagnuolo, *Adolf Loos,* p. 215.

37. "Man, as gregarious animal, used to have to employ different colors to distinguish himself; modern man uses his clothing as a mask. So monstrously powerful is his individuality that it can no longer allow itself to be expressed through clothing. Lack of ornamentation is a sign of spiritual strength." From "Ornament und Verbrechen," in *Adolf Loos: Sämtliche Schriften,* and in English in Münz and Künstler, *Adolf Loos,* p. 231. For further expression of similar ideas see also his essays: "Die Herrenmode" (1898), in his *Ins Leere gesprochen,* and "Architektur" (1910), in his *Trotzdem;* both in *Adolf Loos: Sämtliche Schriften.* See also Gravagnuolo, *Adolf Loos,* p. 51.

38. "The building should be dumb on the outside and reveal its wealth only on the inside." From Loos's essay "Heimatkunst" (1914), in his *Trotzdem* and in *Adolf Loos: Sämtliche Schriften;* in English in Gravagnuolo, *Adolf Loos,* p. 22. Gravagnuolo goes on: "The outside belongs to 'civilization,' the inside belongs to the individual. . . . It is a shell which shelters in intimacy the psyche of the person who lives there."

39. Peter Altenberg published two photos of Loos's apartment in the first issue of the review *Kunst: Halbmonatsschrift für Kunst und alles Andere* (Vienna, 1903), with the following text: "Adolf Loos, my wife's bedroom, white walls, white curtains, white Angora sheepskin"; cited in Gravagnuolo, *Adolf Loos,* p. 102; photos reproduced in Burkhardt Rukschcio and Roland L. Schachel, *Adolf Loos: Leben und Werk* (Salzburg: Residenz Verlag, 1982), p. 83. See also Gravagnuolo's discussion of Loos's bedroom for the Villa Karma: "On the second floor the bedroom is centrally situated and without direct openings to the outside. It is the most secret place in the whole house. Indirect natural light is barely able to filter in through a narrow window covered by a curtain. Apart from this the room is illuminated by artificial light that reflects off the nacreous ceiling and is uniformly diffused as if from a gigantic lampshade. The modern technical conquest of electricity allows perfect control over the quality of the environment, making indiscreet external openings superfluous. Here, one may choose to rest in the room cum verandah with a fireplace next to the bedroom or go on up to the roof garden with its pergolas from where the whole panoramic view may be enjoyed. But inside, the bedroom is hermetically sealed. Here

Eros rules. The alcove is built into a niche carved out of the wall. The blue curtains and the cupboards made out of light ash that run the length of the wall complete the suffused sense of intimacy." Gravagnuolo, *Adolf Loos,* p. 112.

DESIGN

1. On the importance of the concept of decorative art in the formation of early modern art, see: John Hallmark Neff, "Matisse and Decoration: An Introduction," *Arts Magazine* (New York), 49 (June 1975), pp. 85–86; John Hallmark Neff, "Matisse and Decoration: The Shchukin Panels," *Art in America* (New York), 63 (July–August 1975), pp. 38–48. See also Joseph Mashek, "The Carpet Paradigm: Critical Prolegomena to a Theory of Flatness," *Arts Magazine* (New York), 51 (September 1976), pp. 82–109.

2. On Ferdinand Hodler, see: Sharon L. Hirsch, *Ferdinand Hodler* (Munich: Prestel Verlag, 1981; English ed., New York: Braziller, 1982); Hans Ankwicz von Kleehofen, "Hodler und Wien," in *Neujahrsblatt der Züricher Kunstgesellschaft, 1950* (Zurich, 1950); Otto Benesch, "Hodler, Klimt und Munch als Monumentalmaler," in *Wallraf-Richartz-Jahrbuch* (Cologne), 24 (1962), pp. 333–58, and in *Otto Benesch: Collected Writings,* vol. 4, ed. Eva Benesch (London: Phaidon, 1973).

On the special question of parallelism, see also: H. Behn-Eschenburg, "Ferdinand Hodlers Parallelismus," *Psychoanalytische Bewegung* (Vienna), 3, no. 4 (July–August 1931), special issue (Switzerland); Jura Brüschweiler, "La datation du Bois des Frères de F. Hodler et la naissance du parallèlism," parts 1 and 2, *Musées de Genève* (Geneva), 103 (March 1970), pp. 2 ff., and 105 (May 1970), pp. 11 ff.; Peter Dietschi, *Der Parallelismus Ferdinand Hodlers: Ein Beitrag zur Stilpsychologie der neueren Kunst,* Basler Studien für Kunstgeschichte, no. 16 (Basel: Birkhäuser Verlag, 1957); Thomas Roffler, "Der Parallelismus," in *Schweizer Maler* (Frauenfeld and Leipzig: Huber, 1937), pp. 70 ff. and 98 ff; see also Yvonne Lehnherr on parallelism in *Hodler et Fribourg,* exhibition catalogue (Fribourg: Musée d'art et d'histoire, 1981), p. 36.

3. See Werner Hofmann's discussion of Klimt's work with figure-ground reversal, in connection with developments in the study of decorative arts and perceptual psychology, in his *Gustav Klimt and Vienna at the Turn of the Century,* trans. Inge Goodwin (Greenwich, Conn.: New York Graphic Society, 1971), chapter 3. These points apply equally to Moser, I believe.

4. Emil Utitz wrote in 1908, "If you want to put in words very briefly the main event of the last years, it is the conquest of applied art by architecture." "Der neue Stil: Ästhetische Glossen," *Deutsche Kunst und*

Dekoration (Darmstadt), 23, no. 1 (1908–09), p. 74; cited in Eduard F. Sekler, *Josef Hoffmann: The Architectural Work—Monograph and Catalogue of Works,* trans. John Maas (Princeton: Princeton University Press, 1985), p. 120.

5. On the issue of earlier geometric motifs, see Marian Bisanz-Prakken, "Das Quadrat in der Flächenkunst der Wiener Secession," *Alte und moderne Kunst* (Vienna), 27, nos. 180/181 (1982), pp. 40–46.

6. For references on English influence in Vienna, see note 15 of the preceding chapter.

7. See Robert Breuer, "Zur Revision des Japonismus," *Deutsche Kunst und Dekoration* (Darmstadt), 19 (October 1906–March 1907), pp. 445–48.

8. On the role of Biedermeier in the modern movement, see Joseph August Lux, "Biedermeier als Erzieher," *Hohe Warte* (Leipzig and Vienna), 1 (1904–05), pp. 145–55. This article is reprinted in a very interesting exhibition catalogue comparing the design of the two periods: Paul Asenbaum, Stefan Asenbaum, and Christian Witt-Dörring, eds., *Moderne Vergangenheit: Wien, 1800–1900* (Vienna: Künstlerhaus; Gesellschaft bildender Künstler Oesterreichs, 1981).

9. Josef Hoffmann, "Einfache Möbel," *Das Interieur* (Vienna), 2 (1901); translated in Sekler, *Josef Hoffmann,* pp. 483–85.

10. See the "Working Program," published as a pamphlet by Hoffmann and Moser in 1905; in Werner J. Schweiger, *Wiener Werkstätte: Design in Vienna, 1903–1932* (New York: Abbeville, 1984), pp. 42–43.

11. On the Thonet firm, see: Karl Mang, *Das Haus Thonet* (Frankenberg a.d. Eder: Gebrüder Thonet, 1969); Karl Mang, "Michael Thonet's Bugholzverfahren und die Pioniere der modernen Architektur," and Christian Witt-Dörring, "Das Unternehmen Thonet: Eine patriotische Tat," in Stefan Asenbaum and Julius Hummel, eds., *Gebogenes Holz: Konstruktive Entwürfe—Wien, 1840–1910,* exhibition catalogue (Vienna: Künstlerhaus; Eigenverlag Julius Hummel & Stefan Asenbaum, 1979).

12. On Fritz Wärndorfer and his activities as a collector, see Peter Vergo, "Fritz Wärndorfer as Collector," *Alte und moderne Kunst* (Vienna), 26, no. 177 (1981), pp. 33–38.

13. For a full history of the administration of the Werkstätte, including a listing of the directors and shareholders, see Schweiger, *Wiener Werkstätte,* especially p. 267.

14. On Moser's departure, see Schweiger, *Wiener Werkstätte,* pp. 68–69.

15. "Stoclet at first provided large cash payments for those fittings and works of art which were to be produced in Vienna. The WW, however, suffered from virtually continual cash problems and did not always use Stoclet's payments for the purpose intended; for example, it used them to finance the very expensive fitting-out of the Cabaret Fledermaus." Schweiger, *Wiener Werkstätte,* p. 52.

16. Ibid., p. 140.

17. On the program of performances at the Fledermaus, which were very rich for the opening season and fell off sharply thereafter, see Gertrude Pott, *Die Spiegelung des Secessionismus im österreichischen Theater,* Wiener Forschungen zur Theater und Medienwissenschaft, no. 3 (Vienna and Stuttgart: W. Braumüller, 1975), in particular part 2, chapter 6, "Das Kabarett 'Fledermaus.'" See also Egon Friedell, "Geschichte der Fledermaus," in Mathilde Flögl, *Die Wiener Werkstätte, 1903–1928: Modernes Kunstgewerbe und sein Weg* (Vienna: Krystall Verlag, 1929). On the Fledermaus and its place in the contemporary Viennese theater, see Wolfgang Greissenegger, "L'arte scenica," in *Le arti a Vienna: Dalla Secessione alla caduta dell'Impero Asburgico,* exhibition catalogue (Venice: Edizioni la Biennale di Venezia, 1984).

18. The crucial figure with regard to linkage between Viennese artists and the study of children's art was Franz Cizek. See the fascinating study *Franz Cizek: Pionier der Kunsterziehung (1865–1946),* exhibition catalogue (Vienna: Historisches Museum der Stadt Wien; Eigenverlag der Museen der Stadt Wien, 1985); see also Wanda A. Bubriski, "Franz Cizek: Ein Pionier der Kunsterziehung," in Robert Waissenberger, ed., *Wien, 1870–1930: Traum und Wirklichkeit* (Salzburg and Vienna: Residenz Verlag, 1984).

19. See Karlheinz Rossbacher, "Provinzkunst, the Countermovement to Viennese Culture," in Erika Nielsen, ed., *Focus on Vienna 1900: Change and Continuity in Literature, Music, Art and Intellectual History,* Houston German Studies, no. 4 (Munich: W. Fink, 1982).

20. These tendencies are already clearly evident in the Secession group, as a reading of *Ver Sacrum* will show. They feature prominently as well in the work of the Hagenbund group of artists. See Hans Bisanz, "The Hagenbund," in Robert Waissenberger, ed., *Vienna, 1890–1920* (New York: Rizzoli, 1984). See also Peg Weiss, *Kandinsky in Munich, 1896–1914,* exhibition catalogue (New York: The Solomon R. Guggenheim Museum, 1982); and eventually, especially with regard to the "saga style" of Gerhard Munthe in Norway and Akseli Gallen-Kallela in Finland, Kirk Varnedoe, *Northern Light: Realism and Symbolism in Scandinavian Painting, 1880–1910* (Oslo: J. M. Stenersens Forlag, forthcoming). For further discussion of those tendencies in Austria and Germany, see Richard Hamann and Jost Hermand, *Stilkunst um 1900: Deutsche Kunst und Kultur von der Gründerzeit bis zum Expressionismus,* vol. 4 (Berlin: Akademie Verlag, 1967), especially the chapter "Heimatkunst."

21. On the collaboration between folk style and cartoon style in the Hagenbund, see Bisanz, "The Hagenbund." See also my examination of Gauguin's interest in combining caricature and naïve art as allies against naturalism, in "Gauguin," in William Rubin, ed., *"Primitivism" in 20th Century Art: Affinity of the Tribal and the Modern,* exhibition catalogue (New York: The Museum of Modern Art, 1984), especially pp. 184–85. On the radical use of cartoon style in primitivism, see furthermore Adam Gopnick, "High and Low: Primitivism, Caricature, and the Cubist Portrait," *Art Journal* (New York), 43 (winter 1983), pp. 371–76.

22. See Jaroslav Leshko, "Klimt, Kokoschka, und die mykenischen Funde," *Mitteilungen der Österreichischen Galerie* (Salzburg), 13, no. 57 (1969), pp. 16–40.

23. On the *Kunstschau,* see Carl Schorske, *Fin-de-Siècle Vienna: Politics and Culture* (New York: Knopf, 1980), especially pp. 267–73 and pp. 325–44.

24. On fashion in the Wiener Werkstätte, see: Traude Hansen, *Wiener Werkstätte: Mode—Stoffe, Schmuck, Accessoires* (Vienna and Munich: C. Brandstätter, 1984); Ursula Kehlmann, "The Wiener Werkstätte," in *The Imperial Style: Fashions of the Hapsburg Era,* exhibition catalogue (New York: The Metropolitan Museum of Art, 1979); Angela Völker, *Wiener Mode und Modefotografie: Die Modeabteilung der Wiener Werkstätte, 1911–1932,* exhibition catalogue (Vienna: Österreichisches Museum für angewandte Kunst; Munich and Paris: Verlag Schneider-Henn, 1984); Eduard Wimmer-Wisgrill, *Modeentwürfe, 1912–27* (Vienna: Hochschule für angewandte Kunst, 1983); Reingard Witzmann, "Das neue Kleid, 1800–1900," in Asenbaum, Asenbaum, and Witt-Dörring, *Moderne Vergangenheit.*

25. On the reform of female clothing, see: Traude Hansen, "Vom Reformkleid zur Kunstmode," in her *Wiener Werkstätte;* Josef Hoffmann, "Das individuelle Kleid," *Die Wage* (Vienna), 1, no. 5 (April 9, 1898), pp. 251–52; Stella Mary Newton, *Health, Art and Reason: Dress Reforms of the 19th Century* (London: John Murray, 1974); Paul Schulte-Naumburg, *Die Kultur des weiblichen Körpers als Grundlage der Frauenkleidung* (Leipzig, 1903); Henry van de Velde, "Das neue Kunst-Prinzip in der modernen Frauenkleidung," *Deutsche Kunst und Dekoration* (Darmstadt), 10 (1902), pp. 362–86; Leonie von Wilckens, *Künstlerkleid und Reformkleid: Textilkunst in Nürnberg—Peter Behrens und Nürnberg* (Munich, 1980), pp. 198–202. On the development of fashion in Vienna, see also *200 Jahre Mode in Wien aus den Modesammlungen des Historischen Museums der Stadt Wien,* exhibition catalogue (Vienna: Museen der Stadt Wien, 1976). The subject was also dealt with by Adolf Loos in his essay "Damenmode" (1898?), reprinted in *Dokumente der Frau* (Vienna), March 1,

1902, pp. 660 ff., and in *Adolf Loos: Sämtliche Schriften,* ed. Franz Glück (Vienna and Munich: Verlag Herold, 1962).

26. On Emilie Flöge, see: Wolfgang Georg Fischer, "Gustav Klimt und Emilie Flöge, I: Aspekte des neuentdeckten Nachlasses Emilie Flöge," *Alte und moderne Kunst* (Vienna), 28, nos. 186/187 (1983), pp. 8–15, "Gustav Klimt und Emilie Flöge, II: Aus Emilies Welt," *Alte und moderne Kunst* (Vienna), 28, no. 188 (1983), pp. 28–33, and "Gustav Klimt und Emilie Flöge, III: Erinnerungen an Emilie," *Alte und moderne Kunst* (Vienna), 28, nos. 190/191 (1983), pp. 54–59; Udo Kultermann, "Gustav Klimt, Emilie Flöge und die Modereform in Wien um 1900," *Alte und moderne Kunst* (Vienna), 23, no. 157 (1978), pp. 35–36; Christian Nebehay, "Klimt und Emilie Flöge," in his *Gustav Klimt: Sein Leben nach zeitgenössischen Berichten und Quellen* (Munich: Deutscher Taschenbuch Verlag, 1979); Christian Nebehay, "Klimt und Emilie Flöge," in *Gustav Klimt: Dokumentation* (Vienna: Verlag der Galerie Christian Nebehay, 1969).

27. Schweiger, *Wiener Werkstätte,* p. 220.

28. On Wimmer-Wisgrill, see Traude Hansen, "Eduard Josef Wimmer-Wisgrill und sein Werk," in her *Wiener Werkstätte,* pp. 97–138.

29. Schweiger, *Wiener Werkstätte,* p. 228.

PAINTING & DRAWING

1. Makart was the dictator of style in the Vienna of the 1860s and 1870s. For accounts of his career, see: Gerbert Frodl, *Hans Makart: Monographie und Werkverzeichnis* (Salzburg: Residenz Verlag, 1974); Gerbert Frodl, "Begegnung im Theater: Hans Makart und Gustav Klimt," *Klimt-Studien,* special issue of *Mitteilungen der Österreichischen Galerie* (Salzburg), 22/23, nos. 66/67 (1978–79); Ludwig Hevesi, "Hans Makart und die Sezession" (1900), in his *Acht Jahre Sezession (März 1897–Juni 1905): Kritik, Polemik, Chronik* (Vienna: Verlagsbuchhandlung Carl Konegen, 1906; reprint, ed. Otto Breicha, Klagenfurt: Ritter Verlag, 1984); W. Kitlitschka, *Die Malerei der Wiener Ringstrasse,* vol. 10 of Renate Wagner-Rieger, ed., *Die Wiener Ringstrasse: Bildnis einer Epoche* (Wiesbaden: Franz Steiner Verlag, 1981); *Hans Makart,* exhibition catalogue (Vienna: Hermes Villa; Salzburg: Residenz Galerie, 1975); Emil Pirchan, *Hans Makart: Leben, Werk und Zeit* (Vienna: Wallishauser, 1942). Klimt's major ceiling commissions were for the Burgtheater (1886–88) and the Kunsthistorisches Museum (1890–92); see Carl E. Schorske's consideration of these in relation to Klimt's biography in *Fin-de-Siècle Vienna: Politics and Culture* (New York: Knopf, 1980), pp. 209–12.

2. The Siebener and another club, the Hagenbund, were artists' coffee-house clubs in the nineties, each of which became the core of later exhibition societies. The Siebener members were pioneers in the Secession and then in the Wiener Werkstätte. The Hagenbund members later defected from the Secession to form their own, independent organization, including the architect Josef Urban and the graphic artist Heinrich Lefler; their emphasis on folk-style and fairy-tale illustration appears before 1900 and prefigures much of the design that became more dominant in Vienna around 1907–08. On these clubs see: Hans Ankwicz von Kleehoven, "Die Anfänge der Wiener Secesson," *Alte und moderne Kunst* (Vienna), 5, no. 6/7 (June–July 1960), pp. 6–10; Hans Bisanz, "The Hagenbund," in Robert Waissenberger, ed., *Vienna, 1890–1920* (New York: Rizzoli, 1984); Werner Fenz, *Koloman Moser: Graphik, Kunstgewerbe, Malerei* (Salzburg and Vienna: Residenz Verlag, 1984), pp. 19, 20, 246, note 49; *Hagenbund,* exhibition catalogue (Vienna: Historisches Museum der Stadt Wien; Eigenverlag der Museen der Stadt Wien, 1975); Robert Waissenberger, "Der Hagenbund, 1900–1938: Geschichte der wiener Künstlervereinigung," *Mitteilungen der Österreichischen Galerie* (Salzburg), 16, no. 66 (1972), pp. 55 ff.

3. Klimt's father died in 1892, a fact that was likely to have affected his outlook. In this context, see Schorske's discussion of the attitudes toward the generation of the "fathers" in "Gustav Klimt: Painting and the Crisis of the Liberal Ego," in Schorske, *Fin-de-Siècle Vienna.*

4. For a more detailed history of the Secession, see: Ankwicz von Kleehoven, "Die Anfänge der Wiener Secession"; Hermann Bahr, *Secession* (Vienna: L. Rosner, 1900); Hevesi, *Acht Jahre Sezession;* Walther M. Neuwirth, "Die sieben heroischen Jahre der Wiener Moderne," *Alte und moderne Kunst* (Vienna), 9, no. 74 (May–June 1964), pp. 28–31; Robert Waissenberger, *Vienna Secession* (London: Academy Editions, 1977); Robert Waissenberger, "Die 'heroischen Jahre' der Secession," in *Traum und Wirklichkeit: Wien, 1870–1930,* exhibition catalogue (Vienna: Historisches Museum der Stadt Wien; Eigenverlag der Museen der Stadt Wien, 1985).

5. It has often been remarked that, even in historical guise, Klimt's women seem a specific contemporary type. See the discussions of his early naturalism in Werner Hofmann, *Gustav Klimt and Vienna at the Turn of the Century,* trans. Inge Goodwin (Greenwich, Conn.: New York Graphic Society, 1971), pp. 16 ff., and in Alessandra Comini, *Gustav Klimt* (New York: Braziller, 1975); see also Schorske, *Fin-de-Siècle Vienna,* p. 212, and Felix Salten, "Eine schöne jüdische Jourdame" (1903), in Otto Breicha, ed., *Gustav Klimt: Die goldene Pforte—Werk, Wesen,*

Wirkung. Bilder und Schriften zu Leben und Werk (Salzburg: Verlag Galerie Welz, 1978).

6. Carl Schorske makes the apt observation that this statuette could more appropriately be called *vera nuditas* and discusses the meaning of the symbol in Klimt's work. See Schorske, *Fin-de-Siècle Vienna,* pp. 222 ff.

7. The three canvases, originally owned by Klimt after the commission was bought back, were sold to the following collectors. *Philosophy* was acquired by August Lederer in 1905 for a room designed by Josef Hoffmann in his house in the Bartensteingasse in Vienna. Later it entered the Erich Lederer collection in Geneva. *Medicine* became part of the Ditha Moser collection from about 1910–12 on. *Jurisprudence* was also sold to Ditha Moser at about the same time. In 1919 it entered the August Lederer collection in Vienna and subsequently the Erich Lederer collection in Geneva. Eventually all three paintings were acquired by the Österreichische Galerie in Vienna: *Medicine* in 1919, followed by *Philosophy* and *Jurisprudence* in 1944. They were, with other important works, stored in the Schloss Immendorf in Niederösterreich, which was destroyed by fire during the retreat of German soldiers in 1945. For the history of the pictures with a catalogue raisonné of Klimt's paintings, see Fritz Novotny and Johannes Dobai, *Gustav Klimt* (New York and Washington, D.C.: Praeger, 1968), pp. 303–05, 313–15, 318–20, 329–30. See also Alice Strobl, "Zu den Fakultätsbildern von Gustav Klimt," *Albertina-Studien* (Vienna), Jg. 2, vol. 4 (1964), pp. 138–69. For further information on the controversy surrounding the paintings, see Hermann Bahr, *Gegen Klimt* (Vienna: J. Eisenstein, 1903).

8. See Carl E. Schorske, "Gustav Klimt: Painting and the Crisis of the Liberal Ego."

9. Ibid. See also discussions of the university paintings in Comini, *Gustav Klimt,* pp. 20 ff., and in Hofmann, *Gustav Klimt and Vienna at the Turn of the Century,* pp. 23 ff. Other important literature on the subject includes the titles cited under note 7, in particular Alice Strobl's article. See also Marian Bisanz-Prakken, "Programmatik und subjektive Aussage im Werk von Gustav Klimt," in Robert Waissenberger, ed., *Wien, 1870–1930: Traum und Wirklichkeit* (Salzburg and Vienna: Residenz Verlag, 1984), pp. 110–20; Peter Vergo, "Gustav Klimts 'Philosophie' und das Programm der Universitätsgemälde," in *Klimt-Studien,* pp. 94–97.

10. The Vigeland work in question is the large pillar of humanity that is the centerpiece of his sculptural ensemble in Frogner Park, Oslo, known alternatively as "the monolith" or the "needle of mankind." For information on Vigeland, see: Ragna Stang, *Gustav Vigeland: The Sculptor and His Works* (Oslo: Tanum, 1965); Nathan Cabot Hale, *Embrace of Life: The Sculpture of Gustav Vigeland* (New York: Abrams,

232

1968); Tone Wikborg, *Gustav Vigeland: Mennesket og Kunstaneren* (Oslo: Aschehoug, 1983).

11. See Carl Schorske's discussion of this picture in *Fin-de-Siècle Vienna*, pp. 246–54. On the specific connection of the painting with Dante, see Bisanz-Prakken, "Programmatik und subjektive Aussage im Werk von Gustav Klimt," p. 116.

12. The poet Peter Altenberg praised Klimt in these terms: ". . . as a painter of vision you are also a modern philosopher, a totally modern poet! In the act of painting you transform yourself, in an instant, as in a fairy-tale, into the 'most modern of men': something which in the reality of every day you may not be at all!" Quoted in Novotny and Dobai, *Gustav Klimt,* p. 64, and in Schorske, *Fin-de-Siècle Vienna,* p. 225. On the accuracy of Altenberg's assessment, see the defense of Klimt as thinker by Yves Kobry, "Klimt derrière le décor," in *Vienne: Fin-de-siècle et modernité,* special issue of *Cahiers du Musée national d'art moderne* (Paris), 14 (1984), pp. 56 ff.

13. On the program of the Klinger sculpture, see: Elsa Asenijeff, *Max Klingers Beethoven* (Leipzig, 1902); Joseph August Lux, "XIV. Kunst-Ausstellung der Vereinigung bildender Kuenstler Oesterreichs-Secession 1902: Klingers Beethoven und die moderne Raum-Kunst," *Deutsche Kunst und Dekoration* (Darmstadt), 10, no. 1 (1902), pp. 475 ff.; Berta Zuckerkandl, "Klingers Beethoven in der Wiener Secession," *Die Kunst für Alle,* 17 (1902), p. 386; Alexander Dückers, *Max Klinger* (Berlin: Rembrandt Verlag, 1976), pp. 80–93; Marian Bisanz-Prakken, *Der Beethovenfries: Geschichte, Funktion, Bedeutung* (Salzburg: Residenz Verlag, 1977; enlarged ed., Deutscher Taschenbuch Verlag, 1980). See also Bisanz-Prakken's articles on the subject, cited in the Selected Bibliography, under Gustav Klimt.

14. The catalog for the exhibition of 1902 provides the following explanation for the frieze, quoted here in translation from Novotny and Dobai, *Gustav Klimt,* p. 329: "The three painted walls form a continuous series. The first long wall, opposite the entrance: The Longing for Happiness. The sufferings of weak mankind: the pleas of these to the well-equipped strong ones as the outer, to sympathy and ambition as the inner forces that move mankind to take up the struggle for happiness. Short wall: The Hostile Powers. Typhon, the giant, against whom even the gods fought in vain; his daughters, the three Gorgons. Sickness, madness, death. Debauchery and unchastity, excess. Gnawing worry. The longings and wishes of mankind fly over these. The second long wall: The Longing for Happiness finds Solace in Poetry. The arts lead us into the ideal realm in which we may find pure joy, pure happiness, pure love. Choir of the angels of paradise. 'Freude, schöner Götterfunke.' 'Diesen Kuss der ganzen Welt!'"

For a discussion of the frieze in relation to Richard Wagner's essay on Beethoven, see Marian Bisanz-Prakken, "Der Beethovenfries von Gustav Klimt in der XIV. Ausstellung der Wiener Secession," in *Traum und Wirklichkeit: Wien, 1870–1930,* and Bisanz-Prakken, *Der Beethovenfries,* p. 32.

15. A selected bibliography of works specifically devoted to the explanation of the sources—from Dürer to Hodler to Toorop—and the symbolism, would include: Bisanz-Prakken, *Der Beethovenfries;* Alice Strobl, *Gustav Klimt: Die Zeichnungen,* vol. 1 (Salzburg: Verlag Galerie Welz, 1980), pp. 211 ff.; Novotny and Dobai, *Gustav Klimt,* p. 329. For further information concerning influences on Gustav Klimt, see also Hans Ankwicz von Kleehofen, "Hodler und Wien," in *Neujahrsblatt der Züricher Kunstgesellschaft, 1950* (Zurich, 1950); Otto Benesch, "Hodler, Klimt und Munch als Monumentalmaler," in *Wallraf-Richartz-Jahrbuch* (Cologne), 24 (1962), pp. 333–58, and in *Otto Benesch: Collected Writings,* vol. 4, ed. Eva Benesch (London: Phaidon, 1973); Marian Bisanz-Prakken, "Gustav Klimt und die Stilkunst Jan Toorops," *Klimt-Studien,* pp. 150 ff.

16. Schorske sees the Beethoven cycle as suggesting Klimt's move toward a less socially responsible, more world-excluding vision of the role of art; see *Fin-de-Siècle Vienna,* p. 264.

17. On Hodler and parallelism, see note 2 of the preceding chapter.

18. See Werner Hofmann's discussion of Klimt's use of figure-ground ambiguity, in relation to contemporary work on decoration in *Gustav Klimt and Vienna at the Turn of the Century,* pp. 34 ff.

19. On the erotic symbolism of these forms, see Hofmann, *Gustav Klimt and Vienna at the Turn of the Century,* pp. 35 ff. Alessandra Comini has discussed this kind of device in relation to Adolf Loos's premise that all art is at base erotic; see her *Gustav Klimt,* p. 6.

20. Carl Schorske, in *Fin-de-Siècle Vienna,* finds these golden images regressive—an escape to Byzantium in the manner of Yeats. "The organic dynamism of his style in the *art nouveau* period disappeared, in favor of a static, crystalline ornamentalism. In stance as in style, transcendence replaced engagement" (p. 264). ". . . from nature to stylized culture, from direct presentation of psychophysical experience to formal symbolization: thus the journey ran" (p. 266). "Thus in the Bloch-Bauer portrait, Klimt could suggest abstractly, through the particles, conflicting psychological states without directly representing what such states felt like, as he had formerly done" (p. 271). These formulations seem to me to make too large a claim for the earlier work, which I see as neither particularly dynamic nor especially original. They also seem to postulate a completely unmediated efficiency of communication for naturalism (e.g., "directly presenting what such states felt like"). I worry that this argument

233

thus contains the elements for a more general contention that abstraction, or indeed symbolization, is of necessity equated with escapism and falsity—a position I hope Professor Schorske did not intend to take. The last section of his essay on Klimt heavily loads the rhetorical dice, however, to equate naturalism and Art Nouveau with dynamism, real life, and direct confrontation with true, strong feelings, while linking abstraction to empty formalism, self-indulgence, and so on.

21. For information about the breakup within the Secession, see: Otto Breicha, "Gustav Klimt und die neue Wiener Malerei seiner Zeit," *Alte und moderne Kunst* (Vienna), 9, no. 74 (May–June 1964), pp. 32–37; Ludwig Hevesi, "Der Bruch in der Sezession," *Kunst und Kunsthandwerk* (Vienna), 8 (1905), pp. 424–29, reprinted in his *Acht Jahre Sezession*; Horst-Herbert Kossatz, "Der Austritt der Klimt-Gruppe: Eine Pressenachschau," *Alte und moderne Kunst* (Vienna), 20, no. 140 (1975), pp. 23–26; Robert Waissenberger, "Die 'heroischen Jahre' der Secession," in *Traum und Wirklichkeit: Wien, 1870–1930*, pp. 470–71.

22. Otto Stoessel, in the July 13, 1908, issue of *Die Fackel* (Vienna), quoted in English in Edith Hoffmann, *Kokoschka: Life and Work* (London: Faber & Faber, 1947), p. 88n. For further information on the *Kunstschau* and its critical reception in 1908, see Werner J. Schweiger, *Der junge Kokoschka: Leben und Werk, 1904–1914* (Vienna and Munich: C. Brandstätter, 1983), pp. 63 ff.

23. See Eberhard Freitag, "Expressionism and Schoenberg's Self-Portraits," and Wassily Kandinsky, "The Paintings of Schoenberg," in *Schoenberg as Artist*, special issue of *Journal of the Arnold Schoenberg Institute* (Los Angeles), 2 (June 1978), pp. 164–72 and 181–84; Jane Kallir, *Arnold Schoenberg's Vienna* (New York: Galerie St. Etienne; Rizzoli, 1984); *Richard Gerstl (1883–1908)*, exhibition catalogue (Vienna: Historisches Museum der Stadt Wien; Eigenverlag der Museen der Stadt Wien, 1984). For further references on Schönberg and Gerstl, see the Painting & Drawing section of the Bibliography, by artist.

24. See *Schoenberg as Artist*; Kallir, *Arnold Schoenberg's Vienna*.

25. For Kandinsky's view of Schönberg, see Kandinsky, "The Paintings of Schoenberg."

26. On Strindberg's paintings, see: Göran Söderström, *Strindberg och bildkonsten* (Stockholm, 1972); Torsten Matte Schmidt, ed., *Strindbergs maleri* (Malmö, 1972).

27. Cited by Ellen Kravitz in her Foreword to *Schoenberg as Artist*, p. 163.

28. Translated, as *Murder, Hope of Womankind*, in J. M. Ritchie, ed., *German Expressionism: Seven Expressionist Plays* (London: John Calder; Dallas: Riverrun Press, 1980), pp. 25–32. On the play and its reception, see Carl E. Schorske, "Explosion in the Garden: Kokoschka and Schoenberg,"

in his *Fin-de-Siècle Vienna*, pp. 335–38.

29. Hoffmann, *Kokoschka*, pp. 94–95.

30. Ibid., pp. 59–60.

31. For the fundamental work on Schiele's portraits, see Alessandra Comini, *Egon Schiele's Portraits* (Berkeley, Los Angeles, and London: University of California Press, 1974). The early, Klimt-inspired portraits are especially those of Hans Massmann and Anton Peschka of 1909, and of Schiele's sister Gertrud, of 1909.

32. Hoffmann, *Kokoschka*, pp. 52–53.

33. Kokoschka's *The Trance Actor* represented the actor Ernst Reinhold. In a special Kokoschka matinee in the Kabarett Fledermaus, Reinhold recited by heart *Die träumenden Knaben*; Schweiger, *Der junge Kokoschka*, pp. 45–46, 96. On Schiele and van Osen, see: Comini, *Egon Schiele's Portraits*, pp. 47, 50, 203–04, notes 66–68; Christian M. Nebehay, *Egon Schiele, 1890–1918: Leben, Briefe, Gedichte* (Salzburg: Residenz Verlag, 1979), pp. 551–52; Frank Whitford, *Egon Schiele* (New York: Oxford University Press, 1981), pp. 68–72.

34. See especially the series entitled *The Chained Columbus* (1916) and the *Bach Cantata* (1917); on Kokoschka's graphic work, see Hans M. Wingler and Friedrich Welz, *Kokoschka: Das druckgraphische Werk*, 2 vols. (Salzburg: Verlag Galerie Welz, 1975; 1981).

35. On the *Knight Errant*, see Angelica Z. Rudenstine, *The Guggenheim Museum Collection: Paintings, 1880–1945*, vol. 2 (New York: The Solomon R. Guggenheim Museum, 1976), pp. 426–31.

36. See Kokoschka's long memoir of his father, in Hoffmann, *Kokoschka*, p. 22, note 3.

37. See the discussion of Schiele's relationship with Gertrud in Comini, *Egon Schiele's Portraits*, pp. 9–19.

38. For a full consideration of the charges against Schiele, and of the circumstances of his imprisonment, see Alessandra Comini, *Schiele in Prison* (Greenwich, Conn.: New York Graphic Society, 1973).

39. See Comini's discussion of "Allegorical Double Portraits with Klimt," in her *Egon Schiele's Portraits*, pp. 95–99.

40. See Comini on "Allegory as Confession: A Last Self-Portrait with Wally," in *Egon Schiele's Portraits*, pp. 138–39.

41. See Robert Rosenblum, *Modern Painting and the Northern Romantic Tradition: Friedrich to Rothko* (London: Thames & Hudson; New York: Harper & Row, 1975).

42. See for example Comini's discussion of the ambiguities of Schiele's relationship with Klimt; *Egon Schiele's Portraits*, pp. 95–99.

43. See Comini, *Schiele in Prison*, for a complete discussion of the prison self-portraits.

44. For Paris von Gütersloh's statement about Schiele being well dressed, see Frank Whitford, *Egon Schiele*, p. 67.

45. I am indebted to Charles Stuckey for

his thoughts, in lecture and in conversation, on "posing" as a motif in Post-Impressionist and early modern painting.

46. On van Osen's studies of the gestures of the insane, see Whitford, *Egon Schiele*, p. 72.

47. Comini has considered the connections between Schiele's gestures and those of dancers such as Mary Wigman and Ruth St. Denis in *Egon Schiele's Portraits*, pp. 135, 234, note 7.

48. Comini remarks on the "puppet" quality of many of Schiele's portraits and self-portraits, in *Egon Schiele's Portraits*.

49. Max Klinger, *Malerei und Zeichnung* (1891; 2nd ed., Leipzig: Breitkopf & Härtel, 1895). For Klinger's graphic work, see Hans W. Singer, *Max Klingers Radierungen, Stiche und Steindrucke* (Berlin: Amsler & Ruthard, 1909).

50. See J. Kirk T. Varnedoe, with Elizabeth Streicher, *Graphic Works of Max Klinger* (New York: Dover, 1977).

51. On Kubin, see: Jane Kallir, *Alfred Kubin: Visions from the Other Side*, exhibition catalogue (New York: Galerie St. Etienne, 1983); Wieland Schmied, *Alfred Kubin* (New York and Washington, D.C.: Praeger, 1969). For further references on Kubin, see the Painting & Drawing section of the Bibliography, by artist.

52. See Henri Ellenberger, *The Discovery of the Unconscious* (New York: Basic Books, 1970), for a complete treatment of the background of Freud's work.

53. On Brosch, see Otfried Kastner, *Klemens Brosch*, exhibition catalogue (Linz: Stadtamt Linz, 1963). For further references on Brosch, see the Painting & Drawing section of the Bibliography, by artist.

54. Hoffmann, *Kokoschka*, p. 32.

CONCLUSION

1. On *The Family*, see Alessandra Comini, *Egon Schiele's Portraits* (Berkeley, Los Angeles, and London: University of California Press, 1974), pp. 174–80. See also Werner Hofmann, *Egon Schiele: "Die Familie,"* Reclams Werkmonographien zur bildenden Kunst, no. 132 (Stuttgart: Reclam, 1968).

2. Alois Riegl, *Spätrömische Kunstindustrie* (Vienna: Druck & Verlag der Kaiserlich-Königlichen Hof- und Staatsdruckerei, 1901), English ed., *Late Roman Art Industry* (Rome: G. Bretschneider, 1985); Alois Riegl, *Stilfragen: Grundlegung zu einer Geschichte der Ornamentik* (Berlin: G. Siemens, 1893; reprint, Hildesheim: G. Olms, 1975). On Riegl, see also: Dieter Bogner, "Empiria/speculazione: Alois Riegl e la scuola vienese di storia dell'arte," in *Le arti a Vienna: Dalla Secessione alla caduta dell'Impero Asburgico*, exhibition catalogue (Venice: Edizioni la Biennale di Venezia, 1984); Dieter Bogner, "Alois Riegl et l'école vien-

noise d'histoire de l'art," in *Vienne: Fin-de-siècle et modernité,* special issue of *Cahiers du Musée national d'art moderne* (Paris), 14 (1984), pp. 44–55.

3. Werner Hofmann, *Gustav Klimt and Vienna at the Turn of the Century,* trans. Inge Goodwin (Greenwich, Conn.: New York Graphic Society, 1971), pp. 34 ff.

4. Ibid., pp. 36 ff.

5. On Gestalt psychology, see Nicolas Pastore, *Selected History of Theories of Visual Perception* (New York: Oxford University Press, 1971), pp. 268–319.

6. Wilhelm Worringer, *Abstraktion und Einfühlung* (Munich, 1908); English ed., *Abstraction and Empathy: A Contribution to a Psychology of Style* (New York: International Universities Press, 1953).

7. Jules Lubbock, "Adolf Loos and the English Dandy," *The Architectural Review* (London), 174 (August 1983), p. 48. In "Mein Leben: Erinnerungen an Adolf Loos," *Alte und moderne Kunst* (Vienna), 15 (November–December 1970), pp. 4–6, Oskar Kokoschka recalls Loos showing up for duty in an open-collared uniform designed for him by Goldman *&* Salatsch.

8. Adolf Loos: "All art is erotic. The first ornament that was born, the cross, was of erotic origin. The first work of art, the first artistic act which the first artist scrawled on the wall to vent his exuberance was erotic. A horizontal line: the recumbent woman. A vertical line: the man penetrating her. . . . But the man of our own times who from an inner compulsion smears walls with erotic symbols is a criminal or a degenerate. . . . Just as ornament is no longer organically linked with our culture, so it is also no longer an expression of our culture." Cited in Alessandra Comini, *Gustav Klimt* (New York: Braziller, 1975), p. 6.

9. In the words of Karl Kraus: "Adolf Loos and I, he in facts and I in words, have done nothing but show that there is a difference between the urn and the chamber-pot and that culture plays on this difference. The others however, the defenders of positive values, can be divided into two groups: those who take the urn for a chamber-pot and those who mistake a chamber-pot for an urn." From "Nachts" (1918), published in Karl Kraus, *Beim Wort genommen,* in Heinrich Fischer, ed., *Karl Kraus: Werke* (Munich: Koesel, 1955); English translation from Benedetto Gravagnuolo, *Adolf Loos: Theory and Works,* trans. C. H. Evans (New York: Rizzoli, 1982).

10. Allan Janik and Stephen Toulmin, "Adolf Loos and the Struggle Against Ornament," a section of chapter 4, "Culture and Critique: Social Criticism and the Limits of Artistic Expression," of their *Wittgenstein's Vienna* (New York: Simon *&* Schuster, 1973), pp. 92 ff.

11. See note 38 of the chapter "Architecture."

12. Hugo von Hofmannsthal, "Ein Brief," *Der Tag* (Berlin), 1902; reprinted in *Die prosaischen Schriften, 1* (Frankfurt: S. Fischer, 1907); English ed., "The Letter of Lord Chandos," in Hugo von Hofmannsthal, *Selected Prose,* introduction by Hermann Broch (New York: Pantheon, 1952).

In the chronology, the entries for each year are divided into three groups: the works of art, buildings, and design objects that are discussed and illustrated in this volume; related events in Vienna; and a selection of major works and art-related events in Europe and in America. A work produced over a span of years is listed at the year of completion. Page numbers refer to illustrations.

1 · 8 · 9 · 8

Carl Otto Czeschka
Knowledge (p. 18).
Josef Hoffmann
Page from *Ver Sacrum* with Poem by Rainer Maria Rilke (p. 80); Stool for Koloman Moser (p. 82).
Gustav Klimt
Pallas Athene (p. 188); Poster for *Secession I* (p. 106); Studies for *Medicine* (p. 196).
Koloman Moser
Circular Window for Vienna Secession Building (pp. 56, 57); Cover of *Ver Sacrum* (p. 112).
Joseph Maria Olbrich
Vienna Secession Building (pp. 31, 56, 57); Poster for *Secession II and III* (p. 107).
Alfred Roller
Covers of *Ver Sacrum* (p. 112).
Otto Wagner
Perspective Drawing for Karlsplatz *Stadtbahn* Station (p. 24).

■ *Secession I,* first art exhibition of Vienna Secession group, at Gartenbaugesellschaft (Horticultural Society); includes works by Austrian members as well as by Arnold Böcklin, Fernand Khnopff, Alphonse Mucha, Franz von Stuck, James A. McNeill Whistler, and others.
■ *Secession II* opens Joseph Maria Olbrich's Vienna Secession Building; features works by Viennese members, including Gustav Klimt's *Pallas Athene,* and a room for applied arts, including wallpaper designs by Koloman Moser and Olbrich, as well as works by Fernand Khnopff and Anders Zorn.
■ Secession begins publishing periodical *Ver Sacrum.*
■ Künstlerhausgenossenschaft, exhibition society from which Secession members split off, organizes jubilee exhibition honoring fiftieth anniversary of Emperor Franz Josef's coronation.
■ *Kunst und Kunsthandwerk,* periodical devoted to applied arts, begins publication.

August Endell. Elvira Studio, Munich.
Hector Guimard. Castel Béranger, Paris.
Pierre Puvis de Chavannes dies.

Auguste Rodin. *Monument to Balzac.*
▶ London: First exhibition of International Society of Sculptors, Painters and Carvers, with James A. McNeill Whistler as president; includes works by Pierre Bonnard, Paul Cézanne, Edgar Degas, Fernand Khnopff, Gustav Klimt, Max Klinger, Édouard Manet, Odilon Redon, Giovanni Segantini, and Jan Toorop.

1 · 8 · 9 · 9

Josef Hoffmann
Project Drawing for a House (p. 40); Project Drawings for Interiors (pp. 40, 62).
Gustav Klimt
Study for *Philosophy* (p. 196).
Heinrich Lefler and Josef Urban
Design for a Calendar (p. 14).
Adolf Loos
Café Museum (p. 44); "Café Museum" Side Chair (p. 44).
Koloman Moser
Design for Cover of *Ver Sacrum* (p. 80); "Palm Leaf" Fabric (p. 114); "Vogel Bülow" Fabric (p. 81).
Joseph Maria Olbrich
David Berl House (p. 28); Villa Friedmann, Hinterbrühl (p. 28).
Otto Wagner
Cover of *Ver Sacrum* (p. 112); Karlsplatz *Stadtbahn* Station (pp. 24, 30); Majolikahaus and Adjoining Apartment Building at Linke Wienzeile 38 (p. 29).

■ *Secession III,* works by Walter Crane, Eugène Grasset, Max Klinger, Constantin Meunier, Félicien Rops, and Theo van Rysselberghe.
■ *Secession IV,* works by Austrian and foreign members of Secession.
■ *Secession V,* drawings and graphic art, predominantly by French artists.
■ Josef Hoffmann appointed to teaching position at Kunstgewerbeschule (School of Applied Arts).
■ Japanese woodcuts exhibited at Österreichisches Museum für Kunst und Industrie (Austrian Museum for Art and Industry).
■ Joseph Maria Olbrich invited by Ernst Ludwig, Grand Duke of Hesse, to join artists' colony on the Mathildenhöhe, Darmstadt; designs houses for all the artists (except Peter Behrens) and most of the buildings in the complex.

Victor Horta. Maison du Peuple, Brussels.
Charles Rennie Mackintosh. School of Art, Glasgow.
Edvard Munch. *The Dance of Life.*
Paul Signac publishes *D'Eugène Delacroix au néo-impressionnisme.*
▶ Berlin: Berlin Secession formed with Max Liebermann as first president; first exhibition includes works by Arnold Böcklin, Lovis Corinth, Ferdinand Hodler,

Wilhelm Leibl, Franz von Stuck, and others.

► London: Exhibition *L'art nouveau*, organized by Samuel Bing, includes Bing's collection of Japanese prints.

► St. Petersburg: Founding of magazine *Mir Iskusstva* ("World of Art"); contributors include Léon Bakst, Sergei Diaghilev, and Mikhail Vroubel.

1 • 9 • 0 • 0

Walter Sigmund Hampel
Evening (p. 193).
Gustav Klimt
Philosophy (slightly reworked through 1907; p. 152); Study for *Medicine* (p. 196).
Carl Moll
Twilight (p. 190).
Koloman Moser
"Mushrooms" Fabric (p. 114); "Poppy" Fabric (p. 114).
Robert Örley
"Cosmic Fog" Fabric (p. 114).

■ *Secession VI*, Japanese art.
■ *Secession VII*, includes Gustav Klimt's *Philosophy*, first of his three ceiling paintings for University of Vienna.
■ *Secession VIII*, applied arts; includes work of Charles Robert Ashbee, Charles Rennie Mackintosh (p. 84), and others.
■ Group of figurative artists who meet at café Zum Blauen Freihaus resign from Künstlerhaus and form Hagenbund, named after café's proprietor; hold position midway between progressives of Secession and conservatives of Künstlerhaus. Members include Oskar Laske, Heinrich Lefler, Michael Powolny, and Josef Urban.
■ Koloman Moser appointed to teaching position at Kunstgewerbeschule.
■ *Das Interieur*, periodical devoted to applied arts, begins publication with Joseph August Lux as editor.
■ First issue of *Die Quelle* ("The Source") published by Martin Gerlach, reproduces designs by many Secession artists.
■ Walter Crane exhibition at Museum for Art and Industry.
■ Hermann Bahr, writer and critic friendly to Secession, publishes *Secession*.

Paul Gauguin's *Noa-Noa* published in book form (first published in *La revue blanche*, 1897).
Hector Guimard. Métro Stations, Paris (through 1904).
Victor Horta. Hôtel Solvay, Brussels.
Pablo Picasso. *Le Moulin de la Galette.*
► Paris: *Exposition universelle*; includes an interior designed by Josef Hoffmann; Gustav Klimt's *Philosophy* wins award for best foreign painting.
 Auguste Rodin exhibition includes plaster version of *The Gates of Hell* (p. 153).

1 • 9 • 0 • 1

Karl Johann Benirschke
"Flower" Fabric (p. 119).
Adolf Böhm
Landscape (p. 160).
Josef Hoffmann
Double House for Carl Moll and Koloman Moser on the Hohe Warte (p. 41).
Gustav Klimt
Island in the Attersee (p. 191); *Judith I* (p. 189); *Medicine* (slightly reworked through 1907; p. 152).
Joseph Maria Olbrich
"Peacock" Schnapps Service (p. 111); Plate (p. 111); Poster for the Exhibition *Ein Dokument deutscher Kunst*, Darmstadt (p. 110).

■ *Secession IX*, Giovanni Segantini memorial exhibition; Auguste Rodin sculpture exhibition, including plaster model for *The Burghers of Calais*.
■ *Secession X*, includes Gustav Klimt's *Medicine*.
■ *Secession XI*, paintings by Johann Viktor Krämer.
■ *Secession XII*, Jan Toorop with Scandinavian, Swiss, and Russian artists.
■ Alfred Roller appointed to teaching position at Kunstgewerbeschule.
■ Hokusai exhibition at Museum for Art and Industry.
■ Künstlerhaus directors petition government for "Gallery of Modern Art" in Vienna; Secession sends separate message to same effect.

Peter Behrens. Behrens House, Darmstadt.
Joseph Maria Olbrich. Ernst Ludwig House, Darmstadt.
Aristide Maillol. *La Méditerranée.*
► Munich: Founding of artists' association Phalanx by Wassily Kandinsky, who becomes first president.

1 • 9 • 0 • 2

Leopold Bauer
Cup and Saucer (p. 118).
Josef Hoffmann
Installation Design for Max Klinger's *Beethoven* at Secession XIV (pp. 42, 43); House for Dr. Hugo Henneberg on the Hohe Warte (p. 41); Armchair (p. 85); "Long Ears" Fabric (p. 119); "Mushrooms" Fabric (p. 119).
Gustav Klimt
Beech Forest I (p. 192); *Beethoven Frieze* (pp. 42, 154, 155, 197); *Emilie Flöge* (p. 198).
Alfred Kubin
Africa (p. 179); *Self-Consideration* (p. 179).
Koloman Moser
Poster for *Secession XIII* (p. 109); "Purkersdorf" Armchair (p. 83); Sideboard and

Fireplace for Moser's Guest Room (p. 82).
Otto Wagner
Perspective Drawing for Steinhof Church (p. 53); Die Zeit Dispatch Bureau (p. 36).

■ *Secession XIII*, group exhibition; includes works by Die Scholle (Native Earth, Munich artists' union), Gustav Klimt, and Arnold Böcklin; Koloman Moser designs installation.
■ *Secession XIV*, Gustav Klimt creates *Beethoven Frieze* as part of installation of Max Klinger's sculpture *Beethoven*; installation designed by Josef Hoffmann. (Installation also includes reliefs by Hoffmann and murals by Alfred Roller and Adolf Böhm, all of which are destroyed when exhibition is dismantled.) *Beethoven Frieze* left on view another year, then dismantled and sold.
■ *Secession XV*, includes group Sztuka (Polish artists' union), design cooperative Wiener Kunst im Haus (Viennese Art in the Home), and etchings by Edvard Munch.
■ First Hagenbund exhibition.
■ Another Viennese artists' group, Jungbund, forms and has first showing at Künstlerhaus exhibition.
■ Carl Otto Czeschka becomes assistant drawing master at Kunstgewerbeschule.
■ Periodical *Die Fläche* ("The Plane") begins publication (through 1904); reproduces about 700 illustrations by contemporary artists, including J. M. Auchentaller, Max Benirschke, and Marcel Kammerer.

Julius Meier-Graefe publishes *Manet und sein Kreis*.
Auguste Perret. Apartment Building on rue Franklin, Paris.
Henry van de Velde. Interior of Folkwang Museum, Hagen, Germany.
► Berlin: Exhibition of twenty-two paintings from Edvard Munch's series *Frieze of Life*.
► New York: Flatiron Building completed.
► Paris: Exhibitions at Berthe Weill gallery include works by Pablo Picasso and Henri Matisse; Henri de Toulouse-Lautrec retrospective exhibition at Durand-Ruel gallery.
► Rome: *Esposizione internazionale di bianco e nero*, major international graphics exhibition.
► Turin: *Esposizione internazionale d'arte decorativa moderna*.

1 • 9 • 0 • 3

Josef Hoffmann
Design for Covered Bowl (p. 91); "Notschrei" Fabric (p. 88); Tea Service (p. 123).
Albin Lang
Project Drawing for a Bachelor's Room (p. 63).

Adolf Loos
Fireplace and Inglenook from Loos's Apartment (p. 49).
Carl Moll
Breakfast (p. 41).
Koloman Moser
Armchair (pp. 78, 79); Design for Cover of Wiener Werkstätte Brochure *Einfache Möbel für ein Sanatorium* ("Simple Furniture for a Sanatorium"; p. 220); Plant Stand (attrib.; p. 116).
Richard Müller
Project Drawing for a Bedroom (p. 63).
Michael Powolny
Flower Bowl (p. 118).
Alfred Roller
Poster for *Secession XVI* (p. 109).
Otto Wagner
Competition Design for Postal Savings Bank (pp. 58, 59).

■ *Secession XVI*, "the development of Impressionism in painting and sculpture"; includes works by Goya, El Greco, Rubens, Tintoretto, Velázquez, Vermeer, French Impressionists and Post-Impressionists, and Japanese woodcuts.
■ *Secession XVII*, includes work by artists associated with Wiener Werkstätte.
■ *Secession XVIII*, major Gustav Klimt retrospective exhibition, including unfinished *Jurisprudence;* installation designed by Josef Hoffmann and Koloman Moser.
■ Josef Hoffmann, Koloman Moser, Carl Otto Czeschka, and industrialist Fritz Wärndorfer found Wiener Werkstätte (Viennese Workshop).
■ Franz Metzner appointed to teaching post at Kunstgewerbeschule.
■ *Ver Sacrum* ceases publication.
■ Staatliche moderne Galerie (State Gallery of Modern Art) founded.
■ Gustav Klimt visits Ravenna, where he studies Byzantine mosaics.
■ Adolf Loos publishes periodical *Das Andere* ("The Other").
■ Camillo Sitte, early architect of Ringstrasse and former director of Kunstgewerbeschule, dies.

Paul Gauguin dies.
Victor Horta. L'Innovation Department Store, Brussels.
Pablo Picasso. *La Vie.*
Camille Pissarro dies.
Louis Sullivan. Carson, Pirie, Scott Store, Chicago.
James A. McNeill Whistler dies.
▶ Milan: Opening of Galleria d'Arte Moderna.
▶ Paris: Paul Gauguin retrospective exhibition at Ambroise Vollard gallery.

Josef Hoffmann
Box (p. 122); Designs for Three Chairs (p. 83); Perspective Drawing, Preliminary Design for West Façade, Purkersdorf Sanatorium (p. 45); "Purkersdorf" Side Chair (p. 86); Table for Carl Moll (p. 82); Tea Service (p. 124); "Vineta" Fabric (p. 119).
Josef Hoffmann and Koloman Moser
Interior of Casa Piccola, Flöge Sisters' Fashion Salon (p. 100).
Alfred Kubin
Primeval Mud (p. 179).
Koloman Moser
Plant Stand (p. 116); Sewing Box (p. 117); "Zuckerkandl" Armchair (p. 117).
Joseph Maria Olbrich
Creamer, Sugar Bowl, Teapot, and Coffeepot (p. 111).
Thonet Brothers and Marcel Kammerer
Table (p. 89).
Otto Wagner
Drawings for Steinhof Church (p. 33).

■ *Secession XIX*, works by Cuno Amiet, Akseli Gallen-Kallela, Ferdinand Hodler, Wilhelm Laage, Hans von Marées, Edvard Munch, Jan Thorn-Prikker, and E. R. Weiss.
■ *Secession XX*, includes sculpture by Franz Metzner and Hugo Lederer.
■ Secession proposes exhibit of Gustav Klimt's university ceiling paintings in room to be designed by Josef Hoffmann for St. Louis World's Fair, but idea is rejected.
■ Franz Cižek, fabric designer and pioneer in educating children through art, joins staff of Kunstgewerbeschule.
■ *Hohe Warte*, periodical devoted to architecture, city planning, and the decorative arts, begins publication (through 1908); Joseph August Lux, editor.
■ Oskar Kokoschka enters Kunstgewerbeschule; becomes member of Wiener Werkstätte (through 1909).
■ Works by Aubrey Beardsley shown at Galerie Miethke.

Frank Lloyd Wright. Larkin Building, Buffalo.
▶ Brussels: Vie et Lumière group founded by Belgian Impressionists.
▶ Paris: Henri Matisse exhibits at Salon des Indépendants.
 Camille Pissarro retrospective exhibition at Durand-Ruel gallery.
▶ St. Louis: World's Fair; includes exhibition from Kunstgewerbeschule (p. 63).

1 • 9 • 0 • 5

Carl Otto Czeschka
Bracelet (attrib.; p. 142).
Richard Gerstl
Two Sisters (Karoline and Pauline Fey) (p. 164).
Josef Hoffmann
Drawings for Palais Stoclet, Brussels (pp. 65, 66, 68); Candle Holder and Planter (p. 120); Coffeepot (frontispiece); Covered Bowl (p. 91); Eggcup and Spoon (p. 91); Necklace with Heart-Shaped Pen-

dant (pp. 100, 140); Planters, Centerpiece, and Vase (p. 121); Samovar with Stand and Burner (p. 90); Table for Hermann Wittgenstein (p. 90); Vase (p. 83).

Gustav Klimt
Margaret Stonborough-Wittgenstein (p. 199).

Bertold Löffler
Bowl (attrib.; p. 118); Candlestick (p. 118).

Koloman Moser
Bud Vase and Inkstand (p. 120); Cruets and Stand (pp. 86, 120); Designs for Side Windows and Apse Mosaic, Steinhof Church (pp. 33, 55); Necklace for Emilie Flöge (p. 141).

■ Secession XXI, foreign painters.
■ Secession XXII, sculpture by August Gaul, Josef Hanak, Max Klinger, Ivan Meštrovič, and Constantin Meunier.
■ Secession XXIII, contemporary Austrian art; includes Otto Wagner's designs for Steinhof church and for never completed Stadtmuseum.
■ Secession XXIV, Beuron art school.
■ Unable to act as Secession's dealer, Galerie Miethke instead shows Wiener Werkstätte work (p. 116).
■ Rudolf von Alt, honorary first president of Secession, dies (p. 150).
■ University of Vienna art commission rejects provisional installation of Gustav Klimt's ceiling paintings; Klimt buys paintings back from Ministry of Education.
■ After quarrels with other members, Klimt and his followers (the "Klimt Group") withdraw from Secession.
■ Josef Hoffmann, Koloman Moser, and Fritz Wärndorfer produce brochure explaining Wiener Werkstätte's program.
■ Hagenbund exhibition; includes Jungbund works.

Henri Matisse. Luxe, calme et volupté.
▶ Dresden: Formation of artists' association Die Brücke (The Bridge) by Fritz Bleyl, Erich Heckel, Ernst Ludwig Kirchner, and Karl Schmidt-Rottluff.
▶ New York: Little Galleries of the Photo-Secession opened by Alfred Stieglitz and Edward Steichen at 291 Fifth Avenue.
▶ Paris: First exhibition of Fauves at Salon d'Automne; critic Louis Vauxcelles gives them their name at this occasion.
First exhibition of Intimistes, including Pierre Bonnard, Henri Matisse, and Édouard Vuillard, at Henry Graves gallery.
Retrospective exhibitions for Georges Seurat and Vincent van Gogh at Salon des Indépendants.

■ **1 ◆ 9 ◆ 0 ◆ 6**

Ferdinand Andri
Poster for Secession XXV (p. 108).
Carl Otto Czeschka
Centerpiece (p. 137); Silver Box Commem-

orating the Emperor's Visit to the Skoda Factory, Pilsen (p. 96).

Josef Hoffmann
Purkersdorf Sanatorium (p. 45); Anniversary Table for the Wiener Werkstätte Exhibition Der gedeckte Tische ("The Laid Table"; p. 98); Cutlery for Lilly and Fritz Wärndorfer (p. 88); Inkwell (p. 86); "Seven Ball" Side Chair (p. 86).

Gustav Klimt
Farm Garden with Sunflowers (The Sunflowers) (p. 195); Garden Landscape (Blooming Meadow) (p. 194); Fritza Riedler (p. 201); Labels for Casa Piccola (p. 100).

Adolf Loos
Villa Karma, Montreux (pp. 49, 51).

Otto Wagner
Postal Savings Bank (pp. 34, 35, 58–60) and its furnishings: "Postal Savings Bank" Armchair (p. 35), Wall Light Fixture (p. 35), Warm-Air Blower (p. 61), "Sunflowers" Carpet Design (p. 81).

■ Secession XXV, works by members of Die Scholle.
■ Secession XXVI, woodcuts by Wassily Kandinsky.
■ Secession XXVII, decorative arts by Charles Robert Ashbee.
■ Wiener Werkstätte exhibition Der gedeckte Tische ("The Laid Table"; p. 98).
■ Heinrich Lefler and Ludwig Ferdinand Graf (members of Hagenbund) design Hölle (Hell), theater-cabaret in cellar of Theater an der Wien.
■ Michael Powolny and Bertold Löffler found Wiener Keramik (Viennese Ceramics) workshops, separate from Wiener Werkstätte.

Paul Cézanne. Large Bathers; Cézanne dies.
Henri Matisse. Joy of Life.
Pablo Picasso. Portrait of Gertrude Stein.
Henri Rousseau. The Snake Charmer.
Frank Lloyd Wright. Unity Temple, Oak Park, Illinois.
▶ Berlin: Die deutsche Jahrhundert Ausstellung ("German Centenary Exhibition").
▶ Dresden: First exhibition of Die Brücke artists.
▶ Paris: Exhibition of Russian art, organized by Sergei Diaghilev.
Paul Gauguin retrospective exhibition at Salon d'Automne.

■ **1 ◆ 9 ◆ 0 ◆ 7**

Carl Otto Czeschka
Border Design (p. 129); Cover of Program I, Kabarett Fledermaus (p. 129).
Josef Hoffmann
Kabarett Fledermaus (with Wiener Werkstätte; p. 93); Belt Buckle (p. 143).
Gustav Klimt
Adele Bloch-Bauer I (pp. 157, 200); Juris-

prudence (p. 153); Water Serpents I (p. 156).
Oskar Kokoschka
Portrait of an Old Man (Father Hirsch) (p. 206); Illustration for Program I, Kabarett Fledermaus (p. 94).
Bertold Löffler
Tiles for Kabarett Fledermaus (p. 93).
Adolf Loos
Kärntner Bar (p. 49).
Michael Powolny
Tiles for Kabarett Fledermaus (p. 93).
Otto Wagner
Steinhof Church (pp. 32, 33, 53–55).
Fritz Zeymer
Illustration for Program I, Kabarett Fledermaus (p. 129).

■ Secession XXVIII, Munich Secession.
■ Meeting of Gustav Klimt and Egon Schiele begins life-long friendship.
■ Galerie Miethke exhibits Klimt's university ceiling paintings.
■ Carl Otto Czeschka leaves Vienna for Hamburg but continues working with Wiener Werkstätte (through 1913).
■ Koloman Moser leaves committee of Wiener Werkstätte.
■ Wiener Werkstätte opens own sales office in Vienna; postcard and children's picture card (Bilderbögen) series inaugurated.
■ Vincent van Gogh exhibition at Galerie Miethke.

Antonio Gaudí. Casa Milá, Barcelona.
Henri Matisse. Blue Nude.
Joseph Maria Olbrich. Hochzeitsturm (Wedding Tower), Darmstadt.
Pablo Picasso. Les Demoiselles d'Avignon.
▶ Munich: Deutsche Werkbund formed under Hermann Muthesius.
▶ Paris: Paul Cézanne retrospective exhibition at Salon d'Automne.

■ **1 ◆ 9 ◆ 0 ◆ 8**

Carl Otto Czeschka
Illustrations for Die Nibelungen (pp. 95, 131); Vitrine, (p. 97).
Richard Gerstl
The Arnold Schönberg Family (p. 164); Laughing Self-Portrait (p. 164).
Josef Hoffmann
Kunstschau Wien 1908 Exhibition Pavilion (pp. 96, 97); Brooch (p. 143).
Emil Hoppe
Project Drawing for Design of Kunstschau Wien 1908 Exhibition Pavilion (p. 127).
Rudolf Kalvach
Poster for Kunstschau Wien 1908 (p. 134).
Gustav Klimt
Hope II (p. 203); The Kiss (pp. 158, 202).
Oskar Kokoschka
Drawings for Mörder Hoffnung der Frauen ("Murderer, Hope of Women"; p. 185); Die träumenden Knaben ("The Dreaming Youths"; pp. 94, 130); Young Girl in Three

Views (p. 184); Poster for *Kunstschau Wien 1908* (p. 135).

Bertold Löffler
Design for Wine List for Hotel Savoy (p. 221); Envelope for Kabarett Fledermaus (p. 92); Installation of Prints and Posters, *Kunstschau Wien 1908* Exhibition Pavilion (p. 96); Poster for Kabarett Fledermaus (p. 128); Poster for *Kunstschau Wien 1908* (p. 133).

Carl Moll
White Interior (p. 105).

Michael Powolny
Putto with "Spring" Flower Basket (p. 136).

Otto Prutscher
Necklace and Earrings (p. 145).

■ *Secession XXX,* exhibition in honor of Emperor Franz Josef.
■ *Secession XXXI,* modern Russian art.
■ Künstlerhaus holds jubilee art exhibition honoring sixtieth anniversary of Emperor Franz Josef's coronation.
■ Eighth International Congress of Architects held in Vienna; Otto Wagner named president.
■ International exhibition of architecture at Horticultural Society.
■ Egon Schiele first exhibits his work, at Klosterneuberg convent.
■ Oskar Kokoschka, Heinrich Lefler, Josef Urban, and other artists help organize Ringstrasse parade in honor of Emperor Franz Josef.
■ Joseph Maria Olbrich dies, in Düsseldorf. Grand Duke of Hesse requests that Gustav Klimt succeed Olbrich at Darmstadt; Klimt instead recommends Josef Hoffmann, who declines.
■ Albrecht Dürer Association holds jubilee exhibition.
■ Richard Gerstl commits suicide.
■ *Kunstschau Wien 1908* exhibition, devoted to Austrian art, organized by Österreichischer Künstlerbund (Austrian artists' union, more progressive artists who withdrew from Secession), with Gustav Klimt as president. Oskar Kokoschka's first important illustrated work, *Die träumenden Knaben* ("The Dreaming Youths"; pp. 94, 130), is exhibited. Major Gustav Klimt retrospective exhibition; installation designed by Koloman Moser.
■ Hagenbund exhibition honoring Emperor Franz Josef; includes works by members of Sztuka (Polish artists' union).
■ Exhibition of tableaux from Austrian history honoring Emperor Franz Josef; architecture designed by Josef Urban, tableaux groups and décor by Remigius Geyling, Carl Leopold Hollitzer, Heinrich Lefler, and Bertold Löffler.
■ Arnold Schönberg begins to paint.

Constantin Brancusi. *The Kiss* (p. 158).
Henri Matisse. *Harmony in Red* (p. 98); Matisse publishes *Notes d'un peintre.*

Wilhelm Worringer publishes *Abstraktion und Einfühlung* ("Abstraction and Empathy").
▶ Paris: Georges Braque's *Houses and Trees* (painted at l'Estaque) shown at Kahnweiler gallery; in his review, Louis Vauxcelles writes of *bizarreries cubiques* and of *cubes,* later coins term Cubism.

1 ✦ 9 ✦ 0 ✦ 9

Carl Otto Czeschka
Covered Goblet (p. 137); *Nude with Drapery* (p. 182).

Josef Hoffmann
Dance-Card Holder (p. 137).

Marcel Kammerer
Project Drawing for Reception Hall, Grand Hotel Wiesler, Graz (p. 74).

Oskar Kokoschka
Frauenmord and Poster for *Mörder Hoffnung der Frauen* ("Murderer, Hope of Women"; pp. 214, 215); *Hans Tietze and Erica Tietze-Conrat* (p. 167); *Ludwig Ritter von Janikowsky* (p. 207); *The Lunatic Girl* (p. 184); *Peter Altenberg* (p. 166).

Otto Wagner
Perspective Drawing for Neustiftgasse 40 (p. 38).

■ Bertold Löffler joins staff of Kunstgewerbeschule.
■ Wiener Werkstätte sales office opens in Karlsbad.
■ Alfred Roller named head of Kunstgewerbeschule.
■ Hagenbund exhibition; works by Wilhelm Busch.
■ *Kunstschau 1909,* includes works by Gustav Klimt and Egon Schiele as well as Cuno Amiet, Ernst Barlach, Pierre Bonnard, Maurice Denis, Paul Gauguin, Vincent van Gogh, Henri Matisse, Edvard Munch, Maurice de Vlaminck, and Édouard Vuillard. Two plays by Oskar Kokoschka produced, *Sphinx und Strohmann* ("Sphynx and Strawman," satiric comedy) and *Mörder Hoffnung der Frauen* ("Murderer, Hope of Women," drama of sex and violence).
■ Michael Powolny and Otto Prutscher join staff of Kunstgewerbeschule.
■ Neukunstgruppe (New Art Group) founded by Egon Schiele, Albert Paris von Gütersloh, Anton Faistauer, Anton Peschka, and others; first group show at Salon Pisko.

Peter Behrens. A.E.G. Gas-Turbine Factory, Berlin.
Frank Lloyd Wright. Robie House, Chicago.
▶ Munich: Founding of Neue Künstlervereinigung, with Wassily Kandinsky as first president; members include Alexei von Jawlensky, Alfred Kubin, and Gabriele Münter (Franz Marc joins later).

► Paris: Filippo Tommaso Marinetti's first Futurist manifesto published in *Le Figaro*.

1 • 9 • 1 • 0

Leopold Forstner
Female Figure for Vestibule of Palais Stoclet, Brussels (p. 65).
Josef Hoffmann
Decanter, Wine Glass, and Tumblers (p. 89); Samovar with Stand and Burner (p. 125); Tumbler (p. 89).
Gustav Klimt
The Park (p. 160); *Stoclet Frieze (Anticipation*, pp. 72–73; *Fulfillment*, p. 71).
Oskar Kokoschka
Herwarth Walden (p. 184); *Karl Kraus* (p. 184); *Paul Scheerbart* (p. 168).
Bertold Löffler
Design for Wiener Keramik Logo (p. 93).
Adolf Loos
Steiner House (p. 51).
Egon Schiele
The Artist Drawing Nude Model Before Mirror (p. 175); *Dr. Erwin von Graff* (p. 168); *Eduard Kosmack* (p. 208); *Reclining Male Model with Yellow Cushion* (p. 177); *Self-Portrait with Arm Twisted Above Head* (p. 212); *Standing Male Nude, Back View* (p. 174).
Arnold Schönberg
Critic I (p. 165); *Gaze* (p. 165).

■ Hagenbund exhibits works by members of Kéve (Hungarian artists' union).
■ Art pavilion at *International Exhibition of Hunting* features work of "Klimt Group," Secession, and Künstlerhaus.
■ Hagenbund exhibits works by Swedish artists.
■ Ludwig Hevesi, art critic, commits suicide.
■ Arnold Schönberg painting exhibition at Kunstsalon Heller.

Henri Matisse. *The Dance* (second version).
Pablo Picasso. *Portrait of Ambroise Vollard.*
► Berlin: Herwarth Walden founds weekly journal *Der Sturm*, featuring avantgarde music, literature, drama, and visual arts; many portrait drawings by Oskar Kokoschka reproduced (through 1912; p. 184).
► London: Roger Fry organizes exhibition *Manet and the Post-Impressionists*; includes works by Paul Cézanne, Vincent van Gogh, and Henri Matisse.
► Moscow: First exhibition of group Bubnovyi Valet (Jack of Diamonds); includes works by Natalie Gontcharova, Wassily Kandinsky, Mikhail Larionov, and Kasimir Malevich.
► Paris: Large representation of Cubists at Salon des Indépendants as well as at Salon d'Automne.

1 • 9 • 1 • 1

Klemens Brosch
Airship over Linz (p. 180).
Josef Hoffmann and Wiener Werkstätte
Palais Stoclet, Brussels (pp. 46, 64–73).
Adolf Loos
Haus am Michaelerplatz (Goldman & Salatsch Building; p. 48).
Egon Schiele
The Artist's Room in Neulengbach (p. 172); *Reclining Nude, Half Length* (p. 187); *Self-Portrait with Black Vase (Self-Portrait with Spread-Out Fingers)* (p. 209).
Otto Wagner
Ideal Design for Twenty-second Metropolitan District (p. 38).

■ Hagenbund exhibition, includes works by Anton Faistauer, Albert Paris von Gütersloh, and Oskar Kokoschka.
■ Gustav Klimt exhibition at Galerie Miethke.
■ Fashion division of Wiener Werkstätte, directed by Eduard Josef Wimmer-Wisgrill, obtains license to manufacture women's clothing.
■ Façade of Adolf Loos's completed Haus am Michaelerplatz causes public uproar.

Umberto Boccioni. *States of Mind.*
Georges Braque produces his first *papier collé.*
Walter Gropius and **Adolf Meyer.** Fagus Factory, Alfeld an der Leine, Germany.
Wassily Kandinsky publishes *On the Spiritual in Art.*
Mikhail Larionov. First Rayonist paintings.
Henri Matisse. *The Red Studio.*
► Munich: Formation of Der Blaue Reiter (Blue Rider) group by Wassily Kandinsky, Paul Klee, August Macke, and Franz Marc; first exhibition also includes works by Robert Delaunay, Henri Rousseau, and Arnold Schönberg.
► Moscow: Mikhail Larionov and Natalie Gontcharova leave Jack of Diamonds group and create new association, Oslinyi Khvost (Donkey's Tail).
► Rome: Austrian pavilion at international art exhibition features Gustav Klimt's *The Kiss, Jurisprudence,* and *Emilie Flöge*; works by Wiener Werkstätte shown.

1 • 9 • 1 • 2

Klemens Brosch
End of Work (p. 180); *Swallows over the South Shore* (p. 180).
Oskar Kokoschka
"Vortrag O. Kokoschka": Poster for a Kokoschka Reading at the Akademischer Verband für Literatur und Musik (p. 169).
Adolf Loos
Scheu House (p. 51).

Egon Schiele
Agony (p. 210); *Autumn Sun (Sunrise)* (p. 172); *Self-Portrait as a Prisoner* (p. 174).
Otto Wagner
Perspective Drawing for Second Villa Wagner (p. 37).
Eduard Josef Wimmer-Wisgrill
Designs for "Bubi" and "Franziska" Suits (p. 102).

■ Secession XL, posters.
■ Hagenbund exhibits works by Norwegian artists.
■ In Neulengbach, Egon Schiele is arrested and imprisoned twenty-four days for "display of an erotic drawing in a room open to children."
■ Hagenbund exhibition, in spring, is their last in the Zedlitzgasse; Viennese civic authorities forbid further use of exhibition rooms.
■ Josef Hoffmann founds Österreichische Werkbund (Austrian Society for the Promotion of the Creative Arts).
■ Wiener Keramik joins with workshops of Franz Schleiss to form Vereinigte Wiener & Gmunder Keramik (United Vienna and Gmund Ceramics).

Umberto Boccioni publishes *Technical Manifesto of Futurist Sculpture.*
Marcel Duchamp. *Nude Descending a Staircase, No. 2.*
Albert Gleizes and **Jean Metzinger** publish *Du Cubisme.*
Wassily Kandinsky and **Franz Marc** publish *Der Blaue Reiter Almanach.*
Pablo Picasso. *Ma Jolie; Guitar; Still Life with Chair Caning.*
► Berlin: Der Sturm gallery opens with exhibition of works by Blaue Reiter artists, expressionists, and Oskar Kokoschka.
► Paris: Futurist exhibition at Bernheim-Jeune gallery, includes works by Giacomo Balla, Umberto Boccioni, Massimo Carrà, Luigi Russolo, and Gino Severini (exhibition also shown in London, Berlin, and Brussels).

Formation of Section d'Or; first exhibition includes works by Alexander Archipenko, Albert Gleizes, Juan Gris, František Kupka, Fernand Léger, Jean Metzinger, Francis Picabia, and the three Duchamp brothers: Marcel Duchamp, Jacques Villon, and Raymond Duchamp-Villon.

1 • 9 • 1 • 3

Karl Bräuer
Project Drawing for a Bedroom, Primavesi Country House (p. 75).
Josef Hoffmann
Decanter and Wine Glass (p. 89).
Gustav Klimt
The Maiden (p. 205).
Arnold Nechansky
"Pompey" Fabric (p. 101).

Egon Schiele
Man and Woman (p. 213).
Eduard Josef Wimmer-Wisgrill
"Princess Metternich" Coat (p. 103).

■ *Secession XLIII,* includes six works by Egon Schiele.
■ Fritz Wärndorfer forced to leave post as manager of Wiener Werkstätte; emigrates to United States. Primavesi family begins to finance Werkstätte.

Guillaume Apollinaire publishes *Les peintres cubistes: Méditations ésthetiques.*
Umberto Boccioni. *Unique Forms of Continuity in Space.*
Wassily Kandinsky. *Improvisation No. 30, The Cannons.*
▶ Berlin: Herwarth Walden's *Erster deutscher Herbstsalon* opens at Der Sturm; includes works by Robert and Sonia Delaunay, Natalie Gontcharova, Wassily Kandinsky, Mikhail Larionov, Fernand Léger, Franz Marc, Piet Mondrian, and Futurist artists. Guillaume Apollinaire calls it "first Salon of Orphism."
▶ Moscow: Mikhail Larionov organizes *Mishen* ("Target") exhibition; includes works by Kasimir Malevich and Marc Chagall, and children's art.
▶ New York: *International Exhibition of Modern Art* (Armory Show) introduces European avant-garde to New York; includes works by Georges Braque, Paul Cézanne, Paul Gauguin, Vincent van Gogh, Henri Matisse, Pablo Picasso, Auguste Rodin, and Georges Seurat. Exhibition travels to Chicago and Boston.
▶ St. Petersburg: Première of Futurist opera *Victory over the Sun,* with sets by Kasimir Malevich.

1 • 9 • 1 • 4

Klemens Brosch
Birches, Barbed Wire, Fallen (p. 180).
Josef Hoffmann
Austrian Pavilion, Deutsche Werkbund Exhibition, Cologne (p. 50); Primavesi Country House, Winkelsdorf, Czechoslovakia (p. 50); Bracelet (p. 142).
Gustav Klimt
Baroness Elisabeth Bachofen-Echt (p. 204).
Oskar Kokoscka
Pietà—It Is Enough (p. 170); *The Tempest (Die Windsbraut)* (p. 170).
Egon Schiele
Man and Woman (Liebespaar) (p. 175); *Self-Portrait in Jerkin with Right Elbow Raised* (p. 176); *Yellow City* (p. 173).
Eduard Josef Wimmer-Wisgrill
Wiener Werkstätte Room, Austrian Pavilion, Deutsche Werkbund Exhibition, Cologne (p. 99).
Karl Witzmann
Exhibition Room for Decorative Arts, Austrian Pavilion, Deutsche Werkbund Exhibition, Cologne (p. 99).

■ Archduke Franz Ferdinand assassinated in Sarajevo, June 28.
■ World War I begins, July 28.

■ Works by Pablo Picasso shown at Galerie Miethke.

Giorgio de Chirico. *The Mystery and Melancholy of a Street.*
Marsden Hartley. *Portrait of a German Officer.*
Piet Mondrian. *Pier and Ocean* series.
Pablo Picasso. *The Glass of Absinth.*
Antonio Sant'Elia. Project for Città Nuova; Sant'Elia publishes *Manifesto of Futurist Architecture.*
▶ Cologne: Deutsche Werkbund exhibition includes model factory by Walter Gropius and Adolf Meyer and glass pavilion by Bruno Taut.
▶ London: Wyndham Lewis announces Vorticism in first issue of *Blast: Review of the Great English Vortex.*
▶ Milan: First exhibition of Nuove Tendenze group.
▶ Moscow: Vladimir Tatlin holds *First Exhibition of Painterly Reliefs* in his studio.
▶ New York: Exhibition *Negro Art* at Alfred Stieglitz's Little Galleries of the Photo-Secession.
▶ Rome: Exhibition of works by members of Österreichischer Künstlerbund.

1 • 9 • 1 • 5

Klemens Brosch
Memories of the Vienna Skating Rink (p. 180); *View Through the Glass Door* (p. 181).
Josef Hoffmann
Villa Skywa-Primavesi, Hietzing (p. 50); Pendant (p. 144); Wallet (p. 139).
Oskar Kokoschka
Knight Errant (p. 170).
Egon Schiele
Death and the Maiden (p. 211); *Seated Couple* (p. 148); *Self-Portrait with Raised Left Hand* (p. 176); *Two Girls Lying Entwined (Two Models)* (p. 177).

■ Otto Primavesi becomes manager of Wiener Werkstätte; Dagobert Peche becomes a member.

Vladimir Tatlin. Counter-Reliefs and Corner Counter-Reliefs.
▶ Moscow: Wassily Kandinsky returns to Russia.
▶ New York: Alfred Stieglitz begins publishing monthly *291,* dedicated to modern art.
 Marcel Duchamp moves to New York; begins using term "ready-made" for found objects.
▶ Petrograd: *0.10: The Last Futurist Exhibition of Pictures;* includes works by Kasimir Malevich, Liubov Popova, Vladimir Tatlin, and others; Tatlin's Suprematist works shown for first time.

1 · 9 · 1 · 6

Gustav Klimt
Friedericke Maria Beer (p. 102).
Alfred Kubin
War (version of an image originally conceived before 1903; p. 179).
Dagobert Peche
Embroideries (p. 104).

■ Wiener Werkstätte opens fashion shop on Kärntnerstrasse.

Umberto Boccioni dies in military training.
Franz Marc dies in war.
▶ Berlin: Der Sturm mounts Max Ernst's first exhibition.

Österreichischer Künstlerbund, of which Gustav Klimt is president, exhibits at Berlin Secession.
▶ Moscow: *Magazin* ("The Store") exhibition organized by Kasimir Malevich; includes works by Luibov Popova, Aleksandr Rodchenko, Vladimir Tatlin, and others.
▶ New York: Katherine S. Dreier becomes director of Society of Independent Artists.
▶ Zurich: Hugo Ball opens cabaret Voltaire; Dada movement launched by Guillaume Apollinaire, Jean Arp, Richard Huelsenbeck, Marcel Janco, Tristan Tzara, and others.

1 · 9 · 1 · 7

Egon Schiele
Arnold Schönberg (p. 17); *Four Trees* (p. 171); *Reclining Nude with Yellow Towel* (p. 186).

■ Oskar Kokoschka severely wounded at eastern front; suffers near breakdown; settles in Dresden to recuperate and secures teaching post at Dresden Academy.
■ Dagobert Peche founds and manages Zurich affiliate of Wiener Werkstätte (through 1919).

Edgar Degas dies.
Auguste Rodin dies.
▶ Ferrara: Carlo Carrà and Giorgio de Chirico found school of "metaphysical painting."
▶ Leiden: Theo van Doesburg announces program of de Stijl; among participants are Piet Mondrian, Bart van der Leck, and architect J. J. P. Oud. First issue of periodical *De Stijl*.

Mondrian develops Neoplasticism.
▶ Moscow: Aleksandr Rodchenko, Vladimir Tatlin, and Georgii Yakulov decorate interior of Café Pittoresque.
▶ New York: *First Annual Exhibition of the Society of Independent Artists;* includes works by Francis Picabia; Marcel Duchamp's ready-made *Fountain* rejected.
▶ Paris: First performance of ballet *Parade;*

music by Erik Satie, scenario by Jean Cocteau, décor and costumes by Pablo Picasso, choreography by Léonide Massine.

Guillaume Apollinaire coins term *surréalisme.*
▶ Zurich: Opening of Galerie Dada.

1 · 9 · 1 · 8

Gustav Klimt
The Bride (p. 161); *Johanna Staude* (p. 162).
Dagobert Peche
Jewelry Box (p. 104); Poster for Wiener Werkstätte Lace Department (p. 104); "Rosenkavalier" Fabric (p. 101).
Egon Schiele
The Family (p. 218); *Seated Nude in Shoes and Stockings* (p. 186).

■ Four major Viennese artists die: Gustav Klimt (February 6), Otto Wagner (April 11), Koloman Moser (October 10), and Egon Schiele (October 31).
■ *Secession XLIX,* includes major works by Egon Schiele, as well as works by Anton Faistauer, Albert Paris von Gütersloh, Ludwig Heinrich Jungnickel, Alfred Kubin, and Anton Peschka.
■ Exhibition of Schiele drawings at Galerie Arnot.

Guillaume Apollinaire dies.
Marcel Duchamp. *Tu m'* (his last painting).
Ferdinand Hodler dies.
Charles-Édouard Jeanneret [Le Corbusier] and **Amedée Ozenfant** publish manifesto of Purism in their *Après le cubisme.*
Kasimir Malevich. *Suprematist Composition: White on White.*
▶ Basel: Founding of artists' club Das Neue Leben; members include Jean Arp, Augusto Giacometti, and Marcel Janco.
▶ Berlin: Berlin Dada founded by Richard Huelsenbeck.
▶ Zurich: Exhibition *A Century of Viennese Painting* includes several works by Egon Schiele.

▪ BIBLIOGRAPHY ▪

GENERAL

Cultural Background

Benjamin. Walter. *Reflections: Essays, Aphorisms, Autobiographical Writings.* New York: Harcourt Brace Jovanovich, 1978.

Boyer, John W. *Political Radicalism in Late Imperial Vienna.* Chicago: University of Chicago Press, 1981.

Breicha, Otto, and Gerhard Fritsch, eds. *Finale und Auftakt: Wien, 1898–1914.* Salzburg: O. Müller, 1964.

Broch, Hermann. *Hugo von Hofmannsthal and His Time: The European Imagination, 1860–1920.* Edited and translated by Michael P. Steinberg. Chicago: University of Chicago Press, 1984.

Crankshaw, Edward. *The Fall of the House of Habsburg.* New York: Penguin, 1983.

Daviau, Donald G. *Der Mann von Übermorgen: Hermann Bahr, 1863–1934.* Vienna: Österreichischer Bundesverlag, 1984.

Feuchtmüller, Rupert, and Christian Brandstätter. *Markstein der Moderne: Österreichs Beitrag zur Kultur- und Geistesgeschichte des 20. Jahrhunderts.* Vienna, Munich, and Zurich: Molden, 1980.

Fuchs, Albert. *Geistige Strömungen in Österreich, 1867–1918.* Vienna: Löcker Verlag, n.d.

Hamann, Richard, and Jost Hermand. *Deutsche Kunst und Kultur von der Gründerzeit bis zum Expressionismus.* Vol., *Stilkunst um 1900.* Berlin: Akademie Verlag, 1967.

Janik, Allan, and Stephen Toulmin. *Wittgenstein's Vienna.* New York: Simon & Schuster, 1973.

Johnston, William M. *The Austrian Mind: An Intellectual and Social History, 1848–1938.* Berkeley, Los Angeles, and London: University of California Press, 1972.

Kraus, Karl. *"The Last Days of Mankind" by Karl Kraus.* Edited by Frederick Ungar. New York: Ungar, 1974.

————. *Karl Kraus: In These Great Times.* Edited by Harry Zohn. Manchester: Carcanet Press, 1976.

————. *No Compromise: Selected Writings of Karl Kraus.* Edited by Frederick Ungar. New York: Ungar, 1977.

Luft, David S. *Robert Musil and the Crisis of European Culture, 1880–1942.* Berkeley, Los Angeles, and London: University of California Press, 1980.

McGrath, William J. *Dionysian Art and Populist Politics in Austria.* New Haven and London: Yale University Press, 1974.

Musil, Robert. *Der Mann ohne Eigenschaften.* Vol. 1, Berlin: Rowohlt, 1930; vol. 2, Berlin: Rowohlt, 1932; vol. 3, Lausanne: Imprimerie centrale, 1943. English ed., *The Man Without Qualities.* Translated by Eithne Wilkins and Ernst Kaiser. New York: Perigee, 1980.

Die neue Körpersprache: Grete Wiesenthal und ihr Tanz (exhibition catalogue). Vienna: Hermesvilla; Eigenverlag der Museen der Stadt Wien, 1985.

Nielsen, Erika, ed. *Focus on Vienna 1900: Change and Continuity in Literature, Music, Art and Intellectual History.* Houston German Studies, no. 4. Munich: W. Fink, 1982.

Pascal, Roy. *From Naturalism to Expressionism: German Literature and Society, 1880–1918.* New York: Basic Books, 1973.

Rozenblit, Marsha L. *The Jews of Vienna, 1867–1914: Assimilation and Identity.* Albany, N.Y.: State University of New York Press, 1983.

Schorske, Carl E. *Fin-de-Siècle Vienna: Politics and Culture.* New York: Knopf, 1980.

Shedel, James. *Art and Society: The New Art Movement in Vienna, 1897–1914.* Palo Alto, Calif.: Society for the Promotion of Science, 1981.

Traum und Wirklichkeit: Wien, 1870–1930 (exhibition catalogue). Vienna: Historisches Museum der Stadt Wien; Eigenverlag der Museen der Stadt Wien, 1985.

Vienne: Fin-de-siècle et modernité. Special issue of *Cahiers du Musée national d'art moderne* (Paris), 14 (1984).

Wagner, Nike. *Geist und Geschlecht: Karl Kraus und die Erotik der Wiener Moderne.* Frankfurt am Main: Suhrkamp, 1982.

Werfel, Alma Mahler. *And the Bridge Is Love.* New York: Harcourt, Brace, 1958.

Worbs, Michael. *Nervenkunst und Psychoanalyse im Wien der Jahrhundertwende.* Frankfurt am Main: Europäische Verlags Anstalt, 1981.

Zweig, Stefan. *Die Welt von Gestern: Erinnerungen eines Europäers.* Stockholm, 1942. English ed., *The World of Yesterday: An Autobiography.* New York: Viking, 1943; reprint, Lincoln, Nebr.: University of Nebraska Press, 1964.

Art-Historical Background

Ahlers-Hestermann, Friedrich. *Stilwende: Aufbruch der Jugend um 1900.* Berlin: Gebrüder Mann, 1941; rev. ed., 1956.

Ankwicz von Kleehoven, Hans. "Die Anfänge der Wiener Secession." *Alte und*

moderne Kunst (Vienna), 5, nos. 6/7 (1960), pp. 6–10.

Le arti a Vienna: Dalla Secessione alla caduta dell'Impero Asburgico (exhibition catalogue). Venice: Edizioni la Biennale di Venezia, 1984.

Bahr, Hermann. Die Überwindung des Naturalismus. Dresden: E. Pierson, 1891.

———. Secession. Vienna: L. Rosner, 1900.

———. "Ein Brief an die Secession." Ver Sacrum (Vienna), 4 (1901), pp. 227–38.

Billcliffe, Roger, and Peter Vergo. "Charles Rennie Mackintosh and the Austrian Art Revival." The Burlington Magazine (London), 119 (November 1977), pp. 739–44.

Bisanz, Hans. "Edvard Munch og Portrett-Kunsten i Wien etter 1900." Årbok for Oslo Kommunes Kunstsamlinger (Oslo), 1963.

Bisanz-Prakken, Marian. "Das Quadrat in der Flächenkunst der Wiener Secession." Alte und moderne Kunst (Vienna), 27, nos. 180/181 (1982), pp. 40–46.

Breuer, Robert. "Zur Revision des Japonismus." Deutsche Kunst und Dekoration (Darmstadt), 19 (October 1906–March 1907), pp. 445–48.

Chipp, Herschel B. Viennese Expressionism, 1910–1924 (exhibition catalogue). Berkeley: University Art Gallery, University of California, 1963.

Franz Cizek: Pionier der Kunsterziehung (1865–1946) (exhibition catalogue). Vienna: Historisches Museum der Stadt Wien; Eigenverlag der Museen der Stadt Wien, 1985.

Clair, Jean. Vienne, 1880–1938: L'apocalypse joyeuse (exhibition catalogue). Paris: Centre Georges Pompidou, 1986.

Comini, Alessandra. "From Façade to Psyche: The Persistence and Transformation of Portraiture in Fin-de-Siècle Vienna." In Tibor Horvath, ed. Evolution générale et développements regionaux en histoire de l'art. Acts of the Twenty-second International Congress of Art Historians, 1969, Budapest. 1972.

———. "Vampires, Virgins and Voyeurs in Imperial Vienna." In Thomas B. Hess and Linda Nochlin, eds. Women as Sex Objects. Art News Annual 38. New York: Macmillan, 1972.

———. The Fantastic Art of Vienna. New York: Knopf, 1978.

Eschmann, Karl. Es war nicht alles Jugendstil zwischen 1890–1920. Kassel: Stauda, 1982.

Heller, Reinhold. "Recent Scholarship on Vienna's 'Golden Age': Gustav Klimt and Egon Schiele." Art Bulletin (New York), 59 (March 1977), pp. 111–18.

Hevesi, Ludwig. "Die Wiener Sezession und ihr 'Ver Sacrum.'" Kunstgewerbeblatt (Leipzig), 10 (May 1899), pp. 141–53.

———. Acht Jahre Sezession (März 1897–Juni 1905): Kritik, Polemik, Chronik. Vienna: Verlagsbuchhandlung Carl Konegen, 1906. Reprint, edited by Otto Breicha. Klagenfurt: Ritter Verlag, 1984.

———. Altkunst—Neukunst: Wien, 1894–1908. Vienna: Verlagsbuchhandlung Carl Konegen, 1909.

Hofmann, Werner. Modern Painting in Austria. Vienna: Kunstverlag Wolfrum, 1965.

———. Experiment Weltuntergang: Wien um 1900 (exhibition catalogue). Hamburg: Kunsthalle; Munich: Prestel Verlag, 1981.

Holme, Charles. "The Art Revival in Austria." The Studio (London), special issue, 1906.

Howarth, Thomas. Charles Rennie Mackintosh and the Modern Movement. London: Routledge & Kegan Paul, 1952.

Japanischer Farbholzschnitt und Wiener Secession (exhibition catalogue). Vienna: Österreichisches Museum für angewandte Kunst, 1973.

Kallir, Jane. Austria's Expressionism (exhibition catalogue). New York: Galerie St. Etienne; Rizzoli, 1981.

Kantor, Robert. "Art, Ambiguity and Schizophrenia." The Art Journal (New York), 24, no. 3 (1965), pp. 234–39.

Kossatz, Horst-Herbert. "The Vienna Secession and Its Early Relations with Great Britain." Studio International (London), 181 (January 1971), pp. 9–21.

Lux, Joseph August. "XIV. Kunst-Ausstellung der Vereinigung bildender Kuenstler Oesterreichs-Secession 1902: Klingers Beethoven und die moderne Raum-Kunst." Deutsche Kunst und Dekoration (Darmstadt), 10, no. 1 (1902), pp. 475 ff.

———. "Biedermeier als Erzieher." Hohe Warte (Leipzig and Vienna), 1 (1904–05).

Madsen, Stephen T. The Sources of Art Nouveau. New York: George Wittenborn, 1956.

Nebehay, Christian M. Ver Sacrum, 1898–1903. New York: Rizzoli, 1977.

Neuwirth, Walther M. "Die sieben heroischen Jahre der Wiener Moderne." Alte und moderne Kunst (Vienna), 9 (May–June 1964), pp. 28–31.

Pott, Gertrude. Die Spiegelung des Secessionismus im österreichischen Theater. Wiener Forschungen zur Theater und Medienwissenschaft, no. 3. Vienna and Stuttgart: W. Braumüller, 1975.

Powell, Nicolas. The Sacred Spring: The Arts in Vienna, 1898–1918. London: Studio Vista; Greenwich, Conn.: New York Graphic Society, 1974.

Ramberg, G. Zweck und Wesen der Sezession. Vienna, 1898.

Schmalenbach, Fritz. Jugendstil: Ein Beitrag zur Theorie und Geschichte der Flächenkunst. Würzburg: K. Triltsch, 1935.

Schmutzler, Robert. Art Nouveau—Jugendstil. Stuttgart: Gerd Hatje; New York: Abrams, 1962.

Schweiger, Werner J., ed. Wiener Jugendstilgärten. Vienna: Maioli, 1979.

Sekler, Eduard F. "Mackintosh and Vienna." The Architectural Review (London), 144 (December 1968), pp. 455–56.

Seling, Helmut, ed. Jugendstil: Der Weg ins 20. Jahrhundert. Heidelberg and Munich: Keyser, 1959.

Selz, Peter, and Mildred Constantine, eds. Art Nouveau: Art and Design at the Turn of the Century. New York: The Museum of Modern Art, 1960.

Sotriffer, Kristian. "Vincent van Gogh und sein Einfluss in Wien." Alte und moderne Kunst (Vienna), 9 (May–June 1964), pp. 26 ff.

Sotriffer, Kristian, ed. Der Kunst ihre Freiheit: Wege der österreichischen Moderne von 1880 bis zur Gegenwart. Vienna: Buch & Kunstverlag Tusch, 1984.

Ver Sacrum: Die Zeitschrift der Wiener Secession, 1898–1903 (exhibition catalogue). Vienna: Museen der Stadt Wien, 1982.

Vergo, Peter. Art in Vienna, 1898–1918: Klimt, Kokoschka, Schiele and Their Contemporaries. Oxford: Phaidon, 1975; rev. ed., 1981.

———. "Fritz Wärndorfer as Collector." Alte und moderne Kunst (Vienna), 26, no. 177 (1981), pp. 33–38.

———. Vienna 1900: Vienna, Scotland and the European Avant-Garde (exhibition catalogue). Edinburgh: National Museum of Antiquities of Scotland, 1983.

Vetter, Adolf. "Die Werkbundbewegung in Österreich." In Der Verkehr: Jahrbuch des Deutschen Werkbundes. Jena: E. Diederichs, 1914.

Wagner-Rieger, Renate, ed. Die Wiener Ringstrasse: Bild einer Epoche. 11 vols. Vienna, Cologne, and Graz: Verlag Hermann Böhlaus, 1969–70; Wiesbaden: Franz Steiner Verlag, 1972–.

Waissenberger, Robert. Die Wiener Secession. Vienna: Jugend & Volk Verlagsgesellschaft, 1971. English ed., Vienna Secession. London: Academy Editions, 1977.

———. "Hagenbund, 1900–1938: Geschichte der Wiener Künstlervereinigung." *Mitteilungen der Österreichischen Galerie* (Salzburg), 16, no. 60 (1972), pp. 54–130.

———. *Der Hagenbund* (exhibition catalogue). Vienna: Historisches Museum der Stadt Wien, 1975.

Waissenberger, Robert, ed. *Vienna, 1890–1920*. Vienna and Heidelberg: Verlag Carl Ueberreuter; English ed., New York: Rizzoli, 1984.

———. *Wien, 1870–1930: Traum und Wirklichkeit*. Salzburg and Vienna: Residenz Verlag, 1984.

Wien um 1900 (exhibition catalogue). Vienna: Künstlerhaus; Kulturamt der Stadt Wien; Historisches Museum der Stadt Wien, 1964.

Wunberg, Gotthart, ed. *Die Wiener Moderne: Literatur, Kunst und Musik zwischen 1890–1910*. Stuttgart: Reclam, 1982.

Zuckerkandl, Berta. *Zeitkunst Wien, 1901–1907*. Vienna and Leipzig: H. Heller, 1908.

ARCHITECTURE

Achleitner, Friedrich. *Österreichische Architektur im 20. Jahrhundert*. Salzburg and Vienna: Residenz Verlag, 1983.

Ankwicz von Kleehoven, Hans. "Austria and 20th Century Architecture." *Austria International* (Vienna), 1 (1950).

Behne, Adolf. *Der moderne Zweckbau*. Munich, 1926.

Borsi, Franco, and Ezio Godoli. *Wiener Bauten der Jahrhundertwende*. Stuttgart: Deutsche Verlags Anstalt, 1985. English ed., *Vienna 1900*. Translated by Marie-Hélène Agueros. New York: Rizzoli, forthcoming.

Dreger, Moritz. "Die neue Bauschule." *Ver Sacrum* (Leipzig), 2, no. 8 (1899), pp. 17–24.

Feuerstein, Günther. *Vienna Present and Past: Architecture, City Prospect, Environment*. Vienna: Jugend & Volk Verlagsgesellschaft, 1974.

Lux, Joseph August. *Die moderne Wohnung und die Ausstattung*. Vienna and Leipzig, 1905.

Mang, Karl, and Eva Mang. *Viennese Architecture, 1860–1930, in Drawings*. New York: Rizzoli, 1979.

Müller, Michael. *Die Verdrängung des Ornaments: Zur Dialektik von Architektur und Lebenspraxis*. Frankfurt: Suhrkamp, 1977.

Roth, Alfred. *Begegnung mit Pionieren: Le Corbusier, Piet Mondrian, Adolf Loos, Josef Hoffmann, Auguste Perret, Henry van de Velde*. Basel and Stuttgart: Birkhäuser Verlag, 1973.

Uhl, Ottokar. *Moderne Architektur in Wien von Otto Wagner bis heute*. Vienna and Munich: A. Schroll, 1966.

Josef Hoffmann

Baroni, Daniele, and Antonio D'Auria. *Josef Hoffmann e la Wiener Werkstätte*. Milan: Electa, 1981. German ed., *Josef Hoffmann und die Wiener Werkstätte*. Stuttgart: Deutsche Verlags Anstalt, 1984.

Behrens, Peter. "The Work of Josef Hoffmann." *Society of Architects Journal* (London), 2 (1924), pp. 589–99.

Bogner, Dieter. "Die geometrischen Reliefs von Josef Hoffmann." *Alte und moderne Kunst* (Vienna), 27, nos. 184/185 (1982), pp. 24–32.

Borsi, Franco, and Alessandro Perizzi. *Josef Hoffmann: Tempo e geometria*. Rome: Officina, 1982.

Breckner, Gunter. *Josef Hoffmann: Sanatorium Purkersdorf*. Vienna and New York: Galerie Metropol, n.d.

Eisler, Max. "Josef Hoffmann, 1870–1920." *Wendingen* (Amsterdam), special issue on Hoffmann, 3 (August–September 1920), pp. 4 ff.

Fagiolo, Maurizio. *Hoffmann: "Mobili semplici"—Vienna, 1900–1910* (exhibition catalogue). Rome: Emporio Floreale, 1977.

Fanelli, Giovanni, and Ezio Godoli. *La Vienna di Hoffmann, architetto della qualità*. Rome: Laterza, 1981.

Frey, Dagobert. "Josef Hoffmann zu seinem 50. Geburtstag." *Der Architekt* (Vienna), 23 (1920), pp. 65–80.

Gebhard, David. *Josef Hoffmann: Design Classics* (exhibition catalogue). Fort Worth: Fort Worth Art Museum, 1982.

Girardi, Vittoria. "Josef Hoffmann maestro dimenticato." *L'architettura* (Rome), 2 (October 1956), pp. 432–41.

Gresleri, Giuliano. *Josef Hoffmann*. Bologna: Zanichelli, 1981.

Josef Hoffmann, Architect and Designer, 1870–1956. Vienna and New York: Galerie Metropol, 1981.

Hoffmann, Josef. "Einfache Möbel." *Das Interieur* (Vienna), 2 (1901), pp. 193–208.

———. *Josef Hoffmann: Selbstbiographie*. Edited by Otto Breicha. Vienna and Munich: Ver Sacrum, 1972.

Hoffmann, Josef, and Koloman Moser. "Das Arbeitsprogramm der Wiener Werkstätte." *Hohe Warte* (Leipzig and Vienna), 1 (1904–05), p. 268.

Hofmann, Werner. "Josef Hoffmann, ein Formschöpfer unserer Zeit." *Das Forum* (Vienna), 3 (January 1956), pp. 36–37.

Khnopff, Fernand. "Josef Hoffmann, Architect and Decorator." *The International Studio* (London), 13 (May 1901), pp. 261–67.

Kleiner, Leopold. *Josef Hoffmann*. Berlin, Leipzig, and Vienna: E. Hübsch, 1927.

Lane, Terence. *Vienna 1913: Josef Hoffmann's Gallia Apartment* (exhibition catalogue). Melbourne: National Gallery of Victoria, 1984.

Levetus, A. S. "A Brussels Mansion Designed by Prof. Josef Hoffmann of Vienna." *The Studio* (London), 61 (1914), pp. 189–96.

Lux, Joseph August. "Innen-Kunst von Prof. Josef Hoffmann, Wien." *Innen-Dekoration* (Darmstadt), 13 (May 1902), pp. 129–52.

Rochowanski, Leopold W. *Josef Hoffmann: Eine Studie geschrieben zu seinem 80. Geburtstag mit Zeichnungen von Josef Hoffmann*. Vienna: Verlag der Österreichischen Staatsdruckerei, 1950.

Sekler, Eduard F. "The Stoclet House by Josef Hoffmann." In Douglas Fraser, Howard Hibbard, and Milton J. Lewine, eds. *Essays in the History of Architecture Presented to Rudolf Wittkower*. London: Phaidon, 1967.

———. *Josef Hoffmann: Das architektonische Werk—Monographie und Werkverzeichnis*. Salzburg: Residenz Verlag, 1982. English ed., *Josef Hoffmann: The Architectural Work—Monograph and Catalogue of Works*. Translated by John Maas. Princeton: Princeton University Press, 1985.

Vergo, Peter. "Fritz Wärndorfer and Josef Hoffmann." *The Burlington Magazine* (London), 235 (July 1983), pp. 402–10.

Zuckerkandl, Berta. "Josef Hoffmann." *Die Kunst* (Munich), 10 (1903–04), pp. 1–31.

Adolf Loos

Altenberg, Peter. "Eine neue 'Bar' in Wien." *Wiener Allgemeine Zeitung* (Vienna), February 22, 1909.

Banham, Reyner. "Ornament and Crime: The Decisive Contribution of Adolf Loos." *The Architectural Review* (London), 121 (February 1957), pp. 85–88.

Czech, Hermann, and Wolfgang Mistelbauer. *Das Looshaus*. Vienna: Verlag Löcker & Wögenstein, 1976; enlarged ed., Vienna: Löcker Verlag, 1984.

Gilber, Jacques, and Gilles Barbet. "Loos' Villa Karma." *The Architectural Review* (London), 145 (March 1969), pp. 215–16.

Glück, Franz. *Adolf Loos*. Paris: G. Crès, 1931.

———. "Adolf Loos und das Buchdrucken." *Philobiblon* (Hamburg), 20 (September 1976).

Gravagnuolo, Benedetto. *Adolf Loos: Theory and Works*. Translated by C. H. Evans. New York: Rizzoli, 1982.

Hitchcock, Henry-Russell. "Houses by Two Moderns" (Le Corbusier and Loos). *The Arts* (New York), 16 (September 1926), pp. 33–41.

Hofmann, Werner. "Die Emanzipation der Dissonanzen." In *Adolf Loos, 1870–1933: Raumplan—Wohnungsbau* (exhibition catalogue). Berlin: Akademie der Künste, 1983.

Jeanneret, Charles-Édouard [Le Corbusier]. Introduction to "Ornement et crime." *L'esprit nouveau* (Paris), 1 (November 15, 1920).

Kokoschka, Oskar. "Mein Leben: Erinnerungen an Adolf Loos." *Alte und moderne Kunst* (Vienna), 15 (November–December 1970), pp. 4–6.

Kossatz, Horst-Herman. "Josef Hoffmann, Adolf Loos und die Wiener Kunst der Jahrhundertwende." *Alte und moderne Kunst* (Vienna), 15 (November–December 1970), pp. 2–4.

Kraus, Karl. "Das Haus am Michaelerplatz." *Die Fackel* (Vienna), 12 (December 1910).

———. "Die Schönheit im Dienste des Kaufmannes: Offener Brief an Loos." *Die Fackel* (Vienna), 17 (December 1915).

———. "A. Loos, Rede am Grab." *Die Fackel* (Vienna), 35 (October 1933).

Kubinsky, Mihaly. *Adolf Loos*. Berlin: Henschel Verlag, 1970.

Kulka, Heinrich, ed. *Adolf Loos: Das Werk des Architekten*. Vienna: A. Schroll, 1931; reprint, 1979.

Künstler, Gustav. "Der 'Traditionalist' Adolf Loos." *Österreichische Zeitschrift für Kunst und Denkmalpflege* (Vienna), 22, no. 2 (1968), pp. 83–90.

Kurrent, Friedrich. *Adolf Loos* (exhibition catalogue). Munich: Museum Villa Stuck, 1982.

Loos, Adolf. *Das Andere: Ein Blatt zur Einführung abendländischer Kultur in Oesterreich* (Vienna), 1, nos. 1/2 (1903).

———. *Ins Leere gesprochen, 1897–1900*. Paris: G. Crès, 1921; reprint, Vienna: G. Prachner, 1981.

———. *Trotzdem, 1900–1930*. Innsbruck: Brenner Verlag, 1931.

———. *Adolf Loos: Sämtliche Schriften*.

Edited by Franz Glück. Vienna and Munich: Verlag Herold, 1962.

———. *Adolf Loos: Spoken into the Void—Collected Essays, 1897–1900*. Introduction by Aldo Rossi, edited by Joan Ockman, translated by Jane O. Newman and John H. Smith. Cambridge, Mass.: MIT Press, 1982.

———. *Die Potemkinsche Stadt: Verschollene Schriften 1897–1933*. Edited by Adolf Opel. Vienna: G. Prachner, 1983.

Adolf Loos. Special issue of *Bau: Schrift für Architektur und Städtebau* (Vienna), 25, no. 1 (1970).

Lubbock, Jules. "Adolf Loos and the English Dandy." *The Architectural Review* (London), 174 (August 1983), pp. 43–49.

Marilaun, Karl. *Adolf Loos*. Vienna and Leipzig, 1922.

Münz, Ludwig, and Gustav Künstler. *Adolf Loos, Pioneer of Modern Architecture*. Translated by Harold Meek. New York: Praeger, 1966.

Neutra, Richard. "Ricordo di Loos." *Casabella* (Milan), no. 233 (November 1959), pp. 45–46.

———. Review of *Adolf Loos: Pioneer of Modern Architecture*, by Ludwig Münz and Gustav Künstler. *Architectural Forum* (New York), 125 (July–August 1966), pp. 88–89, 116.

Perugini, G. *Perchè Loos*. Rome, 1970.

Rukschcio, Burkhardt. "Speisezimmermobiliar von Adolf Loos um 1900." *Alte und moderne Kunst* (Vienna), 26, no. 176 (1981), pp. 48–49.

Rukschcio, Burkhardt, and Roland L. Schachel. *Adolf Loos: Leben und Werk*. Salzburg: Residenz Verlag, 1982.

Rykwert, Joseph. "Adolf Loos: The New Vision." *Studio International* (London), 186 (July–August 1973), pp. 17–21.

Schachel, Roland L. "Adolf Loos, Amerika und die Antike." *Alte und moderne Kunst* (Vienna), 15, no. 113 (1970), pp. 6–10.

Worbs, Dietrich. "Adolf Loos in Vienna: Aesthetics as a Function of Retail Trade Establishments." *Architects Yearbook* (London), 14 (1974), pp. 181–96.

Joseph Maria Olbrich

Bahr, Hermann. "Ein Dokument deutscher Kunst." In *Bildung*. Berlin: Insel Verlag, 1900.

Clark, Robert Judson. "Joseph Maria Olbrich and Vienna." Ph.D. dissertation, Princeton University, 1974.

Creutz, Max. *Das Warenhaus Tietz in Düsseldorf*. Berlin: E. Wasmuth, 1909.

"Ein Dokument deutscher Kunst": Darm-

stadt, 1901–1976 (exhibition catalogue). Darmstadt: Hessisches Landesmuseum, 1976.

Hauptmann, Peter, and Klara Hauptmann. "The House of the Vienna Secession Movement." *Studio International* (London), 181 (April 1971), pp. 168–69.

Hevesi, Ludwig. "Das Haus der Sezession." *Kunst und Kunsthandwerk* (Vienna), 1 (June 1898), pp. 227–28, and 1 (December 1898), pp. 405–407.

———. "Ein modernes Landhaus von J. M. Olbrich." *Kunst und Kunsthandwerk* (Vienna), 2 (December 1899), pp. 430–44.

———. "Auf Olbrichs Spuren." *Fremdenblatt* (Vienna), October 25, 1908, pp. 17–18.

Hoffmann, H. C. "Joseph M. Olbrichs architektonisches Werk für die Ausstellung 'Ein Dokument deutscher Kunst' auf der Mathildenhöhe zu Darmstadt, 1901." *Kunst in Hessen und am Mittelrhein* (Darmstadt), 7 (1967).

Latham, Ian. *Joseph Maria Olbrich.* New York: Rizzoli, 1980.

Lux, Joseph August. "Ideen von Olbrich." *Der Architekt* (Vienna), 10 (October 1904), pp. 39–40.

———. *Joseph Maria Olbrich: Eine Monographie.* Berlin: E. Wasmuth, 1919.

Olbrich, Joseph Maria. "Das Haus der Secession." *Der Architekt* (Vienna), 5 (January 1899), p. 5.

———. *Ideen von Olbrich.* Introduction by Ludwig Hevesi. Vienna: Gerlach & Schenk, 1899; Leipzig: Baumgärtner, 1904.

———. *Architektur von Olbrich.* 4 vols. Berlin: E. Wasmuth, 1904.

Olbrich-Gedächtnis-Ausstellung (exhibition catalogue). Darmstadt: Ernst Ludwig Haus, 1908.

Joseph Maria Olbrich, 1867–1908 (exhibition catalogue). Darmstadt: Mathildenhöhe, 1983.

Joseph Maria Olbrich, 1867–1908: Das Werk des Architekten (exhibition catalogue). Darmstadt: Hessisches Landesmuseum, 1967.

Schreyl, Karl H. *Joseph Maria Olbrich: Die Zeichnungen in der Kunstbibliothek Berlin —Kritischer Katalog.* Berlin: Gebrüder Mann Verlag, 1972.

Sperlich, Hans G. *Versuch über Joseph Maria Olbrich.* Darmstadt: Justus-von-Liebig-Verlag, 1965.

Sterk, Harald. "Olbrich und der totale Anspruch der Kunst." *Neue Zeit* (Graz), June 19, 1968.

Veronesi, Giulia. *Joseph Maria Olbrich.* Milan: Il Balcone, 1948.

Wagner, Otto. "Joseph M. Olbrich" (obituary). *Hohe Warte* (Leipzig and Vienna), 4 (1908), pp. 257–58.

Otto Wagner

Asenbaum, Paul. "Otto Wagner: Möbel und Innenräume, ausgeführte Interieurs für Wohnungen und Villen." Dissertation, Universität Salzburg, 1984.

Asenbaum, Paul, Peter Haiko, Herbert Lachmayer, and Reiner Zettl. *Otto Wagner: Möbel und Innenräume.* Salzburg and Vienna: Residenz Verlag, 1984.

Aus dem Nachlass Otto Wagners: Unbekannte Entwürfe, Skizzen und Pläne. Vienna: Eternit-Impulse, 1984.

Aus der Wagner Schule. Vienna: A. Schroll, 1901.

Bernabei, Giancarlo. *Otto Wagner.* Bologna: Zanichelli, 1983.

Dreger, Moritz. "Otto Wagner's Kunstakademie." *Die Zeit* (Vienna), 216 (1898).

Frey, Dagobert. "Otto Wagner: Historische Betrachtungen und Gegenwartsgedanken." *Der Architekt* (Vienna), 22 (1919), pp. 1–9.

Geretsegger, Heinz, and Max Peintner. *Otto Wagner, 1841–1918: The Expanding City and the Beginnings of Modern Architecture.* Translated by Gerald Onn. New York: Rizzoli, 1979.

Giusti Baculo, Adriana. *Otto Wagner: Dall'architettura di stile allo stile utile.* Naples: Edizione scientifiche italiane, 1970.

Graf, Otto Antonia. *Die vergessene Wagnerschule.* Vienna: Jugend & Volk Verlagsgesellschaft, 1969.

———. Introduction to *Otto Wagner: Das Werk des Architekten* (exhibition catalogue). Darmstadt: Hessisches Landesmuseum, 1985.

Haiko, Peter. "Zum Frühwerk Otto Wagners." *Wiener Geschichtsblätter,* 29 (1974), pp. 282 ff.

———. "Otto Wagner: Von der Renaissance der Renaissance zur Naissance der Kunst." In *Wien und die Architektur des 20. Jahrhunderts.* Acts of the Twenty-fifth International Congress of Art Historians, 1983, Vienna. Forthcoming.

Haiko, Peter, Harald L. Löwenthal, and Mara Reissberger. "'Die weisse Stadt': Der Steinhof in Wien—Architektur als Reflex der Einstellung zur Geisteskrankheit." *Kritische Berichte* (Hamburg), 9, no. 6 (1981).

Hevesi, Ludwig. "Otto Wagners moderne Kirche (29. November 1899)." In *Acht Jahre Sezession (März 1897–Juni 1905): Kritik, Polemik, Chronik.* Vienna: Verlagsbuch-

handlung Carl Konegen, 1906. Reprint, edited by Otto Breicha. Klagenfurt: Ritter Verlag, 1984.

Hollein, Hans. *Otto Wagner*. Tokyo: A.D.A. Edita, 1978.

Die Kunst des Otto Wagner (exhibition catalogue). Vienna: Akademie der bildenden Künste, 1984.

Lux, Joseph August. *Die Wagner Schule 1902*. Leipzig: Baumgärtner, 1902.

———. *Otto Wagner: Eine Monographie*. Munich: Delphin, 1914.

———. "In memoriam Otto Wagner, Vienna." *Deutsche Kunst und Dekoration* (Darmstadt), 42 (April–September 1918), pp. 198–99.

———. "Otto Wagner und die neue Sachlichkeit." *Deutsche Kunst und Dekoration* (Darmstadt), 62 (June 1928), p. 203.

'Moderne Architektur': Professor Otto Wagner und die Wahrheit über beide. Vienna: Verlagsbuchhandlung Spielhagen & Schurich, 1897.

Neutra, Richard. "Meine Erinnerungen an Otto Wagner." *Baukunst und Werkform* (Nuremberg), 12, no. 9 (1959), p. 476.

Peichl, Gustav, ed. *Die Kunst des Otto Wagner* (exhibition catalogue). Vienna: Akademie der bildenden Künste; Wiener Akademie-Reihe, 1984.

Pirchan, Emil. *Otto Wagner, der grosse Baukünstler*. Vienna, 1956.

Pozetto, Marco, ed. *Die Schule Otto Wagners, 1894–1912*. Vienna and Munich: A. Schroll, 1980.

Roessler, Arthur. "Otto Wagner und seine Schule." In Otto Schönthal, ed. *Das Ehrenjahr Otto Wagners an der k.k. Akademie der bildenden Künste in Wien: Arbeiten seiner Schüler*. Vienna: E. Kosmack, 1912.

Roller, Paul, ed. *Otto Wagner Schule*. Vienna, 1902.

Sturm, Josef. *Schachner oder Wagner, zum Wettbewerb um den Bau des Kaiser Franz Josef Stadtmuseums*. Vienna, 1902.

Tietze, Hans. *Otto Wagner*. Vienna: Rikola, 1922.

Wagner, Otto. *Einige Skizzen: Projekte und ausgeführte Bauwerke*. 4 vols. Vienna: A. Schroll, 1892–1922.

———. *Moderne Architektur: Seinen Schülern ein Führer auf diesem Kunstgebiet*. Vienna, 1895. 4th ed., retitled *Die Baukunst unserer Zeit: Dem Baukunstjünger ein Führer auf diesem Kunstgebiet*. Vienna: A. Schroll, 1914; reprint, Vienna: Löcker Verlag, 1979.

———. *Zur Kunstförderung ein Mahnwort*. Vienna: E. Kosmack, 1909.

———. *Die Groszstadt: Eine Studie über diese*. Vienna: A. Schroll, 1911.

Otto Wagner (exhibition catalogue). Vienna: Historisches Museum der Stadt Wien, 1963.

Otto Wagner: Das Werk des Architekten, 1841–1918 (exhibition catalogue). Darmstadt: Hessisches Landesmuseum, 1963.

Otto Wagner: Vienna, 1841–1918—Designs for Architecture (exhibition catalogue). Oxford: Museum of Modern Art, 1985.

Wagner Schule: Projekte, Studien, Skizzen. Leipzig, 1905.

Wick-Wagner, Luise. "Der Freiheit eine Gasse: Versuch eines Porträts von Otto Wagner." *Baukunst und Werkform* (Nuremberg), 12, no. 9 (1959), pp. 476–84.

DESIGN

Adlmann, Jan E. *Vienna Moderne, 1898–1918: An Early Encounter Between Taste and Utility* (exhibition catalogue). Houston: Sarah Campbell Blaffer Gallery, University of Houston; New York: Cooper-Hewitt Museum, 1979.

Ankwicz von Kleehoven, Hans. "Dagobert Peche als Graphiker." *Die graphischen Künste* (Vienna), 49, nos. 2/3 (1926), pp. 51–60.

———. "Carl Otto Czeschka." *Alte und moderne Kunst* (Vienna), 6, no. 47 (1961), pp. 14–17.

Asenbaum, Paul, Stefan Asenbaum, and Christian Witt-Dörring, eds. *Moderne Vergangenheit: Wien, 1800–1900* (exhibition catalogue). Vienna: Künstlerhaus; Gesellschaft bildender Künstler Österreichs, 1981.

Asenbaum, Stefan, and Julius Hummel, eds. *Gebogenes Holz: Konstruktive Entwürfe—Wien, 1840–1910* (exhibition catalogue). Vienna: Künstlerhaus; Eigenverlag Julius Hummel & Stefan Asenbaum, 1979.

Bangert, Albrecht. *Jugendstil—Art Deco: Schmuck und Metall Arbeiten*. Munich: Heyne, Ratgeber, 1981.

Behal, Vera J. *Möbel des Jugendstils: Sammlung des Österreichischen Museums für angewandte Kunst in Wien*. Munich: Prestel Verlag, 1981.

Bisanz-Prakken, Marian. "Ludwig Heinrich Jungnickel." In *Oskar Laske, Ludwig Heinrich Jungnickel, Franz von Zülow* (exhibition catalogue). Vienna: Graphische Sammlung Albertina, 1978.

Brandstätter, Christian, ed. *Weihnachtskarten der Wiener Werkstätte*. Vienna: Molden, 1979.

Breiner-Neckel, Ilse. "Das Plakat der Wiener Sezession: Beitrag zur Untersuchung der Entwicklungsgeschichte des Plakats." Ph.D. dissertation, Universität Wien, 1958.

Bülow, J. "Architekt Dagobert Peche, Wien." *Deutsche Kunst und Dekoration* (Darmstadt), 32 (1913), p. 363.

Candilis, Georges. *Bugholzmöbel*. Stuttgart: Krämer, 1979.

Eisler, Max. "Ornament und Form: Zu den Arbeiten der Wiener Werkstätte." *Die Kunst* (Munich), 38 (1917–18), pp. 358–60.

———. "Dagobert Peche." *Deutsche Kunst und Dekoration* (Darmstadt), 45 (1919), p. 77.

Feuerstein, Günther. *Vienna Today and Yesterday: Arts and Crafts, Applied Art, Design*. Vienna: Jugend & Volk Verlagsgesellschaft, 1974.

Flögl, Mathilde. *Die Wiener Werkstätte, 1903–1928: Modernes Kunstgewerbe und sein Weg*. Vienna: Krystall Verlag, 1929.

Gerlach, Martin, ed. *Formenwelt aus dem Naturreich*. Vienna and Leipzig: M. Gerlach, 1906.

Giese, Herbert. "Aspekte des Wiener Kunstgewerbes um 1900: Dualismus als Prinzip." *Alte und moderne Kunst* (Vienna), 27, no. 183 (1982), pp. 33 ff.

Glas aus Wien: J. & L. Lobmeyr vom Biedermeier bis zur Gegenwart (exhibition catalogue). Zurich: Museum Bellerive, 1979.

Hansen, Traude. *Die Postkarten der Wiener Werkstätte: Verzeichnis der Künstler und Katalog ihrer Arbeiten*. Munich and Paris: Verlag Schneider-Henn, 1982.

———. *Wiener Werkstätte: Mode–Stoffe, Schmuck, Accessoires*. Vienna and Munich: C. Brandstätter, 1984.

Kallir, Jane. *Viennese Design and the Wiener Werkstätte*. New York: Braziller, forthcoming.

Kohn, Jacob, and Josef Kohn. *Bugholzmöbel* (exhibition catalogue). 1916. Reprint, Munich: Verlag Graham Dry, 1982.

Koller, Gabriele. "Die Kunstgewerbeschule des k.k. Österreichischen Museums für Kunst und Industrie, Wien, 1899–1905." Ph.D. dissertation, Universität Wien, 1983.

Kossatz, Horst-Herbert. *Ornamentale Plakatkunst Wiener Jugendstil, 1897–1914*. Salzburg: Residenz Verlag, 1970. English ed., *Ornamental Posters of the Vienna Secession*. London: Academy Editions, 1974; New York: St. Martin's Press, 1976.

Limberg, Eva. "Verzeichnis der Künstlerpostkarten der Wiener Werkstätte." *Antiquitätenzeitung* (Munich), 13 (1981), pp. 371–80.

Lux, Joseph August. *Das neue Kunstgewerbe in Deutschland*. Leipzig, 1908.

Mang, Karl. *Thonet, Bugholzmöbel*. Vienna: C. Brandstätter, 1982.

Mascha, Ottokar. *Österreichische Plakatkunst*. Vienna: Kunstverlag J. Löwy, 1915.

Meurer, M. *Vergleichende Formenlehre des Ornaments und der Pflanze*. Dresden, 1909.

Mrazek, Wilhelm. *Künstlerpostkarten aus der Wiener Werkstätte, 1908–1915*. Salzburg: Verlag Galerie Welz, 1977.

Mrazek, Wilhelm, ed. *Die Wiener Werkstätte: Modernes Kunsthandwerk von 1903–1932* (exhibition catalogue). Vienna: Österreichisches Museum für angewandte Kunst, 1967.

Müller, Dorothée. *Klassiker des modernen Möbeldesign: Otto Wagner, Adolf Loos, Josef Hoffmann, Koloman Moser*. Munich: Keyser, 1980.

Nebehay, Christian M. *Handzeichnungen, Secessionsplakate* (exhibition catalogue). Vienna: Galerie Christian Nebehay, 1974.

Neuwirth, Waltraud. *Das Glas des Jugendstils: Sammlung des Österreichischen Museums für angewandte Kunst, Wien*. Materialien zur Kunst des 19. Jahrhunderts, no. 9. Munich: Prestel Verlag, 1973.

————. *Österreichische Keramik des Jugendstils: Sammlung des Österreichischen Museums für angewandte Kunst, Wien*. Materialien zur Kunst des 19. Jahrhunderts, no. 18. Munich: Prestel Verlag, 1974.

————. *Wiener Keramik: Historismus, Jugendstil, Art Deco*. Braunschweig: Klinkhardt & Biermann, 1974.

————. *Wiener Gold und Silberschmiede und ihre Punzen 1867–1922*. 2 vols. Vienna, 1976.

————. *Wiener Werkstätte Keramik*. Vienna, 1981.

————. *Josef Hoffmann: Bestecke für die Wiener Werkstätte*. Vienna: W. Neuwirth, 1982.

————. *Wiener Werkstätte: Avantgarde, Art Deco, Industrial Design*. Vienna: W. Neuwirth, 1984.

Oberhuber, Oswald, and Erika Patka. *Frühes Industriedesign Wien, 1900–1908: Wagner, Kolo Moser, Loos, Hoffmann, Olbrich, Ofner*. Vienna: Galerie nächst St. Stephan, 1977.

————. *Eduard Josef Wimmer-Wisgrill: Modeentwürfe, 1912–1927, aus dem Besitz der Hochschule für angewandte Kunst in Wien*. Vienna: Hochschule für angewandte Kunst, 1983.

Pabst, Michael. *Wiener Grafik um 1900*. Munich: Verlag Silke Schreiber, 1984.

Rochowanski, Leopold W. *Wiener Keramik*. Leipzig and Vienna: Thrysos Verlag, 1923.

Schweiger, Werner J. "Tendenzen des Kunstgewerbes um die Jahrhundertwende: Marginalien und Realien in lexikalischer Form." In Helmuth Gsöllpointner, Angela Hareiter, and Laurids Ortner. *Design ist unsichtbar*. Vienna: Löcker Verlag, 1981.

————. *Wiener Werkstätte: Kunst und Handwerk, 1903–1932*. Vienna: C. Brandstätter, 1982. English ed., *Wiener Werkstätte: Design in Vienna, 1903–1932*. New York: Abbeville, 1984.

————. *Wiener Werkstätte Bilderbögen*. Vienna: C. Brandstätter, 1983.

Selle, Gert. *Jugendstil und Kunstindustrie: Zur Ökonomie und Ästhetik des Kunstgewerbes um 1900*. Ravensburg: Otto Maier Verlag, 1974.

Steinlein, Stephan. "Ludwig Heinrich Jungnickel, München." *Deutsche Kunst und Dekoration* (Darmstadt), 17 (November 1905).

Völker, Angela. *Wiener Mode und Modefotografie: Die Modeabteilung der Wiener Werkstätte, 1911–1932* (exhibition catalogue). Vienna: Österreichisches Museum für angewandte Kunst; Munich and Paris: Verlag Schneider-Henn, 1984.

Wendel, Georg. *Österreichisches Kunstgewerbe*. Vienna and Leipzig: Carl Fromme, 1920.

Wichmann, Siegfried, ed. *Konstruktiver Jugendstil, 1900–1908: Wiener Secession* (exhibition catalogue). Munich: Galerie Arnoldi-Livie, 1977.

————. *Jugendstil, Floral Funktional* (exhibition catalogue). Munich: Bayerisches Nationalmuseum, 1984.

Wiener Secession Druckgraphik, 1897–1972. Vienna: Vereinigung bildender Künstler "Wiener Secession," 1972.

Zuckerkandl, Berta. "Erinnerungen an Dagobert Peche." *Neues Wiener Journal* (Vienna), April 19, 1923, p. 3.

Koloman Moser

Ankwicz von Kleehoven, Hans. "Kolo Moser: Sein Leben und Schaffen" (manuscript of lecture, January 1927). Archiv Österreichische Galerie Wien.

Baroni, Daniele, and Antonio D'Auria. *Kolo Moser, Grafico e Designer* (exhibition catalogue). Milan: Padiglione d'Arte Contemporanea; Edizione Gabriele Mazotta, 1984.

Fenz, Werner. *Kolo Moser: Internationaler Jugendstil und Wiener Sezession*. Salzburg: Residenz Verlag, 1976.

———. *Koloman Moser: Graphik, Kunstgewerbe, Malerei.* Salzburg and Vienna: Residenz Verlag, 1984.

Gedächtnisausstellung Kolo Moser (exhibition catalogue). Vienna: Österreichisches Museum für angewandte Kunst, 1927.

Gerlach, Martin, ed. "Flächenschmuck von Koloman Moser." *Die Quelle* (Vienna), folio edition, 3 (1901–02).

Lux, Joseph August. "Josef Hoffmann, Kolo Moser." *Deutsche Kunst und Dekoration* (Darmstadt), 15 (1904–05), pp. 1–46.

Moser, Koloman. "Zu den Kunstverglasungen der Kirche der Niederösterreichischen Landes-Heil- und Pflege-Anstalten." *Deutsche Kunst und Dekoration* (Darmstadt), 21 (1907), p. 106.

———. "Mein Werdegang." *Velhagen und Klasings Monatshefte* (Bielefeld and Leipzig), 10 (1916).

Kolo Moser, Maler und Designer (exhibition catalogue). Vienna and New York: Galerie Metropol, 1982.

Nachlassausstellung Kolo Moser (exhibition catalogue). Vienna: Kunstverlag Wolfrum, 1920.

Oberhuber, Oswald, and Julius Hummel. *Koloman Moser, 1868–1918* (exhibition catalogue). Vienna: Hochschule für angewandte Kunst; Österreichisches Museum für angewandte Kunst, 1979.

Rösler, A. "Zu den Bildern von Koloman Moser, Wien." *Deutsche Kunst und Dekoration* (Darmstadt), 38 (1914).

Ver Sacrum (Leipzig), special issue on Koloman Moser, 4 (1899).

Zuckerkandl, Berta. "Koloman Moser." *Die Kunst* (Munich), 10 (1904).

PAINTING & DRAWING

For general works on painting and drawing, see Art-Historical Background

Klemens Brosch

Baum, Peter. *Klemens Brosch (1894–1926), Carl Anton Reichel (1874–1944), Aloys Wach (1892–1940)* (exhibition catalogue). Linz: Neue Galerie der Stadt Linz, Wolfgang Gurlitt Museum, 1982.

Kastner, Otfried. *Klemens Brosch* (exhibition catalogue). Linz: Stadtamt Linz, 1963.

Kirschl, Wilfried. *Der Zeichner Klemens Brosch* (exhibition catalogue). Innsbruck: Galerie im Taxispalais, 1979.

Oberleitner, Hans. *Gedächtnisausstellung Klemens Brosch: Zum 60. Geburtstag* (exhibition catalogue). Linz: Oberösterreichisches Landesmuseum, 1954.

Richard Gerstl

Breicha, Otto. "Gerstl, der Zeichner." *Albertina-Studien* (Vienna), Jg. 3, vol. 2 (1965).

Born, Wolfgang. "Ein österreichischer van Gogh." *Neues Wiener Journal* (Vienna), September 27, 1931.

Eisler, Georg. "Über Richard Gerstl." *Tagebuch* (Vienna), 21 (July–August 1966), pp. 24 ff.

Gerstl, Alois. "Biographische Aufzeichnungen über Richard Gerstl." *Mitteilungen der Österreichischen Galerie* (Salzburg), 18, no. 62 (1974), pp. 137–40.

Richard Gerstl, 1883–1908 (exhibition catalogue). Berlin: F. Gurlitt, 1932.

Richard Gerstl (1883–1908) (exhibition catalogue). Vienna: Historisches Museum der Stadt Wien; Eigenverlag der Museen der Stadt Wien, 1984.

Hofmann, Werner. "Der wiener Maler Richard Gerstl." *Das Kunstwerk* (Baden-Baden), 10, nos. 1/2 (1956–57).

Kallir, Otto [Nirenstein]. "Richard Gerstl (1883–1908): Beiträge zur Dokumentation seines Lebens und Werkes." *Mitteilungen der Österreichischen Galerie* (Salzburg), 18, no. 64 (1974), pp. 125–93.

Krapf, Almut. "Gerstls Diez-Bildnis." *Die Presse* (Vienna), August 8–9, 1981.

Mikl, Josef. "Richard Gerstl und der österreichische Kunstverstand." *Bau: Schrift für Architektur und Städtebau* (Vienna), no. 112 (1966).

Gustav Klimt

Bahr, Hermann. *Gegen Klimt.* Vienna: J. Eisenstein, 1903.

———. *Gustav Klimt: 50 Handzeichnungen.* Leipzig and Vienna: Thrysos Verlag, 1922.

Benesch, Otto. "Hodler, Klimt und Munch als Monumentalmaler" (1962). In *Otto Benesch: Collected Writings*, vol. 4. Edited by Eva Benesch. London: Phaidon, 1973.

Bisanz-Prakken, Marian. *Der Beethovenfries: Geschichte, Funktion, Bedeutung.* Salzburg: Residenz Verlag, 1977; enlarged ed., Deutscher Taschenbuch Verlag, 1980.

———. "Gustav Klimt und die Stilkunst Jan Toorops." *Klimt-Studien*, special issue of *Mitteilungen der Österreichischen Galerie* (Salzburg), 22/23, nos. 66/67 (1978–79).

———. "The Beethoven Exhibition of the Vienna Secession and the Younger Viennese Tradition of the *Gesamtkunstwerk*." In Erika Nielsen, ed. *Focus on Vienna 1900: Change and Continuity in Literature, Music, Art and Intellectual History.* Houston German Studies, no. 4. Munich: W. Fink, 1982.

———. "Der Beethovenfries von Gustav Klimt in der XIV. Ausstellung der Wiener Secession (1902)." In *Traum und Wirklichkeit: Wien, 1870–1930* (exhibition catalogue). Vienna: Historisches Museum der Stadt Wien; Eigenverlag der Museen der Stadt Wien, 1985.

Breicha, Otto, ed. *Gustav Klimt: Die goldene Pforte–Werk, Wesen, Wirkung. Bilder und Schriften zu Leben und Werk.* Salzburg: Verlag Galerie Welz, 1978.

Comini, Alessandra. *Gustav Klimt.* New York: Braziller, 1975.

———. *Gustav Klimt.* Tokyo: Serge Sabarsky, 1981.

Dobai, Johannes. "Das Bildnis Margaret Stonborough-Wittgensteins von Gustav Klimt." *Alte und moderne Kunst* (Vienna), 5 (August 1960), pp. 8–11.

———. "Zu Gustav Klimts Gemälde 'Der Kuss.'" *Mitteilungen der Österreichischen Galerie* (Salzburg), 12, no. 56 (1968), pp. 106 ff.

———. *Opera completa di Klimt.* Milan: Rizzoli, 1978.

———. *Gustav Klimt: Die Landschaften.* Salzburg: Verlag Galerie Welz, 1983.

Eisler, Max. *Gustav Klimt.* Vienna, 1920; English ed., Vienna, 1921.

Eisler, Max, ed. *Gustav Klimt: Eine Nachlese.* Vienna: Österreichische Staatsdruckerei, 1931.

Fischel, Hartwig. "Gustav Klimt." *Kunst und Kunsthandwerk* (Vienna), 21 (1918), pp. 66 ff.

Fischer, Wolfgang Georg. "Gustav Klimt und Emilie Flöge." *Alte und moderne Kunst* (Vienna): part 1, 28, nos. 186/187 (1983), pp. 8–15; part 2, 28, no. 188 (1983), pp. 28–33; part 3, 28, nos. 190/191 (1983), pp. 54–59.

Frodl, Gerbert. "Begegnung im Theater: Hans Makart und Gustav Klimt." *Klimt-Studien*, special issue of *Mitteilungen der Österreichischen Galerie* (Salzburg), 22/23, nos. 66/67 (1978–79).

Glück, Gustav. "Gustav Klimt: Einige Worte der Erinnerung." *Die bildenden Künste* (Vienna), 2 (1919), pp. 11 ff.

Hevesi, Ludwig. "Kunstschau Wien 1908." *Zeitschrift für bildende Kunst* (Leipzig), 19 (1908), pp. 245 ff.

Hofmann, Werner. *Gustav Klimt und die Wiener Jahrhundertwende.* Salzburg: Galerie Welz, 1970. English ed., *Gustav Klimt and Vienna at the Turn of the Century.* Translated by Inge Goodwin. Greenwich,

Conn.: New York Graphic Society, 1971.

Hofstätter, Hans H. *Gustav Klimt: Erotische Zeichnungen.* Cologne: DuMont, 1979.

Kallir, Jane. *Gustav Klimt, Egon Schiele* (exhibition catalogue). Essays by Thomas Messer and Alessandra Comini. New York: Galerie St. Etienne; Crown, 1980.

Gustav Klimt and Egon Schiele (exhibition catalogue). New York: The Solomon R. Guggenheim Museum, 1965.

Koller, Manfred. "Monumentale Kunst um 1900 und heute: Der Beethovenfries von Gustav Klimt—Entstehung und Schicksal." *Parnass* (Linz), 3 (1984), pp. 19 ff.

Leshko, Jaroslav. "Klimt, Kokoschka und die mykenischen Funde." *Mitteilungen der Österreichischen Galerie* (Salzburg), 13, no. 57 (1969), pp. 16–40.

Lux, Joseph August. "Kunstschau Wien 1908." *Deutsche Kunst und Dekoration* (Darmstadt), 23, no. 1 (1908–09), pp. 33–61.

Nebehay, Christian. "Gustav Klimt als Buchillustrator für die Zeitschrift 'Ver Sacrum.'" In *Festschrift für Dr. Josef Stummvoll.* Vienna, 1967.

———. *Gustav Klimt: Dokumentation.* Vienna: Verlag der Galerie Christian Nebehay, 1969.

———. *Gustav Klimt: Sein Leben nach zeitgenössischen Berichten und Quellen.* Munich: Deutscher Taschenbuch Verlag, 1979.

Novotny, Fritz. "Zu Gustav Klimts 'Schubert am Klavier.'" *Mitteilungen der Österreichischen Galerie* (Salzburg), 7, no. 51 (1963), pp. 90 ff.

Novotny, Fritz, and Johannes Dobai. *Gustav Klimt.* Salzburg: Verlag Galerie Welz, 1967; English ed., New York and Washington, D.C.: Praeger, 1968.

Ottmann, Franz. "Gustav Klimts 'Medizin.'" *Die bildenden Künste* (Vienna), 2 (1919), pp. 267 ff.

Sabarsky, Serge. *Gustav Klimt: Zeichnungen aus amerikanischem Privatbesitz* (exhibition catalogue). Vienna: Historisches Museum der Stadt Wien; Eigenverlag der Museen der Stadt Wien, 1985.

Salten, Felix. *Gustav Klimt.* Vienna and Leipzig, 1903.

Spiegel, Else. "Ferdinand Hodler über sein Kunstprinzip und über Klimt." *Wiener Feuilletons und Notizen-Correspondenz* (Vienna), January 26, 1904.

Strobl, Alice. "Zu den Fakultätsbildern von Gustav Klimt." *Albertina-Studien* (Vienna), Jg. 2, vol. 4 (1964), pp. 138–69.

———. *Gustav Klimt: Die Zeichnungen.* 3 vols. Salzburg: Verlag Galerie Welz, 1980–84.

Ver Sacrum (Vienna), special issue on Gustav Klimt, 6, no. 22 (1903).

Vergo, Peter. "Gustav Klimt's Beethoven Frieze." *The Burlington Magazine* (London), 115, no. 839 (1973), pp. 109 ff.

———. "Gustav Klimts 'Philosophie' und das Programm der Universitätsgemälde." *Klimt-Studien,* special issue of *Mitteilungen der Österreichischen Galerie* (Salzburg), 22/23, nos. 66/67 (1978–79).

Weixlgärtner, Arpad. "Gustav Klimt." *Die graphischen Künste* (Vienna), 35 (1912), pp. 49 ff.

Zuckerkandl, Berta. "Klimts Deckengemälde." *Deutsche Kunst und Dekoration* (Darmstadt), 22 (1908), pp. 69 ff.

Oskar Kokoschka

Benincasa, Carmine. *Oskar Kokoschka, 1886–1980.* Venice: Marsilio, 1984.

Biermann, Georg. *Oskar Kokoschka.* Bibliothek der jungen Kunst, no. 52. Leipzig and Berlin: Kinkhardt & Biermann, 1929.

Bisanz, Hans. *Oskar Kokoschka, die frühen Jahre* (exhibition catalogue). Vienna: Historisches Museum der Stadt Wien, 1983.

Breicha, Otto. *Oskar Kokoschka: Vom Erleben im Leben—Schriften und Bilder.* Salzburg: Galerie Welz, 1978.

Fenjö, Ivan. *Oskar Kokoschka, die frühe Graphik.* Vienna: Euro-Art, 1976.

Goldscheider, Ludwig. *Kokoschka.* Cologne: Phaidon, 1963.

Gordon, Donald E. "Oskar Kokoschka and the Visionary Tradition." In Gerald Chapple and Hans H. Schulte, eds. *The Turn of the Century: German Literature and Art, 1890–1915.* McMaster Colloquium on German Literature. Bonn: Bouvier Verlag, 1981.

Hodin, Josef Paul. *Bekenntnis zu Kokoschka: Erinnerungen und Deutungen.* Berlin and Mainz: Florian Kupferberg, 1963.

———. *Oskar Kokoschka: Sein Leben, seine Zeit.* Berlin and Mainz: Florian Kupferberg, 1968.

———. *Oskar Kokoschka: Eine Psychographie.* Vienna: Europa Verlag, 1971.

———. *Kokoschka und Hellas.* Vienna: Euro-Art, 1975.

Hoffmann, Edith. *Kokoschka: Life and Work.* Introduction by Herbert Read and two essays by Oskar Kokoschka. London: Faber & Faber, 1947.

Kamm, Otto. "Oskar Kokoschka und das Theater." Ph.D. dissertation, Universität Wien, 1958.

Kokoschka Lithographs (exhibition cata-

logue). London: The Arts Council of Great Britain, 1966.

Kokoschka, Oskar. *Die träumenden Knaben.* Leipzig: Kurt Wolff Verlag, 1917. Reprint, Vienna: Jugend & Volk Verlagsgesellschaft, 1968.

———. *A Sea Ringed with Visions [Spuren im Treibsand].* Translated by Eithne Wilkins and Ernst Kaiser. New York: Horizon, 1962.

———. *My Life.* Translated by David Britt. London: Thames & Hudson; New York: Macmillan, 1974.

Leshko, Jaroslav. "Oskar Kokoschka: Paintings, 1907–1915." Ph.D. dissertation, Columbia University, 1977.

Lischka, Gerhard J. *Oskar Kokoschka, Maler und Dichter.* Frankfurt am Main: Lang, 1972.

Rathenau, Ernest, ed. *Oskar Kokoschka: Handzeichnungen.* Vol. 1, Berlin: Ernest Rathenau, 1935; vol. 2, Berlin and London: E. Rathenau, 1962; vols. 3–5, New York and Berlin: E. Rathenau, 1966–77.

Russell, John. Introduction to *Oskar Kokoschka: Watercolors, Drawings, Writings.* New York: Abrams, 1963.

Sabarsky, Serge. *Oskar Kokoschka: Disegni e acquarelli.* Milan: Mazotta, 1983.

———. *Oskar Kokoschka: The Early Years, 1907–1924* (exhibition catalogue). New York: Serge Sabarsky Gallery, 1985.

Schvey, Henry J. *Oskar Kokoschka: The Painter as Playwright.* Detroit: Wayne State University Press, 1982.

Schweiger, Werner J. *Der junge Kokoschka: Leben und Werk, 1904–1914.* Vienna and Munich: C. Brandstätter, 1983.

Spielmann, Heinz, ed. *Oskar Kokoschka: Die Fächer für Alma Mahler.* Hamburg: Verlag Hans Christians, 1969.

Stefan, Paul. *Oskar Kokoschka: Dramen und Bilder.* Leipzig: Kurt Wolff Verlag, 1913.

Tietze, Hans. "Der Fall Kokoschka." *Der Kreis* (Hamburg), Jg. 7, vol. 2 (February 1930), pp. 81–85.

Westheim, Paul. "Oskar Kokoschka." *Das Kunstblatt* (Weimar), Jg. 1, vol. 10 (October 1917), pp. 289–320.

———. *Oskar Kokoschka: Das Werk Kokoschkas in 135 Abbildungen.* Berlin: Paul Cassirer Verlag, 1925.

Welz, Friedrich. *Oskar Kokoschka: Frühe Druckgraphik, 1906–1912.* Salzburg: Verlag Galerie Welz, 1977.

Wingler, Hans M. *Oskar Kokoschka: Das Werk des Malers.* Salzburg: Verlag Galerie Welz, 1956.

Wingler, Hans M., and Friedrich Welz. *Kokoschka: Das druckgraphische Werk.* 2 vols. Salzburg: Verlag Galerie Welz, 1975; 1981.

Alfred Kubin

Bisanz, Hans. *Alfred Kubin, Zeichner, Schriftsteller und Philosoph.* Munich: Spangenberg, 1977.

Breicha, Otto, ed. *Alfred Kubin: Weltgeflecht—Ein Kubin Kompendium/Schriften und Bilder zu Leben und Werk.* Salzburg: Verlag Galerie Welz, 1978.

Brockhaus, Christoph. *Alfred Kubin: Das zeichnerische Frühwerk bis 1904.* Baden-Baden: Staatliche Kunsthalle, 1977.

Esswein, Hermann. *Alfred Kubin: Der Künstler und sein Werk.* Munich, 1911.

Kallir, Jane. *Alfred Kubin: Visions from the Other Side* (exhibition catalogue). New York: Galerie St. Etienne, 1983.

Kubin, Alfred. *Die andere Seite: Ein phantastischer Roman.* Munich: Nymphenburger Verlag, 1908; reprint, Vienna, Linz, and Munich: E. Gerlach, 1952.

Alfred Kubin (exhibition catalogue). Hannover: Kestner Gesellschaft, 1964.

Alfred Kubin: Zum 90. Geburtstag (exhibition catalogue). Salzburg: Galerie Welz, 1967.

Marks, A. *Der Illustrator Alfred Kubin.* Munich: Spangenberg, 1977.

Mitsch, Erwin. *Alfred Kubin: Zeichnungen.* Salzburg, 1967.

Müller–Thalheim, Wolfgang K. *Erotik und Dämonie im Werk Alfred Kubins: Eine psycho-pathologische Studie.* Munich: Nymphenburger Verlag, 1970.

Raabe, Paul. *Alfred Kubin: Leben, Werk, Wirkung (Oeuvre Catalog).* Hamburg: Rohwolt, 1957.

Riemerschmidt, Ulrich, ed. *Alfred Kubin: Aus meinem Leben—Gesammelte Prosa mit 73 Abbildungen.* Munich: Spangenberg, 1974.

Sabarsky, Serge. *Alfred Kubin, 1877–1959: Exhibition of Drawings and Watercolors* (exhibition catalogue). New York: Serge Sabarsky Gallery, 1970.

Schmidt, Paul F. *Alfred Kubin.* Bibliothek der jungen Kunst, no. 6. Leipzig: Kinkhard & Bierman, 1924.

Schmied, Wieland. *Der Zeichner Alfred Kubin.* Salzburg: Residenz Verlag, 1967. English ed., *Alfred Kubin.* New York and Washington, D.C.: Praeger, 1969.

Schneditz, Wolfgang. *Alfred Kubin.* Vienna: Verlag Brüder Rosenbaum, 1956.

Sebba, Gregor. *Kubin's Dance of Death and Other Drawings.* New York: Dover, 1973.

Egon Schiele

Arnold, Matthias. *Egon Schiele: Leben und Werk.* Stuttgart: Belser, 1984.

Benesch, Heinrich. *Mein Weg mit Egon Schiele.* New York: Verlag Johannespresse, 1965.

Benesch, Otto. *Egon Schiele as Draughtsman.* Vienna: State Printing Office of Austria, 1950.

———. "Egon Schiele und die Graphik des Expressionismus" (1958). In *Otto Benesch: Collected Writings,* vol. 4. Edited by Eva Benesch. London: Phaidon, 1973.

———. "Egon Schiele." *Art International* (Lugano), 2, nos. 9/10 (1959), pp. 37–38, 75–76.

Bisanz, Hans. *Egon Schiele* (exhibition catalogue). Vienna: Historisches Museum der Stadt Wien, 1981.

Chipp, Herschel B. "An Early Sketchbook of Egon Schiele." *Artforum* (San Francisco), 2 (January 1964), pp. 32–33.

Comini, Alessandra. "Egon Schieles Kriegstagebuch 1916." *Albertina-Studien* (Vienna), 4, no. 2 (1966), pp. 86–102.

———. *Schiele in Prison.* Greenwich, Conn.: New York Graphic Society, 1973.

———. *Egon Schiele's Portraits.* Berkeley, Los Angeles, and London: University of California Press, 1974.

———. *Egon Schiele.* New York: Braziller, 1976.

Davis, Richard. "Portrait of Paris von Gütersloh by Egon Schiele in the Minneapolis Institute of Arts." *Art Quarterly* (Detroit), 19, no. 1 (1956), p. 93.

Demetrion, James T. *Egon Schiele and the Human Form: Drawings and Watercolors* (exhibition catalogue). Des Moines: Des Moines Art Center, 1971.

Fischer, Wolfgang. "Egon Schiele als Militärzeichner." *Albertina-Studien* (Vienna), 4, no. 2 (1966), pp. 70–82.

Grimschitz, Bruno. *Gedächtnisausstellung Egon Schiele* (exhibition catalogue). Vienna, 1928.

Gütersloh, Albert P. von. *Egon Schiele: Versuch einer Vorrede.* Vienna: Verlag Brüder Rosenbaum, 1911.

Hertlein, Edgard. "Frühe Zeichnungen von Egon Schiele." *Alte und moderne Kunst* (Vienna), 12, no. 95 (1967), pp. 32 ff.

Hofmann, Werner. *Egon Schiele: "Die Familie."* Reclams Werkmonographien zur bildenden Kunst, no. 132. Stuttgart: Re-

clam, 1968.

Kallir, Jane. *Gustav Klimt, Egon Schiele* (exhibition catalogue). Essays by Thomas Messer and Alessandra Comini. New York: Galerie St. Etienne; Crown, 1980.

Kallir, Otto [Nirenstein]. *Egon Schiele: Persönlichkeit und Werk.* Berlin, Vienna, and Leipzig: Paul Zsolnay Verlag, 1930. Reedited, with text in German and English, as Kallir, Otto [Nirenstein]. *Egon Schiele: Oeuvre Catalog of Paintings.* Essays by Otto Benesch and Thomas Messer. Vienna: Paul Zsolnay Verlag; New York: Crown, 1966.

——. *Egon Schiele: Das druckgraphische Werk.* Vienna: Paul Zsolnay Verlag, 1970. English ed., *Egon Schiele: The Graphic Work.* New York: Crown, 1970.

Karpfen, Fritz. *Das Egon Schiele Buch.* Vienna: Verlag der Wiener Graphischen Werkstätte, 1921.

Gustav Klimt and Egon Schiele (exhibition catalogue). New York: The Solomon R. Guggenheim Museum, 1965.

Koschatzky, Walter. "Aus einem Briefwechsel Egon Schieles." *Albertina-Studien* (Vienna), 2, no. 4 (1964), pp. 170 ff.

Koschatzky, Walter, ed. *Egon Schiele: Aquarelle und Zeichnungen.* Salzburg, 1968.

Künstler, Gustav. *Egon Schiele als Graphiker.* Vienna, 1946.

Leopold, Rudolf. *Egon Schiele: Paintings, Watercolors, Drawings.* Translated by Alexander Lieven. London and New York: Phaidon, 1973.

Malafarina, Gianfranco. *L'opera di Schiele.* Milan: Rizzoli, 1982.

Mitsch, Erwin. *Egon Schiele, 1890–1918.* Salzburg: Residenz Verlag, 1974. English ed., *The Art of Egon Schiele.* Translated by W. Keith Haughan. London: Phaidon, 1975.

——. *Egon Schiele: Drawings and Watercolors.* New York: Rizzoli, 1976.

Nebehay, Christian M. *Egon Schiele: Frühe Werke und Dokumentation* (exhibition catalogue). Vienna: Galerie Christian Nebehay, 1968.

——. *Egon Schiele, 1890–1918: Leben, Briefe, Gedichte.* Salzburg: Residenz Verlag, 1979.

Roessler, Arthur. *Egon Schiele.* Bedeutende Künstler: Monatsschrift für Künstler und Kunstfreunde, no. 3. Vienna and Leipzig: Verlag Brüder Rosenbaum, 1911.

——. *Egon Schiele im Gefängnis: Aufzeichnungen und Zeichnungen.* Vienna and Leipzig: Verlag Carl Konegen, 1922.

——. *Erinnerungen an Egon Schiele: Marginalien zur Geschichte des Menschentums eines Künstlers.* Vienna and Leipzig:

Verlag Carl Konegen, 1922.

——. "Zu Egon Schieles Städtebildern." *Österreichische Bau und Werkkunst* (Vienna), 2 (1925–26), pp. 9–14.

Roessler, Arthur, ed. *Briefe und Prosa von Egon Schiele.* Vienna: Verlag Richard Lanyi, 1921.

——. *In memoriam Egon Schiele.* Essays by Otto Benesch, Max Eisler, et al. Vienna: Verlag Richard Lanyi, 1921.

Sabarsky, Serge. *Egon Schiele disegni erotici.* Milan: Edizioni Gabriele Mazotta, 1981. English ed., *Egon Schiele: Watercolors and Drawings.* New York: Abbeville, 1983.

——. *Egon Schiele Aquarelle und Zeichnungen aus den Beständen des Historischen Museums der Stadt Wien und aus amerikanischem Privatbesitz* (exhibition catalogue). Hannover: Kestner Gesellschaft; Vienna: Historisches Museum der Stadt Wien, 1982.

——. *Egon Schiele, vom Schüler zum Meister: Zeichnungen und Aquarelle, 1906–1918* (exhibition catalogue). Vienna: Akademie der bildenden Künste; Milan: Edizioni Gabriele Mazotta, 1984.

Schwartz, Heinrich. "Schiele, Dürer and the Mirror." *Art Quarterly* (Detroit), 30, nos. 3/4 (1967), pp. 210–23.

Selz, Peter. "Egon Schiele." *Art International* (Lugano), 4, no. 10 (1960), pp. 39 ff.

Whitford, Frank. *Egon Schiele.* New York: Oxford University Press, 1981.

Wilson, Simon. *Egon Schiele.* Ithaca, N.Y.: Cornell University Press, 1980.

Arnold Schönberg

Breitenbach, Edgar. "Arnold Schönberg and the Blaue Reiter." *The Quarterly Journal of the Library of Congress* (Washington, D.C.), 34, no. 1 (1977), pp. 32–38.

Comini, Alessandra. "Through a Viennese Looking Glass Darkly: Images of Arnold Schönberg and His Circle." *Arts Magazine* (New York), 58 (May 1984), pp. 107–19.

Freitag, Eberhard. "Expressionism and Schoenberg's Self-Portraits." In *Schoenberg as Artist,* special issue of *Journal of the Arnold Schoenberg Institute* (Los Angeles), 2 (June 1978), pp. 164–72.

Grisebach, Lucius, ed. *Hommage à Schönberg: Der Blaue Reiter und das Musikalische in der Malerei der Zeit* (exhibition catalogue). Berlin: Nationalgalerie, 1974.

Gütersloh, Paris von. "Schönberg der Maler." In *Arnold Schönberg.* Munich: R. Piper Verlag, 1912.

Hahl-Koch, Jelena. "Abstraction et musique atonale: Kandinsky et Schönberg." *L'oeil*

(Paris), 250 (May 1976), pp. 24 ff.

Hahl-Koch, Jelena, ed. *Arnold Schoenberg, Wassily Kandinsky: Letters, Pictures and Documents*. Translated by John C. Crawford. London and Boston: Faber & Faber, 1984.

Hilmar, Ernst, ed. *Arnold Schoenberg Gedenkausstellung 1974* (exhibition catalogue). Vienna: Universal, 1974.

Hofmann, Werner. "Beziehung zwischen Malerei und Musik." In *Schönberg, Webern, Berg: Bilder, Partituren, Dokumente* (exhibition catalogue). Vienna: Museum des 20. Jahrhunderts; Verlag Brüder Rosenbaum, 1969.

Kallir, Jane. *Arnold Schoenberg's Vienna*. New York: Galerie St. Etienne, Rizzoli, 1984.

Kravitz, Ellen. "Schoenberg on Canvas: A Different View of Composer Arnold Schoenberg." *The Enquirer Magazine* (Cincinnati), May 11, 1975, pp. 16–17.

Kropfinger, Klaus. "Schönberg und Kandinsky." In *Arnold Schönberg* (exhibition catalogue). Berlin: Akademie der Künste, 1974.

Linke, Karl. "Gedanken zu Schönberg." *Der Merker* (Vienna), 2, no. 17 (1911), pp. 710–14.

Rufer, Josef. *The Works of Arnold Schoenberg: A Catalogue of His Compositions, Writings and Paintings*. Translated by Dika Newlin. London: Faber & Faber, 1962.

Russell, John. "Schoenberg the Painter." *Keynote* (New York), 6 (January 1983).

Stuckenschmidt, H. H. *Arnold Schoenberg: His Life, World and Work*. Translated by Humphrey Searle. New York: Schirmer, 1977.

Waissenberger, Robert. "Der Bereich der Malerei in Arnold Schönbergs Leben." In *Arnold Schönberg Gedenkausstellung, 1974* (exhibition catalogue). Vienna: Universal, 1974.

Wohlgemuth, Gerhard. "Schönberg und die Künste." In Mathias Hansen and Christa Müller, eds. *Arnold Schönberg, 1874–1951* (exhibition catalogue). Berlin: Akademie der Künste der Deutschen Demokratischen Republik, 1976.

Photographs reproduced in this volume have been provided, in the majority of cases, by the owners or custodians of the works, as indicated in the captions. The publishers have sought as far as possible permission to reproduce each illustration.

The photographers and sources of the illustrations are listed alphabetically below, followed by the number of the page on which each illustration appears. Unless otherwise indicated, a page number refers to all of the illustrations on that page.

Bill Aller, New York: 16, 94 middle, 113, 126, 132, 138

Der Architekt, vol. 9 (1903): 41 lower right

© The Art Institute of Chicago, all rights reserved: 172 bottom right

Chris Burke, New York: 107, 108

Comini, *Egon Schiele's Portraits,* © 1974 The Regents of the University of California: 176 left

Prudence Cuming Associates, Ltd., London: 65 right, 74, 87, 100 top right and bottom right, 127, 140 right, 141, 173

Deutsche Kunst und Dekoration; vol. 3 (October 1898–March 1899): 56, 57 bottom; vol. 10 (July 1902): 42, 43, 154 top, 155; vol. 19 (October 1906–March 1907): 45 (excepting top left), 98 right, 100 top left, 116 bottom; vol. 22 (April–September 1908): 152, 153 right; vol. 23 (October 1908–March 1909): 93 top left and bottom left, 96, 97, 105; vol. 25 (October 1909–March 1910): 47; vol. 34 (April–September 1914): 50 bottom right, 99

Phil Evola, New York: 184 center left and bottom left

© Galerie St. Etienne, New York, all rights reserved: 176 right

Galerie Welz, Salzburg: 154, 197 top

Sidney Geist, New York: 158 left

Marianne Haller, Südstadt: 78, 79

Victor Harrandt, Graphische Sammlung Albertina, Vienna, all rights reserved: 27 center and bottom, 148, 174, 175 bottom, 177 bottom, 179, 182 bottom, 184 bottom right, 196 (excepting top right), 197 bottom left and right

David Heald, The Solomon R. Guggenheim Museum, New York: 170 bottom

Helmut Kedro, Vienna Secession (Vereinigung bildender Künstler Wiener Secession): 31 bottom left

Kate Keller, The Museum of Modern Art, New York: 86 top left, 169, 215

© 1986 David Kellogg, New York: 102 bottom

Kleiner, *Josef Hoffmann,* © 1927 E. Hübsch Verlag: 50 (excepting lower right)

Stephen B. Leek, West Palm Beach: 101 top and center

Loos Archiv, Graphische Sammlung Albertina, Vienna: 44 bottom right, 49 top, 51 top

Georg Mayer, Vienna: 14, 33 top, 40, 55, 57 top, 62, 63, 81, 82 top left, 83 bottom left, 88 top right, 90 bottom right, 91 center, 102 top left and center, 103, 104 bottom right, 114, 123, 124 bottom, 125, 136 right, 137 bottom left and right, 139 top left and right

The Metropolitan Museum of Art, New York, all rights reserved: 101 bottom, 102 top right, 186 left

Franz Michalek, Stadtmuseum Linz-Nordico, all rights reserved: 181

Moderne Bauforme, vol. 13 (1914): 46, 68 bottom

© Direktion der Museen der Stadt Wien: 18, 19, 24, 26, 27 top, 33 bottom left and right, 36, 37, 38, 52, 53, 58, 59, 80, 92, 93 top right, 128, 129 top, 131 bottom, 136 left, 137 top, 139 bottom, 150, 151, 160 right, 172 bottom left, 182 top, 183 top left and bottom left, 184 top left, 188, 196 top right, 198, 209

© 1986 Museum Associates, Los Angeles County Museum of Art, all rights reserved: 94 top, 129 bottom left and right, 214

Nabbutt-Lieven, Vienna: 84

Jerome Neuner, New York: 30

Mali Olatunji, The Museum of Modern Art, New York: 112, 130

Osterreichische Postsparkasse, Vienna: 34

Knud Peter Petersen, Berlin: 28, 31 top right

Photo Achives, Österreichische National-bibliothek, Vienna: 161

© Photo Meyer, Vienna: 218

Eric Pollitzer, New York: 95, 131 top, 172 top, 186 top right

© Georg Riha, Vienna: 54, 60, 61

Serge Sabarsky Gallery, New York: 166, 207

© Roberto Schezen, New York: 31 top left, 32, 35 top, 48, 49 center and bottom, 51 center and bottom

Arnold Schoenberg Institute, University of Southern California, Los Angeles: 165

John Schwartz, New York: 89 top right, 111 top left, 116 top right, 117, 122, 124 top

Sekler, *Josef Hoffmann: The Architectural Work,* © 1985 Princeton University Press: 41 bottom left (from *Das Interieur,* vol. 4 [1903]), 75 (from *Das Interieur,* vol. 15 [1914])

Staatliche Kunstsammlungen Dresden, Gemäldegalerie Neue Meister, all rights reserved: 192

Lee Stalsworth: 106, 109 right, 110, 111 top right and bottom, 134, 135

Courtesy Mme Jacques Stoclet, Brussels, reproduction strictly forbidden: 64, 67, 69–73

Soichi Sunami: 160 left, 167

Tietze-Tilley, Vienna: 2, 120, 121, 140 left, 142 bottom, 145

Kirk Varnedoe, New York: 29, 83 bottom right, 153 left, 157

Ver Sacrum; vol. 1 (1898): 80; vol. 3 (1900): 84 top; vol. 4 (1901): 81

LENDERS TO THE EXHIBITION

Kunstbibliothek, Staatliche Museen Preussischer Kulturbesitz, Berlin

Staatliche Kunstsammlungen Dresden, Gemäldegalerie Neue Meister

Neue Galerie der Stadt Linz/Wolfgang-Gurlitt-Museum, Linz

Oberösterreichisches Landesmuseum, Linz

Stadtmuseum Linz-Nordico

Los Angeles County Museum of Art

The Minneapolis Institute of Arts

Bayerische Staatsgemäldesammlungen, Neue Pinakothek, Munich

The Metropolitan Museum of Art, New York

Musée d'Orsay, Paris

The National Gallery, Prague

Kunstmuseum Solothurn

Galleria d'Arte Moderna di Ca' Pesaro, Venice

Graphische Sammlung Albertina, Vienna

Historisches Museum der Stadt Wien

Hochschule für angewandte Kunst, Vienna

Museum moderner Kunst, Vienna

Niederösterreichisches Landesmuseum, Vienna

Österreichische Galerie, Vienna

Österreichisches Museum für angewandte Kunst, Vienna

Hirshhorn Museum and Sculpture Garden, Smithsonian Institution, Washington, D.C.

Joh. Backhausen & Söhne, Vienna

E. Bakalowits & Söhne, Vienna

Nelson Blitz, Jr.

Werner Blohm, West Germany

Tim Chu

Dr. Wolfgang Fischer, Vienna

Genossenschaftliche Zentralbank, Vienna

Bernard Goldberg

Julius Hummel, Vienna

Alice M. Kaplan

Ellen and Peter Landesmann, Vienna

Mr. and Mrs. Leonard A. Lauder

J. & L. Lobmeyr, Vienna

Miles J. Lourie

James May

Markus Mizné, Rio de Janeiro

Österreichische Postsparkasse, Vienna

The Robert Gore Rifkind Collection, Beverly Hills

Lawrence A. Schoenberg, Los Angeles

Wärndorfer Family

Anonymous lenders

Galerie Norbert A. Drey, Munich

Fischer Fine Art, London

Barry Friedman Ltd., New York

Nele Haas-Stoclet, Galerie Galuchat, Brussels

Galerie Metropol, New York and Vienna

Serge Sabarsky Gallery, New York

Estate of Dr. Otto Kallir, courtesy Galerie St. Etienne, New York

David Tunick, Inc., New York

Christa Zetter, Galerie bei der Albertina, Vienna

In the index, works of art are listed by artist. Page numbers in **bold** refer to illustrations. Birth and death dates are given for artists whose work is illustrated.